What Makes My Heart Sing

An Artist's Journey

LYNN MILLER-TAKACS

outskirts
press

What Makes My Heart Sing
An Artist's Journey
All Rights Reserved.
Copyright © 2022 Lynn Miller-Takacs
v4.0

The opinions expressed in this manuscript are solely the opinions of the author and do not represent the opinions or thoughts of the publisher. The author has represented and warranted full ownership and/or legal right to publish all the materials in this book.

This book may not be reproduced, transmitted, or stored in whole or in part by any means, including graphic, electronic, or mechanical without the express written consent of the publisher except in the case of brief quotations embodied in critical articles and reviews.

Outskirts Press, Inc.
http://www.outskirtspress.com

ISBN: 978-1-9772-4624-0.

Cover Photo © 2022 www.gettyimages.com. All rights reserved - used with permission.

Outskirts Press and the "OP" logo are trademarks belonging to Outskirts Press, Inc.

PRINTED IN THE UNITED STATES OF AMERICA

Table of Contents

Introduction ... i
Acknowledgments .. vii

Chapter 1 ... 1
Chapter 2 ... 3
Chapter 3 ... 6
Chapter 4 ... 9
Chapter 5 ... 12
Chapter 6 ... 14
Chapter 7 ... 18
Chapter 8 ... 29
Chapter 9 ... 34
Chapter 10 ... 40
Chapter 11 ... 42
Chapter 12 ... 46
Chapter 13 ... 50
Chapter 14 ... 52
Chapter 15 ... 54
Chapter 16 ... 56
Chapter 17 ... 61
Chapter 18 ... 64
Chapter 19 ... 69
Chapter 20 ... 73
Chapter 21 ... 78
Chapter 22 ... 81
Chapter 23 ... 83
Chapter 24 ... 87

Chapter 25 .. 92
Chapter 26 .. 99
Chapter 27 .. 115
Chapter 28 .. 117
Chapter 29 .. 122
Chapter 30 .. 123
Chapter 31 .. 133
Chapter 32 .. 136
Chapter 33 .. 140
Chapter 34 .. 142
Chapter 35 .. 145
Chapter 36 .. 148
Chapter 37 .. 153
Chapter 38 .. 159
Chapter 39 .. 161
Chapter 40 .. 163
Chapter 41 .. 168
Chapter 42 .. 178
Chapter 43 .. 182
Chapter 44 .. 183
Chapter 45 .. 208
Chapter 46 .. 210
Chapter 47 .. 217
Chapter 48 .. 227
Chapter 49 .. 228
Chapter 50 .. 235
Chapter 51 .. 239
Chapter 52 .. 249
Chapter 53 .. 253
Chapter 54 .. 255
Chapter 55 .. 259
Chapter 56 .. 264

Chapter 57	266
Chapter 58	268
Chapter 59	270
Chapter 60	277
Chapter 61	282
Chapter 62	286
Chapter 63	294
Chapter 64	297
Chapter 65	298
Chapter 66	299
Chapter 67	305
Chapter 68	312
Chapter 69	315
Chapter 70	321
Chapter 71	325
Chapter 72	328
Chapter 73	339
Chapter 74	347
Chapter 75	349
Chapter 76	350
Chapter 77	356
Chapter 78	359
Chapter 79	364
Chapter 80	366
Chapter 81	376
Chapter 82	380
Chapter 83	383
Epilogue	387

Introduction

For as long as I can remember, I've wanted to write a book, and I have made several attempts but never finished, except with this book, I had a strong desire to see it come to fruition, and it took roughly two years to complete. I have always been passionate about the arts (all of them), and I felt a strong desire to share these passions with my readers.

My story takes the reader along my journey as an artist, crafter, music lover, singer, dancer, entrepreneur, writer, and face painter, and I share my adventures, international travels, conventions, insights, and reflections. You will also learn about other artists I've met along my journey and about their incredible talents and unique accomplishments. The greatest thrill in my life is that I get to hang out with these amazing master artists when I attend conventions—I'm in their environment! As a young girl I was timid and placed artists on a pedestal, one that I felt I could never reach. Over time, however, I gained self-confidence and finally felt worthy of calling myself an artist.

I also share my dreams and accomplishments in hopes that you will be inspired enough to reach for your own dreams. And I relate my experiences meeting interesting people around the world who have had a tremendous impact on me. Their talents and

accomplishments have contributed to my drive and determination to write my book. You will also learn step-by-step how I started my face painting business.

I also talk about music and the arts in my book and take you through my amazing emotional connection with music and the arts. I share the pitfalls, fear, intimidation, self-doubt, disappointments, and failures I've encountered along my journey as well; but we all go through them. Failure is sometimes necessary in order to grow, and we just need to find the courage and strength to pick ourselves up and start again. Our suffering produces endurance, endurance produces character, and character produces hope.

Throughout my career I've had the pleasure of working at corporate events for the following companies as well as at the following festivals:

10th Street Market events – Modesto
Amazon Distributing – Tracy
American Swiss Sausage – Modesto
Baskin Robbin Corporate Headquarters
Big Valley Grace – Modesto
Blush Boutique – Ripon
Boyett Petroleum – Modesto
Brookside Country Club – Stockton
Ca' Momi Restaurant and Winery – Napa
CarMax – Modesto
Certified Farmers Market – Modesto
College of Merced – Merced
Comcast – Modesto
Community Hospice – Modesto
Condor Earth Technology – Stockton
DD's Discounts – Modesto
Del Rio County Club – Modesto
Del Taco – Modesto
Enochs High School – Modesto
EnviroTech Chemical Services – Modesto
Five Minute Car Wash – Modesto
GMP Glass & Pottery Makers – Tracy

Golden Valley Health – Merced
Gould Medical Group – Modesto
Grimbleby Coleman CPAs Inc. – Modesto
Hometown Buffet – Modesto
Inderjit S. Toor Construction – Modesto
Kaiser Permanente – Modesto
Kohl's Distribution Center – Patterson
Le Tote Clothing – Lodi
Les Schwab Tires – Sonora
MedAmerica – Modesto
Medic Alert Foundation – Turlock
Medline Industries – Stockton
Modesto Center Plaza fashion show
Modesto Girls Softball League – Modesto
Modesto Head Start School – Modesto
Modesto Nuts – Modesto
Monterey Village Apartments – Modesto
NAI Benchmark Commercial Real Estate – Modesto
Niagara Bottling – Modesto
Premise Health Center at Gallo – Modesto
Proctor Elementary – Castro Valley
Reply Incorporated – San Ramon
Ring Container Technologies – Modesto
Salvation Army – Modesto
Santa Clara High School – Santa Clara
Saputo Dairy – Gustine
Shayne & Company Creative Marketing
Shelter Cove Church – Modesto
Sixth Star Entertainment – Caribbean cruise ship tours
Sno-White Drive in – Modesto
Sprint store – Modesto
Sprint store – Manteca
St. Stanislaus School – Modesto
Stanislaus County Fairgrounds – Turlock

Staples Distribution Center – Stockton
Sysco Foods – Modesto
Teamsters Union 386 – Modesto
The Revival Center Church – Modesto
The Running Iron Restaurant – Modesto
The Villas at Villaggio – Modesto
Tracy Community Center – Tracy
Tracy Library – Tracy
Turlock Golf and Country Club – Turlock
Vermeulen and Company CPA – Ripon
Village East Apartments – Stockton
Vintage Faire Mall – Modesto
Wente Vineyards – Livermore
Winton-Ireland, Strom & Green Insurance – Turlock

Festivals FaceTheDesign has worked:

American Graffiti Festival
Atwater 4th of July Festival
Atwater Fall Festival
Brisbane Community Fair
City of Tracy – Blues, Brews and BBQ
City of Tracy – Art walk
Daly City Festival
Foster City Festival
Historic Downtown Turlock event
Hornitos Patron's Club Flea Market
Hughson Fruit & Nut Festival
Humboldt Artisans Crafts and Music Festival
Mariposa's Blazin' Hog Barbeque
Mariposa's Butterfly Festival
Millbrae Festival
Oakdale Christian Music Festival
Oakdale Concerts in the Park

Oakdale Cowboy Christmas
Oakhurst Fall Chocolate & Wine Festival
Relay for Life event
Ripon Color the Skies Balloon Festival
Salida Downtown event
Salida Town & Country Parade & Festival
San Bruno Festival
San Carlos Festival
San Jose Children's Funfest
San Mateo Downtown Street Fair
Waterford Heritage Days

Acknowledgments

My book would not have been possible without the support of friends and coworkers who gave me encouragement to write this book.

First and foremost, I give praise to the Holy Spirit for spiritual guidance throughout the writing of this book. I believe God planted the passion in me for the arts, and His guidance has led me to focus and stay on topic of my writing.

I'm grateful for my high school friend Sue Misbach, who introduced me to face painting and encouraged me to keep going.

I'm also grateful...

For Dad's encouraging expression: "If you always do what you always did, you'll always get what you've already got." His message has stuck with me for a lifetime, and I passed it on to my sons.

For Mom, who encouraged me with face painting and advised me to keep thorough business records, journals, and photos of my work. I never realized the importance of my recordkeeping and journaling, but I know now that it was meant to be for this book—to contribute my memories and experiences.

For my longtime dear friend Jack Snell, who was like a surrogate father to me. He was my loving support, confidant, and best friend for many years as I went through single parenting. I couldn't have

started my face painting business without his guidance. He was my rock.

Many thanks to my coworker John Harrington who has been my biggest cheerleader encouraging me to use my gifts and always plotting a new scheme for my business.

And to my dear friends and work partners Stacy and Tanya: thank you for always being there with your support, inspirational ideas and your gentle nudging to keep me going even when I was feeling down—love you guys!

I am grateful to my sister Nancy, who helped me unlock and rediscover my dreams to make them a reality.

Many, many thanks to my friends and colleagues in the industry, as well as the artists and master face and body painters who allowed me to name them in my book.

Thanks to my son Cody, who patiently listened to me chatting daily on the progress of my book.

Without my family, friends, coworkers, and artist colleagues and the inspiring events in my life, I could not have written this book. I hope you enjoy the reading!

Chapter 1

What are the arts anyway? The arts are considered a group of activities done by people with skill and imagination, the expression or application of human creative skill and imagination, typically in a visual form, such as painting, sculpture, music, theater, or literature, producing works to be appreciated primarily for their beauty or emotional power.

Wikipedia defines "the arts" as follows: "The arts are a very wide range of human practices of creative expression, storytelling, and cultural participation. They encompass multiple diverse and plural modes of thinking, doing, and being, in an extremely broad range of media. Both highly dynamic and a characteristically constant feature of human life, they have developed into innovative, stylized, and sometimes intricate forms. This is often achieved through sustained and deliberate study, training and/or theorizing within a particular tradition, across generations and even between civilizations. The arts are a vehicle through which human beings cultivate distinct social, cultural, and individual identities, while transmitting values, impressions, judgments, ideas, visions, spiritual meanings, patterns of life and experiences across time and space.

"Prominent examples of the arts include architecture, visual arts (including ceramics, drawing, filmmaking, painting, photography.

and sculpting), literary arts (including fiction, drama, poetry, and prose), performing arts (including dance, music, and theatre), textiles and fashion, folk art and handicraft, oral storytelling, conceptual and installation art, philosophy, criticism, and culinary arts (including cooking and winemaking). They can employ skill and imagination to produce objects, performances, convey insights and experiences, and construct new environments and spaces.

"The arts can refer to common, popular, or everyday practices as well as more sophisticated and systematic, or institutionalized ones. They can be discrete and self-contained, or combine and interweave with other art forms, such as the combination of artwork with the written word in comics. They can also develop or contribute to some particular aspect of a more complex art form, as in cinematography.

"By definition, the arts themselves are open to being continually redefined. The practice of modern art, for example, is a testament to the shifting boundaries, improvisation and experimentation, reflexive nature, and self-criticism or questioning that art and its conditions of production, reception, and possibility can undergo.

"As both a means of developing capacities of attention and sensitivity, and as ends in themselves, the arts can simultaneously be a form of response to the world, and a way that our responses, and what we deem worthwhile goals or pursuits, are transformed. From prehistoric cave paintings, to ancient and contemporary forms of ritual, to modern-day films, art has served to register, embody, and preserve our ever-shifting relationships to each other and to the world."

Chapter 2

I wonder if creativity is something we are born with. I've heard some say that we are born with a creative gift. The spiritual gift of creativity is supposedly the special ability to spread the awareness of God's glory by creating things and/or new ways of doing things. Art is a gift from God that nourishes the human soul. Like all gifts that God gives, the gift of art is to be developed and then used for His glory.

But what is art for and where does it come from? I often wonder if I was born with my gift from God or if it was genetic. And if it grew from the beauty of living in Humboldt County (Northern California), with its rushing rivers; streams; redwood trees; fresh, clean crisp air; constant rain; and ocean beaches. As an artist, I've pondered how exactly my art can fit into my life and plans.

"It's not precisely your art, or my art: the capacity and ability to create art is not an innate skill. It's a gift, as Edward Yang puts it, for stimulating and 'inspiring human flourishing.' It's a gift that keeps on giving, as long as we keep practicing and giving it. It is a gift we may give to ourselves, to others, to the future, and to our Creator, who made us and gave the gift to us" (from Delanty's post 'Your Art is a gift'). Creating art reinforces and feeds our naturally curious and creative nature. Through it, artists liberate the imagination, which itself

is a gift: we can go wherever we want, any time we want. We find fulfillment and freedom through art making as our skills and knowledge grow, along with our personality and level of accomplishment."

"We have different gifts, according to the grace given to each of us" (Romans 12:6 NIV). I believe God gave me the spiritual gift of creativity. I also realize that I've had a tremendous number of creative influences by special people throughout my life. I am moved and inspired by other artists' works, old architecture, music, and God's creations: the galaxy, sunrises and sunsets, the ocean, rivers, and streams.

Accepting and believing that you are an artist, I've learned, is quite a process. It has taken me many years to finally believe in my gift, accept it as real, and call myself an artist without self-doubt and self-limiting beliefs. I always wanted to be an artist but have always placed artists on such a high pedestal that I couldn't possibly reach. I have always felt unworthy of that desired title.

In 2015, I found the confidence to call myself an artist, and it felt really good for the first time in my life. I no longer compared my skills to those of others and learned that each artist has his or her own unique style, none of which is good or lousy. They are all just uniquely different. One person's style is no better than another's. It took years to believe in myself. I was always envious of other artists' work.

Personal attachment to each piece: The interesting thing is that when I began believing in myself and producing a number of paintings, each piece became an intimate part of me—of my soul—that parting with them was like losing a personal part of me. I think the reason it was so difficult was because it took years for me to finally build faith in myself and to gain the experience. So, for a long time, I wouldn't sell my works. I eventually was able to let go of the personal attachment. Since then, I have shared my art with people and started marketing and selling my artwork. It was quite a transformation for me. When I write, it's a different feeling; writing is also from my heart but is not like having to let go of a special painting.

My writings and journaling will always be with me. I will be sharing copies of my creations.

Self-limiting beliefs: I then wanted to paint all the time and discovered these awful negative thoughts in my head—self-limiting beliefs. I recall learning something about getting rid of these harsh thoughts and excuses from one of my self-improvement workshops. So, I sat down one day and came up with the following "I can't do" list:

- I don't have enough time in a day to pursue my art.
- I'm too tired to pursue art after working my day job.
- People won't like my art enough to purchase it.
- Other successful artists are far more talented than me.
- I won't be able to paint enough to make a living at it.

The "I can't do" list comes from my subconscious self-limiting beliefs. I keep these negative thoughts in mind and try to manage them as best as I can. Since then, I have learned to surround myself with people who will support me and believe in me, people who will help me stretch and grow. I need to reprogram my mind for success and associate it with new beliefs and happiness. No dream is too big. Every goal is achievable. If you want something, feel like you have it, and your thoughts and actions must be in alignment. People who act on their thoughts and desires will be the successful ones in life. Take action.

Chapter 3

The following is my research on the artistic personality of an artist: www.123test.com/artistic-personality-type/: An artistic personality type uses their hands and mind to create new things. They appreciate beauty, unstructured activities, and variety. They enjoy interesting and unusual people, sights, textures, and sounds. They prefer to work in an unstructured environment and use their creativity and imagination. This personality type is especially sensitive to color, form, sound, and feeling. They have a lively spirit and a lot of enthusiasm and can often stay focused on a creative project and forget everything around them. An artistic personality type solves problems by creating something new. Their ideas may not always please others, but opposition does not discourage them for long, and their personality type is impulsive and independent. They are creative, impulsive, sensitive, and visionary, and although they are creative, it may not necessarily be expressed with paint and canvas. Creativity can also be expressed by an artistic personality type through data and systems. They prefer to work alone and independently rather than in teams or with others.

Occupations they will excel at involve working with forms, designs, and patterns. These individuals often require self-expression,

and the work can be done without following a clear set of rules. The following breaks down the personality types of a working artist:

Artistic/conventional: creativity, creating and designing, combined with organizing, arranging, accuracy, and reliability. Typical occupations are copywriter, writer, editor. desktop publisher, art critic, and curator.

Artistic/enterprising: creativity, creating and designing, combined with being entrepreneurial and influential. Typical occupations are freelance photographer; film, stage, or related director; advertising producer; architect; journalist; interior designer; and stylist.

Artistic/investigative: creativity, creating and designing, combined with research, solving, and specializing. Typical occupations are industrial designer, game designer, architect, journalist, and film and video editor.

Artistic/realistic: creativity, creating and designing, combined with working outdoors, animals, operating machinery, working with your hands, traveling, tackling work. Typical occupations are artist, photographer, window dresser, musician, social photographer, documentary maker, floral arranger, goldsmith, silversmith, and landscape architect.

Artistic/social: creativity, creating and designing, combined with helping people, being serviceable. Typical occupations are film, stage, or related actor; singer; hair stylist; makeup artist; dancer; creative therapist; ballet teacher; and social photographer.

Right-brained theory: I can certainly relate to many of these categories because I fit into the right-brained category—the stereotypical artist is highly right brained. I write, paint, and draw with my left hand; however, I use my right hand to do everything else. I actually consider my right hand to be my dominant hand.

The dominant hand is not really a choice because it is not a conscious decision that we make as children. The majority of children will develop a preference to use one hand over the other as they grow. They will soon be labeled as either right-handed or left-handed, and some may even be able to use both or either hand for certain

tasks. This is known as being either ambidextrous or mixed-handed. Hand dominance is the preference for using one hand over the other to perform fine and gross motor tasks and includes activities such as writing, cutting, and catching and throwing a ball. The right-brained person is more intuitive, emotional, and visual, and thinks holistically, synthesizes, and puts things together, etc. Artists have a strong connection between both hemispheres. Right-brained people are said to be more creative, free-thinking. That's definitely me!

Left-brained theory: This type is analytical, logical, detail- and fact-oriented, numerical, and likely to think in words. I don't do well with numbers or calculations. I am, however, very detailed and organized, and at my day job I am organized and detail minded. So, I suppose I could fit into both categories. Logic brain is our brain of choice in the Western Hemisphere; it's the categorical brain and thinks in a neat, linear fashion. As a rule, logic brain perceives the world according to known categories. Logic brain is our censor, our second thoughts.

Chapter 4

I have always wondered what exactly is a free spirit. Is an artist a free spirit? Am I a free spirit? I've been pondering the question because I've often been called a free spirit and wondered if it is a characteristic of being an artist. Although I'm somewhat conservative in my business world, I do have a wild, free-spirited side that thirsts for freedom, adventure, and risk. And according to www.mbgmindfulness the follow are 15 characteristics of free spirits:

First and foremost, free spirits are carefree but also intentional. They don't care about what others think of them and march to the beat of their own drum," Kaiser explains, adding, "They aren't motivated by external societal norms but an inner drive to live with meaning, joy, and fulfillment."

Intuitive: These folks are intuitive and guided by their own strong inner voice. Kaiser explains that they know themselves and what they stand for, living from their heart and trusting themselves and their intuition.

Independent: As you could imagine, free spirits are also usually very independent. While they have no problem getting along with others, they also need space and crave sanctuary, according to Kaiser. "They're content flying solo if that means they can stay true to their convictions," she adds.

Open: Richardson notes free spirits are naturally open people. They're always interested in learning or trying something new, "which can make them more open to new people, ideas, perspectives, etc.," she says.

Authentic: There's nothing free spirits value more than authenticity. They want to be themselves through and through, and they appreciate that same energy from the people in their lives, recognizing authenticity easily in others, Kaiser tells mbg.

Unique: Along with being authentic, free spirits are unique. Because they tend to make their own rules and even adapt philosophies and spiritual traditions to suit them individually, Richardson explains, they are definitely not your average person.

Sensitive: Along with being intuitive and in touch with themselves, Kaiser says free spirits are often very sensitive and even empathic in nature. This sensitivity toward themselves and others is also what pushes them to do their own thing.

Courageous: "Fear" is not a big factor for the free spirits of the world. Not to say they don't experience feelings of fear or doubt, but they simply don't let it hold them back. In fact, Kaiser says, fear is "an invitation to push forward." These people know how to solve problems, so troubles don't easily intimidate them, she adds.

Lighthearted: According to Richardson, some free spirits embody a certain lightheartedness or childlike demeanor that can be very endearing. Their aforementioned courage and authenticity are like that of a child. While one might think this equates to naiveté, free spirits simply don't see the need to take life too seriously.

Contradictory: "As breezy as free spirits appear to be, they are often at war with an aspect of themselves, or in inner conflict that they are seeking to smooth out," Kaiser says. In other words, while they don't like being put in a box, that in itself can become a box of its own. "This makes true free spirits full of contradictions," she explains, like being extroverts who love their alone time, hopeless romantics who bounce from partner to partner, or world travelers who feel isolated, she adds.

Bold: Because these folks are always willing to pave a new path and take the road less traveled, they are natural-born leaders, Kaiser says. It's also not uncommon to see these leaders become self-employed, as they enjoy the freedom that comes from unique career paths.

Nonjudgmental: Again, free spirits are very open-minded, according to Richardson, and this lends itself to a nonjudgmental attitude that's very accepting of others' ways of being. Kaiser notes this makes them easy to be around because even if they're different from someone, they're not going to put someone down because of it.

Adventurous: Kaiser notes these folks live for adventure. In fact, she says, they find stability in it. "They value experiences over objects [and] like to live outside of their comfort zone," she notes, adding that it's typical for a free spirit to move around a lot.

Ambitious: Doing things your own way isn't always easy, and no one knows that better than a free spirit. It requires ambition to forge your own path, but free spirits are born with what it takes. As Kaiser notes, "They dream big and often follow through. They don't like wasting time, and they give 200% in everything they do."

Ever-evolving: And last but not least, the unique nature of the free spirit drives them to continuously grow, according to Kaiser. They're always looking for ways to be better than they were yesterday and continue evolving, all while remaining authentic and true to themselves.

After researching these characteristics of a free spirit, I find that I can relate to quite a few of them myself! Then I often wonder if other artists and free spirits relate to the same.

Chapter 5

Many times I have asked myself what the difference is between creativity and imagination; and from what I researched, basically the biggest difference is that imagination is thinking of something—whether it's an object, place, time, etc.—that is not present, while creativity is doing something meaningful with your imagination.

According to writer Drew Dennis' September 29, 2017, article in The Writing Cooperative by Write Together, he explains the difference in the following:

"Imagination is not the same thing as creativity, although the two are intimately related. While creativity is hard to pin down precisely, it's generally considered as the ability to create something using the same imagination.

Creativity is the act of creating something in the real world, while imagination deals with 'unreal' thoughts that are free from the confines of reality. When we are children, we use imagination all the time. Take an example of the class game, The Floor is Made of Lava—I'm sure you're played it before. The game relies on using some imagination skills to imagine the floor is in fact made of lava. But simply imagining the floor is made of lava is not enough to define the player as creative—they are just using their imagination to participate in the game.

However, the first kid who came up with the game, imagined all the rules, and taught others how to play—they were being creative. They used their imagination to create a game that didn't exist before.

Imagination is a powerful thing. Imagination is necessary for creativity but not the other way around. Imagination comes first. Knowing this, something seems clear: after a certain age our parents, teachers and friends begin to shun imaginative play ... it becomes "weird" for us to play with imaginary friends, make-believe, or give reference to our wild imagination. I can remember this happening to me as I grew older and I'm sure this situation is similar with others. I remember, I didn't suffer from a lack of imagination, it just became abnormal to reference my imagination. Imagination became a private thing rather than a shared experience.

This is probably what maturity is ... it's defined as the ability to respond to the environment in an appropriate manner. Playing imagination games in public is considered appropriate only if you are a child. But at some point, we must grow older and it becomes inappropriate to behave like this.

Perhaps it's not a lack of creativity adults have but rather, a lack of imagination. While we are imagining, we are free from the confines of reality. With imagination, we can hear music that doesn't exist. We are free to visualize unreal things and can be or do anything. As we grow older, imagination becomes less important and we are taught to favor the real world over the imaginary. This might be for the best ... after all who would get anything done if adults spent their days playing lava games?

But, what happens when adults tap into the creative power of their imagination? That's a question worth asking."

After reading his article, I'm convinced that is why my mom never liked it when I day dreamed; because she thought I was wasting my time. Hmmmm, something to ponder.

Chapter 6

This is my story. As a child, I loved lying in a field of green grass full of wild poppies, morning glories, daisies, and dandelions. I'd take a deep breath and inhale the fresh aromatic scent of the flowers and feel the slightly damp grass beneath my body; I didn't care if it was damp. It was my favorite thing to do, and I often went looking for a field just to breathe in the fresh air and take in the natural beauty of my hometown of Arcata in Humboldt County. The early morning dawn unfolded to a brisk morning with the fog rolling in and the promise of a new day.

My memory takes me back to when I was just little and my friends and I would make daisy chains in the grass. We would find daisies with thick stems at least four inches long and slit the stem with our thumbnails, then cut a small slit through the middle of the stem without breaking it in half. We would make the cut just below the flower halfway down the stem and thread the stem of a second daisy through the slit, pushing the base of the stem through until the flower was snug against the slit. Then we'd repeat the process with any number of daisies, making a slit in the next daisy and pushing the third stem through it until we'd made a bracelet, crown, or necklace. When the daisy chain was long enough, we would cut a second slit through the first stem, pushing the last daisy through the slit to make a loop which formed a necklace.

When we were no longer making daisy chains, we would take daisies or dandelions—whichever was in the field we were lying in—and pull off each petal, saying, "He loves me, he loves me not; he loves me, he loves me not." That would go on forever. That was the beginning of my creative adventure.

The important key I learned is this: from the day I started making daisy chains is the day my imagination started developing and I began using this ability to create things from my imagination. And as Drew Dennis quotes from his September 29, 2017 article in The Writing Cooperative, "Perhaps it's not a lack of creativity that adults suffer—it's a lack of imagination."

My friends and I also made chains from Starburst candy wrappers or dollar bills by folding them in a certain way and connecting each piece to form the chain. That was my favorite pastime. I started collecting wrappers and asking family and friends to collect the same—not dollar bills, of course. About seven wrappers make approximately two inches of chain. We would lay one wrapper down on a table so it was long but not tall, with the blank side facing up. Then we'd fold the wrapper in half so the bottom corners touched the top ones and do this step two more times. The color side of the wrapper would be visible and should have been only about a quarter of an inch tall. Then we folded the wrapper in half horizontally and opened it up again, folding it so the outer edges were touching the crease. We then folded the wrapper in half once again and inserted the two ends of one wrapper into the two ends of another wrapper. It's easier to insert the next link if you arrange the previous link with the bend of the fold pointing toward incoming ends. We continued this process until a chain started to form, and you could add on as many wrappers as you wanted. It sounds kind of complicated until you start doing it; then it becomes easy. I did many of these.

My growing years: I was born in 1955 as a redhead and raised in Arcata, California, a small college town in Humboldt County, where there was plenty of natural beauty. I was a very quiet girl and very skinny; no figure at all. In fact, my mom gave me the nickname

Lynni Skinny Diggy Bones...or Lynnettie-ettie, since my full name is Lynnette. We lived about a half hour from the ocean and were surrounded by enormous redwood trees. We spent a lot of time outdoors, rain or shine. Consequently, I grew to appreciate the beauty surrounding me.

According to www.thetravel.com: "Humboldt County in California is known for its magnificent coastal redwoods. The area is home to beautiful forests with a unique silence and grandeur never seen anywhere else in the whole world. Every year, thousands of people flock to the Humboldt Redwoods State Park in south county and Redwood National and State Parks in the north county to enjoy the most scenic drives and hiking trails they have seen in their whole lives.

In addition to those unique parks, the forests, stunning beaches, and preserves make Humboldt County a paradise for outdoor recreation and nature adorers. However, one of the most beautiful spots in the area is the iconic and magical Humboldt Redwoods State Park, which sees thousands of people flocking every year to witness this park's hidden gems and attractions.

And according to Wikipedia, Six Rivers National Forest is a U.S. National Forest located in the northwestern corner of California. It was established on June 3, 1947 by U.S. President Harry S. Truman from portions of Klamath, Siskiyou and Trinity National Forests. It's over one million acres (4,000 km) of land contain a variety of ecosystems and 137,000 acres (550 km) of old growth forest. It lies in parts of four counties; in descending order of forestland area they are Del Norte, Humboldt, Trinity, and Siskiyou counties. The forest is named after the Eel, Van Duzen, Klamath, Trinity, Mad, and Smith rivers, which pass through or near the forest's boundaries.

The forest has 366 miles (589 km) of wild and scenic rivers, six distinct botanical areas, and public-use areas for camping, hiking, and fishing. The northernmost section of the forest is known as the Smith River National Recreation Area. Forest headquarters are located in Eureka, California. There are local ranger district offices in Bridgeville, Gasquet, Orleans, and Willow Creek.

Its old-growth forests include Coast Douglas-fir (Pseudotsuga menziesii var menziesii), Tanoak (Lithocarpus densiflorus), Pacific madrone (Arbutus menziesii), and White Fir (Abies concolor)."

Growing up in Humboldt County was a very wholesome, basic lifestyle where we all learned to appreciate nature and the simple pleasures of life. I loved hearing the rain on the roof and on my windows at night. I loved playing in the rain and splashing in the mud puddles. My parents always told me that I would never melt in the rain and encouraged me to play in it.

My creative projects and games started at home, from cutting out paper dolls to playing "dress up" with my sister (we called it "playing lady"); or playing "store" using our little red Radio Flyer wagon, delivering make-believe groceries from our garage on roller skates; painting with paint-by-number kits; and assembling and painting hobby cars and planes.

Using our imaginations: We would crush empty soda cans and attach them to our shoes, pretending we were tap dancing as they made a clicking sound on the pavement. Back in the day—when there were no electronics, cell phones, or pagers—we punctured a hole in the bottom of an empty food can, threaded a long string through the can about half a block long, and connected one can with another; these were our walkie-talkies. We communicated with each other by yelling into one can and putting the other up to our ear. When both sets of grandparents were visiting, my oldest sister and I would put on fashion shows using our Barbie dolls as the pageant models. Putting on their glitziest outfits, we would crouch behind the living room couch when we had a full audience and parade them across the couch like they were in a pageant, announcing each unique costume for our guests.

Chapter 7

I grew up with a family of talented and creative entrepreneurs, and if creativity stems from our heritage; I believe it's because everyone in my family has some sort of talent. I was born into a bloodline of creative family members. I have always loved all forms of the arts: animation, architecture, design, crafts, calligraphy, ceramics, computer graphics, dancing, drawing, illustration, mosaic, painting, performance, photography, sculpture, stained glass, tapestry, and video. My mom's family came from Yugoslavia, and my dad's ancestors were Dutch, but his dad came from Oklahoma.

Mom earned her bachelor's degree in business administration and pursued her love and passion for music and the arts on the side. She played clarinet in the Humboldt State Lumberjacks Marching Band and performed in a German band with her college friends and colleagues. In addition, she played guitar, piano, organ, accordion, and harmonica.

Mom and her two best friends from high school performed as a professional trio at the Minor Theater in Arcata, playing music from the forties and fifties and according to sources, the theater was one of the oldest in the United States and was built in 1913 for the sole purpose of showing films. I recall one of the popular songs they performed was "On the Atchison, Topeka, and the Santa Fe." This Oscar-winning song

was written by composer Harry Warren and lyricist Johnny Mercer for the 1946 motion picture, The Harvey Girls. In the film, the song is an important element in a nine-minute sequence that charts the growing excitement in the Arizona community of Deadrock as the train arrives. Among the passengers aboard the train are young women who have come to the Southwest to be waitresses, or "Harvey girls," in a Harvey House restaurant. The song became a staple in the repertoire of Judy Garland, the film's star. Garland's photograph is central to the design on the sheet music cover. The illustrations of dance hall girls and Harvey House's waitresses that flank the photo convey graphically the central plot conflict in the movie.

Mom's influence with entrepreneurship, creativity, singing, dancing, and the arts: Mom had the mindset of a businesswoman (influenced by her mother); there was no end to her business ideas and creative solutions. Seeing this during my upbringing heavily influenced me to become an entrepreneur.

Mom was the mastermind in all her and Dad's side business ventures over the years. She encouraged Dad to get involved in Amway, and he was quite successful with many local clients.

They launched a small business selling a product called Pocket Mail, which was the first mass-market mobile email. Although actually a computer, its main function was email, and the main advantages were that it was simple and it worked with any phone, even outside the United States.

They also sold portable security alarms for the home. These devices were perfect for home and travel. You'd hang them on entry or bedroom doors in your house or apartment. The installation was easy with no wiring needed.

For years, Mom was a member of the American Businesswomen's Association (ABWA), a national professional association for women, and she became secretary of the organization.

In later years, she traveled throughout Europe performing with the professional choir from Humboldt State University. Mom also sang with Sweet Adelines International, the world's largest singing

organization for women, established in 1945 and committed to advancing the musical art form of barbershop harmony through education and performances.

During Mom and Dad's forty-plus years of square dancing, they traveled to China and taught people to square dance and even danced on the Great Wall of China! What an honor and experience! In their earlier years of square dancing, they belonged to a group called the Westerners and had dance workshops, performances, and just plain dancing sometimes two to three times a month. Many times we loaded up our travel trailer and our whole family would go to a venue where there was a square dance with an out-of-town caller. Many of these events were held outside on a huge concrete slab, so we kids would hang out or play on the playground or sit along the sideline and watch while they danced.

Mom created everything in her sewing room, from clothing to fancy appliques on towels, pillowcases, sheets, Christmas ornaments, and more. She sewed Barbie doll and Ruthie doll clothes, as well as all of our dresses, and she even made matching square-dancing outfits for her and Dad. She taught us girls how to sew our own garments too. In high school I sewed many of my own dresses, skirts, blouses, and even my prom gowns. She crocheted lacy ornaments to put inside clear ornament balls. She'd make angels from magazine pages by folding each page accordingly, spraying them with a stiffener, and then spray-painting them. She also taught me how to make small gift boxes from greeting cards; I still make them today. In later years she made vintage miniature purses and necklaces using teeny seed beads and Swarovski crystals, in addition to crocheting caps for cancer patients using a special soft yarn.

I was greatly influenced by Mom and Dad's established business before their retirement, and they named it Gold Reflections. They purchased a vendor trailer, wholesale gold and silver jewelry, and specialty piano-tuned wind chimes. They traveled the vendor circuit throughout California, Oregon, and Arizona making many friends and contacts along the way. Their entrepreneurial venture really

inspired me. They met many clowns, entertainers, and face painters over the years, which was the ultimate inspiration for my own business. Seeing their business grow was proof that I could do anything in life that I aspired to do.

Dad worked as a diesel mechanic making creative and effective solutions to the repair of big rig diesel trucks. He was the quiet one behind the scenes and maintained the yard, mowing the lawn; cutting, trimming, and grooming the fruit trees and berry vines; and building and painting fences. Dad designed our backyard and built a small fence in the center to separate the fruit trees and berry vines from the rest of the yard. He also built a platform for a gazebo with a hot tub. He was always building, installing, and repairing things. There wasn't anything Dad couldn't fix! He was very creative when renovating and repairing things, from toasters to lawn mowers to fences, and even cars and their motor home. He always had us kids picking blackberries and apples from the backyard for Mom to make fresh homemade pies. Dad loved making applesauce from his favorite Gravenstein apple trees. He used his culinary skills and made breakfast every morning and pretty much stuck to a weekly schedule of meals. Mondays were cold cereal with buttered toast, Tuesdays were pancakes, Wednesdays were hot oatmeal or cream of wheat with buttered toast, Thursdays were French toast, and Fridays were sometimes poached eggs on toast or soft-boiled eggs with buttered toast. Before each meal he served a healthy slice of fresh cantaloupe or honeydew melon or half a grapefruit with the individual sections sliced and sugar poured over them.

I recall a time when Mom arranged to have a surprise birthday party for Dad, and she invited all of their friends and square-dancing friends. Back in the day, there was a number you could call to get your own phone to ring. When she knew Dad was home and pulling off his boots in the garage, she dialed that number, and the phone rang and rang and rang until he yelled, "Isn't someone going to answer the phone?" When no one answered, he went into the house and everyone popped out screeching, "Surprise!"

Dad's influence: I took woodshop in high school, and Dad helped me build a flower bed in his workshop. He was influential with building and creating things, and with his gardening; he instilled in me the pleasure of planting vegetables. Mom and Dad were rock hounds (collectors of mineral specimens) and traveled to places like Arizona to hunt for rocks and minerals. They'd bring them back home and tumble them in their rock tumbler to make them shiny before selling them. Dad wrapped rocks and gems through his seventies and sold them as pendants on necklaces.

Nana Mary (Mom's mother) was a clerk at the Arcata Justice Court, and she was creative with her sewing, knitting, and crocheting. She crocheted afghans. She was the most fabulous Yugoslavian cook around! She always cooked enough "for an army" and delivered huge pots of casseroles to our house to share. My favorite was her Chicken Paprika Hendl with fresh, handmade gnocci and sauerkraut salad; she cooked with sour cream and lots of butter.

Nana was a businesswoman and a member of Soroptimist International, a worldwide volunteer service organization for women who work for peace and to improve the lives of women and girls in local communities and throughout the world. She was a prominent citizen in the community and had migrated from Yugoslavia at the age of three with her family. I loved Nana; she was special to me. In my later high school years of rebellion, I was given permission to live with her for a period of time. She and I had a special relationship; she understood me without judgment or criticism. She lived in a beautiful, old three-bedroom Victorian house in downtown Arcata, so it was easy for me to catch the bus to high school. There was a hidden tunnel in her bedroom walk-in closet that led to the second bedroom. My siblings and I would play in the "secret tunnel," as we called it. In later years she had it closed off permanently. No more fun for us. During the short time I lived with her, the middle bedroom was mine with huge windows all around. The third bedroom, at the end of the house, was sort of creepy because it was at the end of a dark hallway and you had to step over a large, old-fashioned floor heater vent to get to it.

In the back of her house was an enclosed porch that led to the laundry room. All along the wall were shelves of canned goods. We called it "the shopping center." Keeping the shelves packed with canned goods, I suppose, came from the effects of living through the Great Depression. You never wanted to be without food. So, when there was a sale at the grocery market, Nana would buy not just one but a dozen of the sale items to keep the shelves stocked. Beyond the laundry room was a set of steep stairs that led to the attic. My siblings had great fun playing up there. The attic ran the entire length of the old house and held many treasures, including Mom's vintage baby buggy, holiday boxes and wrapping paper; photo albums; old furniture; a hope chest; and a vintage trunk full of treasures, toys, games, and Uncle John's belongings when he left for the army. I loved exploring in the attic. The house had a huge backyard with a humungous fig tree that always seemed to be producing fruit. Mom was constantly making fig jam. There was a small studio apartment in the back of the yard that Nana rented out.

I was greatly influenced by her ability to cook, and to this day one of my passions is cooking from scratch and creating my own recipes using a variety of ingredients. When I do start out with a written recipe, I always add something extra to the dish. My sons can tell you that! I can't leave a recipe alone. Nana also influenced me as a businesswoman and by supporting her community.

Uncle John (aka Unka) is my uncle (Nana's son, Mom's brother). I was always impressed with his wit and sense of humor. In the summertime Nana Mary and Grandpa John would take my oldest sister, Susie, and me camping at French Camp campground in Leggett, California, with the Mad River flowing behind it. French's had a gas station, grocery store, food shack, and gift shop. I always admired Johnny's crazy movements when he danced with the girls on the concrete patio near the store. He danced the monkey, the twist, the pony, the swim, the Mashed Potato, the Monster Mash, and the Watusi, all from the sixties. He had quite an impact on me as a young school-age kid.

When my sister Susie and I were preschool age, John would build creative forts with separate rooms for us in Nana's living room, using card tables draped with sheets and blankets over them. We crawled around from room to room.

Unka John owned a muffler shop in downtown Arcata and was popularly known as "Muff" because he provided professional service on mufflers. He was a beloved icon in Arcata, and everyone who knew him respected and loved him.

When Unka was a teenager, he had a wild imagination. One time, using acrylics, he painted a colorful, exaggerated cartoon character-like monster with buggy eyes driving a hot rod that was much too small for him. His head was way too big for his body, and his stick shift was exaggeratedly long, extending way out of his car as he planned to cruise full speed ahead.

Unka was good at telling stories too and made up a story about a purple house two doors down from Nana's house. He led us to believe that the house was the home of the Purple People Eater, so we always tiptoed past that purple house so as not to disturb the Purple People Eater. (The Purple People Eater referred to the song "One-Eyed, One-Horned Flying Purple People Eater," Sheb Wooley's hit song of 1958.)

In his career, Unka designed and built a motorized barstool with a drive motor from an early 1960s Ford six-volt, electrical (twelve-volt Ford solenoid) and motor drive shaft. In the late 1970s/early 1980s, the International Barstool Racers Association (IBRA) required strict specifications for building a motorized barstool. He complied with all requirements, except the one where the racer had to be powered by an automotive eight-volt battery. He bent the rules by using a twelve-volt battery instead, which gave the racer forty percent more oomph and made it crazy fast. It was not a sanctioned race, and there were no inspectors; it was just a fun event—no trophies, plaques, or monitory value, just a touch of glory. The fans showed appreciation for the "show," and the media helped promote it. But, sadly, the IBRA season only lasted two

years and then disappeared. That's my Unka, full of creative ideas, and I'm proud of him.

Another creative invention: At age twenty, John inherited from his dad's passing in 1966 (my Grandpa John) a civilian-made, half-ton Dodge. The truck took power train changes over a period of time, but it was still boring and not stylish for him or his peers. So, in 1973, he converted it into a 4x4 in a matter of a few weekends with some help from friends and ended up with an amazing mountain goat. He used it as a daily driver and raced it when there were sand drags on the beach organized by a local dune buggy club. The dune buggy club owned eight acres behind Emerson's Mill.

Another time I remember Unka serving as a DJ on one of the Humboldt County radio stations, and he had singer Gale Garnett as a guest on his program. Gale was born in New Zealand and moved to Canada, making her singing debut in 1960, with guest appearances on television shows such as 77 Sunset Strip. She was signed by RCA Victor Records that same year. In the fall of 1964, Gale scored a number four pop hit with her original composition of "We'll Sing in the Sunshine" and recorded her debut album, My Kind of Folk Songs, for RCA Victor. Riding on the success of "We'll Sing in the Sunshine," which won a 1965 Grammy for Best Folk Recording and sold over one million copies to reach gold disc status, she continued to record through the rest of the 1960s with her backup band, the Gentle Reign. Ironically, my uncle Unka had her sign my little autograph book. What a special memory.

Grandma Frances (Dad's mom) was a very talented woman and worked as a seamstress at Daly's Department Store in Eureka, doing professional sewing and altering bridal gowns. She spent hours teaching me how to make wreaths out of dried nuts, dried flowers, leaves, seeds, pods, acorns, pinecones, leaves, and rocks that we collected on their ranch in Willits, California. She had a love and respect for nature. She taught me how to make flowers out of pipe cleaners and fabric pieces. We folded the end of a pipe cleaner to form a loop and twisted and secured it to create the first petal; then

we did the same for the second flower petal and so forth. We then glued a piece of fabric onto each pipe cleaner petal, let it dry, and bent each petal. We twisted all of the petals together with a pipe cleaner to create the whole flower. We also made driftwood mobiles together. We would collect unique driftwood and seashells on the beach in Arcata and string them with fishline or twine to make the hanging mobiles. Grandma's daughter, Aunt Tula, was also very creative and made several quilts that were entered in numerous quilt shows in Auburn during the time they lived there.

I recall sketching Grandpa and Grandma's cabin in Willits, California. It was an old wooden cabin way up in the hills on several acres of property.

I was greatly influenced by Grandma's love of nature and her art projects using nature. She and I created many craft projects together.

My sister Susie sewed many of her clothes in high school as I did, but she continues to sew for people. She later developed a love for quilting and creates the most beautiful quilts. Each of my family members has received one or more of her finely crafted quilts created with her loving hands. She also quilts for friends and church members and donates quilts to organizations. She says about her passion, "I have enjoyed sewing since I was ten years old when my mother helped me sew my first dress. I have sewn ever since, making clothes for myself, my children, and grandchildren. In 2001 I took my first quilting class and fell in love with quilting. I love to choose patterns and fabric for each project I make. I enjoy making quilts for baby gifts, wedding gifts, retirement gifts, housewarming gifts, and any other event in someone's life that deserves to be remembered. When I am making a quilt, I think about the person or people I am making it for. It brings me a lot of joy to create something that will bring them joy and remember the event it was made for. I have so many ideas, patterns, and fabric for projects that I probably won't live long enough to make everything I want to make."

Before starting a quilt for a friend or acquaintance, she intuitively gets the sense of what they would like (from their interests) and

from what she knows about the person. If a person is struggling with a life event, she finds a way to comfort them with her quilts. She feels it blesses them, and she gets blessed in return. And for friends with serious illnesses such as cancer, she creates special quilts designed specifically for them.

In her earlier years she learned to play the clarinet at Mom's encouragement and also spent years playing the piano.

My brother Brian followed in Dad's footsteps and worked as a diesel mechanic with a well-known truck company using his creative mechanical skills to solve the problems he was assigned to resolve. He also repairs friends' vehicles. He uses creative and educated solutions for every mechanical problem. In his junior and senior years of high school, he and Dad built a Mustang using parts and a body from a 1965 and 1966 Mustang obtained from junkyards and dealers. It took them two years to complete their masterpiece, and they had it painted a beautiful metallic blue. It was a gorgeous work of art.

My other sister Nancy not only sews clothing but also creates just about everything with her sewing machine. She enjoys collecting vintage clothing patterns and designs upcycled clothing in her custom-made "she shed," complete with heat and air and dozens of shelves to store all of her fabric pieces. She keeps busy making coffee cozies and specialty items for clients, as well as face masks due to the Covid-19 demands. She also has an Etsy shop where she sells handmade coffee cozies and vintage fabric and patterns.

Nancy enjoys canning bread-and-butter pickles and several fruits and jams. She is a country girl at heart (since our upbringing was basically in the country). She and her husband Marty have two horses and about a dozen chickens, and they breed purebred French Bulldogs. I was hysterical with laughter and tears one year at a family gathering when she announced that she had knitted a sweater for one of her chickens that was losing its feathers in the winter. That story was the family entertainment of the year. Her creativity definitely has been an inspiration and an influence on me.

Shelly (aka Michelle) is my second cousin, and her mom and my

nana were sisters. Shelly also is my good friend, and we make great travel companions. We have been on two trips together so far. She is a very good photographer and knows just how to create a balanced composition in her photos. She also has an eye for designing her garden and landscaping in both front and back yards. She took a master class in gardening so she definitely knows how to compose a lovely and balanced garden.

My sons, Jason and Cody, inherited the bloodline of creative talents. Jason is creative in building structures. He has built a wooden deck under the direction of a neighbor, a portable wooden bar on wheels for his company, a bed frame, and a chicken coop, to mention just a few. He fabricated a custom truck at one point and did an engine swap for a sale. He's a builder and a salesman. He's always finding ways to make extra money—buying something cheap, fixing it, flipping it, and selling it. Jason is my thrill seeker and thrives on challenge. Cody is my musician and thinker. He enjoys taking a problematic situation and analyzing it. He's also a mathematician and can solve any problem! He plays the keyboard and guitar by ear, learning songs from YouTube videos. Cody is my culinary delight, and there is nothing he cannot create on the grill and in the kitchen. He never hesitates to recommend spices or flavors to go into certain meals. He is selective with what goes into his mouth; it must be prepared properly and healthfully.

Chapter 8

Arts and crafts in grade school were, I believe, a prelude to my painting and face painting experience later in life. My first recollection from kindergarten was that I tended to daydream quite a lot, and Mom was concerned. At a parent-teacher conference, however, my kindergarten teacher, Mrs. Hibler, told Mom, "Lynni is normal, but her heart just beats to the tune of a different drum."

Talk about how painfully shy I was, I once got in trouble by simply nodding my head to Linda Erickson in circle time. Linda, however, had a huge impact on me; she inspired me to become bold with confidence and step out of my comfort zone. I've always gravitated toward outgoing friends, including Linda—the ones with fearless personalities. I don't know if that's because I could learn from them or maybe just to hide behind them for protection. My grade school friend Peggy Lewis was loud and not afraid of anything, and she sort of took me under her wing for protection. Peggy was a tomboyish girl and played tetherball better than any boy in early grade school. She had a powerful punch on the tetherball even though she was disadvantaged with one hand that was crippled. I was in awe of her confidence. I followed in her shadow, but one day she disappeared and didn't say a word. I was devastated since I really looked up to her.

I remember molding a horse out of clay in the first grade. My horse turned out sort of pudgy and low to the ground. His four legs were short and stout. I learned to bake him in the kiln. A kiln is a thermally insulated chamber, a type of oven, that produces temperatures sufficient to complete a process, such as hardening, drying, or chemical changes. Kilns have been used for millennia to turn objects made from clay into pottery, tiles, and bricks. Various industries use rotary kilns for pyro processing to calcine ores, to calcine limestone to lime for cement, and to transform many other materials.

My longtime dearest friend (BFF), Gayle, and I attended just three years of grade school together, and then her family moved on. Her father was a banker so they moved around a lot. But in those three short years, we formed a lasting friendship. Our families knew each other during those years and lived less than a mile apart. Gayle and I loved the arts and spent a lot of our time in her living room singing and dancing to 45-rpm records played on her hi-fi (high-fidelity sound system) one at a time. The hi-fi was popular in the sixties when most electronics in the early part of the decade were separatespre-amp, power amp, and tuner—because they were tubes and receivers (all three components on a single chassis sharing a common power supply).

In third grade we both attended Camp Kimtu in Willowcreek, California (which had been around since the 1920s). It was a weeklong camp for Campfire Girls, where we enjoyed swimming, canoeing, singing, crafts, and, of course, learning more about being a Campfire Girl. We had an assignment to come up with words to a popular tune of our time. We had about five girls assigned to the musical task, but Gayle and I (with our creative imaginations) outshined them all with our lyrics. To this very day, we can sing our song together! We made up words to Petula Clark's popular hit from 1965, "Downtown."

Our version of the lyrics, which we performed the last day of camp, went like this: "When you're lonesome in the summer with nothing to do, you can always go to Kimtu. Where the swimming

hole's cool and the weather is hot, where the swimming's good at Kimtu. And we will still remember the kiosk and Miss Vickie, where mosquitoes bite you everywhere, you always feel so icky. Kimtu's great; the life of Campfire Girls. We like to go camping; we think it's so cool at Kimtu where all the action is. Kimtu blah blah blah blah blah; Kimtu blah blah blah blah blah." Gayle and I couldn't recall the last part of our song. Ha-ha.

Gayle's dad, Ken, built a playhouse in their backyard on stilts with stairs, windows, and a door; it was the coolest thing! Gayle and I got to help him build it by hammering in the nails and helping him put up the walls. We then decorated and painted the interior and got to choose the curtains and hung those too. Then we sort of christened our finished playhouse by dancing around it and singing songs of praise for our great accomplishment. We spent many hours in the playhouse making up songs and doing our homework.

We lived in the beautiful elite community called Bayside, located in a lush valley between Eureka and Arcata, California, surrounded by redwood trees and a creek running through it. On Gayle's property was a ditch with a stream of water running through it from Jacoby Creek, which separated her family's property from the McLeans' property. We both were in love with Doug and Mark who lived just up the road, but we also had a mean streak because they were "boys." We knew they hiked down their part of the hill to visit Gayle and cause trouble because they were typical boys. When Gayle and I were in the second or third grade, we devised a soapy trap across the stream hoping they would trip and fall and end up in the soapy water. We filled the stream with dish soap thinking that the soapsuds would miraculously remain (yeah, right), put a couple of layers of plastic wrap over the trap, and arranged rocks all around the trap to anchor the plastic wrap in place. Then we covered the trap with twigs and leaves as a camouflage so they wouldn't suspect they were stepping into a trap.

Gayle and I as a team had wildly creative imaginations. One summer our families camped together at our favorite site in the

Humboldt County Redwoods, Richardson Grove. Gayle and I went hiking as usual, but one time we came across a poor, dead, little field mouse at the bottom of the trail. Since we were both animal lovers, we knew right away that we had to give it a decent burial. We dug a shallow hole in the dirt, buried it, and covered it gently with dirt, and then we performed a short memorial with kind words for the poor little mouse.

Another time both our moms were involved in Campfire Girls as leaders. One day they drove us to a meeting and sat in the parking lot for quite some time chatting. Soon afterward, they drove home. But to our horror, they drove off without us, leaving us behind! By that time everyone had gone home, and there were no phone booths for miles. Gayle and I managed to entertain ourselves by singing to pass the time. Eventually our moms discovered that they had left us behind and raced back to pick us up.

I was terribly saddened when I heard that Gayle and her family were moving to Corvallis, Oregon, after fourth grade. My sister Susie and I managed to visit their family several times by Greyhound bus after their move.

My sister Susie and I had wild imaginations, and we had a nice-sized sandbox in the backyard of our house in Sunny Brae, a subcommunity of Arcata. We spent hours building and creating garages, tunnels, roadways, and bridges in the sand. We would add water to harden our structures and roads and then would drive our miniature cars over the bridges, through the tunnels, and on the roadways to their garages and homes. That was such a fun experience for us and created somewhat of a sisterly bond. Since our family took many outings to Clam Beach, Susie and I built several sandcastles and were saddened when the ocean waves eventually came and destroyed our creations.

I took a cartoon drawing class in grade school, and my drawing of a cartoon elephant went up in the display case for everyone to see near the entrance of Jacoby Creek Elementary School.

I've had an interest in art for as long as I can remember, and many

times I sketched things that I saw outside. I drew imaginary women and girls with designer dresses, glamorous gowns, and pantsuits.

I began a four-year stint of ballet and tap lessons during fourth grade at LaVerne McCrae's dance studio in downtown Arcata with my grade school friend Vickie. I performed in several recitals. One that I recall was with tap, and my class performed "Chim, Chim Cher-ee" from the 1964 musical Mary Poppins with Dick Van Dyke and Julie Andrews. Julie Andrews played Mary Poppins, a magical and loving woman who descended from the clouds in response to a children's advertisement for a nanny. We as tap dancers were dressed in shiny pink- and white-striped, long-sleeved short dresses, sewn by our moms, that we wore over black leotards. We used brooms as our props to show that we were chimney sweeps. That was my first public performance.

I've always been an eternal dreamer—not the kind of daydreamer that comes up with amazing visions and spectacular ideas but one who daydreamed to escape the real world, I suppose, to escape conforming to the normal.

I had quite a collection of troll dolls and cut out felt outfits for them; I also created a troll house out of a shoe box. I made tables, chairs, and beds out of cardboard and found miniature things like a television set and work desk. Troll dolls were created in 1959 by Danish fisherman and woodcutter Thomas Dam. It was said that he could not afford a Christmas gift for his young daughter Lila and carved the doll from his imagination. Other children in the Danish town of Gjøl saw the doll and wanted one. Dam's company, Dam Things, began producing the dolls in plastic under the name Good Luck Trolls. They became popular in several European countries during the early 1960s, shortly before they were introduced in the United States. They became one of the United States' biggest toy fads from the autumn of 1963 to 1965. The originals were of the highest quality and also called Dam dolls, featuring sheep wool hair and glass eyes. Their sudden popularity, along with an error in the copyright notice of Thomas Dam's original product, resulted in cheaper imitations.

Chapter 9

I recall taking my first drawing classes at Arcata High. I learned from my art teacher, Mrs. Dahl, and I created pointillism drawings with pen and ink, as well as calligraphy. One of my pen-and-ink drawings was of a kangaroo and another was of flowers. I later took a leather-making class and made a purse and a small leather coin pouch. My friends and I would walk downtown and hang out at the leatherworks shop, buying small pieces of leather for our crafting. I loved creating things! I also learned to play the harmonica back then.

Then I discovered a love for poetry, prose and a fascination for creative writing. I took some creative writing classes in high school and found that they opened up my creative spirit. Writing was a way to express my unspoken feelings of anger, contempt, fear, disgust, happiness, and sadness. Since I was shy and unable to express these feelings, the discovery of writing helped. And whether or not I shared my writings, just the practice of getting my feelings down on paper was a huge help. Keeping a journal can be a spiritual practice that allows you to connect internally and express yourself. It can also be a supportive practice during difficult times—one that can help you understand and uncover what you're feeling in the moment. Over the years, I have spent a lot of time journaling about my feelings. It is a way of nurturing my soul.

Chapter 9

I was intrigued with artists who created weekly comic strips in the newspaper. I dabbled in cartoon strips for a while, but again it didn't magically launch me into a career as a cartoon character icon. It was another try to achieve my dream of breaking away from the "normal."

Listening to a flute player is magical to me. The flute, to me, has a delicate, angelic sound that I really enjoy. And someday I will learn to play the flute.

I met my best friend Sue Misbach in our first year of high school and discovered her sense of wonder and vivid imagination. We had PE (physical education) together during the first period and it was cold, cold, cold in the early mornings. One day we snuck away from the others to run in a field of grass behind the school and discovered the awesome beauty of the early morning dew. She said it looked like heavenly angels had come down and kissed the grass leaving diamonds that glistened in the sun, and from that point on, we named that field of grass DG (Diamond Grass).

Later we did a lot of decoupage projects together. We would take a photo or a picture from a magazine, burn the edges, paste it onto a small board or rock, and then cover it with a sealer. I discovered that decoupage is a specific form of crafting that dates back centuries! In its broadest meaning, the art of decoupage is essentially the art of decorating an object with cutouts. Mod Podge is one of many available decoupage glues, each with a different consistency and finish. We enjoyed that craft so much.

I learned how to make sand candles with Sue by pouring melted candle wax from different colored candles into a mold with sand, adding a candlewick before the wax dried. You first dig a hole in the sand and then melt the wax. Put a pot on the stove and melt a cup full of wax. While the wax is melting, add shavings of crayons in your chosen colors to change the color of the wax. Then pour the wax into the sand hole and make sure to hold the wick in the center so it stays in place. Allow the wax to set and harden for about four hours. Once the wax is in, grab a stick, lay it across the candle

(without touching the wax), and let the wick rest on it so it doesn't fall into the wax. Once the wax has hardened completely, carefully dig around the candle until you can lift it out by the wick and brush off any excess sand carefully.

We would also empty wine bottles and put various colored candles in the bottle and let the candle wax drip down over the bottle. Sue also introduced me to the craft, which was a popular thing back in the hippy days. We created these by lighting the first candle and holding it horizontally so the flame was about one inch over the mouth of the bottle. We tilted the candle so a few drops of wax dripped onto the mouth of the bottle. While the wax was still warm, we turned the candle right side up and placed it in the mouth of the bottle and pressed to secure the bottom of the candle by holding it steadily for about thirty seconds until the wax hardened.

Music has also played an important role in my life, and I consider it to be a part of the arts. I was in two choirs during my four years of high school, a cappella choir for my first two years. My fear was to sing solo for auditions, but I did it and I made it! I didn't think I was the greatest singer, but obviously Miss Carroll thought I was good enough to be in both choirs. Remember, I was quiet and shy, so it was quite an accomplishment for me. My best friend, Julie Pope, was also accepted. Wikipedia defines "a cappella" as singing without instrumental accompaniment; some groups use their voices to emulate instruments; others are more traditional and focus on harmonizing. A cappella styles range from gospel music to contemporary to barbershop quartets and choruses. Our a capella group was an organized singing group that performed many pieces of music without accompaniment from the piano. Miss Carroll was our choir director, and Mrs. Smith accompanied some pieces on the piano. We performed at music festivals and schools and also joined with the madrigal choir at commencement.

The highlight was singing for a huge audience at the Eureka Inn for an annual holiday performance, which was always decorated so extravagantly with an enormous Christmas tree that was nearly as tall

as the huge ceiling. Those were good times. We all wore choir robes and waited anxiously in the choir room for our performance. There were many, many choirs from different schools and churches every year. It was quite an exciting annual production. When it was time to perform, we were accompanied by Miss Carol and pianist Mrs. Smith. We'd nervously file in one by one and find our assigned spots on the risers, and as soon as Miss Carol raised her conductor's baton, we sang our hearts out. At the end of each Christmas performance, the encore was always the "Hallelujah Chorus" from Handel's Messiah.

According to Wikipedia, "the Messiah is an English-language oratorio composed in 1741 by George Frideric Handel, with a scriptural text compiled by Charles Jennens from the King James Bible and from the Coverdale Psalter, the version of the Psalms included with the Book of Common Prayer." The music expresses great joy. According to tradition, the audience always stands up while the "Hallelujah Chorus" is being sung because King George II did this at the first London performance of the Messiah in 1743. To this day when I hear the song, it gives me chills.

The beautiful historic Eureka Inn, where we performed each year, is an Elizabethan Tudor Revival hotel that opened in 1922. It fully occupies a city block and has ninety-nine rooms and five suites. The hotel has historically contained up to three restaurants, two bars, two saunas, an indoor spa, and nine meeting venues, all of which has been supported by up to 140 employees. It has the quality of almost unbelievably majestic beauty with its courtyard. Constructed of redwood, it is the largest conference facility and third-largest lodging property in the region. For both architectural and cultural reasons, the hotel is one of the most important buildings on the north coast of California. It was such a thrill and honor performing there.

The madrigal choir was much smaller than a cappella choir, and we made over thirty public appearances. I was accepted in Madrigal in my junior and senior years. The girls wore the same style dresses for performances, and most were sewn at home. We performed mostly at the same venues as the a cappella, but we had the excitement of a

four-day field trip to San Francisco and Sacramento in my junior year to perform at various venues. In later years, Miss Carol retired and was replaced by our new choir director, Mr. Agliolo (aka, Mr. A). In my junior year, we performed with a rock band and sang highlights from Jesus Christ Superstar. Both choirs also performed at our annual Christmas assemblies.

My experience in the choirs gave me the confidence to sing in our high school musicals, including Damn Yankees, How to Succeed in Business Without Really Trying, and Oklahoma. Melody Inn was a student-oriented show based on the ABCs of music and performed by our bands and choirs every year.

I attended summer school classes for further education and fulfillment. One summer our class performed highlights from the musical Oliver! which is a British coming-of-age stage musical by Lionel Bart and is based upon the 1838 novel Oliver Twist by Charles Dickens.

Another summer our class performed the opera Pirates of Penzance which is a comic opera with music by W. S. Gilbert.

I sang with my dear friend Julie Pope in Job's Daughters, which is a fraternal Masonic youth organization for girls between the ages of ten and twenty who are related to or sponsored by a Master Mason and believe in a higher power. Julie and I developed more of a friendship outside of high school. We sang all the time! A favorite memory was when we had sleepovers at our bethel hall. Our intimate group of five made up silly names for each other, and we laughed and sang all night long. We formed a special fivesome and slept in a tiny closet all night, completely separated from the other girls. The "Bad Five" included Julie, Sharon, Candie, Susan and me. Those were such fun times.

Job's Daughters has chapters called bethels in the United States, Canada, Australia, Brazil, and the Philippines. Being in the organization taught us the values of leadership, public speaking, charity, respect for parents and elders, and teamwork. We participated in activities, like bimonthly meetings, fundraisers, service projects,

leadership workshops, theme parties, dances, and so much more! It gets its name from the Book of Job in the Bible, "Nowhere in all the land were there found women as beautiful as Job's daughters, and their father granted them an inheritance along with their brothers," (Job 42:15 (NIV) which allowed the daughters of Job to be independent, confident women who could hold their own in society. And according to Wikipedia, Job's Daughters International is a Masonic affiliated youth organization for girls and young women aged 10 to 20. The organization is commonly referred to as simply Job's Daughters or Jobies, and sometimes abbreviated as JDI (or IOJD, referring to its longtime former name, International Order of Job's Daughters). Job's Daughters welcomes many religions and cultures. The only religious prerequisite is a belief in a Supreme being.

I've always been proud to be a "Jobie." During some of our meetings of Job's Daughters, the song "Nearer My God to Thee" made Julie and me cry every time. We sang it at the end of each meeting. "Nearer, my God, to Thee, nearer to Thee! E'en though it be a cross that raiseth me, still all my song shall be nearer, my God, to Thee. Though like the wanderer, the sun gone down, darkness be over me. My rest a stone, angels to beckon me nearer, my God, to Thee. Nearer, my God, to Thee."

The annually-held Grand Bethel was a statewide gathering of the California members and was a three-day event full of competitions, business meetings, socials, and lots of fun! Julie and I attended twice, and if you can imagine five hundred Job's Daughters from California all in one stadium singing, it was a breathtaking experience never to be forgotten.

Chapter 10

Did you ever wonder if there is a distinct connection between music and arts? I did, which leads to the subject of music, which has an incredible and powerful impact emotionally when we listen to our favorites. Pleasurable music may lead to the release of neurotransmitters associated with reward, such as dopamine. Listening to music is an easy way to alter a mood or relieve stress. There's a brain-music connection from hearing a song associated with a first love or leaving home for good.

According to Psychology Today, below is what they say about listening to music that makes you cry:

Many of you have had the experience of driving with the radio or walking into an establishment with music playing, and suddenly, a song comes on that immediately transports you back into a different time—with memories flooding back associated with something you were feeling when that song was popular. You may have songs you remember from childhood that affect you this way, and sometimes bring tears to your eyes. But why? For many people, music is linked to memories, from nostalgia to trauma. For others, beautiful music is emotionally moving in a positive sense, independent of context. Researchers have observed that music is an interesting field of psychological study because while highly pleasurable, it has no obvious importance for promoting survival.

When sad songs feel good: Katherine N. Cotter et al. (2018) studied the phenomenon of feeling like crying when listening to music. Within a sample of almost 900 adults, they found two primary experiences of remembering instances of crying while listening to music: a class who felt sad, depressed, and upset, and a class who felt "awe," defined as feeling happy, euphoric, inspired, and amazed. Regarding the types of personality characteristics in each class, Cotter et al. note that individuals who were high in openness to experience were more likely to experience "awe," while people high in neuroticism were more likely to be in the "sad" class. Interestingly, they found the sad class to be twice as large as the awe class.

Cotter et al. also looked at how different facets of the experience of feeling like crying were linked to class membership. They found that individuals who reported the experience of feeling like crying from music were more likely to belong to the "sad" class—which contained two-thirds of the sample. Individuals in the awe class wanted the crying experience to happen again, reaffirming that within this class, the experience of feeling like crying is positive, as corroborated by the emotional profile of individuals in this class, and their desire to repeat the experience.

Music and art, particularly painting, have a close relationship. An environment in which music and art take place jointly affects our creative process. Environmental factors like colors, brightness or darkness, smell, and sounds trigger varying emotions and feelings within us.

As such, these sensual experiences enter our creative process and affect our artwork. Evidence suggests that when a particular type of music and painting take place in the same environment, the result of the painting will be distinct.

Chapter 11

I find that different people interpret paintings in different ways based on their feelings, emotions, and mood. When you look at a painting, it is not only the external depiction you are looking at. Every picture holds a deep, hidden meaning and feeling. You can get the feeling when you look at it carefully. You will comprehend the theme, mood, and emotions behind the painting. The point here is that the environment in which the artist made the painting will be visible in the final painting.

According to www.stagemusiccenter.com: "Many artists, psychologists, and musicologists agree on the relationship between music and the arts. Renowned Russian painter and art theorist Wassily Wassilyevich Kandinsky was so fascinated by the link between visual art and music that he used musical terms to name many of his paintings.

There is an opportunity to gain from accepting, exploring, and understanding how music affects arts, especially the painting process. To understand this process, try listening to different musical genres as you paint. The music will affect your subconscious mind, resulting in a different painting.

In other words, different types of music will affect your painting process. For example, it has a powerful effect on mark making and

color choices. If the music has a fast tempo, it will naturally incite fast mark making.

On the other hand, slow music will affect how you choose colors. It will result in a painting that represents the emotions you experienced when listening to music. What this means is that you can interpret music through artwork, such as painting. Give it a shot and see how music alters the marks on your canvas.

Mood, Music, and Painting: Different people interpret paintings in different ways based on their feelings, emotions, and mood. When you look at a painting, it is not only the external depiction that you are looking at. Every picture holds in itself a deep and hidden meaning and feeling. You can get the feeling when you look at it carefully. You will comprehend the theme, mood, and emotions behind the painting. The point here is that the environment in which the artist made the painting will be visible in the final painting.

As explained above, music can affect your mood. In turn, your mood will affect your artwork. This means that if you are listening to a certain music genre while painting and then suddenly switch to another genre, the final painting will reflect this change.

Light Music and Painting: When you listen to sad music while painting, the painting will appear low and gloomy. Light music will affect your painting process in a different way than fast or dark music because every genre of music sets a different mood, which will then be visible in your painting. To start with, play some light and peaceful music while painting a landscape. This will result in a painting that will look more beautiful and realistic. Whoever sees the painting will then have the same feelings that you experienced at the time of painting.

Painters can, unarguably, come up with realistic paintings when they are in a relaxed and calm mood. Combine light music with the lights turned on, and the final painting will light up with bright tones and colors. This happens because music and lights affect your subconscious mind to choose light colors. On the other hand, when you listen to sad music while painting, your mood will be visible in the final painting. The painting will appear low and gloomy.

If you want to paint something cheerful and pleasing, avoid listening to sad music. Instead, switch on a nice, pleasant, and positive genre. Even if you are feeling depressed and low at the time of painting, the music will calibrate your mood to positive. As such, your painting will be beautiful and upbeat. While music is useful as a temporary mood changer, it is not a lasting solution for your mood.

Fast Music and Painting: There are many examples where music has inspired many artists and vice versa. Colors in paintings represent different moods and feelings and music can affect your color choice. This is particularly true when it comes to fast music. When you paint while listening to fast or break music, it will result in an abstract painting with many colors. When you see an abstract painting, you will quickly understand that the artist was listening to fat music and experiencing a spin of emotions at the time of painting.

Depressing Music and Painting: If you are an art lover, chances are you already have seen many dark-themed paintings. The depressing depictions in the painting will make it evident that the painter was listening to sad music and experiencing depressing emotions.

It is natural to assume that an individual who is in a good mood cannot depict sad emotions in his paintings. Chances are the person came up with a depressing painting because he or she was having a bad time or sad moment. Or it can be because the person was listening to depressing music when working on the painting.

In case you are told to create a sad painting, but you are in a pleasant and relaxed mood, then switch on sad music and start painting. Doing so will make it easy for you to create a dark-themed or sad painting. The music will shift your mood from good to sad, which will then reflect in your artwork.

Music and art have a close relationship that has been endorsed by many studies and agreed upon by musicians, psychologists, and artists. The music genre you listen to while painting will affect your subconscious mind and swing your mood. This will result in a painting that reflects the type of music you were listening to while

painting. We cannot disregard or jettison the linkage between music and painting."

Overall, I find the connection between music and art and moods pretty interesting stuff.

Chapter 12

Music has always played an emotional part in my life, and somehow, I seem to feel a connection with certain music when I paint. I recall memories that have pulled at my heartstrings. When my family would go camping in Ukiah, hearing the song "Maggie Mae" by Rod Stewart always had a strong pull on my heartstrings. And the song "Angie" by the Rolling Stones tugs at my heart from memories of the time I spent in the Student Union at College of the Redwoods while earning my AA degree.

I cry whenever I hear "Over the Rainbow" by Israel "Iz" Kamakawiwo'ole, one of the most beloved singers in the history of Hawaiian music. In the summer of 1997, he died of respiratory failure. He was only thirty-eight and just beginning to see the huge success of his version of "Over the Rainbow." Israel's body lay in state at Hawaii's Capitol building, a rare honor. He was born in Honolulu on the island of Oahu, Hawaii.

> Somewhere over the rainbow
> Way up high
> And the dreams that you dream of
> Once in a lullaby
> Somewhere over the rainbow

Bluebirds fly
And the dreams that you dream of
Dreams really do come true
Someday, I wish upon a star
Wake up where the clouds are far behind me
Where trouble melts like lemon drops
High above the chimney top
That's where you'll find me
Somewhere over the rainbow
Bluebirds fly
And the dreams that you dare to
Oh why, oh why can't I?

I also feel sentimental when I hear the song "What a Wonderful World" by Louis Armstrong. This song has a very special meaning to me because my son, Jason, sang it with his group of preschool students, and when he married his bride years later, he chose the song and dedicated it to me as we danced our special mother and son dance on his wedding day. I heard there were some tears among guests.

I see trees of green, red roses too
I see them bloom for me and you
And I think to myself what a wonderful world
I see skies of blue and clouds of white
The bright blessed day, the dark sacred night
And I think to myself what a wonderful world
The colors of the rainbow, so pretty in the sky
Also on the faces of people going by
I see friends shaking hands, saying how do you do?
They're only saying I love you
I see babies crying, I watch them grow
They'll learn so much more than I'll ever know
Then I think to myself what a wonderful world

> The colors of the rainbow, so pretty in the sky
> Also on the faces of people going by
> I see friends shaking hands, saying how do you do?
> They're only saying I love you
> I see babies crying, I watch them grow
> They'll learn so much more than I'll ever know
> Then I think to myself what a wonderful world
> Then I think to myself what a wonderful world.

Another song that brings tears to my eyes when I hear it is "You'll Never Walk Alone." This song always pulls at my heartstrings because of the lyrics and my memories of Mom. It was her favorite song, and I listened to her sing it many times. When it was played at her memorial service in 2017, at my request, I became an emotional wreck.

> When you walk through a storm
> Hold your head up high
> And don't be afraid of the dark.
> At the end of a storm
> Is a golden sky
> And the sweet silver song of a lark.
> Walk on through the wind,
> Walk on through the rain.
> Though your dreams be tossed and blown.
> Walk on, walk on with hope in your heart,
> And you'll never walk alone,
> You'll never walk alone
> Walk on, walk on
> With hope in your heart
> And you'll never walk alone

The wedding song "There Is Love" still has a powerful emotional impact on me. My dear friend Debbie Schussman sang it at

my wedding ceremony when I married Bob. This song was sung by Paul Stookey of Peter, Paul and Mary, folk singers from the 1960s, at their twenty-fifth anniversary concert. When I heard it played on the radio during my drive home from work one day, my lips started quivering and I thought to myself, "What the heck is going on with my emotions?" An immediate memory of our wedding ceremony came up, and I suddenly began to weep with sadness that he was gone.

> He is now to be among you at the calling of your hearts
> Rest assured this troubadour is acting on His part.
> The union of your spirits, here, has caused Him to remain
> For whenever two or more of you are gathered in His name
> There is love, there is love.
> A man shall leave his mother and a woman leave her home
> And they shall travel on to where the two shall be as one.
> As it was in the beginning is now and till the end
> Woman draws her life from man and gives it back again.
> And there is love, there is love.
> Well then, what's to be the reason for becoming man and wife?
> Is it love that brings you here or love that brings you life?
> And if loving is the answer, then who's the giving for?
> Do you believe in something that you've never seen before?
> Oh, there is love, there is love.
> Oh, the marriage of your spirits here has caused Him to remain
> For whenever two or more of you are gathered in His name
> There is love, there is love.

Chapter 13

Creativity definitely has its seasons, doesn't it? I believe it does! Just as nature does, creativity goes through phases of activity and rest.

According to vocabulary.com, When something ebbs, it is declining, falling, or flowing away. The best time to look for sea creatures in tidal pools is when the tide is on the ebb, meaning it has receded from the shore. "Ebb" is often used in the phrase "ebb and flow," referring to the cyclical changing of the tides from low to high and back to low again. This sense of cyclical change can also be applied to other things.

In https://alvalyn.com/4-seasons-of-creativity, Alvalyn Lundgren talks about the four seasons of creativity:

"There's a cycle of creative output most of us go through, and mostly without recognizing it. The cycle is progressive, and each stage is necessary to manage your creative energy—drive and focus—every day. You can think about your creativity in similar fashion to how a farmer tends and cultivates the fields that produce the harvest. A farmer doesn't really produce the crop; the field does. The farmer cares for the field so it can produce the crop.

Likewise, the creative pro's "crop" is produced by their creativity. So your creativity is the field that produces the designs that solve the problems of the world.

Chapter 13

How do you nurture your creativity? There's a regular cycle of creative output most of us go through, and mostly without recognizing it. The cycle is progressive, and each stage is necessary to manage your creative energy—drive and focus—over the long term.

We can think of this cycle as having four seasons. Unlike in nature, a creative season has no defined duration. In nature there's a set 90 days between the summer solstice and fall equinox. But you can move through a single complete creative cycle in a few weeks, months, or even years."

There are four seasons of creativity: rest, cultivation, ideation and implementation. Her article has fascinating information.

Chapter 14

When I decided to write this book, I began slowly with no urgency and wrote whenever I felt like it, and I used my time to gather all my writing journals, travel journals, records I kept on each face painting gig, photo albums, etc. and organized them chronologically according to event dates. Toward the end of the first year, I sped up and was writing every single night after work until I burned out. Then I hit a dry spell for about six months and stopped writing. The dry spell sort of came during the beginning Covid-19 pandemic when my work hours were decreased. I was feeling no motivation at all.

In the last three months of my writing, however, I felt the Holy Spirit hit me really hard to put me back on track, and I started recalling more and more events and had several dreams about my recollections. So, I really sped up my writing, and I was writing until midnight most nights. I believe now that it is all up to the ebb and flow! Fortunately, after my dry spell, my motivation started waking up, and I began to focus on my writing every single night after work and on the weekends until completion. So, there you have it. Seasons are for real.

There is a time for everything ya know? I learned that the message in the passage of poetry centers on God's ultimate authority in heaven and on earth. Humans have mastered many things in this

world, but some elements of our existence are beyond our control. We cannot conquer time; God is the one who appoints each moment. Our lives contain a mixture of joy and sorrow, pleasure and pain, harmony and struggle, and life and death. Each season has its appropriate time in the cycle of life. Nothing stays the same, and we, as God's children, must learn to accept and adjust to the ebb and flow of God's design. Some seasons are difficult, and we may not understand what God is doing. In those times we must humbly submit to the Lord's plans and trust that he is working out his good purposes.

"There is a time for everything, and a season for every activity under heaven: a time to be born and a time to die, a time to plant and a time to uproot, a time to kill and a time to heal, a time to tear down and a time to build, a time to weep and a time to laugh, a time to mourn and a time to dance, a time to scatter stones and a time to gather them, a time to embrace and a time to refrain, a time to search and a time to give up, a time to keep and a time to throw away, a time to tear and a time to mend, a time to be silent and a time to speak, a time to love and a time to hate, a time for war and a time for peace."—Ecclesiastes 3:1–8 (NIV)

In reference to there is a time for everything, the song "Turn! Turn! Turn!" was written by Pete Seeger in the late 1950s and first recorded in 1959. The lyrics—except for the title, which is repeated throughout the song, and the final two lines—consist of the first eight verses of the third chapter of the book of Ecclesiastes. The song was originally released in 1962 as "To Everything There Is a Season" on the Limeliters' album Folk Matinee and then some months later on Seeger's own. The song became an international hit in late 1965, when it was adapted by the American folk-rock group the Byrds. The lyrics were taken word for word from the Bible.

Chapter 15

I was age nineteen when I first moved out in 1974, a year after I graduated from high school. I needed my independence and to get away from watchful eyes, so I moved into a neighbor's house just down the street from our home in Bayside. Lyndsay lived in her grandparents' lovely home while they were away, so it was a perfect beginning for me. It lasted a short time, and later I moved out and in with another girlfriend in a huge house in Eureka (my first of many roommates).

I enrolled as a full-time student at College of the Redwoods and was hired to work part-time on campus at the college bookstore, which was great because my employer arranged my work hours around my class schedule. I worked that job for about two years, and after I had completed all but a few units toward graduation, I was hired full-time by the Work Experience Department, under the direction of Dennis Kheen and later, my favorite boss, Jerry Phillips. Jerry knew my interests and encouraged me to be as creative on the job as I wanted, so I created posters and flyers for the department. I graduated with my associate arts degree in business.

I discovered making Styrofoam wreaths was a fun craft. I wrapped strips of torn fabric around each wreath. I used both heart-shaped and round wreaths. Since Mom was a seamstress,

she would always give me all the fabric scraps I needed for this particular project.

I started painting tennis shoes and ladybugs on river rocks, and beer can labels on hand-held mirrors, and gave them to my friends. I bought the books *The Art of Painting Animals on Rocks* and *Painting Flowers on Rocks.* I also designed a set of stationery with hand-drawn pen-and-ink wild animals that I gave to friends and family members.

Burt Reynolds was my focus in one art class. The assignment was to take an image to sketch and cut a one-by-one-inch square in the center of a piece of paper. Then you placed the paper over the image exposing a one-inch section, thereby focusing on each intriguing detail one square at a time—a great exercise in detail.

Mainly drawing and learning the basics of the art form were my focus during this time and I mainly used pencil and charcoal. It wasn't until later in life that I started using color and learned about acrylics, watercolors, and pastels. I developed an interest in entrepreneurship and would sketch business cards with the intention of someday becoming an entrepreneur.

Dance was always a passion of mine so I took a couple of classes in folk dancing and absolutely loved it. A folk dance is one that reflects the life of the people of a certain country or region. Not all ethnic dances are folk dances. For example, ritual dances or dances of ritual origin are not considered folk dances. Ritual dances are usually called "religious dances" because of their purpose. The terms "ethnic" and "traditional" are used to emphasize the cultural roots of the dance. In this sense, nearly all folk dances are ethnic ones. If some dances, such as polka, cross ethnic boundaries and even cross the boundary between folk and ballroom dance, ethnic differences are often considerable enough to mention.

Chapter 16

Sacramento has been an enormous part of my life that I will never forget. I moved from my hometown to Sacramento at age twenty-two in pursuit of a lifestyle away from a small town where everyone knew my business. I started out sharing a duplex with my high school friend Debbie Schussman, whose family had moved to Sacramento in my junior year of high school. I was determined to make my life in this world but had only $900 in my pocket and a fantasy that I would make it as an artist selling my sketches, greeting cards, and stationery. I ended up working part-time jobs here and there until I found full-time work.

Sketching took up my interest a lot during that time of my life and decided to try my hand at sketching nudes. So I got brave and asked a couple of men I was dating if they'd let me paint them in the nude. Of course, they were thrilled! I also sketched male portraits. It was difficult for me, but I must admit, they turned out looking pretty realistic.

I discovered a love for painting a sunrise or sunset on canvas with the black silhouette of a tree and/or mountains in the background. I created several paintings for my family and friends in this style and painted my first triptych on a set of three canvases and gave it to my sister Susie. It was a beautiful, three-part acrylic painting of a sunset

with black silhouettes of a barn and trees. I painted a similar piece for Debbie's mom with the silhouette of trees.

Michael, a man I was dating, believed he was Poncho Villa, the famed Mexican revolutionary and guerilla leader of the early 1900s. He knew my talent and encouraged me to paint. He had an eight-inch, plastic Pepino, an Italian mouse doll, that he wanted me to paint. I used acrylics on a small canvas board, and that little mouse was my first successful realistic painting. I did a lot of sketching during this time in my life.

Since I was still using my antique black Singer sewing machine, I sewed little stuffed animals from patterns that were inspired by Grandma. These were maybe six inches and included bears, elephants, tigers, dogs, and cats.

Mophead dolls were another one of my crafts. I made these dolls for quite a while by actually using the head of a mop. To make the heads, I cut two five-inch circles, sewed around the circle leaving a space for turning, and filled it with polyfill. I would adorn the doll with bangs, a hat, or ribbon in her hair. I used black paint to make a dot on the face for eyes and added blush on her cheeks. Sometimes I'd include flowers or other trim as desired.

Other crafts I enjoyed doing were knitting fancy scarves and creating small gift boxes from greeting cards. For the scarves, I used fancy, sparkly yarn and knitted loosely to create beautiful decorative scarves. Mom taught me how to create the small gift boxes. They were a big hit! It's like you are repurposing greeting cards by making boxes out of them.

Macramé plant hangers took up many hours of my time and the macramé hangers I made included three-tiered round glass tables that were quite beautiful and very time-consuming. I sold quite a few of them and, believe it or not, also toilet paper hangings. I purchased so many instruction books on this artform; Debbie and I were always running back and forth to Pottery World in Sacramento for supplies.

At another point I purchased blank puzzle sheets, created a

painting of a scene when the puzzles were locked together, and then pulled the puzzle pieces apart. I placed them in the envelope provided with the kit and mailed them off to friends and family as a birthday or anniversary card. The recipient would have to put the puzzle pieces together to see the painted scene. It was so much fun.

There was a website I found that sold uniquely designed baskets and I purchased several baskets and tried my hand at creating dried flower arrangements, which I made into gift baskets that I sold to friends and clients.

I applied to the government for a civil servant position, and I landed my first permanent position as a clerk typist in the legal department at McClellan Air Force Base. I developed close friendships with the attorneys; some were officers and some were retired officers working as civilian attorneys. My favorite, Major Joe Carreto was my boss and he liked me because we shared the same love for the arts. His desk name tag said, "Just Call Me Joe." I had a huge crush on him although he was probably twice my age. He was a sculpture artist, and I was fascinated by the way he saw my face as a sculptor. I recall him saying there was a certain way I tilted my head when I spoke and he wanted to create that image. Once he invited me to his house to sculpt a bust of my head to my shoulders which took a few sittings and turned out very realistic.

Debbie introduced me to Denio's Farmers Market and Swap Meet in Roseville out on Vineyard Road. I got a lot of artistic inspiration from this place. We shopped for so many fun things for our duplex: plants, vegetables, fruit, flowerpots, pictures, and ceramic figurines; we even bought a couch one time. I remember the market was the largest I'd ever seen! It was founded in 1947 and became a local Saturday event. By the early 1960s, Denio's was known as the largest, cleanest, and most efficiently run farmers market, auction, and bazaar in California.

Debbie and I shared a huge interest in music and dance, and during the disco era, we frequented the popular night clubs quite often to people watch and try fancy rum drinks. If we weren't asked

Chapter 16

to dance, we would find someone who seemed likeable, grab them, and take them out on the dance floor. We were not shy during those days! The disco era was my absolute favorite era of music (besides the seventies)—the more disco songs were played, the harder I danced, and I got quite creative from all the dancing. I even entered a couple of dance contests back then. My favorite recording artists were Donna Summer; Gloria Gaynor; the Bee Gees; Diana Ross; KC and the Sunshine Band; Michael Jackson; Village People; Earth, Wind & Fire; Marvin Gaye; Kool & The Gang; the O'Jays; and John Travolta. I could go on and on.

When Debbie moved to Fresno, I was forced to find another place to live so I found a two-bedroom apartment at Hidden Creek Apartments off Highway 80 and Madison Avenue and moved in. There was a sense of peacefulness with the sounds of the babbling creek right outside my apartment. An added benefit was that I was on the second floor facing the creek. I always enjoyed the sound of the running water, especially when the rains were heavy. One time I discovered a crawdad creeping across the sidewalk and making its way back into the rushing waters of the creek.

Nourishment for my soul came to me by sitting on the banks of the American River, as well as enjoying a meal and drinks at Crawdad's Bar and Grill along the river bank on the old Garden Highway, and a popular restaurant and bar now called Swabbies. On Sundays live bands performed outside, and I would sit in the grass on the riverbank and watch the boats go by, people watch, and sometimes sketch the river.

Old Town Sacramento was another way I nourished my soul. My favorite thing to do was visit the area and walk along the old wooden sidewalks and cobblestone roads, visiting the shops, eating ice cream, and visiting the art museums. Sometimes I would find a bench to sit on and sketch people going by. My friends and I would roller-skate around Capitol Mall, people watch, and simply enjoy the feeling of freedom on skates with the wind blowing through our hair.

At one point I did some amateur sign painting for a few small

business owners. Then, somehow, my longtime friend from Eureka, Dave Roberts (who also moved to Sacramento and became my roommate for a short time), convinced his friend, who owned a bar and grill and card room in Folsom, California, to let me paint their business logo on their dance floor. It was quite an honor and experience indeed. My design was then coated with a layer of heavy-duty, commercial-grade lacquer floor coating.

Chapter 17

Another new beginning took place for me: I'd been dating Mike, a sales representative/driver for Keystone Automotive, who had a sales territory from the Bay Area to Sacramento. Ironically, Mike was my oldest sister's brother-in-law. We had a romantic relationship off and on for a while. He was somewhat of a playboy and had girlfriends all along his sales route. I was infatuated with him, but I knew I couldn't have him.

In 1981, Mike introduced me to Bob, his sales manager for Keystone in South San Francisco, who had transferred from Bethlehem, Pennsylvania. Bob and I started dating and continued a long-distance relationship for about six months and would alternate visits between Sacramento and South San Francisco. Bob knew I had a romantic fascination with San Francisco, and he would take every opportunity to impress me with the city. He would wine and dine me and wow me with the magnificent night view of the city lights along Highway 280. The view, of course, was absolutely spectacular. He treated me to the most expensive restaurants in the city. One of our favorites was the iconic House of Prime Rib on Van Ness, a decadent restaurant that prepares the highest-quality corn-fed beef in the Bay Area. Prime rib was carved at our table to our specifications.

Music was a huge part of our lives, and when Bob would visit me

in Sacramento, we would lie on our backs in my living room or in a grassy field somewhere and talk about our love of music and the impact it had on us. Unfortunately, he didn't share my love of dancing, so my dancing years were terribly missing. My favorite music was from the 1960s and '70s, and his was rock and heavy metal. Billy Joel was a favorite of both of us and Bob had actually seen him perform in Allen Town, Pennsylvania. Although the steel industry was based in Bethlehem, Pennsylvania, Billy Joel titled his song "Allentown" because it sounded better and was easier to rhyme.

A favorite of Bob's was "Nothing Else Matters" by Metallica. To this day, whenever I hear this song, I break down in tears because of the strong emotional connection I had with Bob.

> So close no matter how far
> Couldn't be much more from the heart
> Forever trusting who we are
> And nothing else matters.
> Never opened myself this way
> Life is ours; we live it our way
> All these words, I don't just say
> And nothing else matters.
> Trust I seek and I find in you
> Every day for us something new
> Open mind for a different view
> And nothing else matters.
> Never cared for what they do
> Never cared for what they know
> But I know
> So close no matter how far
> Couldn't be much more from the heart
> Forever trusting who we are
> And nothing else matters.
> Never cared for what they do
> Never cared for what they know

> But I know
> I never opened myself this way
> Life is ours, we live it our way
> All these words, I don't just say
> And nothing else matters..

Another song that affects me deeply is "Drive" by the Cars. We saw the Cars perform in Santa Cruz at an outdoor concert, and "Drive" became our song. It is not uncommon for me to break down and sob when I hear this song too.

> Who's gonna tell you when it's too late?
> Who's gonna tell you things aren't so great?
> You can't go on thinking nothing's wrong, oh no
> Who's gonna drive you home tonight?
> Who's gonna pick you up when you fall?
> Who's gonna hang it up when you call?
> Who's gonna pay attention to your dreams?
> Who's gonna plug their ears when you scream?
> You can't go on thinking nothing's wrong, oh no
> Who's gonna drive you home tonight?

Chapter 18

We felt it was time and moved into Bob's two-bedroom apartment. The move took place on the hottest day in Sacramento with a high temperature of 115 degrees; I will never forget that day. Bob and his friends helped move three trucks packed full of my belongings. After loading the last truck with my belongings, we all headed toward the pool fully clothed and falling backward, took the "Nestea plunge" into the pool to cool off. Driving down the highway, we must have looked like three trucks right out of The Beverly Hillbillies TV show. We had stuff stacked so high and strapped down to every truck with fans blowing in the breeze—it was quite comical; we were quite the sight. At one point one of my skimpy negligées escaped from a drawer of my dresser on one truck and flew onto the windshield of another. It was so embarrassing, yet funny. It was quite a memory. Thus, my life began a new chapter in South San Francisco.

During my life in the Bay Area, I didn't paint, but I did dabble with graphic design. Before I found work, I hung around Bob's employer at the time, Keystone Automotive, where he was the general manager and helped out with paperwork and moving product in their warehouse. The funniest thing was that he taught me how to drive the forklift. It was hilarious!

On August 7, 1986, Bob and I were wed at the poolside of the

elegant, historic Eureka Inn. Since I was somewhat of a free spirit, I never liked the thought of being married in the confines of a church and had always wanted to be wed outdoors. Bob's mom and aunt and uncle flew in from Bethlehem to see us get married. We had a small, intimate group of seventy-five guests. Mom arranged for a harpist, and her music was soft and angelic; Debbie, sang "Longer" by Dan Fogelberg with her beautifully trained voice. Grandma (Dad's mom) had altered my simple yet elegant, lacy off-the-shoulders Gunne Sax dress that we found for only fifty dollars at the San Francisco Gunne Sax outlet. Since alterations were her profession, she altered the hemline so it was fashionably longer in the back than in the front; it was breath-taking. As we walked down the aisle alongside the pool, I had a sinking feeling in my gut but had to ignore it since I couldn't turn back or stand him up at the altar like in the movies. We became husband and wife; another new start on life.

One strange thing was my longtime friend Gayle Sarff had planned her wedding date at the exact same date and time, believe or not. So, obviously, we couldn't attend each other's wedding ceremony. It took over forty years before Gayle and I were reunited, but during that time span, we did manage to keep in contact with letters and occasional phone calls. One day I simply decided that forty years was way too long without seeing my dear friend. So in 2017, I arranged a flight to Camas, Oregon, to see her. What a special reunion of friendship.

I met Lynn, a coworker when I worked at Bureau of Land Management and we became really good friends (we nick-named each other "Ditto.) She had introduced me to graphic design and showed me how to create newsletters. So, with her encouragement and advisement, I started generating monthly newsletters for clients she helped set me up with. I even started my own family newsletter which was fun because I got everyone in my family to engage in this project. I then developed an interest in designing business cards and helped several small businesses.

In 1987, Bob and I moved to San Rafael which was a quiet suburb

with a lot of restaurants that had outside dining under a canopy—a very charming atmosphere. I didn't like it at first and was bored, compared to my busy life in Sacramento. We rented a large downstairs flat in a Victorian house on Laurel Way that was divided into several apartments upstairs. The house had the largest kitchen I'd ever had and the rooms were large, and we had a fireplace. Our patio overlooked flowers and trees. The house was located on a steep hill, so we had to walk a steep slope down to a separate garage to get our cars. San Rafael was founded in 1817, and was a hospital mission, tending the sick from Spanish settlements and natives. I painted business windows downtown with holiday designs during that time and painted all the windows of our house. It was a nice place to live and I enjoyed the downtown's romantic ambience.

Bob knew I had a wild streak and that I loved motorcycles. So, being the sweetheart that he was, he bought me my first Honda scooter that was freeway legal. He purchased it in San Francisco from a Honda dealership, and I courageously rode the scooter home that day across the Golden Gate Bridge. What an absolute thrill of a lifetime! My friends could not believe I had done that. And I didn't dare tell Mom; she would have had a fit, not to mention all the worry I would have put her through. I must admit, I was a pretty good rider and never had a spill with it. I rode my scooter and explored all around San Rafael, up in the hills and down by the water and everywhere in town which gave me the sense of freedom and exploration. I worked temporary jobs in San Francisco at the time and commuted mostly on the ferry boat—loving it because it was that feeling of freedom and excitement that I thrived on plus I could have a glass of wine on my trip back home. Bob was commuting daily from San Rafael to South San Francisco. I later landed a full-time job as an administrative assistant in the north end of San Rafael.

Our first son, Jason, was born in San Francisco on May 3, 1988. After my three-month child bonding, I was let go from my job, which was kind of a blessing since I was able to spend a year with Jason before I had to return to work.

Chapter 18

We later decided to move to San Mateo to eliminate Bob's daily commute over the Golden Gate Bridge. I found full-time work at the Congregational Church of San Mateo as an office manager in 1990. During my nine-year employment Zoe Mullery and I got acquainted and we became longtime friends. She worked part-time while getting her MFA in creative writing at San Francisco State. She made quite an impact on me with her writing interest and experience. I recall her advice for writing your personal story: begin with the letter A in the alphabet, writing whatever comes to mind, and continue this process throughout the entire alphabet. She has been an inspiration to me in my writing.

Our second son, Cody, was born in San Mateo on November 19, 1991. I recall Jason creating a Play-Doh version of the hospital while I was in the hospital. We had wanted a brother or sister for Jason and Cody was our answer. After three months I returned to work full-time at the church, which was very difficult as it is for any young mother but we managed to find a great day care for Cody right in San Mateo. Life once again began to continue as normal.

During my employment as office manager at the church, I became acquainted with church members Mike and Kay Harris. She began producing the monthly newsletter and I became enthralled with her ability to work as a graphic designer. Soon she started a business from home as a professional graphic designer. Graphic design had become another avenue of intrigue for me and she invited me to her house many times where I saw how she run her business. She said I was the one who encouraged her in her business, but I think it was the other way around – she intrigued me with her skill therefore she encouraged me.

She became my mentor and helped me develop my own graphic design business but not nearly to the degree that she was doing. Since tools and technology change so rapidly, before the age of transferring documents via electronic transferring, she had several huge volumes of clipart and she would scan each piece individually through her antiquated system into the newsletters. When

technology was updated, she sold me three of those binders for my own business and she updated electronically. Those things were heavy and had hundreds of pages in each binder. Each binder must have measured at least twenty-four by twenty inches.

Chapter 19

Mom was the first to encourage me to face paint in 1989. About ten years before Mom and Dad retired, they invested in a small business, Gold Reflections, and for several years sold gold and silver jewelry. Some pieces were imported from Italy, and they made many business trips to San Francisco to buy wholesale jewelry from the Jewelry Center. They also sold piano-tuned wind chimes and wind socks. Their business took them all over California, Oregon, Nevada, and Arizona as professional vendors at county fairs, street fairs, and festivals. They had a very professional image and display. They purchased a vendor trailer and stocked it with merchandise. The front part opened like a storefront where Mom and Dad stood behind their display. It amazed me how they managed to work their business on the side when both continued to work full-time. And, of course, when they retired, it became their full-time business and purpose, which made a huge impact on me. I didn't realize it at the time, but now I know they are why I have pursued a career as an entrepreneur.

She mentioned to me one day, "Your dad and I see face painters at all the events we attend, and with your artistic talent, I think you should consider face painting." It was an intriguing idea, and I had never considered it as an avenue to pursue, but Mom knew I loved

art and had a talent and knew I could do it. I let the idea go for a long time before pursuing it. Mom kept telling me, "You can do it! You should try it!" I told my friend Sue Misbach about the idea, and she was very excited. Sue was always so enthusiastic and upbeat, and she was very encouraging about the idea. She had read somewhere how to make your own face paints with glycerin, so we experimented, but later we decided to buy paints and not deal with the hassle. We practiced on kids in the neighborhood and went to festivals to observe the face painters and learn from them. After a time, Mom found a notice posted on the bulletin board in their local post office advertising full-face painting by a local face painter. She approached me with the idea of expanding to full faces. Of course, like any new idea, I resisted. Later, however, I took her advice and learned how to paint full-face designs.

One day in 1990, my supervisor, Senior Pastor, Dr. David Brown, asked me if I would be willing to work the church's Pilgrims Festival in the parking lot of the church. My dear best friend and coworker Jack Snell, who was the volunteer treasurer, was a huge influence in my life and encouraged me to face paint for that event. For the festival I had a small card table at my station and a piece of poster board with simple cheek art designs to choose from. I was timid because it was my first-ever gig. My first little customer came up to me, sat in my chair, and excitingly pointed out a cute ladybug for her face. I nervously picked up my paintbrush, swished it back and forth in the acrylic paint, and painted a pretty basic ladybug on her cheek, adding some glitter. She loved it! It was enough encouragement for me to keep painting. Just to see the smile on that child's face was enough for me. I was hooked.

I started out using acrylic paints, not knowing they were not meant for the skin but it seemed logical to me. I practiced on my two young school-aged sons and their friends and school buddies. That was the beginning of my face painting journey.

My next experience was painting for my son Jason's PTA event at his preschool, at the request of the preschool director, Susan. I had

the same setup with my simple cheek designs. The kids loved being painted, and it was enough to encourage me to continue and Jason was a huge advocate for me up into his early grade school years. Whenever he had friends over, they would let me practice on their faces. My biggest hits were Spiderman, Batman, and Ninja Turtle. I practiced many of those designs until I got pretty good at them.

I researched more face designs and practiced on all the neighborhood kids. I took photos of the designs on my kids' faces, printed them, and created a collage of designs for my first sign board. My dear friend Jack was instrumental in encouraging my face painting career and built my first display board. He used a twenty-four by thirty-inch board, sanded it down, painted it brown, and attached a metal handle to the top for easy carrying and attached my sample designs to the board for kids to choose from. I took the board with my chair and table on a wheel-based cart to all of the festivals. This system seemed to work well for me, and at that point I didn't use a canopy. It was a pretty easy setup, and Jack was so good to help me with my face painting.

Still using acrylics in 1990, and for the next ten years, I went on to working several Bay Area festivals, including those in Burlingame, Brisbane, Daly City, Foster City, Fremont, Millbrae, Milpitas, Mountain View, Pacifica, San Bruno, San Carlos, San Mateo, San Jose, and South San Francisco. With each event, I gained more and more experience and excitedly looked forward to the next festival.

At a street festival in Milpitas I discovered there were three face painters at the event; and one of them even offered their art for free! Of course, customers would prefer to have it done for free rather than have to pay. This type of competition eliminated my sales but since it was new to me, I didn't know to ask ahead of time about the number of face painters at the event. I was just so excited to have started my journey that nothing else mattered. Well, after two or three festivals with two or more face painters in competition, I said, "To heck with it," and I became more selective when asked to participate in a street festival. From that point on when I learned there

would be more than one face painter at a festival, I turned them down. I was beginning to gain confidence and choose the events I worked and not just jump at the first opportunity. Instead I investigated it thoroughly to see if it was an event I wanted to participate in. Back in the day, the registration for a festival vendor was affordable, not like it is now.

Another turn in my life took place and because of irreconcilable differences, Bob and I separated in 1998, and he moved back to Pennsylvania where his family lived. I didn't file for divorce until four years later. My life took on a drastic change and I was faced with raising two boys age two and a half and six all alone with no family within three-hundred fifty miles; I became both mom and dad to them but by filling both parenting roles though, my sons and I strongly bonded, and to this day, we are very close. During our separation although Bob and I communicated by phone routinely, the boys and I didn't see him for seven or eight years.

I worked full-time and also had independent typing jobs and wrote newsletters for clients from home, but I always struggled. I found it difficult to face paint at weekend festivals since I had only two babysitters. My career slowed down drastically during that time, as well as my hobbies. However, I was quite creative in the kitchen and enjoyed baking. I oftentimes made heart-shaped pancakes for my sons, especially on Valentine's Day, and heart-shaped French toast from time to time to show my love and devotion for them. I especially enjoyed making heart-shaped peanut butter sandwiches for their friends when they came over. Entertaining their friends was a highlight in my life during those years of being a single mom.

Chapter 20

After seven years of living in Pennsylvania, Bob returned to San Francisco and moved in with our longtime friend Mike. Bob and I became good friends and the boys bonded with him again; and it allowed me to pursue art.

I am filled with gratitude for Bob Knees, my favorite volunteer at the church. He knew my passion and desire for the arts and suggested I check out the Academy of Art University in San Francisco and register for classes. At first, I thought, no way! This couldn't happen to me; I'm not good enough for this prestigious university. But I looked into it, applied, and to my astonishment was accepted! I applied for a student loan and started taking classes—a dream come true. It was the priciest school I had ever attended. The tuition at that time was $700 per unit. Today, I'm sure it's doubled. What a dream it was for a small-town girl from Arcata with big ambitions and what a feeling of honor to be learning at the university. It was the biggest highlight of my life as far as accomplishments, and what a feeling of reward when I completed all of the assignments.

The Academy of Art has buildings all over San Francisco depending on the classes you enroll in. Many classes were held in the evening and some on Saturdays. I purchased an Apple computer, an art portfolio, and the required tools and supplies with my student

loan and with education and experience, I was very grateful for the opportunity. I enrolled with the intent to learn graphic design, but later fine arts caught my attention so I started taking classes in basic design, color, painting, and art history.

My first assignment was to design a professional-looking olive oil label and present each step of the process, from the first sketch to the final product. It was an incredible process that included using tracing paper to sketch the format of the label, choosing a typeface that suited the label, and experimenting with color using colored pencil. We also had to decide on a name for our olive oil. We then had to draw twenty thumbnail sketches of our label, narrow it down to four favorite designs, and then re-create four with colored pencil. We then chose the favorite design from those four and re-created it full size—one in colored pencil and another in black ink. The final design was transferred onto heavy paper, cut out, and transferred onto another paper. We made a presentation booklet from heavy cardboard, binding the book ourselves and adding a special paper for the front and back of the book.

The most unique class I took focused on creating a presentation box or container by hand for those who might be interested in culinary arts and presenting a food product to a potential client. It was a time-consuming process, and each student created his or her own box for presentation.

The academy prides itself on teaching students how to present themselves professionally with a top-notch portfolio. I learned how to make a professional-looking presentation book or folder to present my artwork.

My commute to class was quite a long trek but was enjoyable and entertaining. I would drive from San Mateo to Daly City Bart Station, take Bart to the Powell Street Station in San Francisco, and then, if I was lucky, I'd catch a cable car and ride a few blocks up the steep Powell Street hill to the location where I took Basic Design, and it had the most exciting location. With my portfolio in hand, I'd trek up the steps to the art studio, unpack my supplies, and prepare

for my art lesson. The romance of this experience was so exciting for me. Here I was in San Francisco, sketching in a fifth-floor art studio of a prestigious art university while listening to the cable cars chiming down below from the open windows.

Another class I took was basic sketching. I learned to draw drapery with charcoal, as well as sketching live models with charcoal. I learned a lot about the beauty of the human body. I charcoaled the head of a statue as well as a nude female statue, which turned out pretty realistic looking; the proportions were pretty accurate, which for me is difficult to achieve. We also had some still life setups in the classroom that we drew.

Our class took a field trip to downtown San Francisco and sketched random people in a coffee shop. I sketched an elderly gentleman who was falling asleep at his table while reading his newspaper. I sketched another man who was also snoozing at an outdoor table. Another charcoal sketch I did was of a small round table covered with a floor-length tablecloth. I placed two books on the tabletop. The covering had many folds in the fabric, and the most difficult things for me to draw are three-dimensional folds. It was quite a challenging piece. But I did it. Another charcoal drawing I'm proud of was a still life of a lamp, wineglass, book, and candle. It turned out very good, pretty realistic. It's difficult to sketch or draw subjects using light and shadows in your drawing, and also depth. It's quite a learned technique.

My final project for the semester earned an A+. My subject was a woman's face that I found in black and white on the internet. I drew her with charcoal, showing highlights, values, and shading. I successfully showed the highlights and shadows of her hair. Her eyes were quite realistic, and I was satisfied with the way I sketched her lips, which again, is a difficult technique for me to perfect. I was quite proud of the piece.

In a graphic design class the assignment was to design a book cover and I designed mine from a Stephen King book that I read, *Bag of Bones*.

I learned about the quantity of light reflected in a composition and in reference to pigments, dark values with black added are called "shades" of the given hue. Light values with white pigment added are called "tints" of the particular hue. I was given an education that I'd never known. Another assignment was to paint an abstract face using color scale values which was the most challenging project for me. I chose the face of a man (that I found online) who had a lot of value and highlights. The difficult part was that we had to use the same value scale in black and white on a fourth of the image and the rest in color. With my first attempt, I did not get a favorable grade, but I was not going to accept the grade and was determined to earn a better one, so I tried it again and focused harder on the color scales. I earned a B on my second try. Success!

One day our class took a trip to the Legion of Honor in San Francisco, formally known as the California Palace of the Legion of Honor, part of the city's Fine Arts Museum. The name is used both for the museum collection and for the building in which it is housed. I sketched the statue of Mother and Child, which was created in 1964 by the Morris Singer foundry in London, using the lost wax process.

I sketched the statue of Asclepius, who was a hero and god of medicine in ancient Greek religion and mythology. He was the son of Apollo and Coronis. According to Wikipedia, Asclepius represents the healing aspect of the medical arts; his daughters were Hygieia ("Hygiene," goddess of cleanliness), Iaso (goddess of recuperation from illness), Aceso (goddess of the healing process), Aegle (goddess of good health), and Panacea (goddess of universal remedy). He also had several sons. He was associated with the Roman/Etruscan god Vediovis and the Egyptian Imhotep. He shared with Apollo the epithet Paean ("the"). The rod of Asclepius, a snake-entwined staff, remains a symbol of medicine today. Those physicians and attendants who served this god were known as the Therapeutae of Asclepius.

I continued studying at the Academy of Art for a year and a half before my life changed direction again. Although I didn't finish, I was

fortunate to get a taste of art that would last a lifetime. Life has its twists and turns.

It became too difficult to keep up, classes that I was promised were only offered during the day when I worked, and when I took computer graphics classes it became a struggle because I used an Apple "Plus" at home and the school used updated Apple computers which was a constant conversion issue. This was before the USB flash drive was invented.

Before USB, computers used serial and parallel ports to plug devices into computers and transfer data. Individual ports were used for peripherals like keyboards, mice, joysticks and printers. And expansion cards and custom drivers were often required to connect the devices. This slowed down my progress terribly. Then after all that, my little Apple Plus became obsolete. It was just one thing after another. And being a single mom of two boys existing on a limited budget knowing I would eventually have to repay financial aid for my student loans became terrifying to me. So that ended my days at the academy.

Chapter 21

After some time, I met Herman online and became infatuated with his strong leadership skills and his adorable southern accent, but originally, I had no intention of connecting with him. One thing led to another, and six months later we were pretty much engaged—over the phone and he flew out from Missouri for a visit and stayed for two weeks.

He and I soon began making plans for his move from Missouri to San Mateo. So after his visit, he flew back to Missouri to pack up his belongings, and in 2001, we made the next transition of my life journey happen. I took a one-way flight to Santa Fe, met up with him and we drove his U-Haul truck to San Mateo. He moved in with us but since he didn't care for big city living, after our wedding I agreed to move to the Central Valley, which was actually more affordable.

In 2002, we found a nice-sized rental house in the small town of Waterford, just thirteen miles west of Modesto. Herman loved it, but I was not fond of it nor were the boys. The transition was a huge cultural shock for them; one entering the sixth and the other ninth grade. They hated the transition from city life, but after a time became acclimated to the change and of small town living and adjusted to their new lifestyle and actually found creative things to do as "country boys."

Chapter 21

Waterford had many canals that pumped water into orchards for the farmers. One of Jason's adventures with his newfound friends was to hook up a boogie board (or "skurfboard") to the pumping station that pumped water into the canal and performed a dangerous stunt called "skurfing."

Skurfing is a towing sport, similar to water skiing. The skurfboard, however, is like a surfboard and is usually shorter by about two feet and wider, and has three larger fins that make the board easier to maneuver while being pulled behind a boat. Rather than being pulled by a boat, however, Jason and his friends were pulled by the force of the rapid flow of water from the pumping station. Extremely dangerous!

Another adventure that Jason discovered with his friends was on the Hickman Road Bridge that connects the towns of Waterford and Hickman and crosses over the Tuolumne River. They would connect a heavy cable to the top of the bridge and lower themselves down almost to the river, sort of like bungee jumping. I didn't find out about the game until much later. I think my hair would have turned gray early on if I'd know about it sooner. If I'd not been focusing on earring-making and paying more attention to him, I probably would have pulled my hair out with worry and concern. Cody pretty much stayed to himself but eventually became acclimated to his new sixth grade level and soon made new friends in his class.

I landed a job in Stockton with the ACE (Altamont Commuter Express) train/San Joaquin Regional Rail Commission train as an administrative assistant to the CEO with exciting extra tasks such as designing their flyers and signage. I learned a lot from their graphic designer. I was also assigned to photograph on location. I rode the ACE train and photographed passengers for publicity. I photographed sites under construction for the development of the San Joaquin rail system, as well as before and after shots of the progress. It was important to me because it fed my creative passion and was outside the standard role of a clerical/administrative assistant. I designed their new rider passes, special certificates and pass-holder

vouchers. I also designed a water bottle label for ACE's fifth anniversary celebration. One idea I had, which was never implemented, was to find old rail ties and hand-paint a picture of the ACE train on each one and sell at the train station.

Herman taught me to ride a motorcycle, which was quite different from riding my little Honda scooter. I learned to ride on a Honda 350. We both went through the California motorcyclist training program and earned our Class M1. In 2003 we purchased a Honda Shadow 750. Bikers told me that I handled the bike quite well. I am thankful to Herman for introducing me to the motorcycle world and for encouraging me. He and I took several road trips, and I took on the challenge of riding the curvy roads up into the foothills and even the back roads between Waterford and Sonora. We participated in some motorcycle rides with biker groups, and it was awesome. I never felt motivated to do anything creative during that time of my life and ultimately my marriage to Herman ended in divorced in 2007, after which time my creativity really started taking off.

Chapter 22

I rediscovered my dreams and my love for the arts so I tried my hand at jewelry making. My first inspiration was to make earrings. Years earlier, whenever I visited Grandma in Auburn, she would take me to a park that had a duck pond. We would walk around the park, and I collected lots of duck feathers. I kept the feathers for many years with the idea in mind to make feather earrings. I used those feathers to create my first pair of earrings. Thinking back on my journey, I felt that my heart was being prepared for my calling, and that incident was just one step toward the calling. The following are my experiences with earring sales.

I was accepted in my first arts and crafts show in 2007 at the Waterford Heritage Days festival—the third revival of Waterford's Western Heritage Days. The festival kicked off with a parade downtown, and the Friends of the Waterford Library sponsored a used book sale. The Waterford Lions Club served Lockeford sausage sandwiches and other treats, and there were games and carnival booths. The festival had a great music lineup. There were several vendors and crafters and I was so excited to join them. My inventory consisted of three hundred pairs of earrings at ten dollars each, forty larger earrings at twelve dollars each, and an array of designer gift boxes that I got from Mom. I rented three tables for my display and

set up my little blue canopy. The parade went through the streets that morning, but after that a strong gust of wind came up and unearthed a canopy next to me that toppled into mine. Fortunately, my canopy was saved, but some of my earring displays went down and earrings were scattered everywhere. Fellow vendors helped gather them up and set up my display again. Another gust of wind picked up and knocked down my display again. It was a hopeless situation, so I packed up early, along with many others, and left. I made only seventy dollars in sales, but it was my beginning as a craft vendor.

My second event as a crafter was the City of Hughson's 19th Annual Fruit & Nut Festival. By then I was calling my business Creatively Yours. Mom and Dad, who had many years of experience as jewelry vendors, drove down from Humboldt County to join me and support me. I paid $225 for the space but made only one hundred dollars. Nonetheless, it was another experience for me, and I was grateful that my folks supported me by traveling all the way from Humboldt County. I made some contacts and met a fellow vendor, Robin, who was co-owner of West Coast Candles in Ceres, and she and her business partner invited me to place my earrings in their shop. It was a start. I also got a specialty order for a dangly pair of earrings with a motorcycle charm for a Harley honey wannabe.

Chapter 23

I developed a strong desire to paint with watercolors in 2007, when I discovered that a coworker, Cindy, who was a nurse, painted with watercolors. She showed me the amazing watercolor she painted of an elephant. I knew at that point that was what I wanted to do. I was also attracted to her love of parachuting and admired her thrill-seeking personality. I would never try parachuting like she did, but years later I took some hang-gliding lessons and later had the opportunity to paraglide tandem with an instructor. Over the course of time, she and I had decided to take a watercolor class together. Then eventually I noticed she wasn't in the office anymore, and sadly I learned she was dying from cancer, so our watercolor class together was not going to happen. I was devastated. I was looking forward to having her friendship. She died in 2008 at the young age of forty-eight.

The following paragraphs describe my face painting experience with one event after another which is when my career really started taking off.

I joined the Community Hospice team at an event to face paint. I

didn't make much, but it was yet another opportunity to get my business name out into the community. I had a booth as "Face Painting by Lynn." I painted Community Hospice logos on some faces and painted simple cheek art as well. Using a sandwich board that I had gotten from a real estate agent, I painted fifteen simple designs to choose from: a dolphin, octopus, bat, cherries, heart, balloons, footprints, flag, snake, ice cream cone, lips, rainbow, dinosaur, yingyang, and sunflowers. I didn't make much that day since I was just starting out, but, again, it was one more experience for me.

One of my first experiences painting was at Dutch Hollow Farms just three weeks before Halloween. I wanted to see how I would do at a pumpkin patch so I asked permission from the owner if I could work for free and of course he loved the idea. So I set up my kit at one of their picnic tables and painted pumpkins and different fall-type designs. Three of my good friends from high school (Julie, Sue and Michelle) happened to be visiting and dropped by to watch me in action.

Dutch Hollow grows flowers and provides the community with locally grown products and also offer the opportunity to learn something new about farming. They grow pumpkins for the fall and tulips for the spring.

I learned about Joyful Noise Music and Rock-n-Rod Productions' first annual BBQ & Blues Festival in downtown Turlock so I applied and was accepted. The event was over five blocks long and included great blues music, barbecue, and an old-fashioned street festival atmosphere. It kicked off with a patriotic parade on the main street and a street fair. I recall the mayor spoke at the opening ceremony

on the main stage while one hundred or more classic cars filled the street for a car show. I had a booth with several other vendors. I cleared $200 that day with no booth fee. The event was poorly organized, and vendors were spaced out way too much.

Community Hospice put on a picnic hoedown for their employees at Davis Park in Modesto and I was paid to join them as their face painter. They had food, a bounce house, square dancing, softball game, water balloon toss with employee and DJ Mike Hernandez, hula hoop contest, limbo contest, gunnysack race, 'name that country tune' contest, dance contest, scavenger hunt, bingo, best-dressed contest, and games with raffle prizes.

My next event was sponsored by the Stanislaus County Health Department. The local schools marched in the parade, and there were several craft and food vendors and great music. Al & Wally of the Modesto Nuts made an appearance; it was a fun event. My space was only fifty dollars, and I cleared about one hundred and twenty dollars. I was referred to the event by my favorite Community Hospice volunteer, Joe. My niece Emily came to the festival with her son Anthony, and I painted her pregnant belly with daisies and her unborn child's name, Amelia.

Another event I participated in was by far the most enjoyable although I made only thirty-seven dollars. The festival was sponsored by Pepsi and 98.1 Kiss radio and held at the flea market on Berryessa

Road in San Jose. They had a 10K bike challenge, soccer challenge, dance till you drop challenge, limbo contest, mobile reptile zoo, tennis, an obstacle course, games, pony rides, a petting zoo, mad science experiments, and more. I noticed another face painter across from where I was set up. I was jealous of her extravagant full-face designs; they were stunning. I could tell she had years of experience with her top-notch skills. We introduced ourselves to each other, and I learned that her name was Holly and that she'd been in the industry for several years. At the end of the day, Holly came over to me and observed my setup. She gently urged me to use professional face paints that were FDA approved and made to use on the face. Using acrylic paint is a huge no-no in the face and body painting industry. Holly was instrumental in taking my first step to the next level. I purchased the professional paints and retired my acrylics.

Clear Channel TV invited me to attend their annual garage sale. I set up my booth. Several vendors displayed all kinds of miscellaneous merchandise from new to old. I had a fun time socializing with the public and fellow vendors but made minimal money. If anything, the event gave me more experience and exposure as a face painter.

Chapter 24

My first realization that I wanted to be an artist hit me when my employer, Carolynn, gave me a not-so-pretty evaluation. I had been on the job for just two years at the time, and her review hit me with the hard fact that I was struggling with administrative details on the job. It appeared to her that my choice of work didn't seem to be a natural fit. She was gifted with this insight. What do you mean I'm not a good fit? I thought. Are you firing me? I wondered. This couldn't be; I've worked in this field throughout my working career. She recorded in my evaluation, "I don't think being an administrative assistant is Lynn's choice of an ideal job. I believe she is more artistically inclined and less organized than the job requires. I sense this may not be the right fit for her personal goals to be met." That was the first real indication that I had been working in a field where my square pegs were not fitting into the round holes provided to me. Her endearing words were "Lynn, you need to do what makes your heart sing."

I've always loved art, and with each job I had, I managed to find an artistic outlet, including producing newsletters, flyers, and banners. I had a friend named Sanda, who knew I was frustrated because I was not using my gift. She sat me down and tried to come up with a map of how I could move forward. She was also very good at

troubleshooting and giving loving advice. This period of my life had not been just a transition, but a transformation within me.

As mentioned earlier in the book, I had learned calligraphy from my high school art teacher, Mrs. Dahl. Since then, I've used calligraphy for several things, including a couple of art projects, greeting cards, postcards, and envelopes for Christmas cards. I began volunteering my time at Christmas by printing names in calligraphy on ornaments for my employer. They held an annual tree ceremony for families in memory of their loved ones who were on hospice service and passed during the year. It's a heart-wrenching and tearful ceremony where the family members place the ornament with their loved one's name on the Christmas tree. Some of the years I printed as many as two hundred ornaments in calligraphy. I was told I made a difference for the family members in their grieving process which is quite a humbling feeling.

From that experience, I took on other jobs printing calligraphy on wedding invitations, greeting cards, Christmas cards, and address labels for clients.

In 2008, my sister Nancy led a Christian-based workshop as a life group leader on dreams that helped unlock, rediscover, and resurface my own hidden dreams. We studied the book *Dream Culture: Bringing Dreams to Life,* by Andy and Janine Mason, who led the dream culture program at Bethel Church in Redding, California. The purpose of dream culture was to unlock our dreams and release us to make them a reality. The dream activation exercises at the end of each chapter showed how to turn our ideas into action steps and develop an intentional lifestyle of bringing our dreams to life. Their program resulted in hundreds of people rediscovering their dreams and being coached through the steps of turning dreams into reality. One of the exercises we did was to name one hundred dreams,

Chapter 24

believe it or not! When a desire is fulfilled, it is a tree of life (Proverbs 13:12).

I achieved quite a few of the dreams I'd set out to accomplish from my one hundred dreams bucket list. Some are as follows:

- Hang gliding (paragliding in La Jolla, San Diego—close enough). I did take two lessons of hang gliding locally.
- Zip lining (the jungle of Jamaica)
- Unicycle riding (Well, I tried but couldn't balance it.)
- Parasailing (Grand Cayman, Mexico)
- Lying on an air mattress in the middle of a lake (My son Jason took me to Lake New Mahone.)
- Seeing Tom Jones in concert (I saw him in San Francisco and Stockton.)
- Face painting on an international cruise
- Seeing Heart in concert (San Francisco)
- Seeing Frankie Valli in concert (Fruit Yard Amphitheater, Modesto)
- Seeing live performances of Riverdance, Stomp, and Drumline on stage at the Gallo Performing Arts Center, Modesto
- Having my artwork displayed and purchased
- Being reunited with my grade school friend Gayle (I visited her in Washington after forty years!)
- International travel
- Flying to Pennsylvania to visit my former husband's family (four times)
- Traveling to New Orleans twice
- Learning the art of henna and offering it as a service to my clients
- Attending a face painting convention in Florida twice
- Paying off a $30,000 student loan from Academy of Art University, becoming virtually debt free

The dreams that seemed to ignite the fire in my heart were ones that related to my artistic gift. I recall telling the group that there was no way I could move forward with the dream of face painting on a cruise ship because I would have to fly to Florida, from where many of the ships departed. How could I do that? Nancy's friend, Cindy, boldly announced, "Why not? Simply fly to Florida and then board your cruise ship!" It took me a while to chew on that one. I absolutely had no confidence during that time in my life. But her words struck a chord, and I realized she was right. Why not? So I applied and did it!

Some of the fun dreams I would like to accomplish are rolling around in a mud pit, riding a horse on the beach, taking professional voice and harmonica lessons, touring New England, publishing a book that will motivate readers to reach for their dreams (which has been accomplished with this book), and seeing Billy Joel in concert in New York City (which was postponed due to the Covid-19 outbreak in 2020).

Soon I began sketching and painting with watercolors and acrylics. I did a painting of little houses that looked like a bunch of dice in a field with the heavenly light shining down on them, using acrylic colors of white, purple, and blue, with clouds above. Then I was painting images of Victorian houses in San Francisco, fields of flowers, and cats.

Then I discovered a church in Turlock that made me feel alive, so I joined a group of artists who painted on stage. Gary, who did prophetic paintings, was my inspiration, and I painted alongside him. Prophetic painting is artwork inspired through the Holy Spirit. "Prophetic" could be hearing from God, passing on what the Holy Spirit says, passing on a message; it might have a foretelling character. The Bible calls it edifying, exhorting, and comforting (1 Corinthians

14:3). God uses creative people to share His blessings and healing. It was a new and unusual experience for me, and I painted alongside Gary and one or two other painters on stage. It was a very moving experience for me and gave me the confidence to perform in front of an audience.

Chapter 25

I starting working more and more festivals.

The Hornitos Flea Market was held in October and sponsored by the Hornitos Patrons Club in a tiny town at Hornitos Park and I had a booth. The event included chalk art and a myriad of activities throughout town including a parade, butterfly releases, an art and craft sale, a quilt show, an antique fair, live music, entertainment, a children's area, and a plant sale.

The town of Hornitos just north of Coulterville in Mariposa County is considered to be a semi-ghost town and is fascinating to walk through. I learned that many of their existing structures in the historic downtown had been built by the late 1850s, with most of the remaining ones completed by 1900.

I was prepared to paint my typical small cheek art designs until a young girl got up into my chair and asked if I would paint a full-face butterfly. I had never done full faces before, let alone offer them as my choices. So I tried it, but I felt that my work was inferior since it was my first full-face design. It was horrible! But she liked it and was happy with it, and that's all that matters, right? I made her feel good, and she made my day with her smile.

Chapter 25

My next event I worked was the annual American Graffiti Festival held on the Modesto Junior College campus in Modesto. June 2008 was the first of many times that I worked the festival. The event included a nice variety of vendors, food booths, music, and classic cars. The classic car parade was held on the previous Friday, and traditionally, the cars paraded downtown on J Street as they did in the classic movie American Graffiti. I met a nice guy, Doug, a Kiwanis member, who took a liking to me and kind of took me under his wing. He was very supportive of my art year after year. I eventually gave it up to a fellow face painter since my participation was not so profitable anymore. On the first year Doug asked me to paint something on his face, so I painted some red lips on his cheek. He loved it. They had a wide variety of food, crafts, and specialty vendors.

My booth made only $250 that first year, but I was getting there! Even when I didn't make a huge profit at these festivals, I always enjoyed interacting with clients, kids, and fellow vendors. I had a blast with a young Kiwanian who dragged around a huge stuffed gorilla almost his size and made everyone laugh. That's the key to all this fun—laughter, joy, mingling with others, and making children and adults happy with their painted faces. That's the key!

American Graffiti to this day is wildly celebrated in Modesto and was the first big film from Modesto native George Lucas. The characters of American Graffiti were drawn from people he grew up with in Modesto and the places and scenes in the movie were drawn from his own cruising experiences.

According to Wikipedia, my all-time favorite movie, *"American Graffiti,* is a 1973 American coming-of-age comedy film directed by George Lucas, produced by Francis Ford Coppola, written by Willard Huyck, Gloria Katz and Lucas, and starring Richard Dreyfuss, Ron Howard (billed as Ronny Howard), Paul Le Mat, Harrison Ford,

Charles Martin Smith, Cindy Williams, Candy Clark, Mackenzie Phillips, Bo Hopkins, and Wolfman Jack. Suzanne Somers, Kathleen Quinlan, Debralee Scott and Joe Spano also appear in the film.

Set in Modesto in 1962, the film is a study of the cruising and early rock 'n' roll cultures popular among Lucas's age group at the time. Through a series of vignettes, the film tells the story of a group of teenagers and their adventures over the course of a night.

While Lucas was working on his first film, *THX 1138*, Coppola asked him to write a coming-of-age film. The genesis of *American Graffiti* took place in Modesto in the early 1960s, during Lucas' teenage years. He was unsuccessful in pitching the concept to financiers and distributors, but found favor at Universal Pictures after every other major film studio turned him down. Filming was initially set to take place in San Rafael, California, but the production crew was denied permission to shoot beyond a second day. As a result, production was moved to Petaluma.

American Graffiti premiered on August 2, 1973, at the Locarno International Film Festival in Switzerland, and was released on August 11, 1973, in the United States. The film received widespread critical acclaim and was nominated for the Academy Award for Best Picture. Produced on a $777,000 budget, it has become one of the most profitable films ever. Since its initial release, *American Graffiti* has earned an estimated return well over $200 million in box-office gross and home video sales, not including merchandising. In 1995, the United States Library of Congress deemed the film culturally, historically, or aesthetically significant and selected it for preservation in the National Film Registry. A sequel, *More American Graffiti*, was released in 1979.

Filming: although *American Graffiti* is set in 1962 Modesto, Lucas believed the city had changed too much in ten years and initially chose San Rafael as the primary shooting location. Filming began on June 26, 1972. However, Lucas soon became frustrated at the time it was taking to fix camera mounts to the cars. A key member of the production had also been arrested for growing marijuana,

and in addition to already running behind the shooting schedule, the San Rafael City Council immediately became concerned about the disruption that filming caused for local businesses, so withdrew permission to shoot beyond a second day.

Petaluma, a similarly small town about 20 miles (32 km) north of San Rafael, was more cooperative, and *American Graffiti* moved there without the loss of a single day of shooting. Lucas convinced the San Rafael City Council to allow two further nights of filming for general cruising shots, which he used to evoke as much of the intended location as possible in the finished film. Shooting in Petaluma began June 28 and proceeded at a quick pace. Lucas mimicked the filmmaking style of B-movie producer Sam Katzman (*Rock Around the Clock* and *Your Cheatin' Heart*) in attempting to save money and authenticated low-budget filming methods.

In addition to Petaluma, other locations included Mel's Drive-In in San Francisco, Sonoma, Richmond, Novato, and the Buchanan Field Airport in Concord. The freshman hop dance was filmed in the Gus Gymnasium, previously known as the Boys Gym, at Tamalpais High School in Mill Valley."

In August 2008, I had a booth at a community event in downtown Salida. The event included foods, crafts, information booths, kids' activities, and live entertainment. The parade was free to enter and was a great draw for kids and adults alike. It featured local bands, clubs, farm equipment, and silly clowns in tiny cars. I cleared only $120 that day. I decided I would do better next time.

The annual Atwater festival was held at Ralston Park in the fall of 2008. There were food booths, handcrafted items, local business

and merchant displays, children's activities, local entertainment, a classic car and motorcycle exhibit, and a health fair. When I registered for the event, I was told that I would be the only one face painting, but upon checking in that day, I discovered not only was there a second one, but there was an airbrush tattoo artist stationed directly across from my space. I was livid, especially since I learned that no matter how large the festival, where there is more than one face painter, my profit gets cut in half. I also was angry that the festival committee positioned me right across from other vendors. Airbrushing and face painting are similar, and I feared that I would lose money to the airbrush artist. I learned early on that you don't want to be close to your competition. Luckily, the committee refunded my registration fee when I opted out of the event before it was too late and decided not to participate the following year with the Atwater festival. I learned these lessons early on.

In September 2008, I worked the Mariposa's Blazin' Hog BBQ Festival which was held at the Mariposa County Fairgrounds and sponsored by the John C. Fremont Hospital Foundation. It was always a fun event that included a barbecue competition and the Zydeco Music Festival. Kids danced all around the fairgrounds to the music. The food was fantastic, and the music stage had valley musicians and Bay Area zydeco recording artists for toe-tapping and dancing pleasure. My booth fee was only $50, and I profited only $160. I had worked this particular festival quite a few times and always had a good time, no matter how much I earned.

I had a booth at the Oakhurst Fall Chocolate & Wine Festival in October 2008, which was sponsored by the Oakhurst Area Chamber

of Commerce and Fall Festival Committee. It included chocolate, wine, arts and crafts, games, and music. Vendor fee was $100, and my profit was only $100, so at least I broke even. Interacting with fellow vendors and the public is always so enjoyable for me.

The annual Oakdale Cowboy Christmas Craft & Gift Show was another of my events held in November at the Gene Bianchi Community Center in Oakdale. Fifty vendors displayed their unique crafts and gift ideas with a western flair. Family Christmas photos were made available with Cowboy Santa. He arrived, of course, on horseback.

The Humboldt Artisans Crafts & Music Festival was held in December at Redwood Acres fairgrounds in Eureka, sponsored by the Eureka Fire Fighters and Salvation Army. I signed up for the festival because it was held in my hometown three hundred miles away and I got to visit my family and friends. My profit, however, was only one hundred dollars. At least I got to visit my home again, which was my main intent.

Oakdale Chamber held a series of concerts at Dorada Park every Friday evening from June through August. I was invited to set up my booth during the series and met many people and painted several children. These series of concerts were free to the public with a family-friendly environment, and there was a different band every Friday. Musical groups for this particular year included local bands

such as Remedy (classic rock and country), Good Luck Thrift Store Outfit (country), the community band (instrumental), Steadfast Heart (contemporary Christian rock/praise), Barbara & Jim ('70s and '80s light acoustic rock), Taillights (classical and blues rock), and the Fabulous Blue Notes (jump, swing, and rock and roll). Since I'm a music fanatic, I really enjoyed the music. There's nothing better than feeling the connection with music and art. There was a stilt walker and balloon artist with me at the July concert.

My next event was Color the Skies, which is an annual festival at Mistlin Sports Park in Ripon that is held for three days on Labor Day weekend. The festival always has car shows, food, music, animal shows, tethered hot-air balloon rides, choo-choo train rides, an aerobatic jet team, games, children's crafts, a barbecue, and vendors. Among the sponsors for this particular event were our local Gallo Family Vineyards, Taco Bell, Oak Valley, Community Bank, KAT Country 103 radio, Soroptimist International of Ripon, Frito-Lay, Yosemite Corvette Club, Fleet Feet Sports of Stockton, the Modesto Bee and more. The festival began in 2006 to raise awareness and financial support for Children's Hospital of Central California in Madera County. They hosted a race day that included a two-mile walk/run, a 5K run, and a Children's Fun Run that began at 6:30 a.m., with prizes and medals for the participants. All runners received free parking, a discounted pancake breakfast, custom drawstring bags, vendor specials, and commemorative T-shirts for the preregistered. I participated in the Color of Skies festival for many years.

Chapter 26

In 2009, I established a face painting business startup as the sole proprietor. The following are things I learned along the way and steps I took in the process of transitioning my craft from a hobby to a business and named it *FaceTheDesign*.

Advertising and marketing: Facebook ads are targeted to users based on their location, demographic, and profile information. After creating an ad, you set a budget and bid for each click or thousand impressions that your ad will receive. When you use Facebook's most important ad targeting options, users will see your ads in the sidebar on Facebook.com. I also have ads on Yellowpages.com, Yahoo, Google, and Yelp.

Yelp's website is a crowd-sourced local business review and social networking site. The site has pages devoted to individual locations of restaurants or schools, etc., where Yelp users can submit a review of their products or services using a one- to five-star rating system. It has been a positive tool for me, and I've received several clients from my post on Yelp. I have had quite a few clients look me up on Yelp and have earned a five-star reputation for my business.

At one point, I allowed myself to be conned into paying $300 for a company to take over the advertising for me. What a waste of time and money. Another waste of money was paying a service that supposedly gave me the magical link that combined all the advertising platforms into one so I could access them in less time than if I were to access each one individually. You know, as a first-time small business owner on my own, I reached out to anyone and anything that sounded legitimate and that could help promote my business. How was I to know all the ins and outs?

Magazines are another way to advertise but costly. I placed a quarter page in *HERLIFE Magazine* for $400 in 2013 and received no response from that ad. Then I placed an ad in the kids section of *San Joaquin Magazine* and, again, no *Parents Magazine*. I soon learned that that was not the way to advertise and was a total waste of money, as was placing an ad in the phone book yellow pages, since no one uses a physical phone book anymore. The world now relies on the internet for everything.

Car wraps are another way to advertise. I had Clinton, printer and designer design a car wrap that matched my business card, and he attached it to the back window of my 2005 Chevy Aveo. It faded after three years, so I had him reapply it and it was as good as new. It got me a lot of looks, honks, and a few inquiries and confirmed gigs. Before that, I had a magnetic advertisement on my car made by Vistaprint, which is also a good way to advertise but isn't permanent. After having it on my car for six years, I wanted to purchase a new car so I had Clinton remove the car wrap. I cried over that one. It was like my identity when I drove around town. People began to know me by that ad.

Local advertising is also effective. I've made several attempts to advertise my businesss including posting on social media for help in advertising, making phone calls, distributing business cards and postcards to businesses and on windshields—anything I could think of. I found two people to help, but that didn't last long.

To expand my business, I had my web designer, Marshall,

refurbish my website. I then hired Kimmer, another graphic designer and printer, who developed my letterhead, invoice, service agreement, and photo release, and she consulted me on branding for my business. She gave me assignments to research and create a model release form, determine what message I wanted to get out on social media, determine my ideal client and where they are, look at other Facebook ads and determine the criteria for the commercial customer, research ads from other face painters, create a calendar for the holidays I want to promote, consider a networking group that meets at a time when I can attend, develop a library of images, and become a member of the local chamber of commerce.

I designed my business card through Vistaprint and ordered my first supply of 250. Since the first design, I have redesigned my card numerous times over the years, and currently I have them printed by my friend Clinton. He knows my style, my taste, and my preferences. He also prints my business name on my work aprons.

You need a business name. For two years I used the name Face Painting by Lynn. Then in 2009, when I was establishing my business, I pondered and prayed for a name; and I woke up in the middle of the night from a dream that gave me the name *FaceTheDesign*. It seemed appropriate because I have a photo of my son Cody facing a mirror with his face painted red lobster design. It was perfect! Now that I had a name for my business, I was advised to file the name. A fictitious business name is commonly referred to as a DBA, which means "doing business as…" In California, according to the Business and Professions Code Section 17918, every California business, including corporations and limited liability companies, is required to

register a fictitious business name (DBA) in the county where the business is located if the business is using a name other than its owner's legal given name, or the full legal corporate or LLC name (with its identifier, e.g., Inc., Corp., LLC) as filed and recorded by the California Secretary of State. To register a DBA, you should first search the fictitious business names in your county to make sure the name you intend to use is available. Within thirty days of filing the fictitious business statement, you are required to have the DBA statement published once a week for four successive weeks in a paper of general circulation in the county where the business is operating. The document is called Affidavit of Publication. I paid the filing fees, my business name was official (FaceTheDesign), and I was the sole proprietor. I loved it.

Business license tax certificate: I soon learned that to conduct business, one must file taxes which is different from a seller's permit because I am selling a service and not a product. Any business owner must obtain a general business license in the city in which your business is located. Some California cities refer to a business license as a business tax certificate. Businesses that are operated in unincorporated sections of the state must obtain their license or tax certificate on a county basis. At the start of my business, I was residing in Waterford, so I applied for a business license with the Property Taxes Division of the Treasurer Tax Collector Department through Waterford City Hall. Simple process. I received business license tax renewal notices on a quarterly basis. Then I applied for a business license when I moved to Riverbank.

I'd always had a business license but when I moved from Riverbank to Modesto, I had no idea that I had to reapply for a license in Modesto. I thought my current one would carry me through my business career. Well, somehow, I got to thinking maybe I should

contact the city. Sure enough, I was told I should have applied for one at the time I relocated because I was also relocating the business. No one told me. So I applied for the license with the city. When I told the clerk that I had been operating my business in Modesto for three years since the move, she informed me that I would have a hefty penalty for operating a business without a license. I was so angry; how was I to know? I thought maybe I shouldn't have said a thing! Consequently, I ended up paying three years' worth of back taxes, plus a fine for breaking the law. I was charged an additional fee of one hundred dollars for miscellaneous fees and was told it was like a security fee, but I could request reimbursement of that fee after a certain time.

And since I conduct business in many towns and three to four counties, I had researched the requirement of obtaining a business license in each of those towns. I received a notice from the City of Stockton saying they had discovered that I was conducting business in their city and I was required to apply for a City of Stockton business license. Again, I questioned, what the heck? I complied and applied for a license, so now I receive their business license tax renewal notices quarterly.

Certificate of Liability Insurance: As a professional face painter, entertainer, or performer, you must have liability insurance. Performer liability insurance protects you against the unknown. With a liability policy, you will be covered should your act or service cause damage to another person's property, or if you injure someone during your act or service. Without a liability policy, any claims resulting from your act will come out of your pocket. I have always had a $2 million commercial general liability policy. My carrier is WCA (World Clown Association) from Merrillville, Indiana. Thank goodness, I've never had a claim for accidentally poking a child's eye,

etc. It's a good protection in the industry. On occasion some corporate clients require this insurance and require to be named as the additional insured on my policy during the duration of my services.

Client database: I developed a database of all my clients over the years, which includes headers such as date of gig, client name, address, email address, phone number, child's name and age, type of event, and comments/feedback on the event. The database has helped my recordkeeping so that when a repeat client calls to schedule an event, I simply look them up on my spreadsheet in order to refer back to their information. It's also helpful if you plan to send annual birthday cards to the child a few weeks ahead of their birthday, which also serves as a reminder that you're thinking of them and hoping the parent will invite you again.

Client referral coupons: As an incentive to my clients, I designed coupons giving them a free hour of service when they referred a client to me who booked and confirmed a party. Well, that was unsuccessful but a good idea.

I designed a questionnaire to help me maintain and improve my levels of customer service and satisfaction. It includes categories such as where the client heard of my services, my level of professionalism, child's satisfaction with their face design, and suggestions for how I could improve or change. I include, of course, all my contact information including my profile on Yelp for them to comment on.

Chapter 26

Day planner—an absolute essential tool. I depend on my day planner for all my events and my gig sheets, of course, are stored in it. I slip the gig sheets inside each month and note the time and city of each event on the monthly calendar. I also keep blank gig sheets in my day planner. I have sections for expenses, mileage, client notes, where affluent parents might be found (to recruit my services), goals and ideas, information on my helpers, and client and fellow colleague business cards. This is also where I store a copy of my reference spreadsheet of business colleagues and entertainers. I invoice every client so we both have a paper trail.

Domain name: If you plan to have a website, you need to register for a domain name, which I did for my business. A domain name is an identification string that defines a realm of administrative autonomy, authority, or control within the internet. Domain names are used in various networking contexts and for application-specific naming and addressing purposes. Domain Name Servers (DNS) are the internet's equivalent of a phone book. They maintain a directory of domain names and translate them to internet protocol (IP) addresses. This is necessary because, although domain names are easy for people to remember, computers or machines access websites based on IP addresses.

EIN is a nine-digit Employer Identification Number issued by the IRS and used to identify businesses and individuals for tax purposes. As a business owner, you'll need an EIN to open a business bank account, apply for business licenses, and file your tax returns. The EIN, also known as a federal tax identification number, is used to identify a business entity. There is a technical difference between an EIN and

a tax ID number in the sense that a tax ID number can be issued on the state or federal level, but an EIN is strictly federal (also called FEIN or Federal EIN). A private individual's Social Security number is also an identifying tax ID number. However, most sole proprietors don't need to obtain an EIN and may use their Social Security numbers instead. I filed for one anyway.

Equipment: My setup consists of a six-foot-long, easy-to-carry foldup table, a tall director's chair, and a rolling cart for carrying all of my products. When I know that I will be painting younger children's faces, I like to include a stepstool which makes it easy for the child to get up into my chair. And be careful not to lift the child up into your chair especially if you have a bad back. You want to ask the parent or guardian if the child is unable to hop up themselves.

Event planning sites: Throughout my career, I have listed my business on several event planning sites. Some are local and some are out of the area. I have gotten quite a few gigs through these event planners.

Flyers and postcards: I've designed several flyers over the years for my business. I post them all over the place—in businesses, on windshields of vehicles, and at numerous events. I also have four-by-six-inch postcards that I distribute. I have hired helpers in the past to distribute postcards, but they seem to give up since placing cards on windshields is a boring and daunting task, especially during the summertime.

Chapter 26

Gig sheets: This has been an invaluable tool over the years. I record every detail about the event—the event date, booking date, and type of event (whether it's a birthday party, company picnic, reception, grand opening or any kind of celebration that calls for a face painter). Next, it lists the contact person and their information; cell phone number, mailing address, and email address are essential. Specific directions to the venue also are essential. If I get turned around and cannot find the location, I call my client and get directions. If traffic is unexpectedly heavy and I see that I will be late in arriving to the event, I pull over and call my client.

I also list the birthday child's name and age, so I know what age-appropriate designs to be prepared for, as well as what age-appropriate birthday gift to give them. I record the number of guests expected to attend and the age range of the children. I record the service requested, i.e., face painting, body painting, henna, or glitter tattoos. Then I ask my client if they are set on a time limit for my services or if they are flexible with extending my time if there are children who show up late or more children than expected. I note the start time, the end time, and the agreed-upon fee. I have learned to ask my clients what time the party will start. Many times, a client will book me for the exact time the party starts. Most of the time their guests don't show up right on the hour, so I've learned to advise my client to choose a time for my services approximately an hour or so after the party starts. Many times the adults decide they want their faces painted too. It's hard to estimate the amount of time needed.

I find it helpful to note on the gig sheet if my client plans to have a bounce house or water slide. With bounce houses, the children sweat off their designs, and of course the designs come off in the water. So I use either waterproof paints or temporary glitter tattoos. I also note if the event will be indoors or outdoors; if a table and/

or canopy will be provided; and if the event is going to be at a park, auditorium, hall, or any other public venue. I ask if a parking space or driveway could be provided for me, so I don't have to walk far carrying my supplies. If one cannot be provided, I ask how far I will need to walk to the venue. Knowing the distance helps me gauge the time it will take to walk and determine if I need to take two trips to my car to carry my table and supplies. I record precise location and details of the event, i.e., if it is going to be at a public venue, where I will be stationed at the event, if there will be a parking or park entrance fee, and the name and/or cell phone number of the contact person once I arrive at the venue. So many things to consider!

I record if I need to invoice the client and/or get a deposit, and the method of payment. Since I offer more services, such as temporary glitter tattoos, belly bump painting, and henna, I record that. I also record who referred the client to me—whether it was through word of mouth, my marketing/advertising, social media, or internet search engine, or if they are a repeat client. At the end of my gig sheet, I add any special notes or the theme of a birthday party and the miles I will be traveling to the event.

Invoice: Having an invoice along with a service agreement for your business will not only make you look more professional and help keep you organized, but it will also make people take you more seriously. An agreement is also great to prevent issues, since it should cover most situations and what to expect.

Networking is essential: Over the years of being in business, I have established a base of clients, fellow face painters, and fellow entertainers. Everyone helps each other out. Networking groups can

be beneficial for sharing what your business is about, getting your name out there, making acquaintances with like-minded people, and learning from keynote speakers. I attended a few local Chamber of Commerce mixers, which were interesting. They build your social capital by connecting you to other businesses, giving you access to community leaders, developing relationships, and helping you gain visibility in the community. It's a great opportunity to build your business network by meeting other chamber members and making connections.

Networking within the entertainment industry is extremely invaluable. Over the years I have met several entertainers in the industry, including balloon artists, bounce house vendors, caricature artists, character performers, chocolate vendors, clowns, DJs, face and body painters, graphic designers, henna artists, magicians, makeup artists, photo vendors, photographers, and web designers—everything I need in the business to succeed. This list also comes in handy when a colleague or client asks for a referral in the entertainment industry. In addition, by connecting with fellow entertainers I have developed relationships with several people in the industry.

Organization is also essential: What I've learned from my business over the years has been invaluable. For one, I've learned to be very organized. Without organization, I'd have paints and supplies scattered all over the place. In the earlier years I kept a binder with photos of my progress, and from time to time I go back through it to see how my skill level has improved; plus, it brings back memories of the early years. I have a filing system where I keep important documents, such as business licenses, license tax renewals, design samples, marketing and advertising tips, tax information, and most importantly, records of my year-to-year paid gigs. I also have an electronic copy of everything in case of theft or a fire. At the end of

each year, I scan my business documents and records of gigs and put them on a CD and thumb drive to keep in my safe. God knows, I've learned my lesson from two thefts of my face painting kits. Now everything is safely documented and stored away.

Private parties: When I show up for a private event, I show up on time, have plenty of business cards on my table, and display two or three laminated sheets of popular sample designs for children to choose from. They can choose from my samples, but I also encourage them, especially the young teens, to challenge me with a favorite design, such as their school logo, a sports logo, a comic logo, or a special design from their smartphone.

Suppliers and Vendors: You need to find a good supplier for your professional products. I use several, including Amerikan Body Art, Arty and Rainbow Cakes, Ben Nye, Diamond FX, Elisa Griffith, FAB Face Paint, Glimmer Body Art, Global, Henna Caravan, Jest Paint, Kryolan, Mehron, Mama Clown Glitter, Paint Pal, Paradise, Silly Farm, Snazaroo, Starblend, TAG Body Art, and the list goes on.

Supplies and cleaning methods: The most common supplies needed for your face painting kit are as follows:

Paints. Paints should be suitable for sensitive skin and easily be washable with soap and warm water after use. Acrylic paints should not be used on any part of the human body. Paints should also be fragrance-free to limit irritations and must be non-toxic.

Paint brushes. A variety of sizes are used depending how much area you are covering. The smaller brushes are used for the fine linework. Brushes must be made of nylon to avoid irritation.

Reusable stencils. These are a nice addition to your face design and may be purchased through most any professional supplier.

Cleaning your brushes at a gig

"There are many different ways to get this done, and each painter has their own rules. Some places have very strict regulations regarding the cleaning of your supplies while face painting at an event and you must follow their directions, others leave it up to you, counting on you to make good decisions of course.

There are painters that change brushes with every kid and never double dip their brush, meaning that once the brush has touched the skin they won't touch another container of paint. These face painters usually carry dozens of brushes with them, and have a method in which after using a brush they rinse it, then they spray a sanitizer, like alcohol, on them, and let them dry fully before re using them. At a large festival that might require an extra person around doing that for you. At a small event you might just choose to take enough brushes so that the cleaning happens at home.

Other painters choose to simply rinse their brush in between each kid in a small cup of water. For these kind of face painters we recommend using the Rinse Well as it provides you with a steady stream of clean water and allows you to keep your kit looking clean, instead of having a cup of dirty looking water on your table. It is also a great idea to add a few drops of Lush Brush, a great face painting brush soap that helps you get your brushes cleaner faster and has natural ingredients usually used as sanitizers." (www.JestPaint.com)

Cleaning your sponges at a gig

"Most people would agree that cleaning a face painting sponge

thoroughly while face painting at an event is not an easy task, since sponges are porous and have a larger contact surface with the skin. We always suggest to other face painters to use one sponge per child, and ideally you would not double dip, meaning your sponge would only be loaded once, then you can paint, and then set aside the sponge to be washed at home. With larger sponges you can load and rotate the sponge to reload. Face painting sponges are inexpensive and you can take 50 to 100 to an event without adding a lot of weight to your kit. Once the sponge is used, we suggest throwing them inside a mesh bag so that they can air dry while you continue to paint, preventing them from getting smelly while they are still moist." (www.JestPaint.com)

Cleaning and sanitizing your face painting brushes at home

"Once you get home the cleaning fun really begins! Now you have the time to take care of doing a deep clean without being rushed, hopefully!

To clean your brushes we suggest that you first rinse them really well in a bowl of clean water, you can add a cleansing pad at the bottom of your water bowl to help remove the excess paint faster. Now is time to grab some Lush Brush or your favorite face painting brush soap and put a drop or two on the bristles and work them between your fingers very gently until the soap has worked its way into all of the bristles. Rinse them again and then carefully shape the bristles between your fingers and let them dry out while laying down over a towel or hanging upside down. Do not put your brushes to dry right side up since that pushes moisture into the ferrule, which can cause the glue to come off and the wooden handles to crack.

You can soak your brushes in the EBA Hand Sanitizer Spray and let them dry for a couple of hours. You can also spray your face paints and kit with this product to kill germs with the 70% alcohol base." (www.JestPaint.com)

Chapter 26

Cleaning your face painting sponges at home

"Now that you are back home, you can take care of your sponges. The easiest thing to do is to wash them in your washing machine. Simply toss all of your sponges inside a mesh bag and wash them by themselves. You can use warm water and your favorite soap, just make sure that all of the soap is thoroughly rinsed after washing, and it is always better to use scent free soaps to reduce chances of allergic reactions. We do not suggest using the dryer as it can melt the sponges. It is best to take them out of the mesh bag, squeeze any access water out of them and lay them flat over a towel to allow them to air dry completely before you store them. If you have an issue with pet hair lingering in your washing machine, you might end up with the hair in your sponges, so hand washing might be better in that case.

If you'd rather wash them by hand, then you can use Lush Brush or your favorite face painting brush soap to help remove all stains and paint from them. Some like to soak their sponges first with some soap, and then rinse them. If you use a soap that is safe to be used on the skin, like Lush Brush, then you don't have to worry about 100% of the soap being removed from the sponge before they dry, as the soap residue will not irritate the skin." (www.JestPaint.com)

Mirror. A hand-held mirror is for the child to hold up and see the beautiful designed created on his or her face. At festivals sometimes I use a floor-length mirror propped up against my canopy.

Sponges. Face paint sponges are used to complement brushes and applicators for giving finishing touches to body paint, face paint, powders, gloss, glitter etc. You cut a round sponge in half or quarters to create multiple edges for the application. I use them a lot.

Thank you cards: I always send a thank you card by mail. This is a personal touch that's not done much anymore, and parents

appreciate this kind of gratitude. Sometimes I include a birthday magnet in the card. I try to get a good photo of my client's child's painted face or, even better, a photo of me with the child. I then transfer the photo onto a magnet along with my contact information, and the child's name and birth date, and I send it to my client with a thank you card. It's a great marketing technique that I learned from Gary Cole of Snazaroo.

Website: You will need a website for your business. I launched my first website using a template through GoDaddy.com. It worked for several years until I decided it was time for a revamp and a more professional image. I hired my friend Sue's son, Marshall, to revamp my website, and he did a fabulous job. I have him periodically add and rearrange images. I have had several comments on the professionalism of my website.

Chapter 27

FABAIC (Face and Body Art International Convention) was taken on the Road in June of 2009, and was held at the Double Tree Hotel in Los Angeles rather than their usual venue in Orlando.

It was a two-day mini convention with Marcela "Mama Clown" Murad, Rebecca Tonkovich, Heather Banks, Magic Mike, and Glimmer Body Art for two days of hands-on instruction and painting.

Marcela "Mama Clown" Murad and Magic Mike teamed up to teach us how to bring together the art of magic and face painting. Mama Clown shared her techniques and designs and demonstrated how to use powders to speed up face painting and create works of art in half the time.

Rebecca of Arty Brush Strokes and Heather from Silly Farm demonstrated the newest designs.

Glimmer tattoos were the newest trend at that time among teens and tweens. They are waterproof and great for all events and ages. Macky from Glimmer Body Art showed how to create long-lasting glimmer tattoos to increase our business and take our clientele to another level. And, of course, there was shopping in the vendor room and a hands-on face painting jam late in the evening.

The trip was two-fold because I made it a family trip with my two sons. They stayed with a dear friend of theirs, comedian Gary

Cannon, in Santa Monica. After the convention, we were able to visit with Gary and see him perform at a club. He's quite phenomenal. He had taken Jason in through the Big Brothers Big Sisters program when Jason was just six years old. Over the many years, we've all managed to keep in touch.

Chapter 28

Living Canvas was my second face painting convention and was held at a convention center in San Jose. The following are invaluable lessons I learned from the instructors.

Animal tribal designs: The instructor demonstrated several different tribal designs and stressed the importance of defining your lines with your strokes—thick to thin and broken pieces. The best product for line work is Wolfe brand paints. Mehron Paradise paints are a good middle ground and blend well. A good paintbrush for line work is the DiVinci No. 4 or No. 6. American Painter is cheaper but doesn't hold as much paint. The rounded side of a sponge is used for contouring the eye with designs. The instructor demonstrated how to blend colors with the sponge using a pat, pat, pat motion.

Other tips included using at least seventy percent rubbing alcohol and Ivory soap for cleaning brushes. Stencils are a fun addition to use on the face after the paint has been applied. Eye shadow applicators are good for sprinkling glitter from your container. Kryolan hydro oil is good for removing face paint. For painting teeth, outline the teeth first in black, then plop in the white in teardrop shapes. It is best to use a stiffer paintbrush for this technique.

Illusion and Friends Step by Step Guide to Face Painting is a good

reference for ideas, and James Kuhn puts out a good YouTube for guidance.

An A-frame sandwich board can be used for advertising your designs. Stick your designs on the board with Velcro for your display. Snazaroo iridescent powder is good used as the base for fairies on the face.

Tips for a gig are the following: Smile and be confident, believe in yourself, and tell your client the number of faces you can paint per hour and your average. Ask your client if he or she would like to book the event. Tell your client what you need (table, chairs, etc.) and what you bring to the event (table, tall director's chair, supplies, etc.). You should take a deposit as a retainer fee, nonrefundable, in case the client's check bounces.

More tips include: Record the date you booked the gig, the amount of deposit, and who referred you to your client, and afterward record comments on the event. Make sure your name is known, i.e., digital name tag on social media. Mention your name to kids. Pay special attention to the birthday child. Vistaprint is good for creating business cards and has free products. Coloring sheets are good to promote yourself with your business. Include a photo of yourself on the sheets. Offer parents ten dollars off the party fee to provide you with a list of kids, addresses, and phone numbers. Follow up with those parents with a postcard and ask how you did. Follow up with a thank you card as always.

Marketing ideas: Take out a newspaper ad, or advertise on Craigslist in the categories of arts & crafts and events (where you will be). Check with caterers for your business. It usually takes six times for someone to recognize your name. What doesn't work well are parent magazines and phone directory yellow pages; you will spend too much money. Offer a discount for your services. Have your business name printed on your aprons. Take a photo of the birthday person with you. Other places to advertise: Party City, event planners, restaurants, day cares, preschools, agents, and caterers. Create a phone message with your business name and information.

What to wear to an event: Wear something that stands out; for example, a sequined vest, hat, feather in your hair, a bright, colorful outfit or apron—something that sets you apart from everyone else—something that says, "Look at me!"

I took an invaluable class from Lisa Smiley. Her recommendation was to use sparkling water rather than regular water. The best paintbrushes for line work are No. 5, 6, and 7. Use the same brushes with the same colors, and do not to mix them up. She demonstrated how to paint a dolphin with curly waves using blue and white paints. When you are at a gig, keep a pouch with camera, cash, business cards, license, and your insurance policy. Use a spritzer/spray bottle with a pump to spray your paints.

Lisa is the lead artist and partner of SmileyOrca, based in California. SmileyOrca is a family owned and operated business providing face painting and natural henna design artists for events. SmileyOrca serves Monterey and Santa Cruz Counties around the Monterey Bay Area on the central California coast. Specialties are freehand full-face painting and natural henna designs by trained professional artists for parties, fairs, festivals, and walk-up service at the Santa Cruz Beach Boardwalk.

Her artists attend conventions around the USA and teach the art of painting faces for a living. They participate in forums dedicated to face and body art, and the artists share their knowledge with other artists around the world. In 2001, Lisa started face painting for parties and events, expanding from simple backyard birthdays to employee parties with over five thousand guests.

I met Arla Albers and took her marketing class. She was inspirational in giving tips of the trade and much-needed advice. I purchased her 2006 booklet *Marketing Yourself: What Works and What Doesn't*.

Arla, who lives in Fairfax County, Virginia, is a retired commander in the US Navy and worked as a cake decorator for thirty years and as a clown. She provides face painting, balloon sculpting, and magic. She is a professional face painter who retired after twenty years of performing as GoGo the Clown.

The following is a synopsis of Arla's answers from an interview with the Washington Examiner in 2009: "Full-face painting is easier, it's faster than doing cheek art, and it looks better; and the kids get a feeling out of it. In other words, they become a cat. They become a dog. And the dogs chase the cats, and the cats chase the butterflies. It's actually a feeling that the kids get out of the face painting." Her face painting is at least a four- to five-day-a-week job, working birthday parties, restaurants, and picnics during the summertime, and corporate events. And she face paints herself as Mrs. Claus during December. Her answer to the recipe for a good birthday party is to hire an entertainer, and have ten to twenty children at the party and, of course, a birthday cake. Her advice for parents is to not use acrylics for face painting. Acrylics can burn into the skin and cause permanent scarring; there are a lot of people who don't know that. And her advice for would-be clowns was to go to class. Learn how to clown properly. There is a proper way.

I also learned about designing a website and advertising in another class. Perfect your skills, use photos, and use the computer and the internet to market your business. For photos, be spontaneous. Get a model release if you use photos for marketing purposes. For a more professional look, use a plain background in your photos. For poses, use three-fourths of the face with the head slightly tilted. Use editing software. Some editing tips are as follows: rotating, flipping, cropping, background plain as possible, eliminate red eye, clean up, use the internet. For a domain name choose what is representative of you. Photos for the internet should be two inches by seven inches or 72 DPI (dots per inch). Hosting services control your website. If you build your website yourself, use templates. Don't use animated gifts, music, too many colors, or your life story. Do use plenty of photos to tell your story, easy navigation, and be interactive, fun, professional, friendly, and informative—and be you!

As far as brushes and sponges, you should use synthetic bristle brushes, and when using sponges, use only one sponge per child. They are inexpensive and you cut them in half. Keep your products

in original containers, and use stackable containers from the dollar stores. Kryolan and Wolfe products are recommended. Keep two Wolfe whites, one for pure and one for mixing. You can get simple design ideas from children's books. If a child is tearing from the paint, use glitter to stop the tearing. Arla said, while painting a child's face, "your hand should dance and play!" Put teeny dots on the face to mark where you need your design to start and stop. For a good gold color, she prefers Mehron powder over Wolfe's Gold.

I met Sue, a fellow face and body painter at the convention. Since then, we've been painting buddies and she became my mentor and taught me several of her techniques. Some of her tips are as follows:

Cheat sheets are good to have. Print out sample designs, nine to a sheet and put on three-by-five-inch cards in a box with labels for every category. Working with restaurants, such as Chili's and Red Robin, once a week is a good opportunity for income and exposure as an artist, and you just charge a percentage of your normal rate. Some of the restaurants will give a free meal in exchange for your services. Talk to the manager. Show him or her a sample sheet of your work and a letter of recommendation. Fairgrounds and trade shows are a good thing.

In another workshop I learned that Mehron Paradise paints are preferred for blending colors. When doing a kid's party, have the kids sign a birthday club list. Send a birthday coupon one month before their next birthday. Diamond FX and Wolfe paints are recommended for tribal designs. Use rounded brushes—a medium round brush for swirls and a chisel brush for eye designs. Use a square brush when using Arty Cakes. Follow the teardrops to the focal point on the face. The last line should always follow the line before. When using temporary glitter tattoos, clean the area where you will apply the tattoos with alcohol squares. Apply the stencil, then apply body glue, peel off the stencil, and apply glitter. Remove excess glitter with a brush. Temporary glitter tattoos typically last on the skin five to seven days. Use a lingerie bag for used sponges and take home to clean them.

Chapter 29

The next convention I attended was Living Canvas Convention, San Jose, 2010. One of the first instructors demonstrated her fabulous eye designs using split cakes. She recommended applying shimmer white over your color.

Another instructor demonstrated how to use designs with silver-green and pearl sky-blue paints. A cream-based makeup remover may be used to remove difficult paints. When outlining in black, shade one side only, not the entire design. Wolfe or Diamond Effects are good for line work. After painting your design, spritz the face and then poof glitter onto the face. You can get great ideas from kids' T-shirts.

Mark Reid taught how to paint tiger muzzles and tiger lines, as well as flames. Tiger lines are like parentheses around the face. Don't use Wolfe black around the eyes. He uses a No. 4 brush for his line work. Your base coat must be a light color to create a contrast with the dark color and always work on the opposite side of the face that you would normally work first, then work the other side.

Chapter 30

I attended the Learn 'n' Play Convention, San Jose, January 2011. I took Gary Cole's marketing class and learned amazing tips for marketing yourself. I have used many of his tips for my business that really work. Since this convention, I have attended more of his classes.

He taught basic marketing tips. He advised that it's important to issue thank you cards to clients, as well as to create a magnet for a client's child's birthday and send it to them. He taught how to get your marketing out of its current rut, including exploring your business options, networking, and getting your name out there with advertising.

He also suggested using a lot of colors when creating business cards and including basic business information, such as name, phone number, email, website, and a brief description of what you do. Add "my favorite links" to get more exposure. Set aside ten percent of your gross sales for marketing expenses. Post your business cards at such places as Jamba Juice, doughnut shops, and grocery stores. Don't just stick to one venue, such as birthday parties. Locate corporations. Laminate sheets with eight face designs as choices. Locate party planners for advertising. Create a banner for large events. Create magnetic sheets with a photo of you and the birthday child on it, and send to your client as a thank you card.

In addition to his successes, Gary has also established and grown multiple startup operations as an entrepreneur and C-suite executive, growing two businesses that exceed five million dollars in annual sales while significantly expanding business for each new company. He launched a US-based face paints brand in dozens of new markets, focusing on sports paint, amusement parks, and e-commerce; and he has captured and maintained FDA approval for a product line with five thousand-plus unique SKUs (Stock Keeping Units). He is also the owner of Ruby Red Paints, Inc., in Lewisville, Texas.

Gary lives in Flower Mound, Texas, twenty miles north of Dallas and is the owner of Snazaroo USA, Inc. He also is a world traveler, teaching thousands of new artists how to face paint all over North America, the UK, Mexico, and many other countries. He also runs Party Faces, Inc., a well-known face painting company catering to parties, festivals, and other events. He is the Guinness World Speed Painting record holder for painting 217 full faces in one hour. Gary worked with the original owner and formulator of Snazaroo and launched the brand successfully to become a five million dollar company selling in North America.

After twenty years, Gary broke away from Snazaroo and launched his own brand and formulation under the brand name Ruby Red Paints (made in the USA). His wide variety of unique products ranges from glow-in-the-dark paints to petal sponges to a series of eight fifty-six-page themed how-to books. He has offered more than five thousand different line items under the brand names Ruby Red Paints and Sparklettoo (the glitter tattoo line).

Before Facebook, he had united the world by offering the largest gathering of ace painters, well over seven thousand members, who were linked by email. Gary has taught at amusement parks, zoos, aquariums, and places like the Polynesian Cultural Center in Hawaii. His strength is in training beginners to get them quickly painting three- to five-minute "real world" face designs. His focus has always been to get people to paint good faces, quickly linking to his world record and the tricks to do steps quickly for maximum impact.

Chapter 30

Another master face painter, Brian Wolfe, taught a class on how to paint planes, trains, and automobiles, as well as painting sneers, snarls, grins, gaping maws, and fangs. He demonstrated how to create fleshy colors, mixing white with orange. Brian is cofounder of Wolfe Face Art & FX and is a world-renowned face and body painter with outstanding, extraordinary, and exquisite incredible makeup talents. He specializes in monster makeup.

I met Pashur, master face painter, and had the pleasure of taking his class. Since then, I've taken additional classes from him at various workshops and conventions. He demonstrated sugar skulls, Saturday morning cartoons, glitter, and basic airbrush techniques. I learned that Pashur and Jay Bautista produced a booklet called *Face Paint Guide to Tribal Faces,* which I purchased. He has also produced the booklet *Face Paint Guide to Dragons.* Both booklets are helpful and inspirational.

Pashur grew up in Nashville, Tennessee, and earned a four-year graphic arts and illustration degree at Memphis College of Art. In high school and college, he drew caricatures at Opryland and was the art director of a planetarium and the International Airport in Nashville. He lived in Las Vegas for two years and now resides in Los Angeles.

Pashur has been instrumental in the mainstream inclusion of body painting in current media, and his influence can be seen throughout the industry. He is known for his full-body artistic masterpieces and is an award-winning body painter known throughout the world as the "Picasso of Body Painting." As a professional body painter, Pashur can tailor his designs to fit any theme or style. His

body painting is a hit at the biggest events in the USA, including the Electric Daisy Carnival, Fantasy Fest, Mardi Gras, and Sturgis and Lollapalooza Motorcycle Rally. He has traveled the world and held sold-out body painting workshops in Australia, France, Italy, Spain, Holland, Scotland, Ireland, England, and Hawaii. Pashur's body painting has been published in hundreds of magazines around the world. Past and/or present clients include *RollingStone Magazine, Smirnoff, Playboy, Cirque du Soleil, Nicki Minaj, 5 Seconds of Summer, Toyota, Brooks & Dunn, Penthouse, Daniel Ash, Eve 6, Prius, Wrangler, Rav4, Tundra, Animal Planet, Walmart, Camel,* and *Amity Affliction.*

Pashur has painted for TV shows that aired on VH1, Comedy Central, Spike TV, and TNT, and he was a special guest as a body paint expert on the SyFy channel show, Face Off. Pashur has also consulted for the body painting TV shows Skin Wars and Naked Vegas. In Los Angeles, he continues to innovate and break boundaries with his body painting art.

In addition to his face and body painting, Pashur is an amazing illustrator and designer and has been a contest winner and received several awards for package designs, CD cover designs, posters, and shirts.

I met Lilly, another master face painter, and attended her class on the use of cosmetic grade paints. Among her tips were these: Sanitize between customers. Use a variety of brushes. Hang a mirror from your cart. Make a goal of painting twenty-five faces in two hours, and then you're doing good. She prefers pressed powders, and reputable types of body glue are Pros-Aide and latex-free eyelash glue. I learned to use Star blends on eyelids and cheeks. To keep the same paints together, put in sectioned tube containers. Use liquid eye gloss, and dip in glitter. Lilly also demonstrated professional face painters' tricks and tools, including speed techniques, sanitation, dots, use of the brush, lines,

finding the focal point on the face, use of cosmetic grade products, and purchasing professional liability insurance, which sets you apart from amateur "wannabe" face painters.

Lilly also held a hands-on workshop on 3-D shading, creating jewels and stones with face paints and powders, and painting 3-D necklaces. Her third workshop was teaching one- and two-minute designs, full-face designs, arm designs, speedy boy designs under two minutes, and using pressed powders and split cake strokes. Since our first meeting, I've taken many classes from her and purchased her very informative book: *500 Tips and Tidbits to Boost Your Income.* Lilly has been a huge inspiration over the years and is very humble and easy to talk to.

For many years, Lilly Walters Schermerhorn was best known as an expert in the world of professional speaking, and she has written several books on the subject; it gives her the most joy of any art project she has ever done. She founded the West Coast Face Painters, an online support group for professional face painters. She also teaches classes and has written six books on the subject.

In one of Marcela Murad's workshops she taught the importance of perfect lines with your brush. Her second workshop was a hands-on workshop on the formula for painting hundreds of variations of one of the most popular designs, how to use focal points on the face, and how to use Arty Cakes, Rainbow Cakes, and glitter powders to speed up application. Marcela's third workshop was teaching beautiful butterflies, superheroes, and masks using all the colors of the rainbow. And her fourth workshop was a presentation based on her thirty years' experience as a children's entertainer. She pointed out the character traits and virtues that are vital to the heart of a clown, such as patience, tolerance, and kindness, as well as how laughter is the best medicine.

Marcela Murad, creative director of Silly Farm Supplies and producer of the Face and Body Art International Convention (FABAIC) is a children's entertainer specializing in clowning and face painting. Marcela is also an author, speaker, instructor, and former publisher of the *Face and Body Art International* magazine, as well as the producer of the Face and Body Art International Convention. She is nationally recognized as one of the premier face painters in the country and has been influential in revolutionizing this art form. Marcela has published many books on the subject of clowning and face painting, including her acclaimed series of face painting books that feature variations of one design per book.

As Mama Clown, she has been entertaining children and adults since 1981. She is known for her warm and friendly personality and her ability to deal with young audiences. Three times she has been named "Clown of the Year" by the South East Clown Association and was named an "Angel of Cheer" by the Miami Herald for her work with underprivileged children. Whether she is clowning around, face painting, or teaching, Marcela believes that one of the greatest gifts we can give to others are happy memories, and she cheerfully shares this gift with everyone she meets.

Magic Mike, our entertainer during the convention, is quite a character and is a longtime friend of Marcela's. His theory is whether you are a face painter, clown, storyteller, juggler, or magician, it never hurts to have some extra tricks up your sleeve to entertain during those awkward moments while you are waiting for customers, drawing a crowd, or being asked to fill in for an emergency at an event. He held a workshop and taught how to make solid objects disappear, make several items float in the air, and perform pieces of magic and pantomime that create a big effect with no props at all. He encourages all to be prepared to entertain and to get more out

of what you already have. He also demonstrated juggling up to four balls at once. I have been entertained by Magic Mike many times since this particular convention.

World renowned henna artist Neeta Desai Sharma covered basic information on different types of henna, as well as how to mix the paste, roll cones, and other tips and techniques in her workshop. She gave step-by-step instructions on how to create some popular designs for parties and festivals.

For over two and half decades, Neeta has been adorning brides and inspiring artists with her mehndi designs. A social worker by profession, Neeta has always had a special relationship with henna/mehndi. She is a self-taught henna artist who has been practicing this art for the past twenty-seven years. Neeta was born and raised in India and has traveled throughout Asia, Australia, Europe, and North America, where she has practiced her passion and taught courses on the intricate art of henna. This exquisite form of body art is part of her cultural heritage, and she is proud to be able to decorate each bride-to-be with a pattern unique to her personality, including motifs that express her inner dreams and desires. Although proficient in many styles of henna, Neeta treasures traditional Indian bridal designs and takes exacting care with a high degree of detail in her work. She loves how the mehndi ceremony fits into the entire celebration of Indian weddings and cherishes her role as one of many spokes in the wheel, making a couple's special day a memorable occasion. Once she had a parent tell her, "Your role is so important in a wedding, as it is usually the mehndi ceremony that kicks off the wedding festivities."

Neeta provides henna services throughout Central Valley California (in and around Merced, Turlock, Modesto, Stockton, Sacramento, and Yuba City), as well as the Bay Area (in and

around San Francisco, Fremont, Sunnyvale, San Jose, Sonoma, and Pleasanton). Her henna paste is made with 100 percent natural henna powder, lemon juice, and essential oils. She does not use black henna because she believes it is unethical and dangerous. She can do mehndi/henna for just about any occasion and specializes in bridal mehndi, Sangeet parties, engagements, baby showers, birthday parties, and ladies' night out, as well as school and corporate events and fundraisers. She also loves to extend this art form onto cakes and other media, such as wood, glass, and candles.

Neeta and I have shared many experiences together. I attended her Spring Fling Convention on a cruise ship to Mexico in 2011—my first experience with using henna. I took two more classes from her at a local college, as well as attending two more of her Spring Fling Conventions. Once a year in May, Neeta and I work a grad night event together. She provides henna, and I provide temporary glitter tattoos.

I discovered my new enthusiasm with the henna art form and have started making my own henna paste. I added henna to my services and quickly gained more clients.

As I started focusing on this art form, I researched the history and I found the following informative article The Art of Henna (Omaya Michelle, June 29, 2021)

"What is Henna? Henna is actually a dye prepared from the plant Lawsonia Inermis, more commonly referred to as the henna tree, the mignonette tree, and the Egyptian privet. Apart from its historical use as a form of body art used to adorn the hands and feet of women during social holidays and celebrations since the late Bronze age in the eastern Mediterranean. It is also used as a form of hair dye, and recently, as a temporal substitute to eyebrow pencil or even as eyebrow embroidery—like a temporary tattoo!

Henna lasts about 1-3 weeks on average when applied to the skin, starting with a strong dark brown color for the first two weeks, then fading to a lighter rusty orange. Although, this can depend on both where you put the henna, and how often you tend to wash it. Even though the hands and feet may have the best result, that is where they usually fade the quickest through constant washing.

Like most dyes, the longer the henna paste is left on the skin, the more layers of skin cells are stained. You want as many layers of cells stains as possible for a darker, long-lasting color. One thing to keep in mind is that when you first remove the henna paste, the henna stain has not completely oxidized yet, so the stain starts off a light orange, but gets darker as you wait.

The History of Henna: Historically, henna was used in the Arabian Peninsula, Indian subcontinent, the Middle East, and other parts of North Africa. Henna has been used since antiquity to dye skin, hair, and fingernails, as well as fabrics including silk, wool, and leather. The name is used in other skin and hair dyes, such as black henna and neutral henna, neither of which is derived from the henna plant, but has adapted to the name as they are used for the same purposes.

The earliest text mentioning henna is in the context of marriage and fertility celebrations and comes from an ancient legend referred to 'The Ugaritic legend of Baal and Anath', which has references to women marking themselves with henna in preparation to meet their husbands, and Anath adorning herself with henna to celebrate a victory over the enemies of Baal.

Many statuettes of young women dating between 1500 and 500 BCE along the Mediterranean coastlines have raised hands with markings consistent with henna. This early connection between young, fertile women and henna seems to be the origin of the Night of the Henna, which is now celebrated in all the middle east.

Henna as a Tradition: Henna was celebrated by most groups in the areas where henna grew naturally. It is commonly practiced in religion by Muslims, Sikhs, and others, all celebrated marriages, and weddings by adorning the bride, and sometimes the groom.

Henna was regarded as having Barakah (blessings) and was applied for luck as well as joy and beauty. Brides typically had the most henna, and the most complex patterns, to support their greatest joy and wishes for luck. Some bridal traditions were very complex, such as those in Yemen, where the bridal henna process took four or five days to complete, with multiple applications and resist work.

Henna is also practiced in other social celebrations, one of the most common being the celebratory Islamic holiday of Eid. There are two main celebrations of Muslims, Eid-ul-Fitr, and Eid-ul-Adha. Eid-ul-Fitr is celebrated at the end of the fasting month Ramadan as a gift from Allah and has a special significance for Muslims, hence the use of henna to celebrate.

Henna Today: Nowadays, henna has made its way across the globe, yet many still follow the traditions, accordingly, valuing the initial use of it. It is mostly used with the intent of social celebrations in Asia and the Middle East and North African region but is also used as a form of fashion and beauty—especially now that you can get designs done in different colors such as black and white rather than the original (but natural) shade of brown.

Also, commercially packaged henna, intended for use as a cosmetic hair dye, is available in many countries and is now popular in India, as well as the Middle East, but has also been made popular through culturalization in regions such as Europe, Australia, Canada, and the United States."

Chapter 31

I attended a Sacramento workshop in June 2011, with Pashur as the guest instructor. He started off with tips to benefit everyone and their business then discussed how to contact prospects to increase business and the importance of knowing our target client and who not to contact. He covered portfolios—how many pieces to include, and what works and what doesn't work in a portfolio. He also covered press kits.

In order to promote your business, you should make a list of potential corporate clients, and call each one first to alert them of your forthcoming postcard or email then follow up with a phone call after the promotional piece. You can market to convention centers (get an exhibitors list), all kinds of corporations, car dealerships, etc. Create a business portfolio of your work. Use a high-quality eight-by-ten, leather-bound binder or presentation folder. Every model must be smiling. Start with your best image, only one of each design. Create a press kit including a pocket folder, business card, photo of yourself painting (both you and client smiling), testimonials, newspaper article about you (if you have one), and four sample photos (high range: one boy, one girl, and adults). Then include your name and contact information.

We learned about line work and knowing the importance of

brushstrokes. He covered techniques such as teardrops, swirls, tiger lines, peacock lines, wisps, and fantasy lines; how to make perfect dots and ovals and leopard spots; and what you can do with them, as well as what brushes to use to create these lines and effects. He showed us how to achieve perfect bold tribal lines, double-dagger strokes, thorn strokes, positive and negative lines, and balance through the design then demonstrated where to put the tribal designs, spirals, knot work, feminine tribal designs, biomechanical tribal designs, tribal ghost designs, and blocking. He showed us how to accent with tribal designs within and outside of our designs and how to blend with a brush and a sponge, creating layers to help show depth, the part of a design to be highlighted, and the part that gets shaded. The monster faces with drop shadows were amazing.

We also learned how to create long, flowing flames, blend colors to make flames and give them a crisp black outline with sharp points and then highlight them. You flip the shading on the flames to give them depth, create ghost flames, highlight objects to make them look more like they are on fire and he demonstrated how to wrap flames around an object to appear as if they are engulfed in flames. He continued by showing us how to create amazing designs by using dazzling jewelry and lots of glitter. Elegant pinstriping may be used with glitter accents to create extravagant eye designs. He ended the session with advice on how to push our creativity with exercises to help us think outside the box and paint faster.

I became intrigued with body painting and began pursuing it, studying techniques and designs and placement. I purchased the proper tools and products and the special bra and briefs for women. I was fascinated with Mark Reid's art style. I learned about painting live metallic statues and how to mix Mehron metallic powders and liquid. The mixture can be applied with a brush or sponge, though

a sponge will absorb lots of the product, which is wasteful and does not give as smooth a finish as a brush does. And, of course, when covering large areas like an entire body, you need a large brush, such as the Kabuki makeup brush. When you've finished, you can polish with a soft powder puff or cloth. Because the finish using the mixing mediums is resistant to touch, it is also resistant to glitter adhering so you need to use an adhesive for glitter to stick. I learned that if you want an amazingly shiny, chrome-like finish, you should mix the powders with oil, such as vegetable, baby, or olive oil. That can be applied easily by hand, kind of like a massage and will look incredible, but be aware, it will also be very oily so it takes a lot of shower gel or soap with hot water to remove it from the skin. So I started cutting out forms and designs from magazines and fitting them into practice body templates to see what would look good as body painting, and I started planning strategies. It was a great learning process that I found enjoyment from.

Chapter 32

FABAIC was taken on the road again but in September, in Los Angeles in which I attended.

Brian Wolfe was my first instructor as he shared his tips and expertise. Kryolan hydro oil is used for removing face paints. To paint teeth, first outline in black and then plop in the white in teardrop shapes. Aaron Brothers is a good source for purchasing stiffer paintbrush holders. The magazine *Illusion and Friends Step by Step Guide to Face Painting* is a great source for learning. Look up James Kuhn on YouTube for face painting. According to Wikipedia, James Lawrence Kuhn is an American visual artist and professional clown ("Haw Haw the Clown") from Three Oaks, Michigan. Kuhn is known for his "365 Faces in a Year" in which he painted a different image on his face and head every day for a year. Kuhn has lent his artistic talents to the Canadian indie rock band Young Rival's video "Two Reasons."

He then demonstrated his splattered effect with Wolfe white paint, of course, by flicking it on the face of your subject. A good way to apply glitter is with the back of your brush. Use blue glitter for swirls and teardrops. His workshop was quite exciting and very effective.

Lilly Walters Schermerhorn was the next instructor and suggested dipping a round-shaped sponge with a wooden handle from Hobby Lobby or Michaels into a split rainbow cake and putting it on the face and twisting it for an exciting flow of colors. Alternatively, you could paint a peace symbol in the middle of it if you like, then poof with glitter. Three-fourth-inch brushes make quick butterflies. For an Avatar character, use split cakes with a variety of blues.

Marcela Murad added her expertise on designing bling masks. She suggested to check out Mary Engelbreit for whimsical designs. Find a favorite you like, and figure out how to incorporate it into your style. Practice with every brush you own. Practice teardrops and thick to thin lines. Repetition is essential; don't just practice once or twice. Use rhinestones and gems, and cut them into separate strips and place in small plastic baggies so they are matched. Marcela demonstrated how to paint spiders using long and then short lines, as well as how to paint a unicorn.

Pashur suggested using metallic silver-blue Kryolan for the Transformer character. He was selling his patented X-ray face paint templates and body art templates at the convention. The templates can be placed over any magazine, pattern, or picture, and the designs will show through like magic. You will get an instant design. If you have trouble being creative with your face and body painting designs, Pashur's X-ray templates will give you X-ray vision, enabling you to see cool designs hidden all around you. They can be your guide to creating instant body art designs. I bought a couple that day. He then demonstrated a beautiful tribal design around the eye with turquoise paint and filled it all in with glitter. His workshop was spectacular!

I learned the importance of purchasing the Square credit card reader for clients who want to use their credit card for payment. It has become a handy tool.

Important side note from my experience: When you attend as many conventions, workshops, and classes as I do, you are exposed to a lot of products that are used in demonstrations, and you know that you just "must" have them. I learned a big lesson: When you go home with these new products, unless you plan to devote hours of practicing using the products you just purchased as well as practicing the new techniques you just learned, you won't gain a thing, which is always my downfall. I tend to not make the time that is imperative. My practice time is usually when I have paid gigs where I actually paint faces. In the past I made the excuses that I was a single mom, I worked full-time, I had to shop for food, I was too busy doing other things, and the list of excuses went on. I didn't make the time to practice what I learned. That's the key: You need to cut out the time in your busy schedule and I always found other things that I thought had more precedence. I depended on all the workshops to keep me up to date on new products, techniques and proper hygiene, but after a point, I knew I was just going home to the same old rut and forget what I learned. However, to give myself credit, this has been and continues to be the longest-lasting art form that has contributed to my success over the years.

I met Heather Green, aka Silly Heather for the first time. Heather is the owner of Silly Farm Supplies (taken over from her aunt Marcela Murad) and co-producer of the Face & Body Art International Convention. Since first meeting her, she has been an

inspiration and a support to me throughout my journey as an artist, and she always remembers me every time I see her. She is a delight. Heather astonishes me with the way she conducts herself as a professional businesswoman and yet remains humble. She makes the time to travel, teach face painting, mentor students, blog, and design new products for face and body painting, not to mention raising two handsome young boys.

Heather started her career when she was only fourteen and has turned her passion for art into a full-time career as the head of Silly Farm Supplies. Due to her incredible dedication and business sense, Silly Farm is the world's largest face and body art supplier. Heather travels the world teaching and sharing her love of face and body art. She got her start in face painting because of her persistent aunt and current business partner, Marcela "Mama Clown" Murad. Marcela convinced Heather to try her hand at face painting, and she instantly found a passion for the art. Heather went on to study business and finance, and upon completing her degree, she purchased Silly Farm from her aunt and focused her attention on building a great company. Heather is an avid face and body artist, airbrush artist, children's entertainer, and business entrepreneur. Her love for the art has inspired a video archive of tutorials on YouTube and has helped her develop an easy-to-follow style that benefits new and old painters alike.

Chapter 33

In this chapter I include some of my artwork using watercolor and acrylics.

Glory, 2010, is the title I gave to the acrylic piece that I painted alongside my fellow artist and Christian friend, Gary, at a time when we were painting prophetic images on stage during worship at our church. It was a very spiritual time in my life, and this painting was about God's glory shining down on the town's people.

Pomar Fields, 2010. This acrylic piece was done on canvas when I lived in Waterford, a small town with an abundance of almond orchards that are amazingly beautiful when the pink and white blossoms are in full bloom. So I painted the trees on El Pomar Avenue.

Cluster of Grapes, 2010. I was fascinated with grapes so I painted two full-sized (twenty-four by thirty inches) acrylic paintings of purple grape clusters with a background of pink, purple, and white. I gave one of the paintings to my high school friend Debbie, and sold the other one.

Flowers of Springtime, 2010. The thirty by forty-inch piece was done with acrylic using a conglomeration of flowers of all colors against a background of a variety of pastels.

Out of the Darkness, 2010. My niece, Emily, had just gone through a bad patch in her life and asked me to paint something

that reflected her feelings. So I created the acrylic piece of a colorful butterfly with glitter flying out of a dark cloudy situation, followed by a glittery gold trail to happiness and freedom.

Chapter 34

I enrolled in an outdoor watercolor class through Modesto Junior College adult education in 2010 taught by art instructor by the name of Mary. I don't recall her last name but she was amazing. She conducted her class outside at Jacob Meyers Park in Riverbank, and she only had three other students in her class, which provided one-on-one personal instruction. I learned how to paint leaves and trees with watercolor, which was an invaluable lesson. She took a liking to me and invited me to her home after class.

Her house was a small, older one-story home sitting on an acre of land. Both the front and back yards were ornately decorated with statues, garden figurines, rock formations, plants, fruit trees, shrubs, two small goldfish ponds with running fountains, and flowers everywhere. There was an old couch and three worn-out rocking chairs on her front porch and seven cats moseying about.

Hanging from every inch of the porch overhang was a collection of wind chimes of all shapes and sizes, plants in macramé hangers, and uniquely decorated mobiles made with shells, driftwood, broken glass and ceramic pieces, and rocks. It was a magical place. She invited me inside, and I was greeted by another half dozen or so cats wanting my attention. She showed me her collection of artwork and told me all about her art experience. She told me that her daughter

was also a painter and worked for Disney. She gave me insight about artists and that their creative inspirations come in waves. Sometimes you feel it and other times you don't. You can be in a dry spell for a long, long time before you come out of it, and all of a sudden you will again have bursts of creative energy and ideas, and restart your climb upward from the "wave." At first, I didn't know what she meant by that, but now I know. She said our creative juices are many times inconsistent, and we have our highs and lows. A first encounter with art is like meeting a stranger: it opens you up to new ideas, people, places, and parts of yourself. Later in this book you will read about seasons of creativity.

I look at my own style and believe I am somewhat borderline eclectic. Eclectic refers to ideas or opinions that are taken from a variety of sources and do not follow any one line of opinion or philosophy. By nature, being eclectic is the practice of deriving ideas, style, or taste from a broad and diverse range of sources. That eclecticism reflects one's upbringing, so it comes naturally to the person rather than it having been taught or instilled by others. You might say it's a free spirit.

Mary had invited me to attend a meeting of the Oak Valley Art Society in Escalon. After some encouragement, I decided to attend my first meeting; I joined the association and attended regularly. Each meeting featured a keynote speaker who spoke on the subject of art and sometimes demonstrated an art technique, which I always found fascinating. I painted my first successful watercolor painting of *My Special Kitty*, and I recall that the president of the association, Dorothy, was so impressed with my skill level, she told me, "You are definitely a watercolorist!" Her compliment changed my life forever.

One of the keynote speakers was artist Chloe Fontaine from Oakdale who talked about her art. I was moved and inspired by her work and later took a few of her watercolor classes. What I learned from her was not to strive to be a perfectionist with your art, just play and enjoy the process of creating. She had a huge influence on me, and I had the pleasure at one point to see her home. Her beautiful

art hung on every wall and around every corner. She showed me her art studio and the array of items she collects to create all kinds of things: collages, mixed media art, greeting cards, and bookmarks, just about everything imaginable.

I took two classes from Chloe through Oakdale Community Education. She taught me to play with colors and not stress out over it. So I painted a piece free of perfectionism, as I played with the dance of watercolor paints. I did a total freestyle abstract painting of sailboats in the water. It was quite an effective assignment. Plus, my piece sold!

She became my favorite influential artist and mentor, and I bumped into her from time to time at local art functions. She told me about the book/journal she created with empty pages. The idea was that you choose a page in the book and add something—a sketch, painting, writing, or whatever creative piece you choose. Then you send it on to a friend to do the same; they send it to someone and so on. I love that concept. Some of her friends lived out of the area, so they were mailed the book to complete their portion. It's a great idea!

I took a basic design at Modesto Junior College from a different instructor, and although I already knew basic design, I wanted a refresher to get back into the groove. It was informative, and the instructor was very good. One class session was held outside on campus, and we sketched in the grass. Later I took a watercolor class from the same instructor but I ended up completing only two or three lessons and dropped out of the class because of boredom and not being challenged.

Chapter 35

Spring Fling Henna Convention was held in February 2011. My son Jason had planted the seed some time ago for us to take a cruise to Mexico. I had never dreamed of taking a cruise. But when I found out that Neeta Sharma was holding her Spring Fling Henna Convention on Carnival Paradise to Catalina Island and Ensenada, Mexico, I was so excited that I just knew I had to go. We were finally going to do something other people did! I checked into it, and the cost was only $350 per person since she got a group rate. We immediately made plans. I drove to Long Beach with my two sons, Jason and Cody. What an experience! The cruise ship was incredible and had everything imaginable on board—food, drinks, shopping, massage, art auctions, music, casino, dancing, performances, exercise gym, library, and game room.

Day 1: Catalina Island, San Diego. What a spectacular sight with spectacular houses built on a hillside. Palm trees were everywhere. We walked through the town and enjoyed the shops and sights. We discovered Catalina Dive & Snorkel. Jason was intrigued, so he signed up to try out his first scuba diving experience. He loved the thrill of it but admitted that he would not try it again. Catalina Island was beautiful at night with the houses all lit up and the lights reflected along the water.

Day 2: Ensenada, Mexico. We had a different towel animal show up in our state rooms each day folded by the deckhands. Jason and Cody played the slots, and we enjoyed the comedian Lance Montalto at night. The food, of course, was phenomenal. We toured a winery in Ensenada and did some shopping and I purchased a woolen blanket and a necklace from one of the vendors that approached us.

We rented quads at a shop called Moto Xtreme Baja. I rented a small four-wheeler, Cody rented a larger four-wheeler, almost like a golf cart; and Jason got a dirt bike. What a blast riding down the streets of Ensenada. We were told that it was legal to ride them on the street, so we rode to the beach and raced around on the beach. We saw other passengers from the ship who were enjoying the same thing. Cody's four-wheeler got stuck in the sand, so we had to pull it out. At the end of our ride, we went back toward the cruise ship, where there was an outdoor market on the dock that had great gifts and rum. We also toured a winery which was interesting.

I took a few of the henna classes on board with our henna group. I learned that the most common henna designs are hibiscus, dragons, tribal designs, flowers, stars, and butterflies. I learned about line, shape, and space, and to ask the client what direction they want. Size, texture, hue, value, and intensity were emphasized, along with straight lines connected to jagged lines to create dimension, value/tone/contrast between light and dark in a design and how lines inside your design create depth. The instructor also taught design and composition and bridal clients.

Another henna artist taught the basics and adding "bling" to your design. I met a girl named Anabel in one of the classes and she and I became acquaintances and kept in touch after the cruise. Anabel is a face painter, as well as a clown, and lives in the central valley just a couple hours from me.

A henna artist taught traditional Indian bridal shapes, Arabic style. Another taught a mixology class and how to make henna using 100 grams powder, 1 ounce essential oil, 2 teaspoons plus one-quarter cup sugar, and 1 cup lemon juice. The liquid should be added

first, using a plastic container or stainless-steel bowl dedicated to henna. I also learned how to make a mandala on the skin. Mandalas have long been used in religion, art, architecture, and even psychology as representation of something greater than ourselves. Many henna artists believe that creating a mandala on our skin connects us spiritually with the universe to bring peace and balance to our lives.

"Mandala henna designs not only make for gorgeous and intricate body art, they also can help connect us to the universe and remind us of our place in it. Mandalas have long been used in religion, art, architecture, and even psychology as representation of something greater than ourselves. Many henna artists believe that creating a mandala on our skin connects us spiritually with the universe to bring peace and balance to our lives.

Every mandala has a center point from which the design expands out in radial symmetry. In certain religions like Hinduism and Buddhism, each of the circles can represent a personal quality such as purity or devotion that must be obtained in order to be worthy of reaching the center. When you reach the center, you have become the best version of yourself and will find inner peace." (Mandala Henna Designs by Mihenna LLC April 6, 2021)

The cruise agent was Gori from Chicago. She set us up with the cruise, and years later, somehow, we have managed to maintain a Facebook friendship with the promise of someday visiting each other. I love networking in the industry with the addition of social media.

Soon after the convention I jumped into doing henna, making my own from paste, and painting my friends and coworkers. Soon I was hired to do henna for parties.

Chapter 36

I've journaled throughout my life which has been a way of expressing feelings. So around 2011, I discovered journaling in art which is like a visual diary that you record your thoughts, memories and emotions through images, art and words. It's record keeping combined with creativity.

In November 2011, I attended the performance of Riverdance at the Gallo Center for the Arts in Modesto with a coworker and felt compelled to sketch the ticket. In my art journal I sketched the ticket, the logo, some of the clog dancers and performers, and painted in very loose watercolors. That was a pivotal time when I discovered the love and ability to sketch images with pencil or pen and ink and add watercolor; sometimes I would add a brief journal entry to each piece. It was quite an invigorated discovery. Since then, I've journaled my experiences which helps to express my feelings and memories.

With the encouragement of my dear coworker Rosie, I entered an art contest at a spring art show at Grand Central Station Restaurant in Oakdale—my very first contest. I entered a watercolor painting entitled *My Special Kitty,* and it won second place! My painting has special meaning to me and was during a turning point in my life as a watercolorist; consequently, it's not for sale.

Next I entered the Stanislaus County Fair art exhibit also in 2011. I entered two paintings—the watercolor painting took second place and the acrylic one took third place. I recall feeling somewhat nervous since it was new to me. But the ribbon awards gave me a sense of confidence that I can do this!

I attended several business development workshops and joined several groups in order to gain knowledge for developing my face painting and art business, and for developing skills as a professional businesswoman.

I had a two-year business development membership with Women's Success Network (WSN) in 2011 and 2012. The WSN provided a forum where local businesswomen could meet, support, and educate each other, providing unlimited opportunities for growth and development. Meetings were held during the noon hour once a month, and members were encouraged to exchange ideas, referrals, and resources, and make connections that led to valuable business relationships. The dues were only twelve dollars a month, and I made a lot of acquaintances back then. We had a keynote speaker each month, and business vendors displayed and sold their products or services. Since then, the local group has disbanded.

Through WSN I learned about a one-day business development workshop in which I attended. The keynote speaker taught the following:

- You've got to know where you want to go.
- Write everything down.
- Step on the gas and write down the actions you need to take.
- Make at least three phone calls a day to prospective clients.
- Stay on course and know what you want, believe in yourself, and don't let anything get in the way of your goals.
- Don't look where you think you're going to fall. Look where

you want to go. Stop looking at the obstacle; look beyond it.
- Why would you want to blend in when you were born to stand out? I love that quote!
- Keep your business simple. A confused mind says no. Keep conversations and emails short.
- Ask for help. People, including your family, will rise to your level of expectation.
- Have someone do the work you don't want to do. Delegate.
- Before the end of each day, record at least six things that need to be done the next day.
- "Action is the antidote to despair" (Joan Baez).
- Do something and complete the task.
- If something doesn't work for you now, don't quit. Try it later.

Another speaker at the workshop taught how to look beyond your obstacles, stop focusing on your barrier, and get around people who you want to be like and that businesswomen should ask themselves the following questions:

- What is our purpose?
- What are we about?
- What is our support purpose, and what can we do for our client?
- Use stories of success to support our point, including a powerful opening/introduction statement, specific topic, body to include three to four main topics supported by a story, visual aid, or testimonial.
- Your conclusion should include what you want your audience to do—call to action.
- Your presentation should include honesty/sincerity, eye contact, gestures, and vocal variety. To gain confidence, practice talking about what you are passionate about. This helps you become confident, control the butterflies, and turn the nervousness into energy. It adds impact!
- Step outside your comfort zone.

Another speaker spoke on lessons learned in delivering speeches. Her notes included practice, team up for technology and come prepared for it, and be mindful of your weaknesses, i.e., "um"s and "aw"s. In an exercise, I was to write a list of what I've complained about over the years and then write the blessings of the "what wasn't," which allows you to focus on what is.

Some quotes from the workshop included "When what you have to say is more important than what people think of you, fear will stop being an issue" (Eleanor Roosevelt), and "Visualize it and do it"—the 10 percent/90 percent principle. "We can't control the circumstance, but we can control our reaction" (Stephen Covey).

Another speaker talked about "being happy." See the following:

- Decide to be prosperous.
- Spoil yourself occasionally.
- Make plans and set your goals.
- Stretch your belief system as to what is possible for you to believe.
- Always carry money; learn to trust yourself with money.
- Don't blame people or circumstances for how you are doing.
- Attack every challenge with enthusiasm and commitment.
- Constantly affirm that you deserve to be prosperous and to have money.
- From your earnings, save first and spend what is left.

I became a member of Central California Art Association (CCAA) in 2011 through the local Mistlin Art Gallery in downtown Modesto and displayed several art pieces over the years. It has given me a sense of belonging to the local art community, and I've met several local artists through my membership. A few times I volunteered to help out with their art walk events that are held once a month. I

have also attended art classes/workshops given by local and guest artists.

In 2012, I attended the Women's Annual Business Conference and Vendor Showcase, sponsored by West Side Action. I enjoyed the many vendor exhibits, workshops, networking with women, the buffet lunch, and the keynote speaker. They also had small business resources available.

I started applying for memberships in business organizations and associations, which helped me gain confidence, new friends, experience, and exposure to the art world, in addition to looking good on my art résumé. I joined the following: American Women Artists, Modesto Artist Salon, Western Team Region Art Association, California Watercolor Association, Frank Bette Center for the Arts in Alameda, Grand Theatre Center for the Arts in Tracy, Tracy Arts League in Tracy, Valley Sun Catchers plein air painters in Modesto, Central California Art Association in Modesto, and Oak Valley Art Society in Escalon. I also attended several lunchtime groups that had keynote speakers who touched on a variety of business and marketing topics.

I hired Marshall (who also designed my face painting website) to design a website for my artwork. He did a fantastic job, and I got a lot of look-sees from his work. It was nice to finally have a website to refer customers to when they inquired about my art.

Chapter 37

My first participation in the Art For Justice annual fundraiser was in 2012 when I donated a watercolor painting which for many years I participated in. It was originally sponsored by the Stanislaus Family Justice Center (SFJC) in Modesto to help adults and children affected by trauma heal and access the services they need. The SFJC is a nonprofit community service center that houses many agencies under one roof that work together to rid our community of domestic violence, child abuse, human trafficking, sexual assault, and elder abuse. The SFJC developed Art Restore Kids (ARK), a trauma-informed program for children using art as a therapeutic tool to focus on healing. ARK helps children articulate trauma in their lives in a safe, supportive, and caring environment. The program uses art to guide children affected by violence and/or trauma toward their own empowerment by offering them a way to heal from their experiences.

The sponsorship replaced SFJC with Cricket's Hope, a nonprofit that provides hope to children who have experienced unimaginable trauma. They are a strength-based prevention, education, and healing program for poly-victimized children. They believe that hope provides the motivation for transformation and that providing love is the single most important component of their program. Cricket's

Hope lovingly builds resilience in children using restorative and trauma-informed practices. Their motto is "Where there is love, there is hope."

Cricket's Hope's restorative and trauma-informed practices serve children through art, camp, and specialized programming to help kids become their best and most resilient selves. The organization focuses on trauma-informed restorative care and character development programs that serve trauma-exposed, at-risk children and youth in the Modesto area. They build restorative groups based on love and respect for each other's pain, grief, and hurt. Sponsorship was later transferred to Art of Hope, Cricket's Hope Inc.

At their annual Artists' Choosing Night, local artists are invited to attend and pick out a piece done by a child at the Stanislaus Family Justice Center or Cricket's Hope, interpret that piece through their own medium, and donate it to be auctioned to be purchased. It is a child-inspired art show and sale. Each child paints a piece based on his or her traumatic experience or whatever he or she is struggling with. An evening then is arranged for the adult artists in the community to view the children's creations and choose the piece(s) that "speak to them in their hearts." They are given a month to interpret the child's painting, using their own medium and style to reflect the child's heartfelt feeling. All artwork is then displayed for the public to purchase for the fundraiser.

I painted *Hidden Secrets* in watercolor the first year I donated to the Art For Justice fundraiser. It was interpreted from fifteen-year-old Ann's painting entitled Secrets...I Have Secrets Too. This particular workshop, Project Inner Self Portraits, helps older children look inside and discover more about their inner self. We are used to looking at our outer selves—our looks, clothes, appearance, the image we try to portray. The workshop goes deeper to get more in touch with our inner self. Ann's creation inspired me, and I wrote, "I created this artwork based on a fifteen-year-old girl's portrait of her inner self. I can relate to the struggles to discover our inner self

and not let others influence who we really are. I admire this girl who is working hard at that. I know she will learn to share her secrets with trusted loved ones who will help her grow into the beautiful young woman she is on her way to become."

Later in 2012, I painted a watercolor of the house across the street in Riverbank where I used to live. It was an inspiration to paint, so I grabbed my watercolor sketch pad and started working. It was a good experience for me. I painted it sitting in my garage, trying to capture every detail of the house.

I then began sketching everything in sight. I had discovered my talent and was on a roll. I sketched a local Starbucks coffee shop, a picnic bench at New Melones Lake in Calaveras County, a wheelbarrow and planter from Mom and Dad's backyard, and a mayonnaise jar next to a cantaloupe sliced in half. I then sketched my dearly beloved dad in his easy chair, who fell asleep with a reading book in his lap. In June my sons and I went camping at Fraser Flat in Tuolumne County, and I sketched and added watercolor to some trees at our campsite with one of our bicycles propped up against one of the trees. In July I sketched an oak tree in a park while walking my favorite dog, Toby.

I was on a roll with my art and sketched a collage of random furniture and plants in my living room. Then I took an interest in jewelry art by Holly Yashi (fellow high school classmate) and sketched some of her pieces, which turned out pretty good. Next I sketched a silly image of a woman screaming her head off with her hands up against her head, showing her frustration. I figured I could use the image for numerous projects. Then I sketched four canisters with an apple theme on my kitchen countertop. Another sketch was done while waiting in the lobby of the emergency room for my son Jason. I sketched people sitting impatiently in the chairs.

I also sketched several images from a field trip I took with a watercolor class, led by David, to an Alameda farmers market. From his class I sketched in watercolor a sailboat scene. Then I sketched and journaled pieces of office equipment on my desk at work, my cat in a tree, people walking to the local library, and images from our local farmers market.

I painted some cartoon-like sketches of my face, which turned out comical. What's funny is that I didn't intentionally mean for them to be cartoon characters, but that's how they turned out, and I loved them! I also sketched three of my nieces and a nephew, my classmates sitting together at our graduation ceremony, an old house, and numerous other sketches.

I was inspired to paint *Lounging Feet* in 2012, from a photo I had of a friend, Lathon relaxing with a bottle of beer on his lounge chair. The watercolor painting simply shows his sandaled feet propped up against a fire pit overlooking his backyard of flowers and foliage.

Salvation is the title I gave my 2012 acrylic painting that I created alongside fellow artist and friend Gary on stage during worship at our church. It was of an awesome sunrise shining down on a lake surrounded by Joshua trees.

The watercolor painting *Boats on the Fourth of July* in 2012 was inspired by Chloe, one of my favorite art instructors. I consider her to be my mentor and advisor in painting. In a watercolor class I took from her, she said to "just play" with watercolor and let the pigment do what it wants to do with the water. So with the painting, I did just that. The background is a splashing of pastel yellow, pink, green, red, blue, and violet. When it dried, I added sailboats on the water with pen and ink and included the reflection in the water. It was the most pleasurable and free-flowing painting I've ever done; and the painting sold. Thank you, Barbara.

The watercolor painting *Portrait of Hannah* in 2012 is of my niece and turned out quite likeable. Portraits for me are always challenging. My painting showed the highlights in her beautiful dark-red hair that was braided to one side and draped over her

shoulder. She wore feather earrings and a light-blue, loose-fitting top. I painted the folds and highlights quite well.

I joined a group of artists through a local event Modesto Architecture Field Project in September 2012 where we were given the choice of various locations throughout Modesto to paint. I chose to paint a beautiful castle-like home downtown on Magnolia Street. I set up my easel and chair right across the street from the gorgeous home and painted for a few hours. I named it *Magnolia Street Castle,* and it was displayed at the Chartreuse Gallery for their October exhibit, as well as at the Mistlin Gallery. I chose a delicate ornate frame that seemed to be fitting for my artwork.

I took a watercolor workshop from artist David, an architect by trade at the Frank Bette Center for the Arts, Alameda. We started off in the classroom learning the basic techniques. Then we took our easels and supplies outside and sat across the street from the center and painted the building. David taught us about perspective and using our thumb and a teeny square with a cut-out square inside it to measure perspective. We painted a couple buildings that day. Then we took a field trip and painted at the Alameda farmers market. I felt somewhat uneasy painting in a crowd, but it became quite comfortable, especially when people would come up to me and comment on my painting and start a conversation about art. We then went upstairs to a restaurant and sat outside on the patio to paint the sailboats in the water. It was quite an exciting lesson.

I discovered world renowned watercolorist, illustrator, and author Cathy Johnson and became completely enthralled and obsessed with her watercolor style, so I began trying to use her style. I've had the pleasure of communicating with her online. Cathy lives in Excelsior Springs, Missouri, with her husband, Joseph, in a small Victorian house and a varying number of cats.

Cathy has worked as a naturalist, writer, and freelance artist for thirty-five years and was staff naturalist and contributing editor for *Country Living* magazine for eleven years. She was a contributing editor to *Artists Magazine* and *Watercolor Magic* (now *Watercolor Artist*) and has had a regular column in *Personal Journaling* magazine, where she wrote on a subject she feels passionately about: realizing the importance of creativity in our lives.

Cathy has written and illustrated her own work for a number of national magazines. She has written and illustrated thirty-six books and contributed to a number of others. She teaches online, offering a number of self-directed mini classes through her website. Her paintings are included in a number of private and corporate collections in USA and abroad. She has been a huge, huge inspiration for me for years and I have purchased a few of her books.

Chapter 38

I signed up for a workshop with Jodi Carr and Mark Reid. I had previously met her at one of the local conventions and was so inspired with her fancy eye design work that I decided to register for her one-day workshop, which was also close to home. Plus with Mark Reid being the other instructor, you can't go wrong with that duo! The workshop was held in Jodi's home, so it had that added personal touch.

She started out demonstrating how to incorporate henna into our business and how to use sparkle powder. She demonstrated how to make step-by-step alternating swirls, chain swirls, flower petals, leaves, lines, dots, teardrops, and eye designs and how to find the focal point on the face. She also demonstrated one-minute designs, such as a butterfly, spider, scar, heart, dolphins, and flowers. Next she demonstrated how to paint a cute little unicorn using Paradise Wild Orchid paint with Beachberry for a tattoo rose.

Mark, of course, demonstrated his spectacular designs. He explained that when using his branded glitter gel, Glitter Mark, you are to angle it on its side, not straight up and down, so you can watch it come out.

Jodi is a face and body painter, was the publisher and creator of *American Face Painter* magazine from 2009–11, and ran an online

supplies store for eleven years. She was an early developer and the first seller of rainbow cakes. She cut hundreds of butterfly brushes by hand that she sold in her online store and at workshops and conventions. She created innovative, impactful designs that could be created quickly at event settings. When she became a professional, she started using Wolfe and later added Fantasy World Wide (now reformulated and rebranded as Mikim), Tag, and Global and sold these products in her online store.

Jodi is a seasoned artist based in San Jose, California, who has offered art services to events since the 1980s. She is the owner of Arty Party and offers both traditional and digital caricatures. Her flattering style has made her a popular Bay Area caricaturist with a loyal following. She paints elegant silhouettes for events and also runs a photo booth with quality photos. She offers world-class face painting with detailed masterpieces. Like many face painters, she also does body painting, henna, and glitter tattoos. During the pandemic, she went back to school to update her skills in computer graphics and digital media. I have purchased her products as well as her magazines, which have given me ideas and inspiration for my own business.

Chapter 39

FPBA (Face Painting Body Art) Workshop held in Las Vegas was an exciting and informative convention that I attended that offered a series of body painting workshops. During one body painting workshop, there were several participant/models to paint.

I was on a team of five painters and we painted two models: one was Elvis and the other was Elvis's bride. Emma was the team leader and recommended using Wolfe and Diamond FX, which has beeswax in it and tends to stick longer, asking your client for the purpose of the body painting, and to consider water, sweating, etc. She also recommended using Mac Pro pigments in tiny pots of colors. Tattoo inks are alcohol based. Lowell Cornell brushes are good for pinstriping. Kabuki brushes are typically used for body painting. She recommended checking out a book called *Drawing on the Right Side of the Brain* by Betty Edwards.

Our beautiful model, Erika (Freebird Funnday) who lives in Colorado, was adorable. She was absolutely delightful, and I loved her free spirit; we bonded and had a special spiritual-like connection. To this day we keep in touch on social media. She is a wild, free-spirited dancer and dances to hip-hop music wearing wild, funky, knee-high boots. She's a sweetheart and quite a free spirit like me. She enjoys painting, dancing, and trying funky new hairstyles.

Each of us had a job, and mine was to paint the bride's pearl necklace in white, using highlights to make it appear 3-D. I also painted part of her thigh-high, metallic, transparent stockings. Her upper half was painted by other crew members with, of course, transparent-like white paint to look like sort of a negligée, with off-the-shoulder cap sleeves. We added white butterfly adhesives on her breasts and just above her belly button. We added clamp-on white feathers in her hair, along with her veil. The whole design was quite effective and her painted body was absolutely stunning.

Our model's studly counterpart was to be Elvis and was decorated and body painted by our team. We painted him with a typical sparkly black Elvis jacket with a high collar opened to expose his chest. I helped paint the wild medallion necklace around his neck, as well as his sparkly wide belt with sequins and a huge sequined medallion in the center.

We did a second body painting of a male model in a black-and-white pinstriped suit jacket and pants—all painted on—with a white shirt underneath and a red tie.

At the end of the workshop, all the painted models lined up and with their body painters and strolled down Main Street in Vegas, totally nude except for their painted bodies and props, such as skirts, head pieces, etc. It was quite a spectacular experience!

Chapter 40

I participated in a body painting demonstration for the Frank Bette Center for the Arts in Alameda in which they presented a signature salon show. The show featured artists Sue, Alana, Jessica, Rose, and me showcasing our works. On the opening night, March 2, we did a live painting demonstration.

Alana picked the comic-book superhero Green Lantern to paint on her body builder model. She used nonallergenic, cosmetic-grade theater paints on her models.

I assisted Sue by painting Julia "Butterfly" Hill on model Janel. Hill lived in the redwood tree Luna for two years to publicize the damage that current logging methods were doing to the forests. The painting featured trees, butterflies, and Hill separated from the muddy devastation of landslides and barren land by a jagged line down the model's middle.

Jessica painted Conceptualized Fantasy on her model. She started with a base of colors spread across the model's body in pleasing swaths. She embellished her work with swirling designs of black and white. She said that form-fitting costumes from Cirque du Soleil are first visualized as a body painting before they are made into fabric. Four hours into the session, photographers took photos of the models. Then it was all washed away: ephemeral art, felt by the artist

and model, captured on film, enjoyed by the viewers during the process, and then removed. Our news article, "Body Painters Use Skin as Blank Canvas," was featured in the Alameda Sun newspaper which was exciting.

I then participated in a second body painting demonstration in Alameda shortly after the first one. Sue was the one who again invited me. The session was not as publicized as the previous one but just as fun and quite a learning experience. Alana and I paired up and painted my model, Pam. The theme was good and evil. I painted my half of Pam's upper body as the good with a white lacy pattern on her face, upper-left side of her body and arm. Alana painted the evil on the right side of her face, upper body, and arm. Her design included fire and a demon crawling onto her breast. For a special effect, Pam wore a red glove on her right hand that extended to just above the elbow. It was quite effective. Professional photos were taken of the models afterward.

I learned some cleaning tips: To clean off the paint, the model should rub baby shampoo over her dry body while standing in the shower before turning on the water, as it will help to remove the makeup. The same brushes used for face painting may be used for body painting, and a kabuki brush is used to cover large areas for the base; which differs from face painting where a sponge is used. The sponge is less efficient for body painting. A fixing spray sets the paint after you're finished and will stand up to wear for a few hours. The model should use briefs with a nylon content as the pure cotton ones are harder to paint over; they absorb much more paint and end up a much lighter color than the body painted areas.

I also learned tips for mixing Mehron Metallic Powder with Mehron Mixing Liquid. Use about two to three times as much liquid to powder, and make sure it is thoroughly blended (no lumps) before applying to the body. You must mix only a little at a time as you work, as the alcohol evaporates and will not keep for long if premixed. You need one bottle of powder and one bottle of mixing liquid (4.5 ounces per slim female body), but it is a good idea to have

one in reserve in case of spills or accidents. The mixture can be applied with a brush or sponge, though a sponge will absorb a lot of the product, which is wasteful, and not give as smooth a finish as a brush. Use a large brush if you are covering large areas, such as a whole body. When finished, you can polish with a soft powder puff or pieces of cloth. Because the finish, using the mixing mediums, is resistant to touch, it is also resistant to glitter adhering, so you would need to use an adhesive for glitter to stick.

When painting a model from head to toe, make sure to get them to bend their elbows and knees as you paint so you can cover all of the creases properly. If you don't, you will see the patches as soon as they bend. If you want an amazingly shiny, chrome-like finish, mix the powders with an oil, such as baby oil, vegetable oil, etc. It can be applied easily using your hands, kind of like a massage. It will look incredible, but be aware, it will also be very oily. If skin is sensitive, the oil and powder mixture should not be applied near the eye/mouth/nose area because of the alcohol in the mixing liquid. Alternatively the metallic powders can be used dry in those areas.

I later started doing some body painting on my own and discovered I really enjoyed it. I painted the upper body of my son Jason with black makeup and white splotchy stripes across his chest and face to look like a member of a heavy metal band.

I did some prenatal belly painting using, of course, the same FDA-approved paints that I do with my face painting. I ask my clients what design and colors they want and if they want the name of the newborn included in the design, colors. I ask them to research online ideas and let me know so I have an idea of what I'm about to paint. When they know their theme, I research for more ideas. I sometimes sketched out the design on paper before painting it on their belly. I asked my client to exfoliate and

moisturize well for a few days prior to being painted which helps the paint go on nicely and makes it easier to wash off afterward. On the day of the painting, I asked my model not to wear any perfume or deodorant, as this can interfere with the makeup. I also ask that they moisturize well before the painting time to allow it to soak into the skin. I ask them to bring old, dark clothes to wear home after the painting session. Generally, I suggest that the model rub baby shampoo over her dry body while standing in the shower before turning on the water, which helps wash off the makeup.

Another experience with prenatal belly painting was with my niece Emily. Her belly had an undersea design of sea creatures in the bottom of a blue sea with bubbles, seaweed, fish, a school of tiny fish, and seahorses. She was such a good sport. The second painting I did, also on Emily's belly (during the same pregnancy), was of a blue mama owl holding her baby owl in her left wing on a tree branch covered with tiny, delicate pink flowers. I added some white swirls for an interesting effect.

I painted the pregnant belly of Emily's best friend. Knowing her friend was sort of free and wild with purple streaks in her hair, I decided to paint a purple background with a pink guitar and swirls, stars, and dots. I added the name of her unborn child in black paint outlined in white. I even added a black spider.

The next prenatal belly painting I did was on a coworker. She wanted me to paint a butterfly with purple wings perched on a white lily on a purplish-pink background. I added more white lilies up around the curve of her round belly with a hint of green leaves. I then added in black the name of her unborn child.

Another project combined belly and body painting again on my niece, Emily. I painted a cool, dressy black vest with a white lapel and gold buttons on the upper body. I painted a red- and white–striped T-shirt underneath the vest that went as far down as her pregnant belly. She wore black leggings and long black-and-white feather earrings. I also painted her face with a black-and-white feathery design.

Chapter 40

Another experience involved my friend's daughter, Sabrina, who was over six months pregnant with her first son, Gian. We had a few sessions of painting. I first painted her upper body with a short football jersey in metallic blue, exposing her swollen belly, with her name on her back and the number "24" on her front. I then painted teeny shorts on her lower half in the same color, leaving her belly unpainted. Her mom, my friend Patty, took several professional photographs of her.

My next session with Sabrina was during the second part of her pregnancy; I painted her bare chest with tiny blue and white flowers. On her pregnant belly, I painted a field of colorful flowers and leaves, butterflies, and dragonflies, with Gian's name painted across her belly. She was quite beautiful.

I became acquainted with Steven of Steven's Balloon Art and Entertainment. Steven became one of my favorites. He worked all kind of events with his balloon decorating, bouquets, and animals, and his personality is very comical. He even dressed up to fit a particular party theme. Steven and I worked so many gigs together, and we would jokingly bounce our humor off each other and jokingly badger each other. He was very talented with his balloon art. Early on we were hired to work together for a Castro Valley elementary school Halloween festival. We would ride-share since it was about an hour and a half travel time from Modesto, and we worked the event for years. We developed quite a camaraderie over the years working gigs together and learned a lot about each other's lifestyles. Sadly, he eventually had to give up his gift because he developed chronic pain in his wrists, which made it impossible to continue balloon twisting. Steven was the best partner. Love you, Steven!

Chapter 41

My first Caribbean cruise as a face painter was with the Royal Caribbean, Oasis of the Seas. I began reading about entertainers through social media networking groups and their experiences working the cruise ships. At first, I thought, "No way! I could never do that! I'm not that good, plus I can't fly to Florida to embark on a cruise."

I recall my longtime friend Linda Erickson, from kindergarten, sharing her experience of working the cruise ships as an aerobics instructor. I was always amazed with her courage, and I wanted to do what she had done. Linda had spent her life with people saying she was crazy, a loose cannon, and a rebel without a cause. But she was known for her generosity—giving, loving, and helping others. Linda's artistic side is as a textile artisan.

I also thought of Junior, a longtime coworker, who encouraged me to face paint on a cruise ship. And before long, I found the courage to shed my fear and self-doubt and go for it. I realized that if others could do this, why couldn't I? That's what Junior kept asking me. Thank you, Junior and Linda, for your encouragement and inspiration! I'm sure neither of you realize the impact you had on me and my decision that opened a door for opportunity.

I applied online to Sixth Star Entertainment in Florida and waited

for a reply. A representative from the company finally called me to schedule a phone interview. I was beside myself with joy and disbelief. We set the time, I had the interview, and I was accepted. I was in! The next step was to wait until the schedule was posted so I could pick the cruise I wanted. I chose a seven-day cruise touring St. Thomas, St. Maarten, and the Bahamas. I invited two friends to accompany me, but they cancelled. I had a make the decision to pass up this once-in-a-lifetime opportunity or just go for it alone. I rationalized that since I had come this far, why would I quit now? That was my biggest, most courageous decision outside of my comfort zone.

My son Cody drove me to the San Francisco Airport (SFO), and I hopped on American Airline flight 350 headed for Chicago. The flight was long and uneventful. I had a two-hour layover before boarding flight 556 to Fort Lauderdale, Florida. I was scared to death to do it alone and sick with such a bad cold that I could barely breathe.

When I arrived in Fort Lauderdale, I called fellow face painter and total inspiration, Marcela "Mama Clown" Murad. She had told me to call her at any hour. It was 11:50 p.m., and I felt awful about disturbing her at such a late hour, but she was cordial and told me she would pick me up at the airport shortly. Marcela lives in Hollywood Beach, so she had a fifteen- to twenty-minute drive to the airport. She is the most charming, humble, and loving person. I felt intimidated and small compared to her—this professional face and body painting person, clown, instructor, creator of *Illusions Magazine: The Magazine for Today's Face and Body Artist,* the producer of FABAIC and owner of Silly Farm Supplies, the largest supplier of face and body art supplies. I was just a little unknown face painter from California. I was a mere stranger to her; but I had taken many, many classes from her over the years so she knew who I was. Thank you, Marcela, for graciously inviting me into your home.

Marcela arrived to the airport in no time at all and drove me to her house where I was invited to be her guest for a day until my ship set sail. Her house was a beautiful white cottage a few miles from the beach in the oldest section of Hollywood Beach. It was surrounded by trees, palm trees, bushes, and shrubs. The guest room was cozy with a Mary Engelbreit-style throw rug next to the bed. There was a Tiffany lamp on the nightstand and a doll sitting on a little chair in the corner. The bedroom window was elegantly decorated with two sets of sheer white lace valances that hung in a V-shape over the window. And the comforter on the bed was so cozy looking that I couldn't wait to go to sleep that night! Her brightly colored whimsical hats and clown aprons hung from a full-length hat rack against another wall. The interior was totally decorated with whimsical fairies, butterflies, gnomes, and kittens that made me feel so welcome. It reminded me of a dollhouse, and I was intrigued with every corner of her house. She also had beautiful Victorian lamps throughout the house. Her whole house was decorated with Mary Engelbreit's whimsical designs, including childlike-painted flowers and checkerboard squares of black and white and red and white. Marcela's house was like a fairy-tale cottage.

Her living room had a hutch that was repainted antique-blue and cream colors, and each panel, drawer, and cabinet was hand-painted in the Mary Engelbreit theme, delicately pinstriped. Bookcases were decorated with the same design and held trinkets, knick-knacks, and dolls. There were some small chairs around the room with dolls sitting in them. A small coffee table in the middle of the living room was brightly colored on the top with the black-and-white checkerboard design around the sides.

Marcela's kitchen was like a charming little dollhouse kitchen. The cupboards and drawers were an antique white outlined with bright yellow and green, and in the center of each panel was the most intricate, hand-designed, four-sided polygon with the edges done in the checkerboard square theme. In the center of each design were little red cherries. The countertops were an avocado

green, and the space between the ceiling and the top of the walls was also decorated with the black-and-white checkerboard theme. We were exhausted, so she fed her twenty-five-year-old cat, brewed me some Sleepy Time tea, and sent me off to bed.

The next morning Marcela showed me around town. She bought me some fresh orange juice from the best place in town. I was too embarrassed to tell her that I couldn't enjoy it because my cold had ruined my taste buds, and I couldn't smell anything either. But I'm sure it was wonderful.

The next day was my departure for the cruise ship. She said that when I returned, if she wasn't home, to take a cab to her house and make myself at home. She drove me to the cruise ship terminal, and I was scared to death. I took one look at the huge ship that I was about to board, and Marcela said, "Okay, sweetie, you're on your own!"

Day 1: I was overwhelmed with everything. As I stood in line to process through, I felt somewhat in a daze because I was sick, I had impaired hearing, and my ears were popping. I was exhausted and felt as if everyone was talking in a tunnel. The man who was directing passengers quickly made me feel comfortable. He told me I was doing fine and took my luggage and directed me to the processing area. I made my way through the embarkation line with only one snag. I was asked for my passport and travel itinerary. Instead I presented the letter from Sixth Star Entertainment stating that I was part of the enrichment staff and didn't have a regular itinerary like the other six thousand passengers. The clerk didn't know what to do, so she passed me on to one clerk after another. Someone finally called a person of authority about me—this questionable passenger who said she was part of the ship's enrichment staff. Well, after quite a long time, I was finally allowed to board the ship. Halfway up the ramp I stood back in amazement at the enormous size of the ship. I had butterflies in my stomach and wondered if I could pull this off and why I was here. What had I gotten myself into? This majestic

ship had sixteen passenger decks (eighteen total decks). I really didn't know if I could do this, especially alone. What was I thinking? I pushed forward and proceeded up the ramp of this unbelievable ship and this unbelievable dream.

I was assigned to state room 409. Since I was early for the 5:00 p.m. departure, I strolled around the Royal Promenade on Deck 5 for a while and ordered a coffee drink, a couple of mini ham-and-cheese croissant sandwiches, and a cookie. I couldn't believe that all of the food on the Royal Promenade was free of charge. I found my state room and was introduced to by my deckhand, who was very friendly and helpful. I made a few phone calls and text messages because I was still afraid. I even called Mom and told her how nervous I was, and we chatted for a while. I told her how welcoming Marcela had been. She gave me the encouragement I needed to go forward—she knew I could do this—she always knew I could do it. It was huge for me and a real outside-of-the-box adventure, as well as a test of my confidence.

Once settled in, I met up with Sabrina, the cruise program administrator, and found out there was a second face painter on board, Neva from Florida, and a balloon twister, Kae (Scooter the Clown) from San Ramon in the east Bay Area (with her husband, Glen). We all shared the same work schedule. I didn't care for Neva because she bragged about herself and her life. Kae and I bonded from day one and kept in touch by email for quite a while after the cruise experience.

The passengers went through the mandatory fire drill once we were on board. More milling around followed. I returned to my room and then found my dining area on Deck 4. That night I had hot and sour shrimp soup, prime rib, and baked potato with cherry cake for dessert. It was all very yummy. Later that evening I watched the movie Hairspray and then walked around the ship. I found the two locations where I would be stationed to paint the little kiddos. I discovered Deck 6, Central Park, which had a beautiful terrarium-type setting with birds chirping—it was lovely. It started sprinkling rain on

me so I dashed out of the sudden rain back to my state room, got my supplies organized, and painted some practice flowers. I think I finally fell asleep around 1:40 a.m.

Day 2: I joined one of the face painters and the balloon twister at 10:30 a.m. and we entertained the passengers on deck. During the shift I painted only about twenty kids/adults, but I knew the afternoon shift would be better. I started my afternoon with a horrible cough deep down in my chest with my ears popping again and driving me crazy; rarely do I get sick. At 12:30 p.m. I watched the Rockin' Rhythm Nation Parade on the Royal Promenade deck where the main attractions were held. There were lots of costumed passengers, a stilt walker, and a young woman who performed acrobatics on the high ring. She was amazing.

I took another shift at 2:30 p.m., and the kids were great. I started off in the childcare center on the sixteenth deck and then hustled down to the Boardwalk deck near the carousel. Afterward, I went to Dazzles night club and had a margarita. I met Neva and her husband, Chris and we all danced together and drank. I saw a nice woman that I had met the night before. She and her husband were from Toronto, Canada, had four kids and cruised quite often. I recall that I wanted to keep in touch with the woman; we bonded over the duration of our cruise.

Day 3: I began my day shift at 10:30 a.m. and then again at 2:30 and 3:30 p.m. My shifts were always while we were at sea. When we were at a port I was a regular passenger and was able to take the onshore excursions of my choice—those I had to pay for. I wanted to take in as much as I possibly could, but the tough part was many of the onshore excursions I wanted overlapped with the starting time of my shifts. After my shift I went back to my state room and cleaned my supplies. Since my room was tiny (on the same deck as the deckhands), I had very limited space to clean because the sink was tiny and there was not much room to move around. I had to be creative

with my supplies and was able to make them compact. I established a cleansing system, running my sponges under the faucet and scrubbing them with brush soap over and over, and then laying them across the tiny sink. After I cleaned the brushes with soap, I dipped them in a small container of ninety-one percent rubbing alcohol and let them air dry.

Each time I did a shift I painted something small on my face and wore an apron without my business name since I was known only as an enrichment staff member and could not advertise. I put my supplies in my backpack and had to carry my tall director's chair to each station that I worked. I learned to be extremely organized and had things very compact for my adventure since I had no way of knowing ahead of time how far I would have to walk to each station. I was easily able to maneuver my way through the crowd to my appointed station utilizing my well-thought-out plan. The other face painter wasn't as organized and I was and had to make three trips to and from her room with all the junk she carried!

Later that day I got a Starbucks Frappuccino. You have to pay these vendors because the drinks aren't free. There was a Sorrento's on board with a fabulous variety of pizza. I had wanted to see the Oasis Dreams show outside on the sixteenth deck, but it was postponed due to inclement weather, so instead I went to the ice show, which was inside. Fabulous! As an enrichment staff member, I held a VIP pass and could get in to all of the shows without a reservation or having to wait in line. After the show it was on to the cupcake shop for a delicious cappuccino cupcake with cream cheese frosting piled a mile high! I then went to a comedy show at 9:00 p.m. and ended my night at the Latin Club drinking a Sprite and writing postcards to friends and family. I was looking forward to St. Thomas the following day.

Day 4: I took the St. John Coastal Cruise of national parks and beaches on a scenic ferry boat. After that we had 3½ hours of shopping and exploring the island. I ate lunch at an outside café and then

discovered the adorable shops on the island. I think I would like to live on the island of St. John, except my cousin Shelly lived on the island for six months and said the one thing she hated was their humungous insects. We docked at St. Thomas, US Virgin Islands, where I bought more souvenirs. At 7:00 p.m. I met up with Neva and her husband, Chris, for the aquatic water show of high divers and water acrobats. It was quite a spectacular performance at an outdoor theater.

Day 5: I got up early in the morning to catch the 8:30 a.m. guided tour bus to the butterfly farm in Phillipsburg, St. Maarten. We entered a screened area full of hundreds of beautifully colored butterflies. We were given a delicious rum punch drink while we were there. In fact, everywhere on the islands they served us rum drinks. I learned that the Caribbean is known for making rum. No wonder! I purchased a thirty-five-dollar bottle of Caribbean rum, a package of mini rum bottles (all different flavors), and two medium-sized bottles of flavored homemade rum. After the butterfly farm, the tour guide pointed out everything along the way from the bus. He pointed to a forest-like mountain where the King Kong movie was filmed. I also learned that thousands of Heineken beer commercials were filmed on the island of St. Maarten. I thought it was interesting. I learned the difference between St. Maarten and St. Martin. St. Maarten is Dutch influenced, and St. Martin is French influenced. Each side is uniquely different as far as laws and even selling liquor. Gas prices run about five dollars per gallon on the island.

That evening on the Royal Promenade deck there was a ten-dollar sale on jewelry, watches, and purses. Well, you know I had to check out all the goods since I love to shop for bargains. I was in love with the cruise ship experience! Later I took a short nap on a lounge chair on the open deck and woke up getting rained on. I loved it! I went to the 7:30 p.m. headliner show with Earl Turner who was a great comedian, singer, and impersonator. I ate a huge hamburger and fries at Johnny Rocket's. Then at 9:30 p.m. I enjoyed the

Summer Breeze music concert. The group performed music from Johnny Mathis, Chicago, the Doobie Brothers, Stevie Wonder, and the Righteous Brothers.

Day 6: We cruised at sea again all day, so I worked the 11:00 a.m. and 3:30 p.m. shifts. The rest of the time I got to enjoy the amenities on the ship. After I painted the third child during my first shift, it started pouring down rain with no warning. I was told it happens often. I had to stop in the middle of her tiger face, and the parents helped me quickly move my table undercover. Then came several loud chaps of thunder. Within a half hour the rain stopped just as suddenly as it started. All the kids loved it! And of course, I loved the adventure! In the evening I dined in the formal dining room where the servers wore formal attire. I ordered a seafood salad, the Fisherman's Plate (lobster tail and shrimp), and three mini desserts. It was so yummy, but the atmosphere was too formal for me. I felt more relaxed eating at the buffet at the Windjammer, which offered quite a variety of foods.

After dinner I saw the Come Fly with Me production, an amazing performance with high-in-the-air acrobats, tumblers, singers, and dancers. Later I went to the photo gallery on the fifth deck that posts thousands of passengers' photos each day. I picked out a couple photos of myself and when I mentioned to the clerk that I was with the enrichment staff, I received a fifty percent discount! I then walked around on the Royal Promenade deck and found Veronica's Glass Jewelry and purchased the most beautiful bracelet with colorful broken-glass pieces of brilliant orange and yellow on a black background—a wide clamp-style bracelet of sterling silver. The owner and I started talking, and one thing led to another and she showered me with praise for the artistic tiger faces she saw on the little girl passengers. Then she cut me a deal on my bracelet because I paid with cash so instead of paying sixty-eight dollars, I paid forty-eight dollars.

Chapter 41

Day 7: We arrived in Nassau, Bahamas, at 1:15 p.m. I was ready to go exploring on the port since there was no work that day. I considered taking a water taxi to the island for the tour of Atlantis as other passengers recommended. I learned that Merv Griffin had owned the island of Atlantis and Michael Jackson once owned property there. I hooked up with a very nice family and joined them to go to Atlantis. We caught a taxi for only four dollars each—quite a deal. We walked to the Nassau Paradise Beach Resort Hotel and were in awe of the resort. As we walked through the resort, we saw pools with sea turtles, stingrays, and tropical fish. We found the entrance to the beach and walked along the beautiful white sand. The water was the most clear beautiful turquoise blue. We headed back to the ship in time for the 6:30 p.m. departure.

At dinner I found Kae and her husband so we dined together in the formal dining room. Kae and her husband were both quite a kick—I enjoyed their company tremendously. I ordered seafood salad and a shrimp and lobster plate. We parted ways, and I made a purchase on Deck five of three T-shirts and a Royal Caribbean mug. You've got to have souvenirs, right? We had to disembark the ship the next day by 7:30 a.m.

Day 8 was our departure date. I grabbed a Starbucks Frappuccino and a blueberry scone and left the ship by 7:30 a.m. as instructed. The Starbucks staff had gotten to know me quite well since I was at their booth almost daily. I flagged down a taxi to take me back to Marcela's. One snag was that the cab driver didn't use a GPS, so he didn't know exactly how to get there. Why he didn't use a GPS, I do not know. He kept fidgeting and asking me for the address; I was so frustrated. The fee kept rising and her house was just less than fifteen minutes from the cruise ship. When it rose to forty dollars, I called Marcela for directions. So with Marcela's stern advice to not pay him the full amount, he accepted my twenty-five dollars for the ride. She was my hero!

Chapter 42

When I finally arrived back at Marcela's house from my incredible Caribbean experience, I found the door was unlocked, so I walked in, unloaded my luggage, read for a while then started a watercolor sketch of her living room. She came home around 8:00 p.m. from a clowning gig in Miami. She was the perfect hostess and took me out for sushi on the "strip." I ordered a pineapple shrimp and wild rice dish. I'm sure it was tasty, but with my chest cold, I hadn't regained my full sense of taste. We walked downtown Hollywood Beach Boulevard and pointed out shops and restaurants, had ice cream and hot chocolate and paused a while to watch a belly dancer at a sidewalk café.

The following day we walked along Hollywood Beach; it was extremely windy. We ordered a ham and cheese sandwich and fresh Florida orange juice from an outdoor shop. Marcela sat for a while as I walked out to the water and took a photo of my toes up against the waves. We then drove to the town of Davie where she gave me a personal tour of Silly Farm Supplies in which she's the owner. The reception area was professional looking with a large cherry wood desk and paneling. Literature and products were displayed on the desk and the supply room was like a warehouse, very clean with items neatly placed on the shelves that were labeled for each

product. I noticed two posters on the wall of Marcela as "Marei Poppins," a magical storyteller dressed in an adorable apron with hearts and polka dots, and a colorful hat. Around one corner I was amused to find a tall, whimsical, pendulum clock that reminded me of the clock in the children's nursery rhyme "Hickory Dickory Dock." It was painted with intricate and brightly-colored hearts, polka dots, stripes, the black-and-white checkerboard squares, and cartoon characters.

Silly Farm Supplies carries the largest selection of face and body art products for everyone from beginner painters to seasoned professionals. Each product is handpicked and tested by the staff to ensure quality and reliable use. It was amazing knowing I was in the place that I ordered supplies from and that I felt privileged to be given a tour by the owner. I purchased some items that I didn't already have plus a pair of bright striped stockings. I also purchased the book *Tattoo Johnny* that has three thousand tattoo designs. I figured I could use them as inspiration for my business. The inscription on the back of the book said, "If you're thinking of getting a skull, a dragon, a flower, or even a pinup tattoo, you'll find it in this massive collection. It's filled with thousands of professional designs from Tattoo Johnny, one of the world's leading suppliers of tattoo designs. Take your pick from elegant angels and fiendish devils, beautiful fairies and fantastic mermaids, classic patriotic and military insignias, and so much more. Whether it's armbands, belly pieces, or a full sleeve, Tattoo Johnny has the dream art you're looking for!"

We later picked up her grandson and went to the mall/outlet stores and watched the movie *The Three Stooges*. We both agreed it was dumb, but her grandson loved it. We then made our way to the arcade and watched him play games for at least an hour and then got sandwiches from Subway. Marcela played one of the car games where she sat in the car and maneuvered her way through the obstacle course. It was so much fun to see her being playful and laughing with delight. Later, we dropped off her grandson at his home and went back to her house. Marcela put on an Opra Winfrey

What Makes My Heart Sing

movie about children with autism, which is one of Marcela's concerns and interests.

Marcela shared many stories and secrets of her success, and she showed me books on art, face painting, philosophy, and spirituality. She reads from the Prosperity Bible and believes in loving everyone. She loved the sketch I made for her and said that she would take it to work and hang it. She said it will remind her at the end of each day to stop working and go home. My whole experience with her now seems to be so surreal; I couldn't believe it happened to me—a little unknown face painter. I felt so honored to have had the experience.

The following day we left her house at 8:15 a.m. for the airport to catch my 9:50 a.m. flight back home. We said our goodbyes at the terminal and I checked my luggage and proceeded through security. I got stopped because I was carrying alcohol—I had forgotten the requirements. Long story short, my thirty-five-dollar special bottle of Caribbean rum turned into a seventy-dollar one because I decided to check it in to security rather than tossing it. The guard had me go back outside since my luggage had already been processed through. The rum had to be wrapped separately and I had to pay an additional thirty-five dollars, which I was not happy about. Oh, the lessons I've learned!

As I started back through security with the rum safely checked in, I was stopped again while the guard went through my luggage trying to locate my identification since I didn't have it on me. I was so exhausted at that point and discovered I had misplaced it. The security guard was very nice to me when I finally proved that the luggage was mine; he simply advised me to have some form of identification on me at all times in the future. I have learned so much about traveling.

I finally boarded the plane and settled in for the five and a half-hour flight to San Francisco. As I looked out the window, I sadly watched the ocean from my window and beautiful Florida fade away from sight. I felt sad leaving the most magical, amazingly wonderful adventure I had experienced—It seemed so surreal. When I landed

Chapter 42

at SFO airport (San Francisco), I located the Bay Area Rapid Transit (BART) train and boarded the one headed to the Dublin/Pleasanton station where my car was parked. I got off the train, found my car and I drove another hour and a half home. What a dream come true!

I am so grateful for Marcela's hospitality to basically a stranger. We were familiar with each other from several workshops and conventions in the industry over the years, but her hospitality went above and beyond my expectations. Thank you, Marcela, for your integrity and warmth.

Chapter 43

Tresetti's Fat Tuesday Halloween event was held in downtown Modesto in October. I was invited by Chris Ricci to face paint at his annual event. Chris is the entrepreneur behind the hugely successful yet controversial X-Fest concerts that (among others) were held downtown Modesto from 2000 through 2016. I once introduced myself to him when I went out of my comfort zone and attended one of his planning meetings. So I was happy that he invited me to paint at his event. I painted many swirls, Mardi Gras masks, and Halloween-type faces primarily on adult faces because the event was at night. I also painted goblins and ghouls with an added spooky effect. For the women I added lots of lace around their masks and lots of glitter. The event was somewhat of a challenge as it was not my typical gig face painting children. Since the adults were mingling about in the street, I felt I had to use my recruiting skills so I walked around convincing party-goers that they really needed to have a design painted on their face to complement their Halloween costume. That worked and I was able to recruit quite a few people to sit in my chair! This kind of event forced me to get out of my comfort zone and sell.

Chapter 44

I booked my second Caribbean cruise as a face painter on the Royal Caribbean, Navigator of the Seas, with my high school best friend Barb in March 2013. I hadn't connected with her in several years; I just felt strongly to invite her on the cruise with me. Against my mom's better judgment, I contacted Barb and invited her. She was absolutely thrilled. We had booked our flight to arrive two days before the embarkation so we could tour New Orleans since it was the port of call. To our disappointment we learned that our connecting flight had been delayed, so United Airlines put us up in a hotel in Houston, Texas, the night before. The next morning we flew into Baton Rouge, Louisiana. Barb's cousin Richard picked us up and drove us to New Orleans. He treated us to lunch at La Madeleine French Bakery and Café on the corner of St. Charles and South Carrollton close to where the trolley cars turned. We had to wait in line to order and pay instead of being waited on by waiters or waitresses. Our order was then brought to our table. I had ordered a shrimp crepe with spinach and tomato basil soup, which was excellent.

After lunch, Richard drove us to our hotel and pointed out the streetcars and interesting sites along the way. We had reservations at the Blake Hotel at Lafayette Square, adjacent to downtown's Lafayette Square, checked into the hotel room and promptly took

a nap. The classic, glass-fronted hotel is just an eight-minute walk from the French Quarter's Bourbon Street, a nine-minute walk from the Confederate Memorial Hall Museum and a twelve-minute walk from the Audubon Aquarium of the Americas. Lafayette Square is the second-oldest public park in New Orleans, located in the Central Business District. During the late eighteenth century, it was part of a residential area called Faubourg Sainte Marie.

During my alone time, I reflected and meditated on my surreal experience and felt much gratitude for the once-in-a-lifetime, God-given experience. I wondered how many people actually get the chance to do what I've been able to do. It would not have happened had I not pursued my face painting business. It was quite a dream come true for me.

After waking up from my nap, I braved up and decided to venture out and explore LaFayette Square. I discovered an arts and crafts festival in the Square right next to our hotel. I found out that it was a concert festival sponsored by the Young Leadership Council and that concerts are held at the square every Wednesday from March 6 to May 22 from 5:00 to 8:00 p.m., rain or shine. Wednesday at the Square festivals have live music, tons of food vendors, and art vendors with jewelry, shirts, and other merchandise to purchase with proceeds from sales going to local charities and the music was incredible. Food trucks served up crêpes à la carte (bacon and Nutella crêpes, tomato basil and mozzarella), crawfish nachos with brisket sliders, and smoked Gouda mac ("frencheeze"). Pizza at Theo's and the Jambalaya Girl are always there. Several bar tents were set up, so beer, wine, and liquor were all available, and of course lots of Abita was on tap! I liked this place and couldn't wait to go back!

I met up with Barb later that evening and we walked around the French Quarter on Bourbon Street the rest of the night. Everywhere we went there were bars, restaurants, and souvenir shops and voodoo shops. We ordered a locally brewed Purple Haze beer and then another at the Tropical Bayou Club, where we sat and enjoyed music

Chapter 44

from a band with a guy singing in French and a girl playing guitar. Barb and I later separated and explored the French Quarter on our own.

As I was walking along the strip, I heard someone calling my name and I thought, "What the heck! Who would know me here?" It was Julie Lewis, a former coworker who had moved with her husband, Jonathan, to New Orleans to be near her family. What a coincidence! They invited me to join them at the outside bar of the Maison Bourbon Jazz Club which is one of Bourbon Street's oldest live jazz clubs dedicated to the preservation of America's classical music. Jazz is one of North America's oldest and most celebrated musical genres, traced back to the twentieth century. This legendary club is where many of the most notable jazz musicians performed. And I learned that it is one of only two jazz clubs still existing on Bourbon Street. It was exciting to see someone I knew so far away from home. We enjoyed the jazz band, which played tunes by Louis Armstrong. We ordered the famous Hurricane drink and chatted enjoying each other's company. After a while we said our goodbyes and I headed out on the street for more exploring. I noticed Mardi Gras beads were strewn everywhere—hanging from trees, streetlamps, along the sidewalks, and even down inside the manholes. I found a small café across the street went up to it and ordered a bowl of gumbo. My night finally ended around 1:00 a.m.

The following day Barb and I took a walking tour of the Garden District, full of oak-shaded streets lined with beautiful homes, some were cottages and some were historic mansions. The tour guide led us down the beautiful gardens of St. Charles Avenue, which we learned is on the Mardi Gras parade route. We walked past the Lafayette Cemetery filled with nineteenth-century tombs and walked to Magazine Street. I was fascinated with the fact that so many celebrities own or have owned homes in the area such as Sandra Bullock, John Goodman and Nicolas Cage.

Later in the day following the tour I further explored Magazine Street and ended up purchasing two blown-glass pieces: a glass heart

for Barb, and a green blown-glass bracelet for myself. I discovered some art galleries on Julia Street and a coffee shop where I ordered a Mochasippi Turtle coffee drink and a croissant with spinach and feta cheese. The drink was available in any combination of the flavors chocolate, caramel, vanilla, white chocolate, hazelnut, and peppermint. I was told the coffee drink is similar to a Frappuccino but contains shots of espresso rather than powdered instant coffee.

According to Wikipedia, "Magazine Street is a major thoroughfare in New Orleans. Like Tchoupitoulas Street, St. Charles Avenue, and Claiborne Avenue, it follows the curving course of the Mississippi River. The street took its name from an ammunition magazine located in the vicinity during the eighteenth-century colonial period.

The downriver end of Magazine Street is at Canal Street; on the other side of Canal Street in the French Quarter the street becomes Decatur Street. From Canal through the Central Business District and Lower Garden District, Magazine Street is one-way in the upriver direction; downriver traffic forks to join Camp Street, the next street away from the river. Above Felicity Street to the far Uptown end it has a lane of traffic going in both directions with parking on both sides. It is an RTA bus route.

The street follows the length of the crescent through Uptown. After several miles of residential and commercial neighborhoods, it cuts through Audubon Park, with Audubon Zoo on the river side of the street. The far upper end of the street is at Leake Avenue, a part of the Great River Road, where it turns away from the river in the Carrollton riverbend.

Most of the street is a mix of residential and commercial buildings, generally older houses from the later nineteenth century and similarly aged commercial stretches consisting of antique shops, clothing boutiques, restaurants, and bars. Magazine Street is well known for being a popular shopping district for interested tourists. The street however runs a length of six miles, so it is generally recommended by travel connoisseurs to hail a cab or ridesharing company when shopping in the area. Magazine Street shopping

Chapter 44

offers a unique selection of products many of which are handcrafted and one-of-a-kind pieces."

Since I knew there were face painters all over the world, in preparation for my trip I posted a message on an entertainers networking group that I was looking for a fellow face painter to meet me in New Orleans. Sandra replied to my post, got somewhat acquainted over the phone and through social media then quickly made plans to meet. Sandra, a hairdresser as well as a face painter, lives in Gretna, Louisiana, which is about ten minutes from New Orleans.

We had decided on a day to meet so she picked me up in her fancy red sports car around 5:00 p.m. and showed me around town. What a treat it was for me to have a local person show me around such a magical town. She took me to the Riverwalk Marketplace, located on the Mississippi River downtown off Convention Center Blvd. It has three floors filled with tourist shops, collectible stores and some national chains like the Gap. Sadly, I learned from Sandra that the mall had lost several of the higher-end and corporate chain stores that were there before Hurricane Katrina in 2005. I also learned that the Riverwalk has been successful for over twenty years and survived two disasters. Hurricane Katrina didn't completely flood the mall but shut it down for months because there was no power. And in 1996, the Bright Freight disaster demolished a huge area of the river side of the mall. The Riverwalk has slipped a bit since the hurricane but continues to be successful. She later drove me to Metairie in Bucktown and in another shopping area I purchased some of New Orleans famous pralines. I was told they are pronounced "prawlines" not "praleens" like I've heard so many times.

The following is some interesting history I learned about the candy through research:

NEW ORLEANS (WGNO) – Living in New Orleans, you've probably eaten hundreds or thousands of pralines in your lifetime, but believe it or not, pralines didn't start here.

"A lot of people mistake it for a cookie. It's not a cookie, it's a

candy." Jean Stickney at Pralines by Jean knows how the popular praline candy made its way to New Orleans over 200 years ago.

"When the French settled in New Orleans, they brought the praline with them. At the time, it was just an almond coated in sugar, so when the King's cook decided to prepare them here, they had to use pecans. Pecans are native to New Orleans and almonds aren't, so they replaced the almonds with pecans," Stickney said.

Later, cream and butter were added to make the pralines thicker. Now they're known as the southern praline. They're rich in both taste and history. "Women would make them in the kitchen and then sell them on the streets to make extra money to pay for things," she said. She also wanted to set the record straight about how to pronounce pralines. "If you look in the dictionary, both "praleen" or "prawline" are correct, but here in New Orleans we pronounce it "prawline". In Cajun country, a lot of people say "plarine" and even some in New Orleans call it "pecan candy". There's a few ways to say it, but only way if you want to sound like a true New Orleanian.

June 24th is National Praline Day. Pralines by Jean will be selling special coconut and almond pralines to celebrate. Pralines by Jean is located at 1728 St. Charles Avenue between Polymnia and Euterpe Streets. (by: Kenny Lopez. Posted: Jun 23, 2014/06:41 PM CDT / Updated: Jun 23, 2014 / 06:41 PM CDT)

Later Sandra drove us over the levee (Lakeview area) to show me where the broke in 2005. The Lakeview area, a subdistrict of the Lakeview District area was created to release the flood waters and she told me what happened during the levee break was controversial.

That night we dined at the popular Deannie's restaurant but before dinner we ordered the famous frozen piña coladas, which delicious. While we were spooning our piña coladas into our mouths, she told me that Louisianians don't pronounce their "r's" and "making groceries" means buying them. "Saving them" means putting them away, and Louisianians don't ask you "How are you?" They say "How's ya momma en em?" A true Louisianian will run it all together: Howsyamommaanem? The phrase kind of sounds like "homonym."

Chapter 44

What they are asking is, "How is your mother and them?" The "them" is your family but your momma is the most important.

This new knowledge was hilarious I was so amused that I did some research and found some of the funniest expressions from Louisiana and how to use them. (https://matadornetwork.com)

- Louisianians don't "take a nap;" they "go do-do." The "do" sounds like "doh" as in Play-Doh. Mother to her crank baby: "Go do-do."
- Louisianians don't "cheer;" they yell "who dat?!" This phrase can be used in a couple of ways. "Who dat?" as a question is mostly yelled in support of the New Orleans Saints, the city's NFL football team. The phrase originated from a chant long ago, "Who dat say gonna beat them Saints. Who dat? Who dat?" The chant became a theme in the Crescent City in 2009 as the Saints scored one victory after another leading up to their historic Super Bowl win.
- Louisianians are never "getting ready" to do something; they're "fixin' to do it." The phrase simply means you're getting ready to do something.
- Louisianians don't "grocery shop;" they "go make groceries."
- Louisianians don't say "this is good;" they say "it'll make you slap ya' momma." Slappa "ya' grandma" is also interchangeable. The phrase actually means that you really like something. Customer: "Is the gumbo good?" Waitress: "It'll make you slap ya'momma."
- Louisianians aren't "wealthy;" they get paid "beaucoup bucks." (pronounced "bow-koo" and means "big" or "a lot."
- Louisianians don't "eat" crawfish; they "pinch the tail and suck the head." It is the proper way to each crawfish. After ripping the crawfish tail from the body, you pinch the tail to loosen up the spicy crawfish eat and eat it. Then suck the head of the crawfish where all of the juices and fat live.
- In Louisiana, you don't get anything "extra;" you get a little

"lagniappe." Pronounced lan-yap, the word simply means something a little extra. Usually it's a small token of thanks from a merchant but can also refer to anything extra or bonus. Whatever your lagniappe is, a true Louisianian will always serve it up with a smile and a friendly "Ya'll come back now."

Sandra insisted I try their fried crawfish, étouffée, and blue crab, so I did; and for appetizers we ordered spicy small red potatoes. Everything was so delicious. I think I could get used to this type of food!

The next day Barb and I took an airboat swamp tour in Luling. The airboat was propelled by a huge fan blowing air from the back of the boat more than two hundred miles an hour. I was told it can ride in inches of water and go where traditional boats couldn't go and were designed to take passengers to inaccessible areas of the swamp. The area that we toured was a combination of swamp, marsh, and lake.

The tour guide told us that their swamps and bayous are home to several species of fish, birds, reptiles, and mammals that thrive in their waters. We were hoping to spot a "gator" but only got a glimpse of a baby gator. The tour guide explained that they hibernate in the colder months and experienced captains know exactly where to look for them and during the winter you have more than a fifty percent chance of seeing one. They are usually spotted in the warmer months. Our airboat was a smaller one that had just nine passengers.

Later Barb and I took a fascinated tour of the Destrehan Sugar Plantation, established in 1787, and listed on the National Register of Historic Places. It's the oldest documented plantation home in the lower Mississippi Valley. We were also given an educational tour of the main house. I was fascinated with one of the rooms where there was a display of home remedy samples for certain ailments. Aloe vera was for burns; honey was for asthma, bronchitis, cold, flu, hoarseness, pneumonia, tuberculosis, and ulcers; olive oil (or

sweet oil) was for arthritis, dry skin, earaches, fever blisters, hair loss, hemorrhoids, kidney problems, muscle aches, numbness, and sore throat; kerosene was for arthritis, blisters, cold sores, cuts, fever, hemorrhoids, snake bites, and toothaches. Male urine was for earaches and sore throat. Can you imagine! Earwax was for cold sores, fever blisters, and sties; alcohol (topical) was for corns/calluses, bites, ringworms, arthritis, and fever; baking soda was for bad breath, belching, burns, chest pain, denture problems, fever blisters, flu, cough, hoarseness, rash, and sore throat; cow manure (fresh) was for athlete's foot and fever; sassafras was for anemia; pepper (both black and red) was used for diarrhea, heartburn, and sore throat; leech was used for a black eye; garlic was used for blurred vision, colds, gas, and high blood pressure; eucalyptus oil was used for asthma and finally spider webs were used to stop bleeding.

As we toured the magnificent plantation, we traveled from the French and Spanish colonial periods, through the antebellum grandeur of the sugar barons, to the ravages of the Civil War and the rebirth of reconstruction. We learned that French was the primary language and sugar ("white gold") drove the economy. We were told about family stories of those free and enslaved. The plantation was the home of Marie Celeste Robin de Logny and her husband, Jean Noel Destrehan, the most successful sugar producers in St. Charles Parish. The plantation displayed an original document signed by President Thomas Jefferson and Secretary of State James Madison appointing Jean Noel to the Orleans Territorial Council, which was responsible for creating Louisiana's civil law of government.

Barb and I later went to Harrah's Casino in the French Quarter and had a fantastic dinner of filet mignon and lobster and Banana Crème Brûlée. Barb won $1,000 that night at the casino.

I learned that New Orleans is called the Crescent City because the original town, Vieux Carré (also called the French Quarter), was built at a sharp bend in the Mississippi River. The town was founded in about 1718 by Jean Baptiste Le Moyne, Sieur de Bienville. New Orleans is world-renowned for its distinct music, Creole cuisine,

unique dialect, and annual celebrations and festivals, most notably Mardi Gras. The historic heart of the city is the French Quarter, known for its French and Spanish Creole architecture and vibrant nightlife along Bourbon Street. New Orleans has several nicknames, including the Crescent City, the Big Easy, and the City That Care Forgot. The Crescent City and the Big Easy are the two most common, but perhaps Hollywood South is common among Hollywood types. New Orleans is a major United States port and the largest city and metropolitan area in the state of Louisiana. The city is named after Orléans, a city on the Loire River in France, and is well known for its distinct French Creole architecture, as well as its cross-cultural and multilingual heritage. I will definitely visit New Orleans again!

Day 1: We took a cab to the cruise ship terminal then embarked. The ship left port at 4:30 p.m. headed for Cozumel. I attended the evening's "Welcome Aboard" performance and later met with my cruise activities administrator, Adie. I was assigned to two two-hour shifts for the next day.

Day 2: We ate breakfast at the Windjammer, and then I worked a shift from 11:00 a.m. to 1:00 p.m. and again from 2:00 to 4:00 p.m. Barb and I ate dinner in our assigned dining area and enjoyed roasted duck, lobster bisque, and triple chocolate mousse soufflé. It was fantastic, of course. We then saw a Broadway performance on stage. I purchased a beautiful cubic zirconia ring on the ship. To this day it reminds me of my cruise ship experience.

Day 3: Barb and I took an eight-hour Tulum Ruins and Beach Break tour in Cozumel. The ruins were amazing. Barb got to hold a huge iguana on her arm and kiss it. We learned that Tulum is the best-preserved coastal Mayan Ruins site and is the second-most visited of all the Mayan Ruins sites in Mexico. Tulum is about eight hundred years old and was abandoned by the end of the 1500s. Surrounded by walls, it was a fortress against enemies approaching

Chapter 44

by sea, and was also a major trading port for the inland city of Coba. Tulum is a lookout on top of a forty-foot sheer cliff. On the ferry boat back from the excursion, Barb and I couldn't resist purchasing identical silver necklaces from a vendor. We talked him down from sixty to twenty-five dollars. Imagine that! I wonder how much the necklace was truly worth. In Tulum I purchased a gorgeous handmade turquoise purse and two hand-painted bowls with a matching vase.

That night back on the ship, at seven o'clock, I was asked to face paint kids ages four to six as pirates so they could parade around the ship. So, at 8:45 p.m., the little pirates paraded back and forth on the Royal Promenade deck for the passengers. They loved it. Dinner that evening was prime rib with a dessert of carrot cake layered with cinnamon-nutmeg cream cheese.

Day 4: We got up too late to take the Trolley Roger excursion so we took the ferry to the dock, looked around, purchased more souvenirs, and checked into the Grand Cayman parasailing excursion. What an absolute thrill! I was not scared at all. They strapped us into the chair together and had us scoot on our bottoms to the end of the boat. The boat sped off with such a force that lifted us into the air as the boat moved forward. It was spectacular and at one point the boat slowed down and dipped us into the ocean; it was quite exciting that we both squealed.

For lunch that day on the island, I ordered a shrimp mango wrap with a salad, beets, and some sort of light barley thing. The beach on the island was so beautiful and peaceful. We then took a taxi back to the cruise ship. I was asked to work again that night, so I painted from 7:00 to 8:30 p.m. for the parade of pirates.

Day 5: Jamaica was my absolute favorite island. The residents were so friendly and inviting, not to mention I loved their accents! Barb and I headed down through the gangway at 8:00 a.m. on our way to visit Falmouth, Jamaica. We toured the Chukka Good Hope Estate.

According to www.chukk.com Good Hope is a 2000-acre plantation paradise on the edge of Jamaica's famous Cockpit Country. The ultimate chill-out spot with a shot of adrenaline! Immaculate grounds flank the Martha Brae River, amongst beautiful 18th C stone buildings. Walks, river tubing, ziplines and fascinating architecture are brought to life by excellent guides. Delicious Jamaican country-style food and Caribbean bars are found next to a vast zero-entry swimming pool, boasting six wading pools up to a 50 ft waterfall with plunge pool.

Then we were prepared for ziplining by Chukka Zipline Company in the jungle. Oh, what an exhilarating experience zipping through the jungle of Jamaica! We ziplined from one station to the next; there were seven stations. We stopped at each station and got hooked up again and then were off to the next. At the last station we were hooked up to a rope that went straight down to the ground. It was wild, and the guides were adorable with their "Ya, man" greetings. The tour bus then drove us back to the dock. Before we embarked, we enjoyed the outdoor marketplace where we purchased more souvenirs. Barb bought a carved wooden doll and named him "Party Man." We had a good laugh over that.

Later the winds started kicking up something horrible. I was good with it as long as it didn't turn into a hurricane! Aside from the strong winds, we were entertained by Jamaican women singing and dancing in their traditional costumes and fighting the strong winds. As we walked around discovered stilt walkers dressed in vibrant multicolored outfits.

"Standing tall, confident, and fearless at fifteen to twenty feet in the air dressed in vibrant, multicoloured apparel, stilt dancers always have the audience looking up. Intricate dance routines and moves instantly put the spectator in a trance. Stilt performers have become a traditional component of local celebrations, festivals, carnival parades, and circus routines on the hotel circuit. The art form is part of Jamaica's African inheritance that, though widely practiced, is not fully understood by onlookers." (published September 19, 2018, the Gleaner by Stephanie Lyew.

Chapter 44

According to Wikipedia, "A moko jumbie (also known as "moko jumbi" or "mocko jumbie") is a stilts walker or dancer. "Moko" means healer in Central Africa and "jumbi", a West Indian term for a ghost or spirit that may have been derived from the Kongo language word zumbi. The Moko Jumbies are thought to originate from West African tradition brought to the Caribbean.

A Moko Jumbie character may wear colorful garb and carnival masks. They also frequent festivals and celebrations such as Trinidad and Tobago Carnival.

While the god Moko is from the Kongo (or Congo) and Nigeria, from the Maasai people, Trinidad and Tobago has added their own touch to him. Moko, in the traditional sense, is a god. He watches over his village, and due to his towering height, he is able to foresee danger and evil. His name, Moko, literally means the "diviner" and he would be represented by men on towering stilts and performs acts that were unexplainable to the human eye. In one remote tribe, the Moko rises from a regular man's height to the skies fluidly with no help and descends similarly to leave others to wonder how he performed such an act.

The Moko arrived in Trinidad man "walking all the way across the Atlantic Ocean from the West coast of Africa, laden with many, many centuries of experience, and, in spite of all inhuman attacks and encounters, yet still walks tall, tall, tall. (John Cupid, Caribbean Beat)" The idea of the Moko survived by living in the hearts of African descendants during slavery and colonial life to eventually walk the streets of Trinidad in a celebration of freedom, Carnival. While this figure was rooted in African heritage, Trinidad adapted the figure, notably by adding on Jumbie or ghost to the name. By the early 1900s Moko Jumbies had become an element of Trinidad's Carnival. This figure would walk the streets of Port of Spain and other cities protecting the city and revelers from evil. As part of his role in Carnival the Moko Jumbie would accept donations from onlookers in upper floors of buildings. However, his notable figure of Carnival slowly faded until a drastic revival.

By the early 1990s, Moko Jumbies were essentially non-existent in Carnival, until two men brought this tradition back. These men, namely Moose and Dragon, have brought the Moko Jumbie back to a place of prominence in Carnival and created a new kind of Moko Jumbie. There are two main Moko Jumbie bands in Trinidad, Watusi and Kilimanjaro, as well as several smaller ones. So while the idea of the Moko came from Africa, Trinidad has made it its own."

Day 6: I started my day with breakfast at the Windjammer and then a 10:30 a.m. "coffee chat" with Keith entertainment director. I learned that he'd had his position on the cruise ship for five years and was originally from Las Vegas.

At 11:00 that morning I took a merengue dance lesson with dance instructor Roberto. The merengue is the national dance of the Dominican Republic and also one of the standard Latin American dances and is a combination of two dances: the African and French minuet from the late 1700s through the early 1800s. The merengue has existed since the early years of the Dominican Republic. (In Haiti a similar dance is called the "meringue" or "mereng"). I thoroughly enjoyed the dance lesson.

I worked a shift again at 2:00 p.m. and then hung out on the ship the rest of the day and meeting up with Barb occasionally. For dinner that night I ordered Japanese food and watched Latin dancers perform in the ship's production Showtime. At 10:15 p.m. Barb and I watched the Best of the 70s Show featuring the Royal Caribbean Singers on the Royal Promenade deck. After that I watched the 70s Disco Inferno Street Party with Keith and staff. Disco is my all-time favorite music.

Later on I attended the late-night Studio B for the Quest Adult Game Show. From talking to Keith that night, he told me that I should continue with them on their tour to Italy. Oooooh, I was in dreamland. What was I thinking?

Day 7: I worked more shifts on the Royal Promenade deck from 11:00 a.m. to 1:00 p.m. and then 2:00 to 5:00 p.m. I ate dinner at

the Windjammer stuffing myself with their vast variety of food and later watched the Dancing in the Street Parade and the Farewell Showtime performance.

Day 8 was our disembarkment. Barb and I sadly left the Navigator of the Seas. I loved the cruise and didn't want to leave my magical experience, but it was time to face reality. The cruise ship's staff members, passengers and onboard activities were all so meaningful to me. Many of the passengers that I met were from Michigan, Wisconsin, Boston, Chicago, as well as other parts of the Midwest.

After disembarking, we were back on Decatur Street in New Orleans. Barb wanted to leave right away but I wasn't ready so I left her behind and walked down Decatur Street by myself. I found the famous Café Du Monde and ordered three beignets and café au lait. I was not going to miss this experience to leave early! Café Du Monde is the world's most famous coffee shop and is located at the end of the French Market and the corner of Jackson Square in the French Quarter. Café Du Monde has been serving their beignets and café au lait since 1862. I enjoyed watching the horse-drawn carriage rides on Jackson Square as I drank and ate. What an unforgettable experience.

Barb and I then rented a car and sadly drove back to Baton Rouge where we stayed at the Days Inn and caught our plane from there to fly back home.

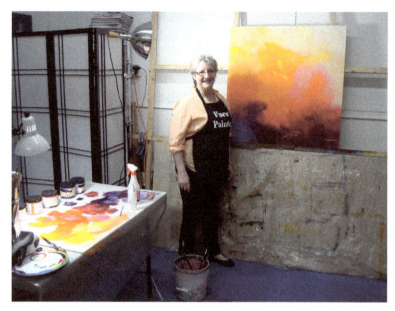

Abstract Dance, acrylic, at Hines studio

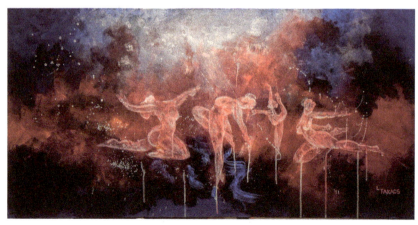

Freedom Dancing, acrylic

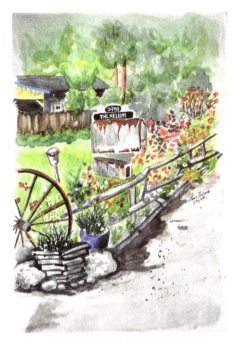

Country Mailbox, watercolor

Covered Bridge, watercolor

Kingfisher bird, watercolor

Eureka Los Bagels Art Gallery, watercolor

Healing Hearts Tree, mixed media

Wave of Blue Wine, watercolor

Luffenholtz Beach, Trinidad, CA watercolor

Historic Carson Mansion watercolor

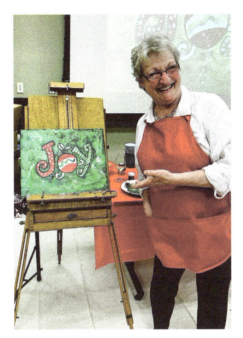

Teaching a Wine and Sip class

Me with favorite business owner & artist Heather Banks-Green

Face painting on a Caribbean cruise

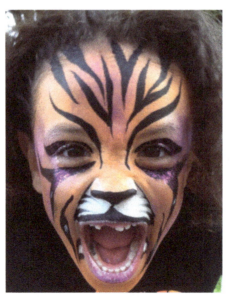

My favorite little painted tiger

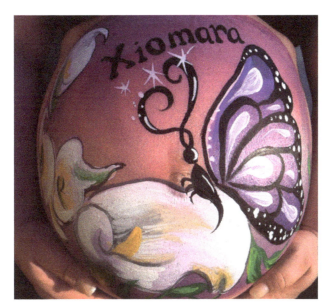

Painted baby belly bump

Painted Christmas baby belly bump

Green monster face on son Cody

Son Jason body painted at Halloween

Me at my happiest after a face painting gig

Me with favorite master body painter Mark Reid

Chapter 45

In June 2013, I registered for Annie Reynold's boot camp in San Bruno on "Easy and Fast Faces for Party Work"—an intense two-day workshop featuring Annie's dark yet delicate style with supervised hands-on body painting. I painted a mermaid on my model in colors of turquoise, black, and white and included bubbles from the sea with ocean creatures. I painted her face and lips turquoise and her upper body, along with one half sleeve on one arm—she was quite sexy. For the photo she wore a gold metallic skirt that resembled a mermaid's tail.

My friend Sue referred me to a client to paint the Hulk on a young man. I was not feeling quite adequate for the job, but I accepted it for the experience. I used green Star blends on his body but I was not comfortable using it since I was not sure of the proper use since I hadn't used the brand before, but it was highly recommended for body painting so I pushed on. I covered his entire body with green with darker colors to show the muscles. I charged him only one hundred dollars since I was a novice and it was a learning experience for me. He was happy, and that's all that counts. I suppose we, as artists, can be as overly critical of our work and don't always feel satisfied with the outcome.

Another client-referral job was body painting two young men for

a grand opening celebration of a local bar in town. I painted vests on their upper bodies with silver metallic paint and red bowties around their necks. They were pleased with their vests; they got a lot of attention and sold many drinks that night!

I had a client who asked me to paint a Christmas design of Mickey Mouse on her pregnant belly. I went to her location and had her sit comfortably in her chair and I painted Mickey, dressed in red Santa pajamas with a white-brimmed Santa hat, taking a snooze on a white fluffy cloud. I painted the background with florescent white and glitter, of course, and three holly berries and leaves I added to the top of the design.

Chapter 46

I had the pleasure of face painting for a repeat client, Anna Goldberg Olide, who hired me for her daughter Giselle's ninth birthday party. I recall walking into their lovely home decorated with an Alice in Wonderland theme. On the dining room table was a birthday cake cleverly designed, of course, in Alice in Wonderland theme, along with elaborately decorated handmade sweet treats. I was directed to go upstairs to Giselle's room where she and her friends were getting dressed in costume as characters in the story. I painted her face with the Queen of Hearts design. Then I painted other theme designs on her friends' faces including the Cheshire Cat and a lot of hearts. Thank you, Anna, for making this a gig to remember.

Later in the year I worked a Baskin-Robbins grand opening in Sacramento. I truly enjoy all the grand opening events that I work because I get to interact with the public and everyone is happy. I painted the company logo on several faces—even those of the employees—who came outside to get their logo and ice cream cones painted on their faces. They event include a DJ who played music during the event. I've worked quite a few Baskin-Robbins grand

openings, and this particular one was recorded live on Good Day Sacramento. Good Day Sacramento is a CW (CBS Warner Bros. Television Network) owned-and-operated television station licensed to Sacramento. Toward the end of my shift the temperature outside had reached 102 degrees, and I started feeling weak and nauseous and feared a heatstroke coming on. So I apologetically cut my line and rushed into Baskin-Robbins. The owner, seeing my condition, immediately guided me to their large ice cream freezer and instructed that I sit down inside the freezer until the nausea passed. That did the trick! After cooling down for quite some time, I was back to normal. What an experience that certainly was!

I was invited to show my watercolors in a September exhibit called Art in the Garden Tour, sponsored by the CCAA, Mistlin Gallery members. I enjoyed chatting with the public who came through and browsed our artwork. I got better acquainted with my fellow artists. It was a beautiful day, and our art was displayed outside on the deck at the home of one of the members. We offered water, drinks, and cookies to the public.

Picasso's Gourmet Deli, located downtown Modesto, specializes in sandwiches using a variety of freshly-made breads each day and local sauces made from sun-dried tomatoes, pesto, honey mustard are used in the sandwiches. Their lattes and cappuccinos are made with locally roasted coffee. Owner Jordi opened the downtown deli in 2000. Local artists display their paintings on the walls as well as does Jordi, and the tables have all been uniquely painted by him.

I had met Jordi several times at arts venues so I knew who he was. I walked into his shop one day to show him my portolio of prints

of my paintings made into greeting cards and asked if he'd be interested in selling them to his customers. Jordi was a very charming man a little older than me and I found him to be very humble and open to my idea. He had gray hair and a gray trimmed beard and spoke with a very strong Sicilian accent, which was also quite charming. He showed me around his collection of artwork and pointed out the large paintings on the walls from other artists. Then we sat down at one of the hand painted tables. He looked through my portfolio and liked my work. But what came to me as a surprise, he closed my portfolio, placed his hands on mine, and said in his adorable Sicilian accent, "Miss Lynn, why do you paint so small? People want to see big paintings. (He motioned with his hands demonstrating "big"). Small is not good. I want to see you paint big and come back in and show me!" It was a wonderful experience talking with this warm and humble person.

In December I joined members of CCAA on a plein art field trip to Duarte Nursery in Hughson to set up work stations for painting. We scattered out and I found a spot where I could see several rows of beautiful pink and red poinsettias to paint using watercolor. I later chose a second location that had rows of deep-red poinsettias in a cluster, and I used this painting for one of my postcards.

I created a watercolor painting, *Hang Gliding,* in December. Since I've always had a desire to try hang gliding, so using watercolor I painted a few hang gliders as black silhouettes against a colorful sky of blue, purple, red, orange, and yellow as an abstract piece.

Chapter 46

2013 was the first year that I printed a series of annual Christmas cards. I painted in watercolor my holiday image and had it printed onto greeting cards and sold them to the public and to fellow employees. The cards were also given to people donating to the organization in which I worked at the time. My first one was an abstract painting entitled *Santa Toy,* which was a Santa ornament on a Christmas tree.

I started having calendars printed from my paintings in January 2014, using Vistaprint and selling them to family members, friends, and coworkers. It turned out to be a tradition that I carried on year after year for about five years. At one point, when I was visiting my hometown, I went to various banks and stores asking if they might be interested in displaying my calendars for sale. A bank in Eureka displayed calendars from local artists on a yearly basis and they were interested in my calendars of their popular local landmarks and buildings and I was placed on their waiting list but never received a callback even though I followed up. It was a great idea though and a good experience in sales.

I developed an interest in book writing and illustration in 2014, and attended a children's book illustrators' exhibition in February at the Sun Gallery in Hayward. The exhibit featured artwork by illustrators of children's books and comic books, as well as by children who illustrated publications. I was so inspired by the presentation and display that I spoke to several exhibitors and gained knowledge

from their experiences and journeys. So I drafted my first children's book based on my childhood experience entitled *If Only I Could Fly*. As of the writing of this book it has not yet been published but I'm working on it.

I later took a class at Modesto Junior College on writing and developing a children's book and learned tips on how to get a book published, traditional trade publishers, mass market publishers, book packagers, small independent presses, educational publishers, subsidy publishers and self-publishing. I also learned about the various formats and genres (identifying your work), submission process guidelines, what the industry is looking for, manuscripts, reader response theory, developing your writing, peers (friends with benefits) and getting the book published.

I then joined the SCBWI (Society of Children's Book Writers and Illustrators), a professional networking organization. I learned that what makes a successful children's book is when your writing can paint a picture in the child's head from their imagination that takes them into the story and when it's something they can either relate to or that delights them.

I've read so many books to my own sons when they were little and always enjoyed making them laugh when I described the story in my own words so they could imagine the scenes and situations in their minds. These were always creative and fun times.

I painted a watercolor entitled *Masked Girl* for the second year of donating to the Art For Justice fundraiser, sponsored by the Stanislaus Family Justice Center in Modesto. It was interpreted from fourteen-year-old Jessica's beautifully created mask. The workshop,

Story Masks, allowed individuals to notice and express the story that lives in each part of their faces in order to honor the knowledge and strength each part has to offer. Jessica's words were "One side of the mask is how I feel sad and a little confused. The other side is how I want to feel." My words were "Feelings are so important. They tell us who we are. We need to nurture our feelings when we're sad and perhaps confused, and declare victory when we are feeling happy. The girl in my painting is sad, but she has decided to remove the mask and conquer her sadness and confusion in order to make herself whole again." This piece sold.

A coworker, Christine, asked me to paint the flowers on the "Little Free Library" box that was in her front lawn. Little Free Library is a 501 nonprofit organization that promotes neighborhood book exchanges, usually in the form of a public bookcase. More than ninety thousand public book exchanges are registered with the organization and branded as Little Free Libraries. The library is a free book-sharing box where anyone may take a book or share a book and they function on the honor system. You don't need to return the same book in order to take another one. If a person takes a book or two from a library, they are asked to bring another one or two to share at that same library or another library in a different area; anyone may contribute or take books. So I used acrylics and painted a beautiful garden of colorful flowers of all kinds. It was quite an inspiring project.

I took a series of evening watercolor classes from Margaret at the Frank Bette Center for the Arts in Alameda in which I drove an hour and a half from Modesto to Alameda once a week. Margaret

was very skilled in the way that she taught watercolor. Her bio states, "Art has always been part of my life. I am now devoting my time to capturing images of water scenes and moods: the quiet reflections, the boats and sailing, the people, birds, and animals hanging out around water. I do commission portraits of people, animals, yachts, and homes, as well as scenes from nature." We met for about eight weeks and used the upstairs classroom in the center. Margaret was such an inspiration to me and taught me how to paint such a simple subject as an apple and how to step-by-step create a three-dimensional effect. I learned quite a lot from her and cherish the time I spent under her instruction.

In February I displayed my artwork at the Expressions Art show in Tracy. It was their twenty-third annual juried show, so it was an honor to have my painting accepted. Only the best pieces are accepted. I entered *A Wave of Blue Wine,* a twenty-two-by-thirty-inch watercolor of a wineglass with hues of blue wine spilling out and swirling around like waves of the ocean.

Chapter 47

I was hired for my third cruise on the Royal Caribbean, Serenade of the Seas, in April 2014, with the port of call being New Orleans headed to Key West and the Bahamas. My cousin, Shelly, agreed to accompany me on the cruise. It was the first time she and I traveled together. We didn't spend a lot of time together as adults and lost contact over the years, but we kept bumping into each other in public places since we both lived in South San Francisco. I invited her to join me at an art show and after getting reacquainted, I asked her if she'd accompany me on a cruise. She agreed, and that was the start of reconnecting as family. We bonded and quickly became compatible travel companions.

Since our departure was from New Orleans, we decided to take a couple days to explore the city which would be my second visit to the city. We flew United Airlines, landed at the airport and took Uber to the Sheraton. The hotel was on Canal Street in the Central Business District, has 49 stories and is the sixth tallest buildings in New Orleans. We learned that the hotel was evacuated when Hurricane Katrina struck in 2005. There were one thousand people in the hotel during the storm that were taken to the Sheraton in Dallas.

Shelly and I enjoyed the typical touristy things, ordered the famous Hurricane drink at Pat O'Brien's and strolled down Bourbon

Street. We experienced the famous étouffée, a stew-like dish of seafood or chicken simmered in a sauce that starts with a light or blond roux.

"In simple terms, roux (*pronounced "roo"*) is a mixture of flour and fat, roasted together into a nutty paste. It's a foundation for many dishes like béchamel sauce, gravy, stew, mac and cheese, gumbo, Alfredo sauce and more. So, even if you've never heard of the term before, you mostly likely have made it. A roux is typically used as a thickener for cream sauces, gravies and soups. Dark roux has the least thickening power, but it adds amazing flavors in dishes, like gumbo. Unlike raw flour, roux produces nice and smooth texture in gravies and sauces. If you add raw flour into a liquid to thicken, you'll get lumpy mess with an unpleasant doughy flavor. Roasting the flour in fat removes that raw flour taste." (Published: 3/16/2020 Updated: 6/08/2021 in sweetandsavorybyshinee.com)

And according to Wikipedia, in French, the word "étouffée" (borrowed into English as "stuffed" or "stifled") literally means "smothered" or "suffocated" from the verb "étouffer."

Étouffée is a dish of shellfish, simmered in a sauce made from a light or blond roux, served over rice. It is most commonly made with shellfish, such as crab or shrimp. The most popular version of the dish is made with crawfish. Depending on who is making it and where it is being made it is flavored with either Creole or Cajun seasonings. Although Creole and Cajun cuisines are distinct, there are many similarities.

In the case of the Creole version of crawfish étouffée, it is made with a blond or brown roux and sometimes tomatoes are added. A blond roux is one that is cooked, stirring constantly, for approximately 5 minutes to remove the "raw" flavor of the flour and to add a slightly "nutty" flavor, while a brown roux is cooked longer (30 to 35 minutes) in order to deepen the color and flavor.

Around the 1950s, crawfish étouffée was introduced to restaurant goers in Breaux Bridge, Louisiana; however, the dish may have been invented as early as the late 1920s, according to some sources.

Chapter 47

Originally, crawfish étouffée was a popular dish amongst Cajuns in the bayous and backwaters of Louisiana. Around 1983, a waiter at the popular Bourbon Street restaurant Galatoire's brought the dish to his boss to try. At the time, most New Orleans restaurants served French Creole cuisine, but this Cajun dish was a hit."

Blues and jazz performers were playing their instruments all along the strip, on the sidewalks and in the bars. Some played in the style of Louis Armstrong. We went into a voodoo shop where the owner read our palms and used Tarot cards.

According to Wikipedia, "Tarot card reading is a form of cartomancy whereby practitioners use tarot cards purportedly to gain insight into the past, present or future. They formulate a question, then draw cards interpret them for this end. A regular tarot deck consists of 78 cards, which can be split into two groups, the Major Arcana and Minor Arcana. French-suited playing cards can also be used; as can any card system with suits assigned to identifiable elements (e.g., air, earth, fire, water)."

We learned that these cards serve as a conduit between the soul and the consciousness and they could reveal what is in the unconscious. So we had our fortunes told. Voodoo is a sensationalized pop-culture caricature of "voudon," an Afro-Caribbean religion that originated in Haiti, though followers can be found in Jamaica, the Dominican Republic, Brazil, the United States, and elsewhere. It has very little to do with so-called voodoo dolls or zombies.

The next day Shelly and I had breakfast at Poppy's Crazy Lobster Bar and Grill on the waterfront and ordered shrimp and grits for breakfast. The restaurant offers buckets of steamed seafood, N'awlins favorites like po' boys and jambalaya, fried seafood, and cocktails in a waterfront space.

We boarded the Creole Queen for the New Orleans historic battlefield cruise on the mighty Mississippi, then we toured the Chalmette Battlefield and National Cemetery Visitor Center (Jean Lafitte National Historical Park and Preserve). According to the brochure, focusing on three hundred years of New Orleans history,

the cruise is offered twice daily and narrated by a local historian. According to National Geographic, The Battle of New Orleans was the final major battle of the War of 1812, fought between the British Empire and the newly formed United States. The battle, which took place on January 8, 1815, featured the British aggressors' intent on capturing New Orleans, which they thought would give them control of the vast majority of the newly acquired Louisiana Purchase. The battle itself was fought on the grounds of the Chalmette Plantation, roughly 8 kilometers (5 miles) southeast of New Orleans, Louisiana.

The Battle of New Orleans is referred to by many historians as the greatest American land victory of the war. American troops, led by future President Andrew Jackson, defeated the much larger British force, which bolstered U.S. hopes for a speedy end to the war.

The battle is also famous for some of the characters involved, including noted French pirate Jean Lafitte who, with his fellow pirates, fought for the U.S. military and even claimed special accolades in the field of artillery.

The importance of Louisiana (especially New Orleans) to the fledgling United States was tantamount to success in the war at large, and the continued growth of the nation. In 1907, the battleground was established as a federal park, which currently resides in Jean Lafitte National Park and Preserve, and acts as a reminder of the importance of the battle that took place there. New Orleans was one of the most important port cities in the U.S. at the time. The city allowed access to the Mississippi River, an important route for both transportation (of both troops and civilians) and shipping. Many strategists during the War of 1812 saw control of the Mississippi River as control of the war itself.

Highlights of the tour included the founding of the city by the LeMoyne brothers, the expansion of the city into the "French Quarters" of the Treme and Marigny, the Louisiana Purchase, and the critical Battle of New Orleans. The excursion at the battlefield included a guided tour and talk by national park rangers. The boat took us to the French Quarter's waterfront to visit the site of the

1815 Battle of New Orleans in Jean Lafitte National Historical Park and Preserve.

Later, we walked through the French Quarter and visited the French Market where we purchased fleur-de-lis jewelry from a local vendor, Calvin, and became acquainted with him. The French Market (Marché Français) is a series of commercial buildings spanning six blocks in the French Quarter. We learned that founded as a Native American trading post predating European colonization, the market is the oldest of its kind in the United States.

We later ordered a plate of the famous oyster po'boys for dinner at the Praline Connection. The restaurant is an entertainment destination in the French Quarter with its menu of beans and greens, chicken and ribs, po'boys, and, of course, pralines. We enjoyed the jazz in the street. We came across a very happy character with long hair who was greeting everyone, and many outdoor vendors who were selling their arts and crafts even in the light rain.

We took a Garden District walking tour where homes owned by Nicholas Cage, Anne Rice, John Goodman and Sandra Bullock were pointed out. And according to (https://touringlouisianaplantations.wordpress.com), the magnificent Brevard-Rice House was built in 1857 for Albert Hamilton Brevard. A previous owner of the beautiful house was novelist Anne Rice and her husband, poet and painter Stan Rice, in 1989. We learned that The Brevard-Rice House is a particularly fine example of the large, narrow and long, two-story residences built in the Garden District in the prosperous decade that preceded the Civil War. The 1850s Greek Revival style residence boasts nearly 9,000 square feet on three floors with five bedrooms and six full baths. The home features period touches such as murals in the dining room, ornate millwork and beveled mirrors. It also has a large, heated salt-water pool, fish pond, guest house, staff house and "lush grounds with maintained gardens." There are five bedrooms, six full baths and two half-baths.

We took the "Hop-on Hop-off" tour bus and drove past the Louisiana Superdome and learned that Mercedes Benz purchased

the name rights after Hurricane Katrina in 2005. Seats at the Superdome have since been replaced or refurbished, and new ones added; there are new club facilities and restrooms, and new video systems and scoreboards installed.

We then strolled down Magazine Street that goes from the Central Business District and the Warehouse Arts District through the Garden District and Uptown. We had lunch at Mother's Restaurant on Poydras Street with a Ferdi Special po'boy, dressed and pressed. Very yummy.

We discovered Dianna Knost's Cottage of Curiosities, AKA Stella Gray, a little uptown cottage built in the 1860s, located at 4422 Magazine Street where I purchased a stained glass fleur-de-lis piece to hang in a window. She opened her unique shop in 2012 which included a carved vestibule from a Paris church, a chest from Singapore, an antique tribal drum from Africa and a dining table layered with an animal hide. She also had a collection of organic finds, jewelry, pottery, tribal textiles, animal hides, and unusual art and home décor. Since this writing, I learned that she closed the shop in 2018 but had infused her home with the same aesthetic.

We hopped back on the tour bus heading to St. Charles Avenue where we discovered several Mardi Gras beads still hanging on lampposts, trees, and down inside manholes. We learned that the Mardi Gras celebration was originally a family celebration. Jackson Avenue is home to Mardi Gras World in the Arts District. Mardi Gras World is a tourist attraction where guests tour the 300,000-square-foot working warehouse where floats are made for the Mardi Gras parades. Next time maybe we will visit the warehouse. We ate breakfast at the Sheraton before we boarded the cruise ship and had gumbo.

We learned that Oak Alley Plantation in Baton Rouge is where Gone with the Wind was filmed in 1939. Although people still arrive in Atlanta expecting to visit Scarlett O'Hara's Deep South estate, not a single scene of the classic film was shot in Georgia. Virtually all of the movie was filmed at what was then Selznick International Studios. We later had lunch at the Windjammer and relaxed by the

pool. That night we watched a performance at the Windjammer from Motown 50s and 60s. It was fabulous!

Day 1: Once we had boarded the ship and were settled in, I met with my activities manager for shift details. Shelly and I then had dinner at Giovanni's onboard restaurant starting with antipasto appetizers, followed by grilled lamb chops, gnocci and tiramisu for dessert.

Day 2: From the choices of excersions offered, we took a trolly tour around Key West and stopped at the famous Ernest Hemingway home and learned of its history. It was the most fascinating tour. Ernest Hemingway Home and Museum is home to as many as fifty six-toed cats and we saw many of them all around the estate.

I had never read Hemingway's books but I was fascinated and purchased three of his books that afternoon at the bookstore. In researching Mr. Hemingway on Wikipedia, the following is what I found:

"Ernest Miller Hemingway (July 21, 1899–July 2, 1961) was an American journalist, novelist, short-story writer, and sportsman. His economical and understated style—which he termed the "iceberg theory"—had a strong influence on twentieth-century fiction, while his adventurous lifestyle and public image brought him admiration from later generations. Hemingway produced most of his work between the mid-1920s and the mid-1950s, and he won the Nobel Prize in Literature in 1954. He published seven novels, six short-story collections, and two nonfiction works. Three of his novels, four short-story collections, and three nonfiction works were published posthumously. Many of his works are considered classics of American literature. Hemingway was raised in Oak Park, Illinois. After high school, he was a reporter for a few months for the Kansas City Star before leaving for the Italian front to enlist as an ambulance driver in World War I. In 1918, he was seriously wounded and returned home. His wartime experiences formed the basis for his novel A Farewell to Arms (1929).

Hemingway married Hadley Richardson in 1921, the first of four wives. They moved to Paris where he worked as a foreign correspondent and fell under the influence of the modernist writers and artists of the 1920s' "Lost Generation" expatriate community. His debut novel The Sun Also Rises was published in 1926. He divorced Richardson in 1927 and married Pauline Pfeiffer; they divorced after he returned from the Spanish Civil War, where he had been a journalist. He based For Whom the Bell Tolls (1940) on his experience there. Martha Gellhorn became his third wife in 1940; they separated after he met Mary Welsh in London during World War II. He was present with the troops as a journalist at the Normandy landings and the liberation of Paris. Hemingway maintained permanent residences in Key West, Florida (in the 1930s) and Cuba (in the 1940s and 1950s). He almost died in 1954 after two plane crashes in as many days; these consecutive accidents left him in pain and ill health for much of the rest of his life. In 1959, he bought a house in Ketchum, Idaho, where he ended his own life in mid-1961."

After the amazing tour, we ate lobster Reuben sandwiches at the Six-Toed Cat Café, which was quite a decadent experience. Then we walked back to the cruise ship with fellow passengers. I mentioned that I had wanted to get a tattoo in New Orleans, and one of my fellow passengers recommended a local tattoo shop on Magazine Street. Shelly and I later lounged by the pool and drank a guava lava drink and read a book. Dinner that night was Caesar salad, jumbo prawns, and for dessert crème brûlée.

Day 3: We toured the Atlantis underground archaeological dig that included an aquarium tour. We wandered around, purchased some rum cakes, shopped, and found a café and ordered conch fritters with a yummy dipping sauce along with a sweet rum drink. At sunset we sailed on a catamaran for two hours till 11:00 p.m. When we got back on the ship, we found passengers line dancing so we joined in dancing to my favorite song to line dance to: "Electric Slide."

Chapter 47

Day 4: We docked at Coco Cay Beach (aka Little Stirrup Cay) privately owned by RCCL (Royal Caribbean Cruise Line). The island is only one mile long and a third of a mile wide, and its beautiful white sandy beach is reserved for RCCL's guests. There were three cruise ships in the harbor, and the lifeboat called a "tender" took passengers from the cruise ship to the small island for a special barbecue just for the guests. Shopping was available, and I purchased some tropical island dresses for myself and shirts for my sons. We found two empty beach chairs together and just lounged for quite a while getting up once in a while to dip our feet in the warm tropical water. When the ship's horn sounded, we headed back for our curfew then later back on the ship I face painted children at 6:30 p.m. who paraded on the main deck that evening as pirates. We had dinner again at the Windjammer.

Day 5: I worked an early shift at 10:30 a.m. in the Adventure Ocean kids' area. Then I ate lunch at the Windjammer. There was a walk for Make-A-Wish Foundation that afternoon around the ship for a donation, and we earned a T-shirt for walking. After participating in the walk, I lay on the sun deck. At 5:00 p.m. I had a private appointment to paint a passenger's face for the formal night. She was a sweetie. I painted an elegant, sparkly design of swirls on the side of her face to match her gown. At 9:30 p.m., we joined a disco dance party that lasted until 1:30 a.m.; it was a blast.

Day 6: My last shift was at 10:30 a.m. at Adventure Ocean and by 12:05 p.m. the Parade of Flags kicked off. I purchased two gold bracelets and ate at Windjammer again for lunch. I sketched a watercolor for Katrina, the activities manager. That night was a demonstration/dance performance of Michael Jackson's "Thriller." Passengers had been learning this dance for a few classes. At the beginning of the performance, my wonderful spokesperson, cousin Shelly, announced to the dance director that I was the onboard face painter and that I could paint the performers' faces as zombies to fit

the scene. Long story short, the director loved the idea and I ended up painting forty dancers' faces very quickly. It was quite a thrilling experience. At the end of the performance I was recognized for my face painting, which is always nice. The entertainment director gave me two mugs and a T-shirt for my work.

One of the late-night shows we attended was a parade of people from the late-night adult show. We were instructed that every time we'd see the winner of the show, who had to wear a king's crown, we were to salute him and address him as "King." It was so much fun. What was so special about this tour was that the passenger count was small and personal, and I had a personal conversation with Katrina. I ended up sketching a watercolor painting of the two of us and gave it to her.

Day 7: Departure. Sadly, it was the day we had to depart. I grabbed a Danish and one last coffee drink from Starbucks. Shelly and I headed back to the Shelton Hotel in New Orleans. Daniel, our friendly baggage clerk at the hotel, was very helpful and told us where we could store our luggage with him locked up until we were ready to leave. So we stashed our luggage and walked to the French Quarter one more time and found a tattoo shop at 501 Frenchmen Street. It was early in the morning, and I was determined to get my first tattoo right then and there in New Orleans because the city was so magical to me. Since we had met several residents on our tour and learned the meaning of the fleur-de-lis which is very special to New Orleanians, I got a tattoo the outside of my left ankle with the fleur-de-lis. It was simple and yet so beautiful with deep purple and yellow colors which are two of their Mardi Gras colors. I was so excited and proud of my very first tattoo! I was given instructions on how to care for it. After I was done, we walked to the renowned open-air Café du Monde coffee shop on Decatur Street for café au lait and beignets. And that was the end of our unforgettable cruise.

Chapter 48

Love Modesto is an annual citywide volunteer day usually in April. I participated in the event that year and set up a booth in the street blocked off for vendors. Love Modesto works with nonprofit service providers, schools, and government entities (i.e., social workers) to find out the needs of people in the community. They then connect with churches, businesses, and individuals to present those needs as simply as possible.

At my booth I must have painted a hundred faces that day! My mistake though was that I should have asked the children I was painting if they were a part of Love Modesto because I ended up face painting kids for free that I later learned not part of the program—an invaluable lesson learned!

Chapter 49

In May of 2014, I finally had the privilege of attending, for the first time, FABAIC (Face & Body Art International Convention) in Orlando. I'd always wanted to go, and I finally did! It was the thirteenth annual international convention. I flew in from the San Francisco airport and joined my roommate, Sandra, from Gretna, Louisiana (who had responded to my roommate request). What an experience of a lifetime! The weather was perfect and the hotel was in a nice quiet area away from the city. From our hotel room we could see a little pond with ducks floating in it. It was very relaxing. I learned such invaluable lessons throughout the convention. There were instructors for face painting, body painting, balloon twisting, henna and clowning. Sandra brought a huge ice chest of cooked crawdads, a pasta dish, water, orange juice, and all kinds of snacks, bread, and sandwich-making stuff so we would save money and not have to eat out for every meal.

The hotel seemed like a magic land filled with colorful balloons, artists walking around with balloon hats and wrist bands, and vibrant painted bodies and faces—quite a carnival-like atmosphere. I bumped into face and body painters, balloon artists, and instructors that I'd met at other workshops and conventions throughout my career. This industry is amazing to me. You gain a sense of camaraderie

Chapter 49

with fellow artists who are also like-minded. At the entrance of the convention were several elaborate balloon creations that reached to the ceiling with glitter everywhere and balloon formations all around the perimeter of the main meeting room.

I got a chance to meet master face and body painters Wiser and Jay Bautista and took some classes from both. They posed together for me in black T-shirts. Jay's said, "Not Wiser," and Wiser's said, "Not Jay." It was hilarious. Everyone thought they could pass as twins because they were of the same build, same height, and both bald with clean-cut black goatees—both hysterically animated. Wiser's specialty is graffiti art, and Jay's is tribal art. I learned quite a lot from both of them.

Every night there was entertainment on stage and/or jam sessions where everyone was invited to bring their supplies and practice on each other. I learned more just by walking around and observing what everyone else was doing. From time to time, I offered myself as a model and got a beautifully designed face mask or arm or leg design.

There was a body painting contest, and at the end of the convention, there was a lineup of the models along with their artist, and the winners were announced. It was spectacular. The professional talent exhibited by the artists was amazing. That night the wedding engagement of one of the models and her artist was announced on stage which drove the crowd crazily wild with their clapping, cheering, and whistling.

I had the privilege of seeing again master face and body painter Mark Reid. Mark is a professional painter from Dallas. He is a traditional artist and has been painting since the age of ten and is versatile in style and capable of creating art involving any logo or genre. He was born in Roswell and raised in Dexter, New Mexico, where his journey into art began. Mark started out farming but began face painting at a small festival in his hometown in 1997. He used acrylic paints for the first seven years until someone introduced him to professional makeup.

Mark is known worldwide for his ability to transform the human face and body into works of fantasy and illusion. His reputation and extreme talent have led him to be the most requested international face and body art instructor in the world. He has also performed live demonstrations on television and was featured on I've Got a Secret game show in Hollywood and in the 2008 Penthouse Club Calendar. He has also done makeup for American Horror Story: Coven, and was featured on the Travel Channel for the documentary Sturgis Raw and his body painting events. He also painted for Hugh Hefner at the Playboy Mansion and Leigh Steinberg at the 2008 Superbowl party. As an international instructor, he travels the world lecturing and demonstrating his skills to artists and entertainers worldwide. He also performs across the US for corporate promotional events.

Mark told me he left the workforce to teach face and body art after winning the 2004 International Face and Body Art Championship. He has been to twenty-six countries and has taught in twenty-two of them. He had Mark Reid™ Signature Brushes created to his exact design specifications. He also designed Mark Reid™ GlitterMark with the professional face and body painter in mind. GlitterMark is the fine cosmetic-grade polyester glitter in GlitterDust suspended in an alcohol-free, water-based gel to give the artist the ability to create fine lines and details.

His other awards include these:

- First place in body painting at the 2004 FABAIC (Face and Body Art International Convention), Orlando, Florida (his very first competition)
- Sixth place in body painting at the 2007 World Body Painting Championships, Seeboden, Austria. He competed against eighty artists from twenty-three countries.
- Sixth place in face painting at the 2007 World Body Painting Championships, Seeboden, Austria
- Third place at the 2008 Face and Body Art Association Instructors Competition, Orlando, Florida

- First place at the 2008 Festival der Farben Face Painting Competition, Freiberg, Germany
- Third place in body painting at the 2008 World Body Painting Championships, Seeboden, Austria. He competed against sixty-five Artists from twenty countries.
- First place at the 2008 Welsh Elite Body Painting Championships, Llanelli, Wales

Today, Mark is farming pecan trees for his uncle Gilbert Gomez and helping to take care of his aunt, Elsie, but he still finds time to fill his schedule with painting. "In order to be successful in life," Mark has said, "you have to fall in love with what you do. If you're not in love with it, the chances of being successful are next to nothing. If you're madly in love with something, you want to do it and you can feel it in your heart, then you can become great."

I had attended many of his workshops over the years, but he is so big in the face and body painting world, I was sure he wouldn't remember me. He is in contact with millions of people around the world, so I was tickled pink to get a photo of me kissing him on his cheek at a large face and body art convention and another photo with his arm around me and both of us being silly and sticking out our tongues for the camera. It was hilarious. One thing I can say about this creative environment is that everyone is cheerful. Everyone's day-to-day problems and worries are forgotten during these conventions. It's just such an amazing experience that I will never forget.

In Heather Green's marketing class, "Paint Me Green," I learned to gather business cards from fellow face painters and follow up with them with a personal card or email. She advised us to plot out our goals and list three things that have set us back. We should then ask ourselves if we are a thinker, persuader, doer, organizer, creator, or helper; and the kind of person we are will determine how we will accomplish those three things. We should also ask ourselves what is not working, seek guidance from a mentor, and decide on a plan of action and stick to it! When I have my vision, I can make my life

around that. She taught us at birthday parties to make it a must to take photos of the birthday person with us and email it to the parent after the party.

Her slides included the following:

- Good is the enemy of great!
- Leave here with a great mindset.
- Make great a goal.
- Look for the things that bring you great pleasure.
- There is profound happiness in achieving great results.

Her strategy for a guaranteed way to book corporate/trade show gigs: Go to your local convention center, get a calendar of events, contact event organizers to get a list of vendors, and contact each vendor for an event to offer your services. You will book at least two events per month if you follow this strategy consistently. I also learned to list two goals, list two excuses you make daily related to goals, name two daily routines related to your business, name the business guru you'd like to meet, name two things holding you back from your goals, and list two things you have accomplished this year.

In another marketing class I learned to have the mindset that I'm taking the opportunity to market my business. Ask each child in line to write his/her parent's email address on my list. Market to local dental/orthodontists' offices and restaurants for gigs, and to conference centers or trade shows and Groupon for advertising.

Minding your business: The thing I feared most is the prospective client saying I'm too expensive—the client who says no. I learned that it's not about being the best; it's about being better today than I was yesterday. Plant the seeds! Make yourself unforgettable!

Sugar skulls: A Kabuki brush used with white powder for the base provides the best result. For the cheeks use the illusion of sunken-in cheeks and extend the white into the hairline so there's no hard line. You can apply precious gems with a "smoothie blender." These large eye shadow style applicators are known in our industry as smoothie

blenders or velvet blenders and are made from soft fabric or foam with a flexible piece of plastic inside. To use them you rub the applicator back and forth on the surface of your cake powder until the powder loosens up. They're a good tool to have. Then you add glitter to the lips.

My career goals were to triple my revenue, and gain more repeat clients and corporate clients. Not completely successful but good goals. My action plans were to distribute four-by six-inch postcards and hang them around high-end places that moms frequent, distribute flyers, and conduct cold calls.

The vendor room was jam-packed with people every single day and night. There were vendors from all over the world selling their supplies: paints, glitter, aprons, books on techniques, brushes, stencils, and everything you can imagine for this particular craft.

One of my very favorite professionals in the industry, Heather Green, is owner of Silly Farm Supplies, and took over the business from her aunt Marcela. Heather is not only professional, she is a knowledgeable, creative, and innovative business owner. She is the humblest person and always remembers my name, which amazes me! She gets in there and works the booth alongside her helpers, handling the cash register and taking orders from clients.

I took part in a contest painting children's faces that were attending the convention with their parent(s). I painted a little eight-year-old girl who wore a pajama top with cartoon character Dora the Explorer on it, and she had on Dora pajama bottoms with, of course, Dora slippers She was adorable. I painted a pink butterfly outlined in black on her face, a unicorn horn in the middle of her forehead, and added lots of glitter. Each of the contestants got a small gift for participating.

My roommate, Sandra, and I painted a green monster mask with horns on a Snazaroo product rep. It was so fun because he told us that he was looking for face painters to promote his product at PTA events, and he would pay for our flight to his area. It was promising but fell through. It was quite an exciting thought though and would

have been another invaluable experience. The rep never called us back.

People were walking around throughout the convention had elaborate swirls painted on their faces, butterflies, tribal designs, cat and tiger faces, tribal designs, flowers on shoulders, monster masks and sugar skulls. I even marveled at seeing a beautifully painted very elaborate butterfly across one model's shoulders and back. Two models were adorned with gorgeously detailed henna designs on their shoulders, hands, and backs—all with colorful glitter.

On one of the entertainment nights, we enjoyed a dancer dressed as Michael Jackson. He performed an amazing dance, doing the famous moon walk replicating Michael Jackson's moves. He was quite delightful.

Chapter 50

I participated in a downtown exhibit at the Tracy Art Walk and painted quite a few kids' faces. In addition, I displayed prints of my watercolor paintings and sold a few, which I was happy about.

Art in the Family was a unique event created by one of the CCAA members in which members of the association were invited to participate with their family members to create a "family" art piece or pieces. I was thrilled that my sister Nancy and her daughter Emily participated in the project. It was entitled Love That Binds. The piece included two of Emily's photos of beautiful scenes from our hometown, including one of lavender flowers and the other of a mailbox along a picket fence lined with flowers. My piece was a watercolor painting of Emily's photo. And Nancy added her delicate string of crocheted hearts that connected all of our art pieces. It was quite an impactful display.

I had my watercolor paintings of redwood trees printed and made up into postcards. Diana, owner of the Peg House in Leggett, was my first client I approached and showed her the postcards of her well-known Peg House located across Highway 101 from Standish Hickey State Park. When I was growing up my family frequently camped at Standish Hickey which is what prompted me to paint that area. As an adult when I traveled Highway 101 toward home, I always stopped at the Peg House for a break and snacks from the store.

She liked my idea and purchased a good number of my postcards to display in their gift shop. Owners Gary and Diana have been serving the community and the needs of travelers for over twelve years. They created an outdoor Redwood stage as a music venue, and the barbecue stand on their patio. The name was derived from the general store and gas station built with pegs instead of nails to join the timbers and it has been a landmark along US Highway 101 since the early days. She told me she bakes brownies and cookies daily for their customers. So she became my first client.

I sketched and watercolored several other images of the popular Redwoods in Richardson Grove State Park. I was on a roll as an artist and entrepreneur, and felt more and more like Mom with her business sense. Being from Humboldt County, I knew all the popular tourist attractions along 101 in Northern California. I approached next the owner of Confusion Hill, another popular tourist attraction, and he agreed to purchase fifty postcards to display in the gift shop. He became a client.

Confusion Hill is a roadside attraction in the small town of Piercy. The attraction, which opened in 1949, includes a "gravity house" which is a structure built to give interior visitors tilt-induced optical illusions, similar to the perspective on a gravity hill. I learned that in 1955, the owner added a miniature train to carry passengers through

the Redwoods to the top of Smokestack Hill, passing through the "world-famous Twin Tree Tunnel." The Mountain Train Ride is narrated by its conductor/engineer points of interest are pointed out along the thirty-minute ride.

My next stop along 101 was the famous Drive-Thru Tree also in Leggett. That owner purchased several postcards and has been a consistent client of mine over the years. The manager of the gift shop at Richard's Grove also bought several postcards that year.

I have several repeat clients with my postcard business, including Drive-Thru Tree, Confusion Hill, and Many Hands Gallery in Old Town Eureka. Among my Humboldt County watercolor series, I had my watercolor painting of the historic Carson Mansion of Eureka made into prints and postcards that I sell to Humboldt County gift shops.

Many Hands Gallery features a variety of local artisans, as well as imported treasures from around the world from artist cooperatives, fair trade organizations, and general importers. They became a client.

I also sold some greeting cards of my watercolor to Holly, owner of Holly Yashi jewelry in Arcata. I went to high school with Holly, so it was a thrill that she purchased some of my greeting cards. Since 1981, Holly Yashi has been making quality, handcrafted artisan jewelry in her design studio in Arcata—our hometown. For over thirty-five years her style of colorful and lightweight niobium metal is what makes her jewelry unique. She uses Swarovski crystal pearls, Bohemian and dichroic glass, and hypoallergenic metals in her jewelry, all of which is crafted by hand in small, high-quality batches, one piece at a time.

December 2014, was the second year that I was asked me to design annual Christmas cards for the company's donors, employees,

and public. That year's designs were entitled *Believe* and *Tree Reflection*. *Believe* was inspired by their annual fundraising Christmas tree event and *Tree Reflection* was inspired by the Christmas tree in their lobby with white poinsettias all around the foot of the tree.

Chapter 51

Another pivotal point in my life was when I registered for Stephanie Gagos' "Hell Yes" Journey workshop in January of 2015. Stephanie's workshop was a learning process that helped me develop goals for my face painting, henna, and art business. We had to create a "hell-yes" list, a "maybe" list, and a "hell-no" list of goals. One of the goals on my hell-yes list was to meet people who are like-minded and have an artistic interest with whom I could network. A goal on my maybe list was to write a book, and one on my hell-no list was to no longer engage in conversations with negative people who just want to settle in life. (At the time of this book writing, I am proud to say that I accomplished all these goals.) The word that I settled on for her workshop was "gumption" which is a boldness of enterprise, initiative, or aggressiveness; guts, spunk, common sense, or resourcefulness; courage. The sub word I chose was "enterprise" which is an undertaking, especially one of some scope, complication, and risk; one that requires boldness or effort. My daily feel-good practices included listening and dancing to music and visualizing my art dream coming to fruition.

I set goals during her workshop to take a risk every day including making five cold calls per day, asking repeat clients for referrals, following up with five prospective clients, and calling clients to

whom I sent postcards. I was gung-ho when I started performing these tasks, but the problem is that it takes persistence, time, effort, and motivation to make it a routine. My biggest obstacle was working my eight-to-five job. I was tired by the time I got home and didn't have the motivation to work on these goals which is why I always gave up.

We were given an assignment to write about how our desire and passion came to be and when it first arrived in our heart, or how we knew we just had to pursue our passion. We wrote about what those moments were like, if we remembered the seeds we had planted at that time, and when the longing became so strong that we could no longer resist moving forward. It was quite a powerful exercise. Telling our stories allowed us to create meaning, solidifying the importance of what we had chosen to say yes to. It allowed us to put language to what stirred our hearts so deeply that we were willing to take the risk and leap into the unknown. Our stories have the power to carry us through even when we doubt ourselves. Being seen in our stories strengthens our relationship with our yes and invites others to be a part of our experience. We don't have to do it alone.

Another pivotal point in my life was when I finally began believing in myself and got involved with art groups, gallery showings, and designing Christmas cards from my watercolor paintings. For the first time I allowed myself to believe that I am an artist without self-doubt.

Another day of the workshop was considered an "unpacking" of sorts with questions we were asked to answer:

Q: What would become available to us as a result of saying "hell yes?"
A: Opportunity because I've opened the door and invited opportunity in.
Q: How will it affect those around us as a result of saying "hell yes?"
A: People will be pleased to see a more eager, fearless,

enthusiastic person with new focus, drive, and motivation to achieve the goal I've said "hell yes" to.

Q: What will it allow you to have, do, or be as a result of saying "hell yes" to what you have chosen along your journey?

A: I would have a sense of accomplishment and worthiness. I would hope to be a much happier person, fulfilled and satisfied, knowing this is what I was created to do. I would feel free to do what makes my heart sing. What the "yes" is saying to me is "Lynn, now that your vision is clearer to you, you should feel much stronger with the fire within to pursue your art passion. You should feel more comfortable by now in taking risks and asking what you need. One of your fears has always been that when the fire goes out, you'd dive into a depression with feelings of hopelessness for your dream. Because of the Hell Yes journey, feel strong that your fire will not go out and you will continue to pursue your dream nonstop. The fire will intensify with each passing day, and as your eight-to-five job gets harder and harder for you to stay, you will realize more and more that you no longer fit in that box. With each risk you take and with each step you take toward your burning goal, the old you will take a step backward while the new you will emerge."

You will feel triumphant:

1. Having won a battle or contest; victorious (successful, winning, conquering, undefeated, unbeaten).
2. Feeling or expressing jubilation after having won a victory or mastered a difficulty (jubilant, exultant, elated, rejoicing, joyful, joyous, delighted, gleeful, proud).

"My risk for today" was to find out about art classes from a favorite artist that Stephanie follows. After looking at his website and reading his story, I felt discouraged. Rather than feeling encouraged by his work,

I felt all the negatives in my life and started spiraling down into self-defeat. Then I gave myself a "yes" talk, but out of fear I emailed him instead of making a phone call. I gave myself another "yes" talk, and after some pretty wild heart pumping, I called him, hoping he wouldn't answer. He did; he answered! I stumbled through my conversation with him, and by the end of our conversation, he ask that I send him some of my artwork. He said not only would he give me a private all-day lesson showing me his techniques, but he would also have me paint side by side with him on the same canvas! I was thrilled!

"Facing Your Fears" Journey workshop also with Stephanie Gagos was an invaluable course on women's empowerment led me to another turning point in my life. I had grown in confidence and empowerment as a woman from her first workshop. Before her teachings, I lived an ordinary life with an ordinary eight-to-five job with no particular goals in mind. I knew I wanted to do something with my artistic gift but never had a real direction, not to mention I had a total lack of confidence and I had no gumption to push myself out of my comfort zone. This voice of fear was telling me I didn't have what it takes to succeed, and my artwork would never sell because I was just an artist wannabe; I didn't quite measure up.

The two workshops with Stephanie gave me confidence as an artist and empowerment as a woman and also the opportunity to communicate with fellow female artists around the world who are like-minded. Through her exercises, I learned how to stretch my art and break loose from the negative beliefs and messages in my head and how to take risks to move through my fears. I learned how to manage my fear and not run from it and how to start trusting my intuition. I used to feel like I was racing against time.

I learned that we project our own perceived shortcomings onto others that we should be saying to ourselves. We are judging

ourselves. If I am offended by your arrogance, it is because I am not embracing my own arrogance. I also learned about negative language regarding money, relationships, and self-confidence and how to eliminate self-limiting beliefs. I needed to choose an area in my life where I was feeling most challenged by business and career. I wanted to be recognized as a talented artist. Some of the downfalls were there's not enough time in a day, my full-time work keeps me tired, my successful fellow artists are more talented than I am, and I won't be able to paint beautifully enough to make a living. I needed a clear intention using specific language. I'm learning to trust my intuition.

In 2015, I enrolled in a life-changing online business development workshop with Natalie Ledwell called USM (Ultimate Success Master Class): Taking Your Success to the Next Level. I was taking a lot of business development workshops during the time, thirsty for knowledge and information on how to grow my business as an entrepreneur. This proved to be another pivotal, life-changing time, in which I grew tremendously with my art and interaction with new friends and business colleagues. Natalie's workshops taught me to achieve my goals and gave me the confidence to move forward.

She says, "There is nothing more delicious than living a life on purpose and making a difference, regardless of how many people you influence." Natalie is a risk taker, nonconformist, and rule breaker and maker who believes nothing is impossible. She's also an internationally renowned motivational speaker, best-selling author, law of attraction guru, host of The Inspiration Show and Wake Up TV! and cofounder of the revolutionary personal development company Mind Movies. She lives in Southern California and her mission is to empower ten million people all over the world to lead lives fulfilled with joy, happiness, and passion—the lives they were destined to live. Natalie has owned several successful businesses and has

traveled all over the world. One of her life mottos is "I'll try anything once, and twice if it's good."

So I practiced what I learned from Natalie and watched her uplifting podcasts.

The following is what I've learned from USM:

- Creating an abundant vibration, and I learned to do daily success rituals.
- Setting a powerful intention and creating clear goals; and setting your intention, creating powerful affirmations, choosing specific actions, and finding your happy place.
- Creating empowering affirmations and embrace happiness and fulfillment.
- Activating the law of attraction in our lives.
- Taking inspired action, which leads to inspiring results.
- Eliminating self-limiting beliefs—a powerful lesson for me since I carried around a lot of self-limiting beliefs. During her module we shared our self-limiting beliefs. I learned how self-limiting beliefs take root and block our success.
- Defining our core values. We'll always make the right decisions by knowing our core values.
- Finding your passions: discover what truly excites you.
- Breaking through our challenges and overcoming any challenge—negative people, energy drainers, safekeepers—and how to escape the influence of negative people.
- Using our thoughts and language for success—powerful thoughts and language that serve you every day. Your language reinforces your thought patterns. We learned about the power of words.
- Staying connected to the source: what is source energy and how do I tap into it? Compromising ourselves, following our instincts and intuition, meditation, creating a peaceful and relaxing setting, and observing our thoughts.
- Putting it all together—everything we learned.

It was a fabulous course that is essential to learning about one's self and learning the power and strength we all have to pursue the goals that we must have to succeed in life.

We were assigned to create a Minds Movie video of our dreams—one of positive affirmations using photos and positive quotes. Mine was empowering because I illustrated all my passions, desires, and dreams. The topics on each slide of my YouTube video are as follows:

- I control my own schedule.
- I am creative every day of my life.
- I am a winner.
- I have freedom to do what I want.
- The sky is the limit.
- I soar to new heights with drive and ambition.
- I have freedom to travel.
- I paint the sky my own colors.
- New Orleans is my second home.
- I am a successful entrepreneur.
- I hang glide for ultimate pleasure.
- I make a difference in people's lives.
- I cruise twice a year.
- I have an abundance of cash flow.
- I enjoy the ultimate vacations.
- I live in the house of my dreams.
- My art is recognizable around the world.
- The Caribbean is my home away from home.
- I have several art exhibits.
- I ride cross-country on my Honda.
- Through determination I will achieve recognition for my art.
- My daily action steps will result in financial freedom.
- I am successful and self-reliant
- My sons are my "why" for living.

It was a powerful exercise that I still play back from time to time to remind me of my abilities, successes, dreams, and goals.

After completing the workshop, I finally allowed myself to be called an artist. Before then I had always felt so small and unworthy of the title. How could I ever call myself an artist? I always wanted to be one, but held artists on such a tall pedestal that I couldn't possibly be one. I felt unworthy of that position. The title scared me. But I finally earned the confidence to call myself an artist, and it felt good.

One of my study buddies I met online in Natalie's workshop was Pat from Canada. We remain Facebook friends and chat once in a while. She paints floral pieces using acrylics and teaches art classes. I enjoy her motivational thoughts that she periodically posts on Facebook.

My second study buddy I befriended was Nancy, who lives in St. Louis. You will read later about her.

Another study buddy was Carol, who lives in Ohio with her husband and five dogs. You will also read about her later.

I learned that we need to remove our disempowering beliefs and surround ourselves with positive people who will support and believe in us. We need people who will help us to stretch and grow which will give us new beliefs and happiness. No dream is too big, and every goal is achievable. If you want something, you need to feel like you already have it—envision it. Your thoughts and actions must be in alignment. The people who act will be the successful ones in life. You must take action.

I learned about the Artist Hines in 2015, from Stephanie Gagos who adores his artwork. I discovered he lives in Novato, California,

and his studio is in Sausalito, just north of the Golden Gate Bridge. I called him and scheduled an all-day private lesson on his abstract technique in intuitive art.

The experience was fabulous. He taught me his technique for intuitive abstract art, and together we created a beautiful art piece. As we stood side by side in front of the blank canvas, he instructed me how to paint using his technique and would occasionally add his part to the painting. At one point, he let me paint on my own and would settle back in his chair and play smooth jazz on his guitar. It was such an invaluable, inspirational experience of a lifetime.

Right before the completion of my art piece, he told me to simply add a scribble of something like a checkmark or a simple stroke to make it exciting and random. I entitled it *Abstract Dance*. I learned also from him to never date my work and to use a color for my signature that won't distract from the painting; it needs to blend in with the colors.

It was my first experience with intuitive art, and I was hungry for it. This artform is a spiritual, connected art process that allows the art to lead the way as images form through the layers of paint and a variety of other media. You create art using an inner, heart-centered awareness—it is a way of creating that is about connecting with your emotions and responding to what feels right. Intuition is that image of a child reaching for the red crayon rather than the blue without hesitation. You do it intuitively.

Hines says, "In your abstract painting there are no negative judgments, just decisions and to keep yourself open to 'happy accidents.' These are things that just happen on the canvas that you consciously would never have done. You just cover the canvas with paint and wait to find the event that's happening on the canvas, and at some point, the canvas is going to reveal to me or each other the painting." He likes to put on an aggressive song to keep him moving and allows him to let go. In the whole 'dance of painting' he uses the brush like a brush but also uses it like a sledgehammer and really presses it into the canvas. He says: "Abstract painting is an adventure; a journey.

I don't plan my paintings but arrive at them. Abstract painting is spontaneity. It is the intuitive physical act of painting, the dance that interests me. Everything that happens on the canvas is simply an opportunity for observation, for change and something new, allowing me to tap my subconscious to utilize my academic knowledge of painting and technique throughout the painting process until inevitably I arrive at what satisfies me."

Chapter 52

The following are a few of my paintings and some of the thought process and/or feelings behind the paintings. Enjoy!

I painted *Words of Inspiration* in 2015, and gave it to a friend who nearly cried because I used her own words of inspirations for her business and goals. Using acrylics, I painted the background was splashes of colors and butterflies with positive words including love, faith, live your dream, inspire, resilience, persistence, and hope. The canvas was twelve inches wide by thirty-six inches tall which was different for me and quite a change.

Another piece I painted was on an eleven-by-fourteen-inch canvas using a crazy combination of acrylic colors that flowed into each other sort of psychedelically which is why I entitled it *Psychedelica*. This piece sold.

My twenty-four by thirty-inch piece that I entitled *State of*

Confusion, was an experiment where I used watered-down acrylics dripping them onto the canvas which I thought was really interesting. I was feeling confused at the time of this creation and it kind of expressed that and gives that precise effect—confusing!

Another one I painted I entitled *The Emerging.* The interesting story about this painting is that years before I painted a boring acrylic piece of a reddish flower on a twenty-four by thirty-inch canvas. I had put it aside for years until I was looking for something to paint, and my eldest son suggested that I take that piece and redo it as an abstract. That is indeed what I did. I took the piece and added to the left side of the flower an abstract cloudy effect (that I learned from the Artist Hines) with colors of blue, green, yellow, orange, and red, and I called it *The Emerging* as if the old flower was emerging into a new realm. The print sold but I still have the original which means a lot to me so it's not for sale.

I painted *Unleashed,* a twenty-four by thirty-inch piece when I was feeling a bit of turbulence in my live so the abstract could be interpreted in different ways. I painted the background blue with white sky and toward the bottom I used black and red. To some, it could mean the positive overcoming the negative. This piece sold.

My acrylic abstract painting, *Green Warrior.* The twelve by twelve-inch piece gives you the sense of a green warrior fighting against the colors of green and yellow against a sky of dark blue. This piece sold.

Chapter 52

I created a piece entitled *Forgotten Paradise* which was an image in my imagination of a beautiful paradise beach with a lake in the forefront surrounded by wild foliage, and pink tropical flowers on the left and a wild reddish-orange sky up above and light blue trees in the background. This piece sold.

Songbird was a quadriptych painting done on four canvas panels of six by six inches. Placing all four pieces together the composition was an abstract background with a gradation of colors of black, dark brown, orange and yellow with a black silhouette of a songbird sitting on a branch. This piece sold.

Mikhail's Delight was an abstract piece created from my imagination and inspired by my neighbor, Mikhail, who was kind of eccentric in his ways. I painted a silhouette of a city in black in the background and a blue-colored reflection in the water in the foreground. The sky was of black and white suggesting a storm coming in, and the foreground which was kind of a turbulence of black and white gave the illusion of a black hole going into the turbulence or water. The hole could have the illusion of an escape from reality or whatever the creative mind conjures up. It was a fun piece to work with.

White Fire was an abstract diptych painting from my newfound

interest in abstract. At the suggestion of Cody's friend Mike, my painting consisted of two thirty-six-inch by twelve-inch canvas panels; each positioned sideways, one on top of the other forming the design. I had painted the background of both panels blue with white flames dancing upward. Mike, of course, purchased it. My coworker Patti purchased a duplicate print of it.

I was inspired with my newfound freedom with abstract-style painting so I created *Freedom Dancing*. I painted clouds of white, dark blue, black and dark red with stars with acrylics, and a red haze running through the center. Five cloud-like images of naked ballet dancers with white paint dripping from them are the main subjects of the composition. It was quite a different painting for me.

One day in early spring my coworker JoAnn was in the process of planning her wedding ceremony to Pete and asked if I would paint their money box for them. She handed me a wooden box and wanted Hawaiian ocean images painted on it. So with acrylics I painted an ocean and tropical flowers on each four sides of the box and on the lid I painted an ocean and added the bride and groom's names and wedding date. I created a three-dimensional effect by using molding paste to create ripples in the ocean waves. It was quite a different piece and it turned out beautifully.

Chapter 53

I participated for the first time in the annual Stanislaus Artists Open Studio Tour in the spring. Since I had missed the deadline to sign up, I was invited to do a live demonstration of my art for Nasco Supplies instead, which was at least a way to get "my foot in the door." I was intimidated at first because it would be a "raw performance" and definitely way out of my comfort zone. But after some thought, I figured it had to be very similar to face painting in front of a group of strangers and even the prophetic painting I'd done in the past, right? So I decided to accept their offer and what an experience it was. I discovered that I was quite comfortable interacting with the public and encouraging customers to have their child's faces painted. It was quite a positive learning experience, and I really enjoyed myself.

The Friday night before the open studio tour I joined ten or more fellow artists to promote the event, and we displayed our artwork at the Gallo Center for the Arts in Modesto. I met fellow artists Monica who showed her fine line paintings of animals; Doug, who was displaying his sketches; Rita, who was displaying her acrylics; and Tammy, who was displaying her pottery.

I chatted with local patrons who were there attending the symphony that night. I displayed two of my abstract acrylic pieces, *The*

Emerging and *She Told.* A Sixteen-year-old young man was interested in *The Emerging* and wanted to know how I created it. He then joined his mother in the theater to watch the symphony performance.

After the concert ended, I was surprised to see that the young man had brought his mother over to me. After some discussion with her about budgeting and determining if he had enough money to afford the painting, he fell short. His mother, however, offered to loan him money for the balance. I was thrilled! They paid me and took the painting that night. What happened next was the young man told me that he was drawn to my hearts painting, *She Told.* I explained the meaning and purpose of it and that it was going to be entered in an upcoming Art For Justice event and that if he wanted it, he should check it out at the event. Well, the event came and went, and the painting didn't sell. Amazingly though, one year later, I received a phone call from the director of the Art For Justice, and she said, "A young man just purchased your painting!" I was amazed that he remembered it from a year before and came back for it.

Chapter 54

I started taking an interest in working with seed beads which are little teeny miniature beads that sort of look like plant seeds which is where they got the name. I took a class from a bead shop downtown to learn to make a many-layered seed bead bracelet. I chose purple beads, and my clasp was a larger-sized clear crystal. The project took me three workshop sessions to complete; it was extremely challenging because of the small size of the miniature beads and the complexity of the pattern. It turned out to be an elegant piece of jewelry that I hope to pass down to my sons/daughters-in-law as a family heirloom.

Then I signed up for two evening classes on the techniques of playing the harmonica at the local community college. I'd had my own harmonica since I was a kid, and early on, I learned some basic songs like "Michael, Row the Boat Ashore," sung by Peter, Paul and Mary; and "On Top of Old Smokey," an old folk song from Burl Ives. I wanted to further develop my technique and learn the wah-wah sound that is produced by inhaling or exhaling on any one hole of the harmonica. A chord, I learned, is a combination of three or more notes played together and in some songs you can play two notes together which is called a double stop. When you blow or draw air through the harmonica, the reeds inside the instrument vibrate to

produce sound. These reeds are tuned to vibrate a certain frequency to produce specific notes. Blowing into the harmonica can produce one note, and drawing air from the harmonica produces another note. I wanted to learn again because my crazy dream is to sit on the sidewalk in the French Quarter of New Orleans and belt out wah-wah sounds from my harmonica. The classes were fascinating but I never quite got the hang of perfecting the wah-wah sound. "You're supposed to hold the harmonica in your left hand between your index finger and thumb and curl the rest of your left hand fingers behind the harmonica to form a cup shape. Then with your right hand, you join your thumb and index finger to make a loop which you then slide over the end of the harmonica. This loop will be the hinge that you use to open your closed cup and make the wah-wah sound." (tomlinharmonicalessons.com)

Some of my art was accepted into the 2015 California State Fair Fine Art Competition and also the Annual Central California Arts Showcase. Other exhibits that my art has been shown in included Central California Art Association member shows and the annual Exhibit of Fine Arts, Tracy Art League Gallery.

I donated *Psychedelica* to my third year participated with the Art For Justice fundraiser, sponsored by the Stanislaus Center (Modesto). It was interpreted from six-year-old Alina's painting entitled The Safe Place. Alina's words were "I feel safer here than in my house." My words were "Alina's creation inspired me with my abstract painting done with fluid acrylics where the paint moves freely like a river—a river of freedom. In this river, you can imagine safety. It's a safe place."

Chapter 54

In September of 2016, I participated in the Modesto Artist Salon art exhibit held at the Queen Bean Coffee House in Modesto. It was an all-day event and pretty cool. Among the participants were AmyAnna and Monica, both of whom I had become acquainted with through art exhibits. My son's friend, Michael, was also accepted in the exhibit for his first time. The exhibit included music by VCR Beatbox, Reflection Duo, Three Second Rule, and Sound by Sleek the Geek. It was quite an exciting day and I sold a couple of art pieces which is always a plus.

I entered *Springtime Blooming* (twelve by eighteen inches) in the annual Spring Obsession Art Show watercolor exhibit at the Ironstone Vineyards in the small old mining town of Murphys. I felt timid with my submission, but I forged ahead and drove up to Murphys, which is about sixty-two miles from my house. I had been there only once on a motorcycle run, so I vaguely recalled the little town.

According to Wikipedia, Murphys is an unincorporated village located in the central Sierra Nevada foothills, between Lake Tahoe and Yosemite National Park, in Calaveras County. A former gold-mining settlement, Murphys' main street today is lined with over two dozen wine-tasting rooms and surrounded by local vineyards. The town is popular among tourists and transplants from the Central Valley and the San Francisco Bay Area. Murphys is known by its colloquial nickname as "Queen of the Sierra" and is one of the more affluent communities in Calaveras County. The drive, it seemed, took forever. When I entered the town, I followed the GPS directions, and the dusty road finally led me to the vineyards. I submitted my painting

and walked around the grounds for a while and visited the visitors' center and gift shop. It was a great art exhbit. Although my entry didn't place in the contest, the experience was well worth it plus I sold the original to Carole Richard, a former coworker. Very proud day!

I painted *She Told* for the fourth year that I donated to the Art For Justice fundraiser for the Stanislaus Center (Modesto). My art piece was interpreted from ten-year-old Divanai. The workshop, Heart Stories, supports children and teens in sharing their hearts and stories through art and gives them an opportunity to listen to their hearts, value the stories within them, and know that others want to hear them too. Divanai wrote, "My sister is brave. She is the one who told." I wrote, "The significance of the sister's courage and strength with coming forward to break the silence is life giving. Now the circle can be broken, and the healing can begin. Her sister has given her the sense of safety and hope for the future, and the tears now shed can be tears of healing, joy, and empowerment for Divanai and her sister."

Chapter 55

In 2016, I was given the exciting opportunity of being the featured artist in my hometown displaying my artwork in a solo exhibit at the Los Bagels Truchas Gallery, Old Town Eureka. I give credit to my longtime friend, Linda Erickson, who got me into the venue. I exhibited my series of Humboldt County watercolors and later had them copyrighted as the "Humboldt Collection." That was a huge highlight in my life as an artist and quite an honor for me to be recognized in my own hometown.

The idea of painting local icons from my hometown stemmed from the suggestion of a coworker and my biggest cheerleader, John Harrington, who has always given me suggestions, prayer, and encouragement to keep going. His constant words were "You can do it; you have the talent." In fact, he had nicknamed me "Paint Princess." He told me I needed to create a painting that has meaning for each individual buyer. So I painted several of the local icons that I knew would touch the hearts of area residents. I started following a Humboldt County Facebook group of photographers and found many photos of the local beauty, so when I found one that inspired me, I painted it and told the photographer, asking for their permission to enter the painting in the exhibit. I give much credit to all of them.

I am especially grateful for one local photographer, Sherril Good; I was totally inspired by her photos of fences and flowers. I painted two of her photos that were entered in the exhibit: Eureka Backyard Flowers (orange flowers along a fence) and Rusty Backyard Gate (an old gate falling and rusted). Both paintings sold.

A reception was held for me at the gallery, and many art lovers showed up. I enjoyed chatting with the patrons and answering their questions about my paintings and their meanings. Many of them could personally relate to some of the pieces since many were of popular Humboldt County historical icons and favorite scenes from the area. Some of my longtime friends came out to support me. On the second day of the exhibit, I drove my parents to the venue, which was exciting to them. Both the Eureka Times Standard and the Arcata local press printed articles about my exhibit.

The Eureka Times Standard printed the article entitled "Humboldt County inspires artwork." It read, "Lynn Takacs is the featured artist at Truchas Gallery at Los Bagels in Eureka for the months of June and July. The gallery will be showing her newest works entitled 'The Best of Humboldt' (including her Humboldt County collection). Takacs was born and raised in Arcata and currently lives in Modesto. She took art classes at Arcata High School, earned an AA degree in business from College of the Redwoods and studied fine arts and graphic design at College of San Mateo, as well as Academy of Art University in San Francisco. Her art was accepted in last year's annual Central California Arts Association (CCAA) Showcase in Modesto and Turlock. Other exhibits have included CCAA member shows and the annual Exhibit of Fine Arts at the Tracy Art League Gallery. She also participated this year in the annual Stanislaus Artist Open Studio tours, and she is an ongoing participant in the annual Art For Justice fundraising event sponsored by Stanislaus Family Justice Center in Modesto. She credits her Humboldt County collection to Humboldt's local photographers for inspiration."

They then printed a second article with the headline, "Artist has her first solo show. She is showing her artwork this month at Truchas

Gallery in Los Bagels, 403 Second Street, Old Town Eureka. The show is entitled 'The Best of Humboldt.' Takacs first discovered her art interest in grade school when she took a cartoon class and her cartoon elephant earned a proud space in the school's display cabinet at the front of the school. She continued to take art classes throughout her life. Her head was always 'in the clouds' dreaming of art because she always knew she wanted to be an artist. Her mother had a huge influence on her using her art abilities in her early 30s. She encouraged Takacs as a face painting artist, which ultimately led to jobs on cruise ships touring the Caribbean. This is Takacs's first solo art show. She has more than forty original art pieces for sale. An 'Arts Alive' reception is set for Saturday 6-9:00 p.m."

From that exhibit I learned to believe that I could do it and that not all of my art would be for everyone, but each piece would eventually reach the heart of the right person—the owner. I've learned to be patient and not give up and that in order to grow, I have to put myself out there and toot my own horn because no one else will. I've also learned not to shy away from saying who I am, what I do, and what I plan to accomplish and also that taking a risk is not as scary as I thought especially when I take steps to achieve my goals. In fact, I get better at it with practice.

Among the pieces displayed at the exhibit were the following:

- *Pampas Grass*: wild grasses with a background of the ocean. (sold)
- *Making the Best:* one of the locals paddling through the flood waters in Arcata.
- *Jetty Splash*: Arcata ocean waves splashing. (sold)
- *Sunnybrae Backyard:* one of the local's backyard sunrise in the community of Sunnybrae. (sold)
- *Carson Mansion*: historic icon in Old Town Eureka. (sold)

- *Hopland Sunflowers*: my niece photographed these sunflowers in the small town of Hopland. (sold)
- *Trinidad Beach*: beautiful beach in Trinidad. (sold)
- *Mid-Day Poppies*: beautiful red and orange poppies with the brilliant sunlight showing through.
- *Luffenholtz Lookout*: popular Luffenholtz beach in Trinidad. (sold)
- *Baiting for Sable Fish*: local fisherman at Woodley Island in Eureka.
- *Winter in the Bottoms*: old barn in a field with geese in an area of Arcata known as "The Bottoms."
- *Ritz*: historic Ritz building built in 1885. (sold)
- *Nighttime Ritz:* The Ritz once came to life as a popular bar scene at night. (sold)
- *Bim's Arcata*: from Arcata archives, a popular downtown hangout for youngsters. (sold)
- *Restoring the Turret Carson Block Building*: restoring of the historic monument.
- *Old Arcata Road Flooding*: car splashing through flooded waters in Arcata.
- *Woodley Island Fisherman*: statue of a fisherman that honors those "whom the sea sustained…and those it claimed." The statue was sponsored by the Commercial Fishermen's Wives of Humboldt through community donations and was dedicated in 1981.
- *Jerry's Calla Lilies:* a local resident's calla lilies in his yard.
- *Richardson Grove State Park*: series of watercolors inspired by memories of many years of family camping at Richardson Grove. It was like our home away from home.
- *Centerville Beach Thistle*: beach in Ferndale. (sold)
- *Eureka Backyard Flowers*: orange flowers along someone's fence. (sold)
- *Rusty Backyard Gate*: old gate falling and rusted. (sold)
- *Country Mailbox*: a heartfelt scene from the neighborhood in which I grew up during my high school years.

- *Brookwood Covered Bridge*: many memories of walking down the road from our home in Bayside and sitting on the edge of the covered bridge for peace, serenity, privacy, and meditation. It was such a peaceful place, and listening to the quiet babbling brook was so calming. (sold)
- *Los Bagels Eureka*: the venue where my watercolors were displayed in 2016. (sold)
- *Eureka Theater*: favorite historic icon in Eureka. (sold)
- *Sunset at Moonstone*: Moonstone Beach County Park was a favorite place we visited as a family just to play in the sand. The park is on the north side of the Little River mouth near Trinidad. The beach is popular with surfers and also with families who can play safely in the slow river current. Depending on the time of year you visit, the river can be wide or just a trickle. Moonstone is a picturesque beach with rocks and larger sea stacks poking up out of the surf. The large two-humped rock island known as Camel Rock is visible to the north. (sold)

The exhibit was a huge success, and I sold more than a dozen originals and prints to residents. A few locals even contacted me after the exhibit asking to purchase more. It was quite a proud moment in my life as an artist and was quite a meaningful experience because I was sharing my artwork with folks in my hometown, my roots. From this memorable experience, I copyrighted my Humboldt series of paintings.

"A goal should scare you a little, and excite you a lot." –Joe Vitale

Chapter 56

In 2016, my *Healing Hearts Tree* painting was featured on the front cover of a company booklet for grieving children. The booklet would be used as a tool to help guide them through the grieving process.

Painting has given me purpose and a sense of inner peace. The tree in *Healing Hearts Tree* (done in mixed media) symbolizes our inner strength that stands tall and strong at the end of each day, and the warm colors of the sky illustrate the beautiful sunset. The hearts are releasing our sorrow and fear, allowing our spiritual guidance to heal us through grieving. Art has always been an exhilarating experience for me. I am inspired by art because of the freedom—my imagination is set free. Each painting I complete is a celebration of the instinct that guides my every brushstroke. Painting keeps me in alignment with my purpose and on track with who I really am and I paint because it makes my heart sing. I used watercolor, acrylic and alcohol ink and just played like my mentor Chloe taught me. The original painting sold as well as a print of it.

Chapter 56

Then I was asked to display my artwork downtown at the ModSpace Tech exhibit in which local businesses host for artists. It was an exciting adventure to display my works for an entire month at the venue. I displayed about twenty paintings.

Chapter 57

Fellow face painter and balloon twister, Carolyn, owns Balloon Creations in Sacramento. In the fall one year I registered to attend a workshop she hosted with Pashur as the guest instructor. He mainly taught how to paint Halloween zombie faces. He demonstrated three faces (I've listed steps and techniques for each face below):

Zombie Face No. 1: Sponge black paint around the mouth; load your brush with white and then yellow with a No. 4 or 5 brush for the zombie teeth. Use dark red on the outside of lips with a sponge and then add a little red around the sides of the mouth. Swipe black on the nose with black paint and then red. Drag a wet brush through the black and red for veins. Use Ben Nye Fresh Scab with a stipple sponge or a Popsicle stick. For blood spatter, use a large toothbrush for flicking blood.

Zombie Face No. 2: Use a splotchy black with a sponge and dark blue for a rotting effect. Use Mehron Paradise White and blend all together, with white streaks coming down the neck. Use Krylon black for the zombie face. Use a No. 5 Filbert brush for around the drips and then sponge in the rest. Use a No. 5 round brush and lime green for creating teeth. For zombie skin, apply with a Popsicle stick and rub all over the face.

Zombie Face No. 3 Create splotchy black using Krylon black and

Mehron Paradise white with your sponge and dark blue for a rotting effect. Blend together and make white streaks coming down the neck. Use paintbrushes for grease paints, and separate them from face paints.

Later in a summer workshop I learned that the Ben Nye palette can be a lifesaver in the hot and humid summer months. You can use a smoothie blender or Popsicle-shaped eye shadow applicator for your design base. Then paint the line work with your favorite paint, such as Wolfe or DFX. One good thing about the Ben Nye pressed powders is that you can use them with water and then turn around and use them dry. Not too many powders can do that. It's fun to take silver Mehron powder and put it on top of the Wolfe metallic silver paint, add a spritz of water, and stir. Then paint as usual. It works great and gives great coverage.

Chapter 58

For the fourth year my employer asked me to create their annual Christmas card so my 2016 card design was entitled *Christmas Bears* inspired by the annual fundraising Christmas tree events.

During this time in my career I was into painting designs on wine bottles. Using acrylics, I painted brightly colored swirly designs on each bottle and, of course, added glitter and ended giving some of them as Christmas gifts.

Later I painted on the outside of clear Christmas ball ornaments and dripped alcohol ink inside the ornaments. I experimented with alcohol inks, thanks to the inspiration from my friend Debbie Boudreau, who does gorgeous work with the inks. I experimented on tiles, ornaments, and Yupo paper. Yupo paper is a unique alternative to traditional art paper. It's a synthetic, pulp-free (tree-free) paper that is made in the US from 100 percent polypropylene. It's super smooth, durable, and waterproof—watercolor paints rest on the surface rather than absorbing into the paper. When dry, you get much more brilliant color than you would with something more absorbent. I enjoyed experimenting with these new techniques.

From time to time, I was asked by my employer to paint signs for fundraisers. One time I painted two sets of cornhole boards with the company name and logo on them. Cornhole is a beanbag toss

game in which players take turns throwing small bags of corn kernels at a raised board with a hole in the far end. Another time I was asked to paint the company logo on large river rocks to be used as paperweights to hold down stacks of literature on table displays at vendor exhibits. Another time I was asked me to enter a decorating contest at one of their care-home partners. So I painted a designer Halloween pumpkin with a haunted house complete with bats, spiders, and ghosts. Another contest I entered at yet another carehome was a Christmas wreath wrapped in leaves from a Douglas fir tree and decorated with blue ornaments, pinecones, and ribbons, and then sprayed with white frost snow. It was gorgeous.

Chapter 59

My second time at FABAIC (Face & Body Art International Convention) in Orlando was in June 2017. I shared a room for the second time with Sandra from Gretna, Louisiana, and one other roommate. Sandra brought boatloads of homemade crawfish meals again with an ice chest packed with food and drinks to minimize our eating expenses. She is a phenomenal cook and a hairdresser by trade. Like me, face painting is her side business.

The sun was so warm and pleasant during a break in between workshops so I took my box lunch out to the hotel pool and asked a fellow convention attendee if I could sit next to her. I became acquainted with Paula Martin who lives in Tennessee and used to live in Los Angeles. Paula and I quickly became acquainted that day and formed a friendship. Since the writing of this book, Paula and I have become Facebook friends. She has an amazing talent. In addition to being a face painter, she paints pet portraits, and during the Covid-19 pandemic, she has sewn beautifully colored masks. She lives with her husband and several dogs. She loves the outdoors and hikes and sails. More about Paula later.

In one of the workshops, I met Raquel from Patterson, just forty-five minutes from where I live. That was her first time at FABAIC, and we became friends. It's amazing that we flew all the way to Florida

to meet when she's practically in my own backyard. To this day, Raquel and I are still friends and share ideas and clients within our local networking group and support each other as entrepreneurs.

The following is what I learned from the many workshops:

Bring on the bling: Use a Popsicle stick with water to dip into your glitter. Make your own gems and store them in a small binder inside plastic sleeves. Use flower stencils for embellishment. Use the same one-stroke design on the eyelids as you use on the forehead. Chunky glitter is the newest thing to add to a design. Use star stencils instead of painting stars freehand; it's quicker and more accurate.

Butterflies: Use a No. 3 long liner brush. Apply body glue to the areas you want your bling placed. Use daubers to dip into the glitter glue, pick up the teeny gems, and place them on your design. When using glitter on boys' faces, they seem to accept it more if you call it "dude dust"! They now think it's cool. For line control, laminate a "last in line" sign with your business information, punch two holes at the top of the sign, and string a ribbon or string through it. This can then be hung around the neck of the last child in line with the sign hanging down their back. Or use spray chalk to spray a line on the grass "start here." That way kids won't crowd you while you're painting.

Creating clients: Target your audience. Contact clients past, present, and future. Have a goal of maintaining your client base. If you refer a fellow face painter to a client and that person is not professional or is grouchy, ask the client to let you know that and then deal with it. It's good to reach out to conference centers and trade shows. Analyze your area; see what type of people live there. Target the places parents go. Find out where kids go. Make a list of dentists, doctors, nursery schools, preschools, karate schools, parks, pizza parlors, swim teams, party stores, sports arenas, pediatricians, feed stores, pet shelters, country clubs, etc. Make a category for small children, day care centers, and nursery schools. Tell the director that you entertain children.

Creative ideas: Create 50-cent necklaces with unicorns, rainbows,

fairies, etc. for kids who can't get painted. Ask prospective clients if they have an area in their business where you can place your business cards or flyers…maybe a countertop, file cabinet, or waiting room. Keep a list of where you left your business cards, and keep track of which location you gained clients from. Always purchase several business card holders to keep with you, so whenever you come across places where you want to advertise, you are prepared. Learn when and where there are day care center trainings or early learning coalitions; be there with your business cards! Learn about the Department of Children & Families (DCF). Wear your apron when you show up. Wear your business card on a lanyard around your neck. Put your business cards on a magnet. Keep separate books on past clients and prospective clients. Revive and rebuild your client list. Send birthday cards one month before a child's birthday reminding parents that you are available. Tell parents that you have memories of painting for their son or daughter the year before. Bring a gift for the child to their party.

Holiday designs: The instructor demonstrated some cute little holiday designs on the face using split cakes. She uses googly eyes on her dragons. Other tips include the following: Use finger daubers for stenciling paints. Use one brush per color, which saves time, rather than switching colors on the same brush. Clean your brushes with liquid soap. Use tattoo glue and dab areas with a Q-tip. Spray your brush with alcohol and dab into your glitter. You should charge your client a nonrefundable deposit so you are somewhat compensated for the lost opportunity for work if the client cancels. Give your client a ten percent discount if they pay in full. Operate from prosperity not scarcity. Some good book reading to consider for building your business includes *Getting Things Done, Living Forward, Purple Cow, Tools for Titan,* and *Rework.* Keep a "best self-journal" that makes you write your goals and keeps you on task. Create a short video from your phone to tell the birthday child that you are excited to be at their party.

Check out Steve Harvey's YouTube video *You Gotta Jump to Be*

Successful. He says this: "You must identify your gift and live in it. If you don't live your gift, your education won't take you anywhere. The only way to get your parachute to open, you've got to jump. You have to jump off that cliff and pull that cord. When you first jump, your parachute won't open right away. You're going to hit the rocks. But eventually the parachute has to open. That is a promise of God.

You gotta jump. That's the only way to get that abundant life. You can play it safe and deal with it without the cuts and pains, but if you don't jump, your parachute won't open. That's the only way to get to that abundant life. Before you die, jump! Every successful person has made the jump. When God created us, he created a gift in all of us. When you hear about or see people soaring by and you hear about them doing wonderful things, have you ever thought maybe this person has identified their gift and is living in their gift? The Bible says your gift will make room for you, not your education. If you don't use your gift, that education will only take you so far. So the only way you're going to soar is that you've got to jump. If you don't ever use your gift, you'll just end up going to work."

Art on the spot: For painting lips, use a chisel brush and start with the point to the inside of the lip and lean in to the full painting. When blackening eyes, paint the eyes black and have the model look up to see where the paint leaks into the crease of the eyelid. Then use that extended line as the guide for the whole eye shadow. I met Sandra Bates from Ohio in this class.

Mindful matters: The energy you bring to the party will set the tone. Pay attention to your purpose without judgment. Let things happen, and don't overthink or judge your thoughts. Think about your professional goals. Focus on the moment you are in, and ask yourself what your mindful goals are. Quiet goals help the busy goals.

I met up with my dear friend Connie Lyon (she attends most major conventions) and the following tips are from her own words: "Create "I Love Tips" buttons. Be as attractive as possible and stand out as much as you possibly can. Wear outfits and colorful headgear

that stand out. My "why" is to follow my passion, perfect it, and make kids and adults joyful with my art because my passion dies when it's being held back. When my passion is held back, I am not happy. My "what" is to pursue my passion full-time with no longer being held back."

I met Paula at the FABAIC conference at the poolside during a lunch break. I saw her sitting alone so I asked if I could join her. We quickly became acquainted and I learned we had several similarities. She had a sister in Los Angeles and had moved to Tennessee for love. She was a dog lover like me and had similar artist experiences. We became friends.

Paula says this about her life: "My life is an open book. I bring my art into it in sections, mentioning that my inspiration comes from nature. My idea of a good time is being outside gardening, hiking, camping, tubing, and cooking. They say people are left brained or right brained. I have concluded I am right down the middle! As a student I was always adept in math and science but would spend my boring class time doodling on my folders and sketching animals. I was born in Southern California and was raised by a single mom. We moved to Florida when I was fifteen, and I spent much of my time daydreaming on the beach, watching the birds, dolphins, manna rays, and the like. I always had a great love of nature and the ocean. I moved out on my own at seventeen.

I met my first husband who had a bait shop on the Indian River in Florida and was introduced to air boating, alligators, manatees, and all the wonderful fish in the brackish waters! We later moved to Kentucky to become homesteaders. I spent much time walking through the woods getting to know the different variety of bugs, mushrooms, wildflowers, and trees of that region. We grew our own vegetables in the summer. The marriage lasted only two years.

Chapter 59

I continued driving a truck for another five to six years, driving for the country music industry. I drove for many of the big names such as Brooks and Dunn, Tim McGraw, Reba, and Charlie Daniels. While touring I met the love of my life.

At this point I decided to come off the road and go to college. We both had a pipe dream of having our own coffee shop, so I went to college to gain knowledge on having my own business. I took some art courses as a reward. Nothing much became of either of those paths until my sister introduced me to face painting.

That's when I learned the truth about myself! I am highly motivated by money, and I have to enjoy what I am doing to earn it. It was a slow and rocky start, but I gradually grew my business and employed other face painters as well. I have also taught face painting at the local community college. My business has come a long way from when I first started, and the amount of amazing, creative talent that is in our world just amazes me. But face painting is a seasonal thing. So I started thinking of other ways to supplement my income.

One day I saw a craft magazine with wooden kitchen utensils with wood-burned designs. I showed my first simple pieces to my hubby and some friends, and they loved them. I was inspired to create more. I bought a professional burner and practiced more. They have become a big hit, and I love making them; my designs are organic in nature, mostly consisting of plants and animals, and I sell my spoons in shops. But alas, Covid-19 came along and shut down all my outlets for selling. So once again, I find myself trying to reinvent and with no way to sell my spoons or do face painting, I have lost my desire. With both of us having no income, I jumped onto the face mask train, and we both worked twelve- to sixteen-hour days trying to keep up with demand.

Then the commercial market caught up and business slowed. When my goods were no longer in demand, I once again lost interest! I faced the reality of having a real job. I just recently entered a local craft show and was planning on selling my spoons and whipped together wall hangings with macramé and found wood objects with

air plants on some. I burned some designs onto beads for macramé potholders, etc., anything I could create to bring in some income, but Covid-19 reared its ugly head again and the show was cancelled.

The defeat really got me down, and I was ready to give up art in all forms. But that wouldn't be true to myself because I always must create. I don't need to be the best or most original, but I must create. I plate my food like a chef and arrange my houseplants on their mantle by composition, and I will continue to craft things from found objects. I will continue with my pet portraits and strive to loosen up my painting style. That left-brain, right-brain thing—that is what holds me back. I'm too uptight to paint the loose free style that I love."

Chapter 60

I really thought I had a body painting opportunity at a coffee shop in 2017. I spoke with the local manager of Bottoms Up over the phone and he seemed to be open to the idea of me body painting the coffee servers since they served the public in bikinis. I thought by painting their upper bodies, it would draw more attention and possibly even bring them more business.

As printed in Yahoo! Entertainment in the Entrepreneur section, June 19, 2015: "A Coffee Shop Franchise Where the Baristas Wear Almost Nothing Is Actually a Thing. You could call it "the Hooters of coffee," but even that seems too tame. Bottoms Up Espresso made an appearance at the International Franchise Expo in New York this week, standing out in a hall filled with franchises from The Halal Guys to Mosquito Joe. The concept, which labels itself the world's most recognized bikini coffee shop, only got its franchise disclosure documents approved about a month ago. Now, it's ready to welcome some new franchisees.

"I think we're just a fun, good place to go," says Bottoms Up Espresso co-founder Nate Wilson, who co-founded the first location in Modesto, California in early 2011. There are currently six locations, all in the Golden State.

The Bottoms Up menu is filled with suggestive beverages like the

Blonde Bombshell espresso drink (made with toasted marshmallow, caramel and white chocolate) and the Sex in your Mouth twisted energy drink (guava, passion fruit, peach strawberry and orange juice). Servers wear bikinis—or something like them—a fact that is extensively documented in the company's semi-NSFW social media accounts. The lower end of the investment range is $25,000 to $50,000, as the drive-thru concept allows for fewer expenses than a typical coffee shop.

Perhaps surprisingly, men aren't the only customers. "We actually do have a high [number] of women clientele," says Wilson, who says that the chain's high-quality ingredients are just as important to success as its busty baristas. "Women come through, they try it, and then they love the drinks so they keep coming back." (NSFW above refers to "Not Safe for Work" which is Internet slang or shorthand used to mark links to content, videos or website pages the viewer may not wish to be seen looking at in a public, formal or controlled environment. Wikipedia)

All locations only serve drive-thru or walk-up customers; the chain has no plans to expand into the walk-in market common among "breastaurants" and other bikini-restaurant concepts.

While the concept hasn't signed a franchisee yet, Wilson says it shouldn't be long, with around 300 leads from interested franchisees that the newly-approved franchise is currently sorting through."

The manager was an hour late, and when he did show, he changed his mind and was unreceptive to my idea. I thought my brainstorm would have been a fabulous venture. Oh well, it was a cool idea. I will approach him again someday.

I donated *My Protector* in the fifth year of participating in the Art For Justice fundraiser. My art piece was interpreted from nine-year-old Juan's painting. The workshop was "My Scarecrow." Scarecrows

have been used by farmers to frighten away intruders (crows) and keep them from eating their valuable crops. This activity helped children focus on protection. They could make their own special scarecrow to scare off their intruders. It also provided the opportunity for them to identify what was valuable to them. (For example, crops are valuable to farmers.) During the workshop, they could notice what, for them, needed protection. My words were "This young man's protection is the scarecrow too. My watercolor sky emanates from Juan's sky and offers protection under the tree."

I had a second opportunity to display my watercolors in my hometown of Arcata at the popular downtown Plaza Grill inside Jacoby Storehouse (which back in the day was the old Bistrin's Department Store). It was another boost to my art career, as well as another reason to visit home again. A short piece was posted in a local newspaper with the display too. It read "Jacoby Storehouse, 791 Eighth Street, Arcata, Wine Pour to benefit Friends of the Dunes at Pasta Luego; watercolor paintings by Lynn Takacs in Plaza Grill; representational drawings by Jay Brown in the Mezzanine Gallery" and so on. Jay arranged for my exhibit. Thank you, Julie and Rich Villegas, for presenting the opportunity for me.

I painted for the second time *Eureka Boat Docks*, a remake of an original that I painted for my nana years and years ago when I lived with her for a short period of time. The painting is of the Eureka boat docks in Old Town Eureka at sunset. The boats were painted in black with a background of the colorful sunset. I don't know what happened to Nana's original painting, but the remake ended up in Mom and Dad's bedroom above the headboard of their bed for several years.

I joined members of the Mistlin Gallery and took a field trip on a chartered bus to Legion of Honor Fine Arts Museum of San Francisco to tour the exhibit "Claude Monet: The Early Years." My friend Yolanda accompanied me on the bus tour. It was a fantastic exhibit and quite an inspiration.

According to Wikipedia: Oscar-Claude Monet (November 14, 1840–December 5, 1926) was a French painter, a founder of French Impressionist painting, and the most consistent and prolific practitioner of the movement's philosophy of expressing one's perceptions before nature, especially as applied to plein air landscape painting. The term "impressionism" is derived from the title of his painting Impression, soleil levant (Impression, Sunrise), which was exhibited in 1874 in the first of the independent exhibitions mounted by Monet and his associates as an alternative to the Salon de Paris. Monet's ambition of documenting the French countryside led him to adopt a method of painting the same scene many times in order to capture the changing of light and the passing of the seasons.

From 1883, Monet lived in Giverny, where he purchased a house and property and began a vast landscaping project that included lily ponds, which would become the subjects of his best-known works. He began painting the water lilies in 1899, first in vertical views with a Japanese bridge as a central feature and later in the series of large-scale paintings that would occupy him continuously for the next twenty years of his life.

Another urban sketch group tour I joined was with a San Francisco group. A faculty member from Modesto Junior College led

our local group of four on the bus trip to the campus of UC Berkeley. The faculty member was an instructor who taught drawing, color, 2-D design, and 3-D foundation design. I took a few classes from her, and she was very inspirational. A few of us drove to a quiet location on the Berkeley campus and set up our easels, camp stools, and sketch pads for a couple hours and chose subjects to sketch. I recall sketching a lamppost, an old historic building on campus, and a young couple holding an informal wedding on the grass. As they recited their wedding vows, someone played Bruno Mars's song "Marry You" afterward. The bride and groom's guests were dancing and clapping, and they all held a white balloon during the celebration. It was a great event to watch from afar. Later my sketch group gathered up our things walked down the street, found a small pizza parlor and ordered pizza and beer.

I later joined a sketch group and signed up to paint the Sacramento Tower Bridge which is a lift bridge across the Sacramento River linking West Sacramento in Yolo County to the west with the capital to the east. There were maybe a dozen local artists who wanted to complete the task. And at the end when we showed our sketches, the coordinator told me she thought my sketch was the best. What a thrill and more encouragement!

I came upon my fifth year creating my employer's annual Christmas cards for their employees. That year's card was entitled *Holiday Snowy Window,* inspired by their annual fundraising Christmas tree events.

Chapter 61

I had been selling my art for a few years when I heard about a workshop called Making Art, Making Money. After resisting for over a year, I learned that my online Canadian artist friend, Pat, had enrolled, so I decided to enroll as well. I wanted to learn how to increase my productivity, self-confidence, and focus on selling my art. The instructor was an artist from San Francisco.

The online workshop taught me the proven eight-part process for building a profitable creative enterprise. Since I enrolled with the intent of learning how to sell my paintings, a few years later I realized the process could also help me increase my face painting revenue. So I skimmed over my notes and applied what I learned to my business. It helped tremendously with my growth and knowledge as an entrepreneur. We had to work with study partners to succeed. I met and worked with partners from all over the US and Canada. Carolyn was my main partner; then I worked with Ann, Nancy, Pat, Marilyn, and Kiki.

The program is an innovative and interactive online education program for independent artists. In a nutshell the following is what I learned from the program:

- To identify my fears upfront because fear can kill success and

happiness.
- To identify my attitude and self-concept and if negative, my success as an artist is not going to work as well.
- To motivate and engage my subconscious.
- To identify my self-limiting beliefs and learn how to unblock emotional blocks in my unconscious. I also learned meditation techniques.
- To purge projects that led me away from focusing on what needed to get done.
- To identify my skills and learn how to improve my bad habits.
- To know my resources in order to help me succeed.
- To identify and define my smarter goal in order to take steps toward it.
- To create value above and beyond my art and learn what target market I could best serve. My product is an emotion—art when you feel it—and is personal and unique. I am the only person who can make my art.
- Four-part code. Your "why" is your creative purpose—who you are and what you stand for and against. Your "what" is your mission. Your "how" is your unique value proposition. Your "who" is your target market.
- Through a series of exercises, I discovered my why is when we believe in ourselves and trust our instinct, we will find our inner strength. My what is when we don't believe in ourselves; we have low self-esteem and operate out of fear. My how is to help people to empower themselves and find their inner strength and confidence through reflection on my art. My who is affluent women who are searching to find inner strength and confidence.
- To approach my ideal customers.
- To create a SWOT analysis (strengths, weaknesses, opportunities, and threats).
- To create a unique value proposition.
- To create a business plan and a milestone map.

- To build my ideal customer—my avatar, where to find them and how to reach them.
- Branding—referrals—social media.
- Selling the product through guided conversations and building rapport
- To create an up-front agreement.
- To find my prospect's problem or pain and solve it with my art.
- How to talk about money and ask for a sale—deliver the goods.
- To learn about copyrighting.
- To list creative assets.
- To track inventory of my art.

All in all, the workshop was most invaluable; I learned so much about myself and my art and became acquainted with five women as my study buddies. One of them, Nancy, I had the privilege of meeting in person in St. Louis. I keep in touch with another one, Pat, pretty regularly. These friendships are very special in my heart with what we all shared and pursued together—a common interest.

I completed the exercises in each lesson and found them delightful and interesting. Some were difficult, but I got through them. In the copyrighting lesson, I took my Humboldt County series of watercolor paintings and submitted them for copyright. I was successful. It was quite exciting for me. I learned that ineffective art marketing involves sleazy sales tactics, selfish manipulation, and self-involved artist statements. In order to succeed as an artist, we must learn how to market and sell our art without feeling like a sellout, compromising our integrity or surrendering our authority to permission-based art establishments. Striving for a successful art career by building a résumé and hoping to show our art is a futile formula for success. We don't dream of success; we plan for success. We don't discount our art; we get paid 100 percent upfront. We don't enter art contests or work for free; we know our niche. We don't build art careers; we

build businesses.

I think the most I took away from it was coming up with my four-part code—branding, copyrighting, and tracking the inventory of my art, created and sold. I now have all my artwork organized on a spreadsheet and know who purchased it and for how much, as well as the date I painted each piece. I also learned to never discount or give away your art to people merely because they are friends, coworkers, or neighbors. I am a businesswoman in business to make money and not give away my work. Also, when asked to donate a piece to a nonprofit, do not lose sight of your purpose by giving away your art.

One downfall for me, upon completing the semester, was learning that I should find my target market and sell to them what they want, rather than what I want. Through this process I learned something about me and that it's difficult to paint "on demand" if I don't feel the movement or inspiration in my heart. I also learned that by entering art contests or submitting art to galleries, I am hoping that my art sells. I'm lucky if it does sell, but the galleries typically take forty percent of the profit (so to absorb that fee, I jack up the price to cover it). And if it doesn't sell, although I gain exposure and admiration as an artist, I lose the money I paid for the admission fee. Consequently, my desire and motivation to paint and my spirits were dampened for some time.

Chapter 62

In April 1, 2018, I boarded the Jewel of the Seas, one of Royal Caribbean's cruise ships, bound to Puerto Rico with my son Cody. It was quite a welcoming trip since Royal Caribbean had temporarily discontinued their entertainers and face painters' program for cruising. It lasted four long years and I was used to cruising every year. The decision was made due to a few entertainers, face painters, and balloon twisters who had bitterly complained that the opportunity was unfair. When they resumed the program, however, it was extremely limited for the face painters and since I had been on their cruises more than once, I was afraid I would not be considered. Luckily, I did get accepted. There were some snafus though.

I made all the travel arrangements and we were ready to go. We drove to the San Francisco airport from Modesto, paid for parking, and started processing through security. In a horrifying discovery, Cody realized he didn't have his passport. I was panicked! I didn't want to take the trip without him because it had been four years since the last one and I was afraid to do it alone. If Cody couldn't join me, I wasn't doing it alone, period; I was ready to cancel. We tried everything, calling our friends and dog walkers who had keys to our apartment to try to find his passport in his room—nothing. More panic!

Chapter 62

As a last resort, Cody decided to drive all the way back home (an hour and a half) to find his passport. He found it and sped back to the airport to join me. I really thought it was not going to happen, and I was ready to give up and go home. God is good. Cody made it back to the airport just in time. By the time his name was called for the fourth and last time, he made it! What a miracle! I believe it was meant to be after all.

We barely made the flight right before the doors were closed. I took a deep breath; gave a prayer of gratitude; and was finally able to relax. We settled into our seats—mine was by the window. The view from above was amazing and the flight was smooth. Hours later we landed, made our way to the cruise ship terminal and processed in.

Day 1: I visited St. Maarten, Kingdom of the Netherlands. Sadly, we viewed abandoned boats in the water from Hurricanes Irma and Maria of September 2017, both category 5 hurricanes with over 110-mph winds. We first toured Martinique, West Indies. I learned some very interesting facts about the difference between St. Maarten and St. Martin. I was fascinated with the information that I learned:

"While it is not the only "split" island in the Caribbean, St. Martin versus St. Maarten is unique in many ways. Unlike the lengthier and decidedly more infamous border that separates Haiti and the Dominican Republic, the dividing line between Dutch St. Maarten and French St. Martin is open, free, and breezy. Indeed, this uncommon border has long been among the most peaceful the world has ever known. How the Dutch and French finally partitioned the island makes for a great story. Supposedly, the two groups held a contest. Starting at Oyster Pond on the east coast, they would walk westward—the French along the northern edge, the Dutch along the southern—and where they met, they drew a dividing line across the island. The French set off, having fortified themselves with wine, the Dutch with gin. The ill effects of the gin, however, caused the Dutchmen to stop along the way to sleep off their drunk; consequently, the French were able to cover a much greater distance. In

truth, though, the French had a large navy just offshore at the time the treaty was being negotiated, and they were able to win concessions by threat of force. The treaty was signed on top of Mount Concordia in 1648. However, the border was to change another sixteen times until 1815, when the Treaty of Paris fixed the boundaries for good.

There are differences between the two islands, of course. The Dutch side speaks predominantly English, despite the official language being Dutch; the French side speaks French. The Dutch call it "Saint Maarten," while the French call it "Saint Martin." The Dutch side uses 110 volts, same as the US, whereas the French side uses 220 volts. The Dutch side officially uses the Netherlands Antillean Florins (NAF, or guilders) while the French side uses the euro. However, on the Dutch side, the US dollar is dominant and the most common currency used. On the French side, the euro is still dominant. Philipsburg is the capital of the Dutch side, while Marigot is the capital of the French side. The country code for the Dutch side is 721 (as of October 2011), while the country code for the French side is 590. Calling from one side to the other is considered an international phone call. Each side has its own international airport, despite the island being as small as it is.

St. Maarten is probably the only place in the world where France and the Netherlands share a border, since they don't touch each other in Europe. There is still some unity on the island though. They both have nice beaches, island culture, and trade winds, and since so many American tourists come to the island each year, the American dollar is accepted everywhere and English is spoken on both sides. It seems like the tourists are the ones who unify St. Maarten and St. Martin!"

Day 2: St. Croix, Virgin Islands. St. Croix was a beautiful island and the beach we visited was peaceful with not too many tourists. It appeared to us that the favorite local beer according to the islanders was Carib. Carib Brewery is an industry leader and has dominated

the regional market in the production of go-to beverages for locals and visitors. Carib Brewery brands are internationally recognized, and the Carib Beer insignia is known around the world as a symbol of the Caribbean's blue waters and year-round sunshine.

Day 3: Martinique. The northern Caribbean side of Martinique had a very charming and authentic atmosphere. Martinique is a unique Caribbean island, famous for its hiking trails. Its great rain forest had breathtaking views along the entire tour. Our starting point of the tour was in the middle of an impressive mahogany forest, and from there we were directed toward a beautiful "Himalayan" bridge. After crossing the bridge, we ascended toward the emerald-green world of beauty.

The rain forest tour was incredible. We had to wear rain gear as we hiked down into the rain forest. We enjoyed its beauty then suddenly it rained on us which was refreshing; I have always enjoyed a good rain. We reached a one-hundred-meter-high waterfall, with the water running down from a nearby volcano. Many tourists jumped into the water, splashing around and enjoying the experience. I learned that in the rain forest you can see an assortment of stunning flora and that there are more than four hundred species of trees in Martinique, three times as many as in Europe! When we reached the top we enjoyed the view of both the Atlantic and the Caribbean side of the island and some of the peaks located nearby.

We later toured a banana plantation. Our tour guide showed us the plantation and told us about the process of growing bananas. We learned that plantains are of the banana family. These bunches look like bananas but are bigger, bright green, and thick-skinned—and are not bananas. Plantains can be found in the high-end grocery stores. The preferred way to cook plantains is to fry them. Peel and cut them diagonally or in rounds into quarter-inch-thick slices. Drizzle just enough oil into a nonstick skillet to coat the bottom of the pan and place it on medium heat. When the oil begins to simmer but not smoke, add plantains (work in batches) and fry for 1½

minutes on one side; then flip and cook for one minute on the other side. Remove the plantains from the pan and drain on paper towels. Continue frying in batches until all of the plantains are fried. Then sprinkle lightly with sea salt to give a sweet/salty taste to them. We also learned that plantains are native to India and the Caribbean and serve an important role in many traditional diets. When used in cooking, they are treated more like vegetables than fruit. You're most likely to encounter them at your favorite Latin, African, or Caribbean restaurant baked, roasted, or fried up as a delicious savory side. (I found some plantains when we got home and tried the recipe; they were delicious.)

The entertainment that night on the cruise ship was a group portrayed as the Village People dancing and singing some of the group's popular songs. I had my photo taken with one of the sexy Village People.

I painted many passengers that night (children and adults) that the ship gave me a complementary bottle of wine from Tisdale Vineyards from Modesto. Amazing! Every night, as with every cruise ship, we had a daily towel formed into an animal. One night we had an elephant wearing sunglasses; another night we had a frog with sunglasses and a cigar made from a pen and another one sitting up reading the daily schedule.

During my off time from working, two young staff members conned me into painting their face so I painted a pirate face on the guy and a panda face on the girl. I was given an assignment nearly every day only when the ship was out to sea and not at port. Sometimes I was stationed in a center location of the ship, and other times I was assigned to the day care area painting pirates on the little ones for their big pirate parade through the ship. I painted a lot of swirls and tropical flowers on children and adults. The women especially enjoyed having their bare shoulders, arms, or faces painted with tropical flowers. We had such fun that night. Cody and I hung out on one of the upper decks at the bar near the pool. Amazingly enough, I found Cody reading a book at the bar.

Chapter 62

Day 4: Barbados, West Indies. We toured all around, lounged on the beach, and sipped fancy rum drinks. While walking around town enjoying the sights, we discovered a KFC restaurant. We saw an old pirate ship in the water, which was interesting. It was sort of a casual day and we ended up relaxing on the beach and occasionally dipping our feet in the water. We both read our books, and Cody drank the local beer while I had the special rum drink of the day. I found some jewelry vendors and, of course, had to purchase some locally handmade jewelry. I bought a bowl made from dried banana leaves. Later we enjoyed the nightlife on the ship and socialized with fellow passengers on the deck in the pool area. There was beautiful art at the ship's port with flowers, island people, and sea life.

Day 5: Grenada was our next island stop. This island is known as the "Island of Spices." So we just had to purchase their special spices and came home with many! I found a House of Chocolate that I would have loved to visit but it was closed. I purchased some island necklaces for my coworkers made of nutmeg, ginger, cinnamon, and cloves; the scent was heavily aromatic from the spices. We took a bus tour ride around town and then up a long twisty road to Fort Frederick, St. George. We didn't get to see inside the fort, but a guide gave us a brief history, and we got to see it from the outside. It was originally built by the French for security after they captured the island from the British in 1779. The French believed the British error in design was to have the canons facing out toward the sea, instead of inland, in case of a land attack. Therefore, the French had the canons built facing toward Grenada, instead of away, earning it the nickname the "backward fort." The fort is about a mile and a half from St. George's, and it's quite an uphill climb, but it's easily walkable, driven to, or toured with a guide. The views are 360 degrees and something of a wonder for the island. It has a quirky and deadly history worth exploring. We didn't learn that much though. Afterward we lounged on the beach and then headed back to the ship.

On the last day of our tour, Cody and I took an independent

walking tour through the old section of San Juan. It was before noon and not many shops were open, but we discovered this particular restaurant down one of the narrow cobblestone streets called La Mallorquina, which I learned is an historical icon in the heart of Old San Juan that has a delicious local menu in a quiet, relaxed atmosphere. We walked in to order a drink. We figured, what the heck? You only live once, right? We learned that it was the oldest restaurant in San Juan (160 years old). We had a couple of drinks at the bar, personally prepared by the head waiter/bartender Gregory Arzuaga. He was totally adorable, and I fell in love with his charm and dimples. He was about my age and paid special attention to me. We talked about our taste in music, and he asked me who my favorite musical artist was. I told him I had many, so Gregory took a guess at a possible favorite recording artist and came up with Elton John. Hoping to please me with his choice of music, he put on the CD. He later allowed me to videotape him as he demonstrated how he makes the famous mojito in San Juan.

In the video Gregory said, "This is the mojito that we make in the oldest restaurant here in Puerto Rico, and this young lady in front of me captivated me with her smile, so I will tell her what the ingredients are for this drink. The key ingredient is fresh mint leaves with granulated sugar that are mashed up in a wooden muddler, which is a local thing. We mash it up and add club soda and lemon juice and our favorite Bacardi Rum, add a twist of lemon, and we chill and strain so there are not a lot of leaves in your mouth when you drink it. That is how you make a mojito. Thanks for that smile!"

He told us about the famous restaurant and that it is pricey, but the food is worth every penny. I learned from other patrons that among the many delicious menu items, these are just a few: Pastelón, a classic Puerto Rican dish made with layers of thinly sliced plantains, ground beef, and cheese (the Puerto Rican version of lasagna); Chicken Mofongo, mashed plantains with garlic, olive oil, and pork cracklings shaped into individual balls and accompanied by beans or rice; grouper stuffed with crab meat; rice and squid; and

Arroz Mamposteao, stewed beans and rice. This iconic Puerto Rican rice dish originated from the need and want to make a different dish with leftover white rice and red stewed beans. Sometimes it is prepared with ripe plantain pieces mixed in with the rice.

Gregory and I became Facebook friends, but so sadly, a year later, one of his friends notified me on Facebook that Gregory had died from a massive heart attack. How does that happen? Life is a mystery, that's for sure. That was the end of our cruise to Puerto Rico—very memorable. What I love about these international experiences is the opportunity to meet people from different areas all around the world, and I learn so much about their culture.

Chapter 63

Early one morning my neighbor, Matt, alerted me that my car had been broken into and a side window was shattered. My car was unmistakably mine because it had my business ad as a wrap across my back window. My heart raced, and I went outside to investigate, hoping he was wrong but my suspicion was confirmed and was horrified to discover that someone had stolen my prized possession face painting kit. I just happened to be scheduled for three gigs that Saturday and I had put my kit and supplies on the back seat of my car the night before in order to save time. My kit was in plain sight, and the thief probably thought he or she was scoring electronic equipment since it was in a tall black case. Instead, he or she got a kit of expensive supplies worth hundreds of dollars, not electronic equipment. My newly-purchased stencils, mirrors, and binder of sample paintings were also gone.

Needless to say, I was so distraught that I couldn't sleep much that night, and I became depressed for the next week or so over the theft. The incident cost me $600 of revenue because I was so upset I found someone else to fill in for me. I even cancelled the farmers market event which was scheduled for that Saturday. April is normally one of the most lucrative months for me and continues on through the summer months. From that experience, I felt

low-spirited for quite a while. Then I was charged $145 for auto glass replacement. Later I discovered that my credit card reader was also stolen along with my business records. And since I hadn't backed up that year's records yet, I was at a complete loss and had to rely on memory and some repeat clients.

I am blessed with such a wonderfully supportive face painting network. A former face painter, Cheryl, from the Bay Area, saw my distraught Facebook post and offered to give me her supplies and her old kit since she had retired from her business. I drove to her place to pick up her supplies. She used to be one of the instructors at the local California conventions and workshops that I had attended. Another face painter plus my best friend also donated money to help replenish my supplies.

I had a second vehicle break-in early January the following year and again lost my kit along with all new and replaced supplies, as well as my purse. I was hired for a one-year-old's birthday party in the early evening at a reception hall in Modesto. I had several children in my line, and it was quite a busy event. After my shift ended, I packed up my kit and supplies, put them in the trunk of my car in the parking lot, and headed back into the hall to get some food and my table. I didn't think to lock my car since I was planning to be just a few minutes. When I returned to my car, just minutes later with takeout food and my table, I made the horrible discovery that I had left my car unlocked and my kit, supplies, and purse were gone. They had been stolen right out of my trunk! The thief must have been watching me come and go from the hall, had entered my vehicle from the driver's side, and unlatched the trunk with the lever.

It was the second theft of my kit! I would just love to get into the head of the thief to see what he or she was hoping to find. I was stunned and beyond belief that it would happen a second time. I ran back inside the hall and asked my client if I had left my kit inside by mistake. When she said no, I froze. How could this happen again?! This had never happened to me. Again, the thief got away with my newly purchased stencils, paint, and glitter, as well as several little

unicorn heads and bling that you add to a child's forehead to complement the swirly design.

There was no expense for a broken window (luckily for that); just another police report to fill out. I found out later that several other vehicles in the parking lot were also broken into that night. So the thieves had been casing the place. That time my friends Debbie and Liz each sent me fifty dollars to help cover the loss. I was frustrated since my second credit card reader was stolen from my kit along with stencils and adhesive decorations. I am so grateful for my friends and fellow face painters who supported me in my time of crisis. Another lesson learned!

Chapter 64

I took a watercolor workshop in Copperopolis with my artist friend Sylvia Mireles in 2018. We painted a sweet little snowbird on a branch. I posted it on social media and sold it immediately! I then had a print made for a coworker because she loved it.

Sylvia and I met several years ago by chance at a Mistlin Gallery function in Modesto and chatted a bit, but we didn't run into each other again until a few years later. She and I were on the membership roster for the art group through the gallery, and we reconnected and had lunch a couple times, went to a local art showing, and became friends. We both signed up for a workshop at the Mistlin Gallery taught by a guest instructor from the San Francisco Bay Area. The subject was a beautiful water scene with rocks. It was, for me, incredibly advanced, and I tried and tried but felt like a failure and dropped out after the second day of instruction. The subject was incredibly beautiful but became increasing difficult and frustrating with each step. What a feeling of defeat and failure it was for me. I know how to work with watercolor, but I'm used to painting freestyle (my style), so it was way too advanced for me. But that's okay; not everyone paints the same style.

Chapter 65

I painted *Unleashed* and *Empowered* for the sixth year that I donated to the Art For Justice fundraiser. My art piece was interpreted from thirteen-year-old Samantha. Her words were "If you don't stop looking in the past, you will never see your future." My words were "The young artist's heart tugged at my heart and really resonated with me; I just had to interpret her painting. I used acrylic paints and textures on canvas. I wanted to keep with her theme of a heart, but her message called me to paint a girl reaching with outstretched arms, welcoming freedom from her past. The woman in my painting is basically coming from a place she needs to leave behind and emerging into a beautiful place of hope, trust, peace, and empowerment."

I always enjoy participating in these events because they're fun yet challenging. With the art pieces from each child, I try to imagine myself in their shoes and what they experienced or are going through. I am amazed how a certain piece speaks to me and makes me want to interpret that child's painting to reflect their heartfelt feeling. It's a strong, spiritual, and emotional connection to that child. With each interpretive art piece I paint, I feel that in some small way I am comforting that child and letting them know someone cares, even though we are not allowed to see the children. All my art pieces sold at these fundraisers.

Chapter 66

Traveling to Italy has been a dream of mine and on my bucket list as long as I can remember. I want to show readers that had it not been for the revenue from my business and the profits from my paintings, I would not have been able to take this fabulous once-in-lifetime trip to Tuscany. I have an intense love and fascination for architecture in the old countries. And just knowing that I walked on the same cobblestone streets, gazed out at the same ocean, and stepped inside the same ancient monuments and cathedrals that famous artists from the Renaissance had—as well as having been inside the museums, chapels, and monuments in which royalty of that time once stood—gives me chills up and down my spine.

In October I traveled to the Tuscany region in central Italy; its capital, Florence, is home to some of the world's most recognizable Renaissance art and architecture, including Michelangelo's David statue and Botticelli's works in the Uffizi Gallery and the Duomo basilica. Its diverse natural landscape encompasses the rugged Apennine Mountains, the island of Elba's beaches on the Tyrrhenian Sea, and Chianti's olive groves and vineyards. I felt truly honored that I was able to take the trip and be exposed to the paintings of the Renaissance period and their fabulous art!

I learned from the tour guide that Italy has produced many

brilliant minds that have made their mark on art history. During the Renaissance, the Italian city-states were at the center of an incredible flowering of visual culture that would not only influence generations to come but would also redefine what it meant to be an artist. Painters and sculptors came to be seen not only as craftsmen but also as men of learning who could express something deeply personal.

Our guide also pointed out that Italy has been the epicenter of European art for centuries, with Italian artists contributing a massive amount of work to our cultural history. If you were to ask someone to name a famous artist or a famous painting, it's likely that one of these artists would be the first to spring to mind! From the time of the Roman Empire, with sculptures and relics that have great historical significance, to the cultural explosion of the Renaissance, and to the modern day, Italy's impact on art has been incredibly substantial.

The ten most famous Italian artists are Leonardo da Vinci, Michelangelo Merisi da Caravaggio, Titian, Raffaello Sanzio da Urbino, Michelangelo di Lodovico Buonarroti Simoni, Sandro Botticelli, Giovanni Bellini, Artemisia Gentileschi, Donato di Niccolò di Betto Bardi, and Gian Lorenzo Bernini. What an honor to be among them in history.

In preparation for my trip, I learned some basic Italian greetings so I could communicate somewhat with the locals. It was a guided tour through a tour agency and although I took it alone, I was joined by forty other tourists from around the world. It was quite fascinating, sharing the same interests with these strangers. By the end of the tour, many of us bonded, but it was sad knowing I'd never see them again.

Day 1: My driver picked me up from the airport and drove me to the hotel. As he drove through Rome, I noticed that his radio station was playing American music, so I asked him, "Musica classico?" He appeared pleased to hear me speak in Italian. He answered, "Si!" He changed the station to an Italian one and then seemed very content,

humming and whistling to his music. I figured since I was in Italy, I wanted to take in all I could of their culture.

When I arrived at my hotel room and settled in, I slept all night and joined my tour group the next morning at seven thirty for breakfast. I met some fellow travelers and then returned to my hotel room and slept all day! Orientation was at 5:30 p.m., and then we went to dinner, enjoying Italian pasta, veal, roasted vegetables, and, of course, Italian wine.

Day 2: After a 6:30 a.m. breakfast, we took off to Vatican City to tour St. Peter's Square and Basilica and the Colosseum. On this tour I got acquainted with three gentlemen who were cousins traveling together. They called themselves the "Jersey Boys" because they lived in New Jersey. They were quite comical and kept me entertained throughout the tour. We traveled through the countryside to Hotel Columbia in Montecatini Terme, Italy, where we spent the next six nights. One of our evening meals was at the Fattoria il Poggio and Cantina in Montecatini. Montecatini Terme is a town in Tuscany, Italy, known for the art nouveau Parco delle Terme spa complex. Works by Joan Miró and Claes Oldenburg hang in the MO.C.A. (Montecatini Contemporary Art), located on the first floor of the Town Hall. A funicular climb to Montecatini Alto village, home to the Torre dell'Orologio, a medieval clock tower, plus the Romanesque church of Santa Maria a Ripa and sweeping views. We got a tour and history of the olive vines in the Tuscan Hills of Montecatini. For appetizers we had prosciutto, salami, pecorino toscano cheese, and dried tomatoes in olive oil. Then we had spelt (faro) soup with a tomato base, pasta with cheese, sausage, chicken, potatoes, and lettuce sauté. After our fabulous meal, we were served a strong dessert wine with biscotti dipped in it. I learned from Giuseppe (who lives in Sicily) the Italian word for cheers is "saluti." On our way back to our hotel the entire busload of people was singing—happily from the Italian wine that was served.

Day 3: We spent the day sightseeing and shopping at the Piazza

Santa Croce. We toured Vatican City and then saw the Michelangelo's incredible statue of David at the Galleria dell'Accademia in Florence. I learned that David is seventeen feet tall. It was gigantic. We shopped and did some sightseeing in Florence. Later that evening, we, as a VIP tour group, were served a special dinner on the fifth floor of the museum.

Day 4: We spent the day at Cinque Terre. We then departed for La Spezia, where we took a boat to the villages of Portovenere and Liguria. Then it was on to Unesco, which is protected by Cinque Terre (five villages), and shopped in Monterosso. Our tour guide pointed out a vacation home which was approachable only on foot by hiking down a horribly treacherous climb on a hill. I met a most handsome harpist, Riccardo Locorotondo, who was playing on the grounds of Portovenere. He was gorgeous with his long hair and played his harp like an angel. I had a short conversation with him about his music and purchased two of his CDs.

We then took a train and viewed the hills covered with the marble quarries of Carrara. We learned that the Apuan Alps above Carrara show evidence of at least 650 quarry sites, with about half of them abandoned or worked out. The Carrara quarries have produced more marble than any other place on earth. Working the quarries has been dangerous and continues to be so to this day. In 1517, Michelangelo climbed Mount Altissimo in Tuscany and found the marble of his dreams.

Day 5: We visited Vinci, the home of Leonardo da Vinci. The town was beautiful with buildings of stone and cobblestone streets. We then visited the walled city of Lucca with many churches and cathedrals. We had a meal that included Bolognese sauce, which is made with carrots, onions, celery, olive oil, red wine, and tomato sauce. Exquisite!

Day 6: We toured the medieval cities of Siena and San Gemignano

Chapter 66

for shopping and sightseeing. Siena was preparing for its biannual Palio Horse Race. We walked through the cobblestone streets.

I purchased a pair of beautiful dark-red leather boots from a shop in Siena, and the shop owner and I had a nice exchange of a few Italian words that I had learned. Before I left, he said, "Chia bella," which means "Goodbye, beautiful." It was obvious he was impressed with our Italian conversation.

Day 7: We continued to experience the Tuscan lifestyle and toured Pozzolatico where we, as a VIP tour, learned to make pasta and ravioli by hand at a privately owned vineyard in the Tuscany region. We then visited Pisa, the Square of Miracles, and then went back to the Vatican Museum and got to see the Leaning Tower of Pisa (Italian: torre pendente di Pisa), or the Tower of Pisa (torre di Pisa). It is the campanile, or freestanding bell tower, of the cathedral of the Italian city of Pisa, known worldwide for its nearly four-degree lean, the result of an unstable foundation. According to Wikipedia, the tower is situated behind the Pisa Cathedral and is the third-oldest structure in the city's Cathedral Square (Piazza del Duomo), after the cathedral and the Pisa Baptistry. The height of the tower is 55.86 meters (183.27 feet) from the ground on the low side and 56.67 meters (185.93 feet) on the high side. The width of the walls at the base is 2.44 meters (about 8 feet). Its weight is estimated at 14,500 metric tons (16,000 short tons). The tower has 294 or 296 steps (the seventh floor has two fewer steps on the north-facing staircase).

The tower began to lean during construction in the twelfth century due to soft ground, which could not properly support the structure's weight, and it worsened through the completion of construction in the fourteenth century. By 1990, the tilt had reached 5 ½ degrees. The structure was stabilized by remedial work between 1993 and 2001, which reduced the tilt to 3.97 degrees.

We shopped for fresh produce at a local Florence food market to make our own meal for the night. I got to taste their local bread

called focaccia. Focaccia is a flat, oven-baked Italian bread similar in style and texture to pizza; in some places, it is called "pizza bianca." Focaccia can be served as a side dish or as sandwich bread. What an unforgettable experience!

Chapter 67

I had opportunity to see St. Louis for the first time. The Kapital Kidvention was scheduled for November so I hopped right on it and registered online. With these conventions, you connect with fellow artists who want to share the expense of a hotel room. Many times you can have two or three women in a room—sometimes four—to cut corners and save money on expenses. This is a great way to meet fellow like-minded artists who are striving for the same thing you are, and it's a great way to connect and develop friendships. Then someday when you travel you have someone to visit if you find yourself in their area.

My flight went smoothly but a little bumpy as we approached St. Louis. I arrived safely and found the temperature to be extremely cold—something I don't often experience, and it was snowing, which was even more exciting! I shared my hotel room with two roommates, Ann, who lives in Iowa and is the owner of Fancy Cheeks, and Donna, who lives in Chicago. I usually feel I can trust fellow artists and entertainers that I meet at these conventions, knowing that each one has the same interests and goals to learn more techniques and grow their businesses. The convention leaders provided food trucks every day in front of the Hilton as an option to purchasing hotel food or driving out in the snow to find a restaurant. It was a

unique experience for me to stand out in thirty-degree weather waiting for my food. It was fun though, and I never complained. Anything like this is always an adventure to me. It was such a dream come true and quite an unforgettable experience. I felt like a child in the snow for the first time and had someone take my picture outside with no jacket. My roommates thought it was the most hilarious thing. My Wisconsin friends, Connie and Billy, had driven their own vehicle to the convention, so they drove us to a restaurant.

These kinds of conventions are always filled with excitement, creative energy, and laughter. Convention-goers are constantly walking about, rushing from room to room with their faces or bodies elaborately painted. The lobby was decorated with colorful elaborate balloon structures at the entrance of the main meeting hall. I turned around and someone photographed me kissing a life-sized balloon figure of a cartoon character. A huge room or rooms are always designated as the vendor area where you can purchase products, props, aprons, balloon or face painting kits—everything you can imagine.

The general session began with the coordinator talking about the convention, the house rules, and the vendor room.

I attended Lilly's class where she demonstrated full and fast two-minute face designs. She sprayed down her kit with white distilled vinegar and instructed us to use separate brushes for separate paints, and use one flat brush for each split cake. The following were her instructions: Use finger daubers on stencils with powders. Use smoothie blenders with chunky glitter. When working with Star blends, use one teaspoon at a time to repot into a pill container, using a few drops of hand sanitizer and pressing down into the pot with wax paper. Mist the face to make glitter stick.

I attended a class on henna and the instructor noted the following: after applying the henna paste to the skin, the orangey color is the skin oxidizing stain progression and the dye is always releasing. Don't use fresh lemons; use lemon juice. Cajaput or lavender essential oil is used in the henna mix. Mix the henna, place plastic

wrap and then paper towel over the bowl and then use something to weigh it down with. The paper towel will change the color. Henna stains the dead cells of the skin.

In instructor Donna's class, she gave the following instructions: a pill box may be used to store different colored daubers. She demonstrated how to paint a snowflake kitty. Using Mehron Paradise Metallic White, you start by making triangles on the eyes with a petal sponge and down the nose. Use frosted blue from Silly Farm for your snowflakes. Use DFX White with a long liner brush for the kitty whiskers.

Another instructor demonstrated the use of powders from Silly Farm and Jest Paint. And the following were her instructions: Use ultimate eye primer with a flat, rounded makeup brush. You cannot apply with a smoothie blender; instead use your finger and pat, pat, pat. Use Mehron to mix with your regular paint to make it more water resistant.

Another instructor recommended the following: putting a variety of chunky glitters in compartments of a pill box. Use baby shampoo and white vinegar to clean your sponges. Glycerin-based paints include FAB/Superstar, Kryolan, and Mehron Paradise, which are great for a lot of coverage. Wax-based paints are used for line work and include Wolfe, DFX, TAG, and Party Explosion. Global is a strong black; Hybrid is glycerin and wax and Chameleon and Global are in this category.

Heather Green, owner of Silly Farm, spoke at the general session on "Marketing Dos and Don'ts" as a small business owner. We as face painters typically have zero to little budget to allocate for marketing so she demonstrated ways to jump start the marketing of our business. In addition, she showed us how to connect and turn relationships into sales.

Another instructor spoke about how to increase your income by 20 percent and that you should raise your rates by 10 percent or within 10 to 15 percent of the comparable price of our colleagues. He suggested removing prices from our website and to read the blog Anatomy of

a Booking: You Booked It! (http://www.workingactorwisdom.com/blog/2015/3/18/anatomy-of-a-booking-you-booked-it)

I attended a class where the instructor demonstrated painting sugar skulls using sponges with Mehron Paradise on his designs. He suggested using a chisel brush on black eyes, shimmer powders over Mehron Paradise paint, stencils over the face for texture and Glitter Mark liquid glitter angled at a slant and not just straight up and down. A half-face sugar skull face should not be cut exactly in half; it should overlap.

An instructor from North Dakota suggested creating pages of visual art using www.istock.com for illustrations; to look for shapes, images, and brainstorming; search visual references on each subject: pinterest.com for artwork, tattoos, kids' sites, flyers, and magazines. Look for images that work together and noted that your style is what you feel comfortable doing.

Joselyn demonstrated animal muzzles and noted the following: Go only out to the natural laugh lines. Use a bit of white under the nose and use one color per sponge, so there is room for blending. When painting a flower, start with a dot and then work the petals.

The nightly jam sessions included face painting and balloon twisting competitions and artists practicing their art forms on one another.

The next day I took a class where the instructor gave the following tips and tricks to use in the trade: Use a piece of lace over your design for a nice effect; keep your lines curved and not straight; use a focal point right down the center of the nose; use the natural eye flow with big and little strokes; when painting a clown smile, do not paint outside the smile line, and use uneven lines and strokes; use the facial structure as a guide; keep your highlights just above the cheek bone. For a quick, three-dimensional leaf, dip just the tip of your green brush into black. Turquoise and brown make good colors for shadows. When painting butterfly wings, you separate the wings further apart. Put a small headlamp in your kit. Ask hospitals for bad X-ray film which you could for cutting your stencils from. Use Glad Press'n Seal plastic food wrap for practice sheets.

From another instructor, I learned: for line control, use numbered poker chips and hand them out to the kids in line, starting from the end of the line. Go to the back of line and take a photo of the last person in line so you know who the last person was. Add glycerin drops and smash with a fork to paint, and then add water drops to your paint and; use saran plastic wrap to smooth it out. With boiling water swirl your paint brushes in boiling water for ten to fifteen seconds. Pull the bristles of your brush with hair gel and let them dry overnight. You can use a flat brush and cut it to create a butterfly brush. Touch the skin with the end of a disposable mascara wand to to make snowflakes. If you are working for tips only, create a sign that reads, "Tips are my only tip tonight." Add Mehron mixing liquid in your paints to make your paint water resistant. Then clean it off with water when done.

More suggestions given were: Wrap balloons on the ends of your tablecloth and it will keep the tablecloth down. If a child's eye starts watering, have the child curl their toes or, pinch between their thumb and fingers, or rub the back of their neck to stop the watering. Netting from oranges or potato bags can be used for stenciling. Change your name from face painter to face artist. We as artists need to change our product from face paint to face makeup. When you stay in a hotel, stockpile on their soaps; they are the best soaps for cleaning your brushes. Swirl the end of your Q-tips in the paint and use for creating dots in your face design. ChapStick is good to use to hold the glitter. Use Natural Nails and cut in half to create vampire teeth. Apply with Pros-Aide. Use a tiny strainer to clean kabuki brushes.

In one of the general sessions guest speaker and magician Murray gave a presentation on "It's All About the Media." He taught the following: the art of getting into the press and the use of YouTube videos and social media, and how they relate to children's entertainers. Murray is a Las Vegas celebrity magician who performs on the CW's (television broadcasting) "Masters of Illusion," headlines at Planet Hollywood in Las Vegas, and is a social media star with over 400 million online views.

Guest speaker Steve Snyder spoke about *The Self-Employed Entertainer's Complete Guide to Federal Income Tax*. He is a self-employed entrepreneur and talked about preparing the small business owner's tax returns. He noted that small business owners and entrepreneurs don't have the luxury of putting high-powered tax accountants on staff to figure out complex tax laws. He walked the class through Schedule C and noted that deductions often get overlooked. He helps sole proprietors get a better grasp of business expenses and how to report those expenses so that they are categorized properly. He also can help untangle the tax code and maximize your refund (or at a minimum, pay the least amount you owe).

In another class I attended the instructor suggested using blank face templates, place twelve faces on a sheet, and laminate them for a presentation board. The following were more instruction: when using split cakes, use an angle brush and dip just the tip into water; then touch onto a towel and load the brush. It will stay wet longer. Use a petal sponge in a square rainbow cake to get more coverage. DFX Evil Rose split cake is a great color for roses. For one-stroke flowers, saturate your brush with white, wipe the tip onto a towel, and then load your brush onto a dark color. Try Global brand Neon Lollipop for fun strokes.

One of the guest speakers spoke on building family entertainment and the power of a brand. If you have a poor mentality, you're going to attract poor customers. No matter where you live, there are those who are willing to spend money and appreciate quality. I can assure you that your nearest BMW dealer doesn't think like that, and you shouldn't either. Rather than having a self-defeating mentality, look up, not down. Think about what it takes to bring your brand and offering up a few notches. Think about how you're perceived and where you've acquired customers. You are never going to grow a brand and get ahead financially if this is where you are positioning your brand. Reach higher, and reach for the kinds of consumers who are willing to pay you and treat you like any other professional. As an entertainer, you and your brand are inseparable in the eyes of the

customer. The key to higher fees and long-term growth is building a brand where the client wants you and you alone.

In another general session, Heather Green spoke on "Pin Perfect and How to Use Pinterest to Increase Your Bookings and Search Engine Optimization" and added that ninety percent of Pinterest users are parents between the ages of twenty-four and forty-five. These are the customers we are looking for!

After one of the day's workshops, I decided to enjoy a glass of wine and met face painter Cenema from Tennessee at the hotel bar. It's funny how I meet people at these conventions! I love these connections with fellow artists/entertainers.

I met instructor/artist Elisa Griffith several years ago, but I bonded with her at the convention. Elisa is a transformation specialist from Transformation Studio Ardmore in Oklahoma, a freelance makeup artist, and designer of Color Me Pro powders. She is such a sweetheart. I told her that I had the opportunity to face paint a high school Lion King cast, so I asked for her professional advice. She took me under her wing and gave me personal advice. To this day, she recognizes my name on social media and hugs me at every convention I attend.

Some face painters create the base work of their design using Star Blends or regular face paint and then use Elisa's powders with a smoothie to add color, or they add stencil patterns to their designs. If you want an even bolder look, she recommended using a primer first so the powder has a base to grab on to.

One of the last classes I attended was Nick Wolfe's demonstration of "Dangerous Dragons." He demonstrated different styles of face painting such as full-face, mask, and cheek art, as well as different types of dragons. Nick's designs are so elaborate and realistic; his talent is amazing.

The closing ceremony was our final farewell and nightly jam session, with a face painting balloon twisting competition, and games. It's always sad to say goodbye to these magical conventions.

Chapter 68

After the convention, I was invited to stay overnight and visit my artist friend Nancy, who I became acquainted with as an online buddy from the "Making Art, Making Money" semester in 2017. Nancy works with acrylics and has sold many beautiful abstract pieces, and she also displays her art in exhibits. I took Uber to her house, walked up the snow-covered steps, and rang the doorbell; she welcomed me with open arms. I was also greeted by her seventy-pound Australian shepherd named Chivas. It was like we had known each other forever. She originally was from the San Francisco Bay Area but had moved to St. Louis. We soon discovered that we have many similarities in our personal lives, as well as in our creative lives. We are both single, independent, and creative, and we both enjoy the same music, food, entertainment, house style, and interior decorating. We also both have blond hair, love animals, and own a motorcycle.

Nancy's house is exactly the style I love. It is a three-bed, three-bath, 2,160-square-foot, single-family, gingerbread-style home built in 1940. Her living room has hardwood floors, cove ceilings, a gas fireplace, and stained-glass windows. She has a formal dining room that opens to the breakfast room. The sunken family room has a gas fireplace. Her bedrooms are upstairs and she has a huge family room with a bar area and heated floors downstairs. I had never heard of

heated floors before! She also has a den/office in the basement that she uses as her art studio.

The next day Nancy showed me around St. Louis. We walked around town and visited the famous Gateway Arch, which is a 630-foot monument made of 142 stainless steel sections, concrete, and structural steel. According to Wikipedia, it's the world's tallest arch, the tallest man-made monument in the Western Hemisphere, and Missouri's tallest accessible building. As part of the Jefferson National Expansion Memorial, the Gateway Arch commemorates the accomplishments of nineteenth-century westward pioneers and celebrates the city's role as the Gateway to the West. We rode to the top of the arch inside a tiny tram that took only four minutes. The elevator cars are only four-feet high, so the ride is not advisable for someone who has claustrophobia. At the top you can see panoramic views of Illinois and Missouri. We were told that on a clear day you can see thirty miles in either direction. The view was spectacular!

One thing I love is music and particularly blues and jazz. Later that day we had a fabulous meal at the Broadway Oyster Bar and ordered crab-topped oysters. For my entrée, I had angel hair pasta in a buttery white sauce with lobster and wild mushrooms. Again, Nancy and I seem to have so many similarities—I think we were meant to be sisters. We ended up at Beale on Broadway listening to blues singer Kim Massie.

According to her website, "She was one of the most recognizable vocalists in the Midwest. Her ability to sing not only the blues but rock, pop, country, gospel and R&B has earned her two Best Female Vocalist of the Year Awards from the Riverfront Times as well as the Grand Center Visionary Award in 2005. Kim made her television debut in 2016 covering "I Finally Forgot Your Name" by Long Tall Deb during the season premiere of Good Behavior on TNT.

This proud grandmother of six has shared the stage with artists such as Cyndi Lauper, India Arie, Nelly, and Chuck Berry. Kim has performed for organizations such as Major League Baseball, Purina, Boeing, and at esteemed venues and events such as the Missouri

History Museum, Big Muddy Blues Festival, Fenton Days Festival, Peacefest, Pride Fest, Davenport Blues Festival, Emerald City Blues Festival, and the Blues Rising Festival.

Kim Massie's reign in the St. Louis entertainment scene pushes beyond the gates of the stage: her personality is a drawbridge to the audience. Kim's audiences can expect to make requests and hear her make every note of it. "Don't worry, I got my iPad!" she assures fans as she settles in on stage. Though, if you're requesting a song, a dollar won't cut it: she'll assure you of that too though if you forget.

"Diva" is a title that Kim Massie proudly embraces, and this award-winning vocalist has earned it. A boomerang child who moved to Ohio and later returned to the Gateway City, the "Siren of Song" has claimed Beale on Broadway as her home, performing celebrated, groove-inducing tunes several times a week. Often classified as a blues songstress, Massie isn't content to limit herself to one genre; her legendary voice also packs punch on rock, gospel, funk, jazz and more. Slip her $20, and prepare to be blown away by her rendition of Stevie Wonder's "Superstition" or Led Zeppelin's "Whole Lotta Love." Two snaps up for this diva!"—River Front Times, Special Edition 2014." (quoted from her Bio)

Kim and I became Facebook friends. Later I learned with deep sadness that on October 12, 2020, we lost our beloved Kim. Her legacy will live on in the hearts of the many musicians she inspired and the unforgettable moments she gave to so many fans.

Chapter 69

Next I registered for FPBA (Face Painting Body Art) Convention in Washington, DC in January—an opportunity to see another city I'd never been to. I took a Lyft from Modesto to the San Jose International Airport for the convention. The driver's name was Anthony, maybe in his early thirties with a long black beard. He talked non-stop throughout our two-hour drive about his desire to become a successful screenplay writer. He said he had gone to school for it and had written several screenplays, but he had not yet submitted them. He was also a serious movie buff and shared his dreams with me in detail naming his favorite movie producers and how he studied them. Indie films and documentaries were his favorites and recommended I see Pulp Fiction with Samuel L. Jackson, John Travolta, and Bruce Willis. He told me he'd viewed Pulp Fiction three hundred times! Crazy! Boogie Nights was also a movie he recommended with Burt Reynolds. I gave him a twenty-dollar tip mainly for the entertainment and I believe he will achieve his dreams and desires. He advised me to write something every single day if I wanted to write a book.

We reached the San Jose International Airport and said our goodbyes. Thank God I had registered with TSA. I rushed through security in ten minutes without a hitch and found my gate with time

to spare. I found a shop and purchased travel slippers, trail mix, and over-the-ear earbuds. I tried to use my debit card, but to my dismay the card didn't work; my pin wasn't being accepted for some reason. I tried not to panic, so I phoned my credit card company for an answer and they straightened it out.

The flight was crowded, and I there were crying children seated close to me. We touched down at Washington Dulles International Airport at 11:30 p.m. I inadvertently left the book that I was reading on the plane, and unfortunately no one turned it in. I messaged for a Lyft driver to take me from the airport to my hotel.

The driver circled around a few times and could not locate me. Then we lost our connection because my cell phone battery went dead, and I couldn't recharge it in the terminal because I had the wrong USB cable so I ended up getting an expensive cab and paying seventy dollars plus a twenty-dollar tip, and the cab driver preferred not to take a credit card. Luckily, I had just enough cash to pay him. I normally don't have that much cash on me. I finally arrived at the Hilton Hotel at a very late hour. It was a true test of my nerves, but I made it.

My convention roommate, Jennifer, is the owner of Beyond Balloons LLC and a certified balloon artist at the Paper Shack. She studied chemistry at West Liberty University and lives in Wheeling, West Virginia. I arrived at the hotel only to discover that she and I were bumped from our hotel room due to overbooking at the Hilton. But since my cell phone was dead, I didn't receive her message until much later. We finally connected and got settled in another hotel by 1:00 a.m. and were exhausted. We didn't get much sleep before our day started at the convention.

The convention, like all other face painting/body painting/balloon art conventions, was fabulous and welcomed us in a lobby filled with a colorful balloon archway. I connected with my longtime face painting friend Connie from Racine, Wisconsin, who gave me a cherry-filled kringle from her family's Danish pastry shop, Bendtsen's Bakery (since 1934). What a special treat! She brings these only to

her special friends. The weather was cold, cold, cold outside, which is unusual after being used to my California temperatures. But to me, cold weather was exciting, and I felt like a kid. I wanted to play in the snow.

There was a welcome introduction to kick off the convention and announcement about the workshop schedule, food availability, house rules, etc. Twice during the convention Connie and Billy, along with their young apprentice Xandria (aka Miss X), chose to leave the convention during dinnertime and drive to restaurants in town. What an adventure.

Before we were dismissed to our breakout sessions, the convention coordinator held a general session on success principles and how the artist/entertainer can dramatically improve their performance and results with the right tools and support.

My first class was with Carol who suggested using good branding on Facebook. The following are more of her tips: Add emojis on Facebook. To boost your post, identify a specific audience. Learn to use portrait mode. Get someone to take photos of you with the children you're painting. Include a tagline on your business Facebook page with the location of where you are working. Post your public event and boost it. Tag a business or organization when you perform at a public event. Post on your Facebook business page that you had so much fun at so-and-so's event. Tell the families that you are posting. Your post is designed to appeal to a certain group. Tag the group when you post. Find and post to a Pinterest mom's group in a specific demographic. Take a group photo from your gig with your banner and kids in front of the banner, and post it on the client's Facebook page. On the weekend before your gig, post a shout-out to the birthday person that you are looking forward to their party. Do a give-away party package for those who will "like" your business page, tag it, and share it. Have a drawing, and then do a post on social media when someone has won the prize and tag them. Include a deadline for the winner to collect the prize. For a behind-the-scenes post, show people what you are doing to prepare for a gig. Recycle

photos from a previous year's post. File seasonal photos in a folder and post them to promote your upcoming holiday events. Stores usually start putting out their holiday merchandise early; so should you. On a slow weekend, post your old photos. A suggested Netflix documentary is *Root Cause.*

In a general session, Heather Green, owner of Silly Farm, gave a presentation on "Social Savvy: Social Media for the Creative Entrepreneur."

Instructor Christina demonstrated how to make poodles with UV paints and recommended using white paint behind a rainbow design makes it pop and Mac glitter.

One night Connie and Billy invited me to their room to share pizza for dinner along with Miss X who was learning the business and taking in as much as she could.

The vendor room was open before and after each session and was crazy busy with artists and entertainers wanting to purchase the newest and greatest products for their business. You get to rub elbows with the vendors and fellow artists that you've met over the years at other conventions if you are a frequent convention attendee like me. You also get to see the master face and body painters at their vendor booths, as well as watching their demonstrations on willing participants. It is such a thrill with so much energy in the room; I can't put it into words.

The nightly jam sessions were crazily busy with artists practicing painting on each other. Some artists ended up dragging themselves away at two o'clock in the morning and returning to their hotel rooms totally exhausted.

In a general session with Marianne, she discussed promotional materials and talked about how to design your business card, as well as exploring the most effective and powerful ways to promote yourself using banners, signs, and other promotional materials in an affordable way.

Guest speaker Keith talked about the steps to becoming a full-time entertainer. Decide what you want to accomplish. Prepare with

an emergency fund of $1,000. Save three months of basic costs/expenses. Pay down credit cards. Eliminate unnecessary expenses. Set financial, creative, and reading goals. Focus on market research and what services you offer, and decide who your audience is and define that target. Act by taking action. Set up your business structure, business name, federal and state tax ID, insurance, and a separate bank account. Make a plan. Value proposition: what makes you attractive to your clients? Market the need; is there a need? How will you address the need? Competition: who is already offering your services? Target marketing: who are you marketing to? Make sure you have a website and get yourself out there!

I took a class from Onalee, an instructor from New York who taught us to wet our sponge to erase mistakes rather than wipe them off. Leave the eye area open and fill in with a smoothie blender. Rake the brush for white whiskers on a kitty.

At another general session the coordinator gave a presentation on "How to Make a Full-Time Living Doing What You Love," showing business and marketing techniques designed to bring in more profit.

Instructor Shawna taught us to keep aloe vera gel in our kits and to dip your finger into the gel and then dip into chunky glitter. Nyx is a good glitter primer. Use an alcohol wipe, makeup remover, or olive oil to remove the design. Watch for glitter cream on Silly Farm for the eyelids. For eyelids, color first and then use Nyx followed by chunky glitter with a flat brush. Pat with the flat brush. Put your brushes in a standup case.

Instructor Aubrie taught us to use stencils with a medium-density sponge. Spray set makes paints sweat resistant and is made for priming the skin; it's good for outdoor events. Petal sponges are good for fading out and fading from big to small with your stencil. Apply your glitter first and then do your line work. She recommended Royal Langnickel as a great brush that you can find at Michaels or Hobby Lobby. For a cheek mermaid design, she recommended using a mermaid scales stencil over your paint. Rinse your stencil in a cup of water to wash off the color. If you want to make your sponges

look more professional, use iDye for dying them black. That way, you won't get that awful, ugly color stain. You can purchase a cheap chili pot to simmer your sponges in to dye them black. When using your sponge to put down the stencil, use only the tip of the sponge, not the whole sponge.

Guest Speaker and author, Christopher Weed, spoke at another general session giving the best tips for quality Facebook posts. His information was so valuable that I purchased two of his books. Some of his highlights he included were: quality photos, videos, Facebook content, an event post, tagging a business or organization, the Pinterest Mom, the boomerang video post, the banner post, the five-star review post, the pre-weekend birthday shout-out post, the behind-the-scenes post, the localized post, the recycled photos post, the slow-weekend post, and what to say and what not to say in a post. He also included information on how to build and maintain an effective direct-mail marketing program and how to maintain lists.

The banquet dinner was a special event where you get to sit with your favorite artist friends, wind down from the most awesome weeklong convention, and enjoy a relaxing dinner. We got to see the contestants for the body painting competition, who paraded onto the stage along with their artist. It's the most mind-blowing experience seeing the fabulous art on the bodies. The dinner also included a comedy hypnosis show and closing remarks from the coordinator.

The convention ended sadly, having to say goodbye to my newfound friends.

Chapter 70

I had scheduled a few extra days off work so I could explore Washington, DC, with Connie and Billy. They had been there several times and showed me around. So, following the FPBA convention, since they had a car rental, we first drove to the Hard Rock Café for lunch. I ordered a humungous plate of loaded super nachos that, of course, I couldn't finish.

We toured Ford's Theatre and learned about the fateful night of Abraham Lincoln's assassination. According to the history, the theater opened in August 1863 and is famous for being the site of the US president's assassination on April 14, 1865, by John Wilkes Booth. Ford's offers inspiring theatrical productions, interactive museum exhibits, and engaging education programs. We watched a wonderful performance reenacting Lincoln's life and assassination as if we were right there during that time and experiencing it. It was chilling. You can immerse yourself in America's past while finding meaningful connections to our world today. Ford's Theatre is operated through a public-private partnership with the National Park Service. The red building across the street from the theater is where he was taken to die.

We then viewed the Lincoln Memorial, an American national treasure built to honor the sixteenth president of the United States.

According to Wikipedia, "It anchors the western end of the National Mall across from the Washington Monument. The grand Lincoln Memorial towers over the Reflecting Pool. The best way to approach the memorial is from the east, by the Washington Monument and the National World War II Memorial, which will put you at the edge of the Reflecting Pool, a shimmering expanse that illuminates the grand structures honoring our most storied leaders. You then can stroll toward the memorial and watch as it gradually gets larger. When you stand directly in front, gaze at the handsome marble columns surrounded by greenery, part of a design inspired by ancient Greek temples. There are thirty-six columns, each one representing one state in the US at the time of President Lincoln's death. The memorial is 190 feet long and 119 feet wide and reaches a height of almost 100 feet. You climb the stairs leading to the interior and look up. There, etched into the wall, is a memorable quote: "In this temple, as in the hearts of the people for whom he saved the Union, the memory of Abraham Lincoln is enshrined forever."

One morning my friends didn't want to get up early so Miss X and I went off on our own to explore the city. I had previous experience with the Hop-on Hop-off city buses so I reserved two tickets for our trek. We ventured out into the thirty-degree weather to find the city bus stop. I was convinced I knew what I was doing because I had done this many times before and had reserved our spot. Long story short, we must have waited at least thirty minutes for the right bus, which never came! I know we were at the right bus stop. Several tour busses came and went, but not the one we needed. Poor Miss X, she was shivering badly but never said a word but was a trouper. I finally suggested that we walk to the nearest visitors' center and find out what was going on. We never got a straight answer, so we took a cab back to the hotel and called it a day. It was all right; I always enjoy experiences like that. I'm never afraid to get lost because I can always find my way back to square one by asking.

We later visited the tall Washington Monument directly across the pond. According to Wikipedia, the monument is an obelisk built

to commemorate George Washington, once commander in chief of the Continental Army during the American Revolutionary War and the first president of the United States. The monument was designed by Robert Mills and eventually completed by Thomas Casey and the US Army Corps of Engineers. It memorializes George Washington at the center of the nation's capital. The structure was completed in two phases of construction, one private (1848–1854) and one public (1876–1884). Built in the shape of an Egyptian obelisk, evoking the timelessness of ancient civilizations, the Washington Monument embodies the awe, respect, and gratitude the nation felt for its most essential Founding Father.

George Washington's military and political leadership was indispensable to the founding of the United States. As commander of the Continental Army, he rallied Americans from thirteen divergent states and outlasted Britain's superior military force. President Washington's superb leadership set the standard for each president that has succeeded him. The Washington Monument towers above the city that bears his name, serving as an awe-inspiring reminder of his greatness. The monument, like the man, stands in no one's shadow.

We then drove to the Cuba Libre Restaurant & Rum Bar on Ninth Street. According to their menu the restaurant features classic and contemporary Cuban cuisine by two-time James Beard award-winning chef, Guillermo Pernot. Their menu featured "tantalizing tastes derived from the exotic island's culinary traditions, which includes Spanish, African, Creole, and Asian influences. The restaurant's atmosphere transports guests to Old Havana circa the 1950s. One-of-a-kind millwork and architectural salvage, including unique doors, gates, cabinetry, furniture, and accessories, help capture the essence of old Cuban architecture. Colorful exotic foliage and large potted palm trees add to Cuba Libre's open-air, tropical ambiance. Featuring over seventy rums, Cuba Libre's refreshing house specialty, the mojito, is made from the authentic Cuban recipe of combining rum, fresh lime juice, fresh mint leaves, a splash of soda,

and most distinctively, sugarcane juice pressed daily on site." Connie introduced me to my second mojito. I ordered a decadent meal of seared duck with Swiss chard in a delicious orange sauce.

Another day the four of us traipsed through the snow-sprinkled road to a spa where we treated ourselves to heavenly services. Connie and I had a wonderful pedicure, Miss X had a manicure, and even Billy had a pedicure.

Billy drove us all around DC, pointing out several main icons; I had never dreamed that I would experience something like that. I learned that he had spent quite some time in DC in the military and even lived there for a length of time and knew the city quite well.

My trek from the hotel back to Dulles airport was an experience. I called for an Uber driver and not really knowing what I was doing, I reserved a driver of a four-passenger vehicle. The driver came to my location quickly; I packed my bags into his car and got in. I was running late for my departure, and I told the young Israeli driver that I was in a hurry and he couldn't make stops for other passengers. He scolded me because I had reserved a car scheduled to pick up several other passengers along the way. I was inexperienced and didn't realize the protocol. Well, he compromised after we talked a bit, and he decided to make only one stop for a second passenger.

After the drop-off of that passenger, he scolded me again, but as we started talking during the drive, he lightened up and became quite nice and understanding. We had a long talk about our cultures, our interests, etc. He told me that he had moved to DC after leaving his wife and child and shared his life struggles with me. I believe it was meant to be for him because if it hadn't been for the incident, he may not have had the opportunity to share his frustrations if he had picked up other passengers. I felt good after that. Things usually happen for a purpose, God's purpose. We became friends after the long drive, and he ended up being quite charming. It was definitely a win-win situation.

Chapter 71

Connie and Billy had worked as a team for seventeen years at that point as full-time professional clowns and balloon twisters, and Connie was also a professional face painter. Their business name is Cuddles and Billy Boy. She has worked in the industry for over twenty-five years. She's a fun person and easy to get to know and pour your heart out to. She wears purple and blue streaks in her hair and tells me we need to stand out and be noticed. Billy is a quiet, soft-spoken individual and doesn't socialize with the crowd. He accompanies her to all the classes and conventions. I do know that when you get him alone and away from a crowd of people at a convention, he opens up, and you get to know him. Connie and I bonded and formed a friendship for years to come. Although we lost touch over the years, we reconnected at a St. Louis face painting, body painting and balloon convention in 2018.

This is Connie's story. Connie first worked at a grocery store called Randall's in Racine. She had a huge pin collection that she wore on her smock—the arms, back collar, and front. The pins were given to her by different clients over the years. She was on the front page of the Racine newspaper a couple times wearing the smock. One day in June 1992, she was checking out a woman in line. The woman asked if she would sell her the pin that said "Have you hugged a clown

today?" Connie told her no; they were not for sale because her clients had given them to her. The woman then proceeded to tell her that she was a clown in Racine by the name of Sneakers and that she should think about becoming a clown too. Connie thought, "Yeah, right lady!" The woman told her she was so friendly, and the people loved her. "Just look at all your pins!" Sneakers said she would return in a month and ask her again, and if Connie was interested, Sneakers would take Connie to a clown club in Delevan, Wisconsin, the following month.

Connie asked her mom, her sisters, and her son what they thought of it, and they all thought it would be great! Connie said yes, and the rest is history. She told me that Jodi Carr was a big part of her learning. They went to lunch and dinner together, and Jodi taught her how to make bows and fairies. Jodi would give her personal lessons by faxing her drawings or step-by-step instructions on how to make a monkey for example. She became close to the Wolfe twins, Brian and Nick, and attended many conventions and classes where they were teaching. Anything in class that she needed to know, they painted on someone for her...even if they had never done it before. That's how great they were. A full-face painted car was one of their teachings, and they came out with a book on mobile and flying things. Connie still uses those designs.

The presidents of clown clubs wanted instructors, and they knew Connie painted as Cuddles, so they asked her to do a class here and there in California, Nevada, Arizona, and Wisconsin. Connie was an instructor for several years and ran in the circle with master face painters such as Mark Reid and the Silly Farm staff. She taught at the Laughlin, Nevada, conventions, as well as the Western Region Clown Convention, the San Francisco Clown Alley, and an Atlanta conference.

When Connie attended her first clown club, she met Billy in a group of clowns, but she didn't care much for him because he had five kids, and she didn't want any part of that! Besides, Connie was too busy going to conventions to learn her trade, including magic,

Chapter 71

balloons, puppets, face painting, and games. It was a lot. She focused at first on balloon creations (and she was good at it). Then she had to learn face painting, but all that was available at the time were German crayons that were used with water. One of her clown friends, the Alley, told her to use a paintbrush to take the paint off the crayon; that way it was easier to get thinner lines and have more control of your lines. So she did, and it worked for her. Doing small art or "cheek art," as we say in the industry, wasn't her thing so she decided to try full-face designs. She painted tigers and princesses. She decided to date Billy five years after meeting him. He asked her to do a gig with him and she accepted.

And that's her story. I always look forward to seeing her at the conventions.

Chapter 72

Emily was a second-time client in Tracy, and I was thrilled to paint for her three-year-old daughter Stevie's birthday party again. I was all set and arrived at the event early. I started unpacking my table, chair and supplies. Because of my experience with the previous two vehicle break-ins, I was super cautious with security so I locked my car as I was accustomed to doing and was ready to go. But to my horror I discovered that I had locked my car with not only my keys inside my car but also my kit. I couldn't do the job without my supplies. What a panic! Luckily, one of the parents at the party called AAA emergency service, and they came to my rescue in less than a half hour. They opened my car door, and I was able to retrieve my supplies in order to do the job. Thank God, the event was a success after all!

A local little league baseball coach hired me to work their opening day. I should have known that since it was a small town in Stanislaus County it might not be a success and I was right. I tried my hardest by walking around the entire field trying to recruit kids to have their faces painted but I didn't get much response. I think I had

Chapter 72

maybe five kids that day! I didn't have the heart to charge for the full hour and a half that I was hired for so I settled for a free hotdog and soft drink as payment. I need to learn what gigs work and what don't. And this type of event—unless there's a decent number of kids—just doesn't work.

In March I was hired to work two hours at a local cell phone store for their client appreciation event at two different locations; two different weekends. Both gigs paid well, and the Modesto location brought in a pretty good audience, but no one showed up at the Manteca location. So I informed my contact that I didn't care to work the second hour with no business, and then I left; that was a disappointment since we all were hoping for a crowd.

I was hired for a picnic in the park for special needs children. I had no idea what to expect for the hour but it was quite an experience. Painting for special needs children humbled me, and I felt compassion for them. There wasn't a huge number of kids, but I walked around each craft table trying to recruit them to be face painted. In the end, I decided not to charge the leader. I run my business from my heart basically—not that I give away my business for free—but when I see a nonprofit organization that really shouldn't be charged, I will work for free. I'm not so cut-throat that I must make a profit every time.

I was hired for a gig with a repeat client, Joselyn, for her

eight-year-old daughter's birthday party. Joselyn was a third-time repeat client, and the party location was only a bit out of my standard thirty-mile territory so I didn't charge her a travel fee. She asked me to "cut her a break" with a twenty-five-dollar discount, so I did since she was a repeat client. At that point, I was still running my business as the "good ol' girl" and not quite as professional as I should have been. When I arrived at the party and started painting, the number of guests kept growing and growing. It became more crowded in my tiny area to paint, and guests kept bumping into me. The client had also hired a mobile mixologist with full bar accommodations, a DJ, a bounce house for the kids, and a huge variety of catered food; yet she still wanted a twenty-five-dollar discount from the "small face painter" so she could afford to wow her guests with huge entertainment. I began to feel resentment growing.

When my shift was up, I still had four kids who wanted to have their face painted. I had to hunt down my client in the crowd to see if she wanted me to continue, but it would cost her more money. She again asked me to cut her a break. I told her no and that I already had given her a discount. No more discounts! I was angry at that point. She agreed to pay me full price if I agreed to paint the additional four kids, so I painted them. When I finished, I had to again hunt her down and wait another ten minutes for her to hug and socialize with her special guests before I finally got my payment.

Lesson No. 1 learned: No more discounts for individuals, no matter how many times they've hired me—nonprofits only. Lesson No. 2 learned: Require payment in advance. If not honored, client will agree to pay an additional twenty-five dollars that will be billed to them; put it in a contract. Lesson No. 3 learned: Give all clients an invoice and a contract with requirements. Lesson No. 4 learned: Have client reserve a parking spot for me. Lesson No. 5 learned: Require a twenty-five-dollar deposit. Lesson No. 6 learned: I will no longer be compromised; if the client wants a cheaper face painter, I will gladly refer them to one.

That did it for me—good business lessons learned. My intention

Chapter 72

is to rework my client invoice, as well as add a contract to include the requirements of the above. I used to have a contract, but over the years, somehow I became the good ol' girl and started running my business casually.

I sold my reliable 2005 Chevy Aveo that I'd had for fourteen years when an opportunity to purchase a new vehicle arose. My car wrap on the back window that I'd had for six years had to be removed. I was so sad when I watched my printer friend, Clint, remove it. I almost cried because it was part of my identity as a business.

I was hired for an end-of-the-year school carnival in Modesto due to someone cancelling at the last minute. I've run across the situation from time to time where someone cancels on a client without substituting another face painter. The event went well, and I painted several kids, and some teachers and parents as well. The teachers were very impressed with my work and integrity and promised to hire me again next year.

I attended a women's leadership business development and networking conference in May in which I was invited by my friend Terry, a professional clown and balloon twister for many years. She and I attended the all-day conference "Unleashing the Brilliance of Women in Leadership" at downtown Modesto Centre Plaza at the Doubletree Hotel. There was a good lineup of speakers, including two councilwomen. Topics included "Without Permission on

Human Trafficking" by Kristi Ah You. Other highlights included asking for what you need and believing in yourself. Vendors of all kinds displayed their products. The variety included purses, jewelry, businesswomen's attire, plants, insurance, essential oils, mobile devices, makeup, jellies and jams, plasticware, graphic design, and business consultation.

I chatted with my friend in between presentations about how she became a working clown of twenty years and how she took the huge leap. She had no plan when she decided to quit her job, nor did she have money saved; and she was fifty years old. That, to me, is gutsy! I admire her persistence.

Terry had good advice for me for growing my business. One of the things she does is barter with services for partial payment of her membership fees for the local city chamber of commerce. Their membership fees run about $300 a year; much too high for a small business owner. So she offers her clowning/balloon twisting services for free in exchange for partial membership dues. Not a bad idea! I will try other chamber of commerce organizations just outside my local area.

I took away a couple of things from the women's conference. I learned some things from one of the speakers, Tami, who offers life coaching and retreats. She gave a mini exercise on paper called "Creating Strong Leaders: Connecting Values and Vision" that was to determine if my values in my life and in my business are fear-driven or conscience-driven. After doing the self-assessment, I learned that many of my values are fear based, pretty sad. The next part of the exercise was to clarify our values and create our vision. Since she had only fifteen minutes to talk, it was a short exercise, not enough time to go into details. But it was enough to spark my interest to inquire about her life coaching.

Keynote speaker Michael discussed return on investment (ROI). He helps clients crush the noise and distraction in order to navigate the confusing planning and performance process, resulting in leadership excellence and organizational improvement. I learned from his

advice. He said to be competitive so you can inspire others. Some bullet points included taking the next level of discipline, asking yourself where you are now, planning is preparing, using the right resources, identifying what is working and what is not working, and setting deadlines in your action plans. Not having a written plan makes it impossible for others to help you grow your business; that's what I fail to focus on. I've had a business plan for years since I started my business in 2009, but I have never worked the plan and measured the goals. So it's useless at that point. Denzel Washington is his idol, and he has some profound advice as far as growth. Giving up is not an option.

Another keynote speaker Dana Wright is a global organization development consultant, who leads clients through transformational processes around strategic planning, employee engagement, and leadership. She had good advice that I agree with: Know your why, know your business, and know yourself. Know what you are compassionate about—your vision, purpose, and reason. What values are attached to your business? I really liked her point of taking yourself on a quarterly retreat with your business plan and problem-solving. Ask yourself, "How am I doing? What's working? What's not working?" That is golden advice.

Much of these business and personal development strategies are similar to Bay Area artist Ann Rea's course on how to sell your art without feeling like a sellout. Many business concepts and theories are the same. It had been two years since I graduated from the course, and I realized that although my painting career had its ups and downs, my face painting business had been consistent over ten years. I believed if I took the course again, I would benefit from it the second time around. And by applying it to my business, I thought I could thrive this time. So I gave it a shot. I learned a lot from the course and gained quite a bit of insight. Later I went through my notes again and applied them, which made a lot more sense.

Another repeat corporate client hired me for an event with Rizo-Lopez Foods, Inc. The event was held outdoors at a huge private residence, and there were lots and lots of kids and several activities. Sparkles the Clown was there doing her bubbles and clowning. It was certainly to be a next-year repeat client for sure!

Another repeat corporate client from Santa Clara High School hired me for their grad night held again Boomers Amusement Park in Modesto from 11:00 a.m. to 4:00 p.m., grueling hours. As my seventh-time client I did temporary glitter tattoos for the high school graduates. They loved it. That particular year was quiet and I was told out of four hundred graduates only fifty were at the event, but we had fun anyway. Neeta has always been there with me doing her fabulous henna designs, and there was always a balloon twister/magician from the Bay Area, as well as a caricature artist also from the Bay Area, maybe Vallejo.

I worked a gig for Five Minute Car Wash in Modesto for their American Graffiti car show. It was not very well attended as far as kids go, but we all still had a good time! I was challenged to paint two young adult faces and did well. The DJ, Bob, who I met many years ago, captured me with his wit and his interaction with the audience. The entertainment industry is such a small world sometimes where I meet artists/entertainers over the years again and again. As it is, Bob is the uncle of Mike, a former coworker from my day job and it had been several years since I worked a gig with him. He invited me to join him at an upcoming Fourth of July event in Manteca. Networking is a crucial element of our industry.

Chapter 72

In July another repeat corporate client hired me for a second time for their annual company picnic at the Wine and Roses Resort in Lodi for two hours. I hired three balloon twisters for them and two face painters (Raquel and Liz). It was, again, a successful event. My favorite balloon twister, Daryl, and I recruited two more twisters from Sacramento and Grass Valley. Fellow face painters Raquel and Liz and I have worked several gigs together over the years and have developed a camaraderie. It's nice to have a support group.

Some days just don't go well for a face painter. One morning in August before heading off to a hospice fundraiser event in Stockton for some reason I could not decide what to wear. I must've tried on ten different outfits before I made up my mind. I made it to the event on time. I set up my station and didn't have children for a while, so I decided to move my car to a free parking lot where I was closer. I wasn't feeling particularly cheerful that day but I always manage to put on a smile for my clients, no matter what. The face painting business isn't always peaches and cream, and sometimes I don't like the business end of things.

I worked from 9:30 a.m. to 12:30 p.m. It was a hot day—over one hundred degrees—and miserable because of the heat. Toward the end of my shift, I started getting impatient and announced that the last few kids would have to get simple designs due to my time limitation. That went fine and the line was drawn; however, the father of the last in line asked if I'd paint a wolf design on his daughter's face, which was in my advanced binder of designs. I did, but it took a while. It turned out pretty good. Then, of course, he wanted a tribal design, which I love painting, so I didn't turn him down. Most

of my clients were young adults from a youth academy, which was fun because they wanted unique designs and words that their commander used in their training.

I worked a hot August gig for a regular client at the Dust Bowl Brewery in Turlock. Communication with the new contact person was not exactly clear and the late afternoon heat was unbearable making me irritable. I was not feeling particularly pleasant at all. I was not given precise details where I would be. You'd think by now, after ten years in business, I would ask about such details. Luckily, I found a parking space close to the event, and three men wearing bright-orange jackets came over to me immediately after parking to ask if I needed help with transporting my equipment. My first thought was "Wow, this was impressive that the company would provide personal assistance!" They weren't employees at all; they were just regulars headed for the brewery and were kind enough to help me carry my equipment and supplies to the location.

I began my shift in that awful heat. A young woman next to me was setting up her station for arts and crafts for the kids. She and I got acquainted and agreed that the heat was going to be a challenge to work in. There were not enough umbrellas, so she had another umbrella brought over to our location. As the sun moved, she started adjusting the umbrella to cover us. In the process, a sudden gust of wind nearly knocked her over when the umbrella became top heavy. In my attempt to help, somehow the base toppled onto my foot, leaving a nasty bruise for several weeks. We got it set up with the help of a parent. The event started off slow. I had a new helper, Gavin, to assist with line control, photo taking, changing my water, etc. He was bored and hot, I'm sure because his first event was very slow. He was a sweetheart, however, and did what I asked of him, including planting my postcards on

patrons' windshields. It was an experiment to grow my business, and it worked well.

As I was face painting the manager who hired me, I learned that coincidentally she was involved with the Small Business Development Center (SBDC) and invited me to contact her for business development. It's incredible how the law of attraction works! We connected, and she was willing to help me accelerate my business and learn more about Facebook advertising. What I learned from the event, since it was at a public location, was to make sure the kids in line were from my paid client and not from the general public. I had kids enter the line whose parents were just hanging out and thought my face painting was for the general public. So, that's a lesson to be learned.

Another repeat client, Armando, hired me for his six-year-old daughter's birthday party—I love his parties. He is a good guy and very family-oriented with six children. I referred my balloon-twisting friend and associate, Kevin, for his party and he was a big hit! Armando and I talked about last year's balloon twister that he had found online who was a disaster and a total idiot. I had met the twister a few times at other gigs. He was a total looser and acted like he was drunk. Who knows? Maybe he was! The only professional thing about him was that he dressed as a clown. He told dumb jokes to the kids that were not kid-appropriate, he moved way too slowly, he showed up late, and he kept coming over to my station to talk to me even though he had a lineup of kids waiting for him! Unbelievable! I finally told him that he needed to stop talking to me and that I was working and so should he. Consequently, my client was thrilled with my colleague Kevin, who was professional, talented, reliable, and funny.

The party went well as all Armando's parties do. I painted my usual designs but also painted adults and young adults with flowers

up and down their arms. I had attracted the young preteen boys at the party who, to my surprise, asked me to paint specialty designs, such as brand names of skateboard companies, etc., on their arms. They loved it! It's always a sense of fulfillment when I can please the preteen age group with my skills. And I'm always up to the challenge.

I met Kevin in 2013, while working a gig together. Over the years Kevin, Berkle the Clown, and I have worked side by side and have referred each other to gigs. Whether he is portraying himself, Capt. B. A. LLoon, Dazzling Dexter, or the Great Spumoni, his guests are amazed and nearly falling out of their chairs with laughter. He is a birthday party clown, magician, and a family entertainer.

Since the beginning of my business, I think out of all my designs I've painted in my career, a cute little tiger face that I painted on my great niece, Amelia, has always been my absolute favorite. And with her pose and jubilant expression, the image is priceless to me and forever in my heart.

Chapter 73

I had the opportunity to join a Trafalgar Tour Group on the "European Whirl Tour." On October 3, 2019, I landed in London, waited an hour for my luggage, and missed my tour driver due to a snafu. A driver was supposed to be included in my travel voucher but wasn't, so in my anguish and worry from being a stranger in a new place and not knowing my way around, I tried not to panic. I ended up hiring an Uber driver (thankful that the service is international), who drove me to the Tower Hotel where the convention was being held. I paid him ninety-two dollars and arrived at the hotel by 1:00 a.m. The weather was fifty-five degrees with a light sprinkling of rain. It was refreshing, but I was too exhausted to enjoy it. I brought several USB cables with me for phone charges, necessary for the conversion, but none seemed to work on my iPhone. Luckily, I found the right converter at the airport gift shop and purchased it. I slept for a few hours and then got a call from my tour guide, who gave me the details of the following day's tour that included the changing of the guards at Buckingham Palace.

I had arrived two days before the scheduled tour, so I walked around the Tower Bridge by myself and felt very comfortable with all the other tourists walking around. I found a restaurant on the other side of the bridge where I had my first official London-style fish

and chips with mashed peas. These peas were not at all like ours in America; in fact, I had never even heard of mashed peas! I learned that they call their mashed potatoes mashers and their elevators lifts.

I purchased a two-day pass on a tour bus that had the Hop-on Hop-off option. I took the bus to Westminster Abbey and toured Buckingham Palace—an amazing tour! We were not allowed to take photos inside. The room called the Quire is where royal couples are married and hold their coronation ceremonies (crowning of a king or queen). It was spectacular. The Abbey was filled with centuries of history, tombs, and shrines of many kings and queens of England. I purchased several souvenirs in the gift shop and spent the rest of the night outside with a glass of wine enjoying the Tower Bridge all lit up. The atmosphere was very comfortable with tourists mingling just outside my hotel, and there were some food and gift vendors set up. I could easily do it again on my own. Later I enjoyed a lovely dinner of cod, chips, and salad at a sidewalk bar and grill. What a thrill knowing that I had been at Westminster Abbey and had toured Buckingham Palace where royalty have been for hundreds of years and are still!

I ordered a caramel macchiato from a Starbucks vendor in the hotel and met up with the tour group of thirty-three. Side note: I noticed in that part of London several people smoked and women still wore miniskirts.

Our tour guide led us through London on a pre-tour and ended with the house guards' parade outside Buckingham Palace. I learned that when The Queen was in, a royal flag was flown above Buckingham Palace so people would know she was in.

According to www.royal.uk/royal-standard, "The Royal Standard represents the Sovereign and the United Kingdom. The Royal Standard is flown when The Queen is in residence in one of the Royal Palaces, on The Queen's car on official journeys and on aircraft (when on the ground). It may also be flown on any building, official or private (but not ecclesiastical buildings), during a visit by The Queen, if the owner or proprietor so requests." And according to Wikipedia,

"If the Union Flag flies above Buckingham Palace, Windsor Castle or Sandringham House, it signals that The Queen is not in residence." Consequently, The Queen was not in during our tour.

Our tour guide also pointed out the London Eye, which opened in 2000. It is Europe's tallest Ferris wheel. You can go up in the capsule, and with the rotating Ferris wheel, you can see the entire city view in maybe one and half hours. After the pre-tour, we went our separate ways, which was nice since I enjoy exploring on my own. I walked around Parliament Square and Fleet Street and saw St. Paul's Cathedral and the Albert Memorial. The Albert Memorial, directly north of Royal Albert Hall in Kensington Gardens, was commissioned by Queen Victoria in memory of her beloved husband, Prince Albert, who died in 1861.

Day 1 was the first official day of the tour. We had a wonderful tour guide who lived in Amsterdam and was extremely knowledgeable, giving us a worldly education on each place we visited. We took our bus to St. Pancras International train station where we hopped on the Eurostar to Brussels, Belgium. We breezed into Holland with a half-hour bus stop before arriving in Amsterdam. We had fun traipsing in the misty rain and discovered the well-known Red Light District. That evening we took a riverboat dinner cruise down the Rhine River—Amsterdam canal belt—and passed the home of Anne Frank and her family before they went into hiding from the Germans for two years during World War II. It was sad seeing her family's house, and after the tour, I immediately purchased the book *The Diary of Anne Frank*. There were many beautiful castles along the way.

We stopped in Heidelberg–Altstadt, Germany, for a short time to shop and tour the Church of the Holy Ghost. The Church of the Holy Ghost is the most famous church in Heidelberg and stands in the middle of the marketplace in the old center of Heidelberg, not far from Heidelberg Castle. The steeple of the church, rising above the roofs, dominates the town. It opened in 1398!

Day 2: We drove to Munich and saw where the Munich Olympic Stadium was for the 1972 Olympics. We took a walk through the Hofbräuhaus, and it was pointed out that the first Nazi meeting was held upstairs in that building in 1920. We saw the show called Tyrolean Evenings with the Gundolf Family (of Innsbruck).

We then toured the magnificent Mariensäule and according to Wikipedia, "The Mariensäule is a Marian column located on the Marienplatz in Munich, Germany. Mary is revered here as Patrona Bavariae (latin: Protector of Bavaria). It was erected in 1638 to celebrate the end of Swedish occupation during the Thirty Years' War, to be precise, following a respective vow by Duke Elector Maximilian I of Bavaria if the ducal residential cities of Munich and Landshut would be spared from war destruction. The column is topped by a golden statue of the Virgin Mary standing on a crescent moon as the Queen of Heaven, created in 1590. The figure was originally located in the Frauenkirche. Mariensäule Munich was the first column of this type build north of the Alps and inspired erecting other Marian columns in this part of Europe.

At each corner of the column's pedestal is a statue of a putto, created by Ferdinand Murmann. The four putti are each depicted fighting a different beast, symbolizing the city's overcoming of adversities; war represented by the lion, pestilence by the cockatrice, hunger or famine by the dragon and heresy by the serpent."

Day 3: We toured Venice, Italy, and took a cruise down the Juneca Canal from St. Mark's Square. In the Alpine area, an archaeological find was pointed out of a body in the ice that had been frozen for five thousand years. Incredible!

We then took a boat trip on the famous gondolas in Venice, something I had wanted to do since I first learned about them. According to www.wonderopolis.org, "Gondolas were once the main modes of transportation in Venice. Today, they are mainly used by tourists. However, they still play an important role as traghetti, or ferries, over the Grand Canal. The earliest gondolas featured a felze,

or small cabin. It protected riders from the weather. The windows of the cabin could be closed with louvered shutters. These gave rise to Venetian blinds, which cover the windows of many homes today. At the height of their popularity, there were about ten thousand gondolas in Venice. That number has fallen to fewer than five hundred today. Today's gondolas are open to the air. This allows tourists to have a better view of the city. By law, gondolas must also be painted black. The boats also often have a special ornament on their front. Called the *fèrro* – meaning "iron"—it can be made of brass, stainless steel or aluminum. In addition to being decorative, it helps to balance the boat. It acts as a counterweight to the gondolier who stands in the back of the boat."

Day 4: We got to see the Vatican museums and the Sistine Chapel. The Sistine Chapel is in the Apostolic Palace, the official residence of the pope, in Vatican City. According to Google Arts & Culture, "The Sistine Chapel is a chapel in the Apostolic Palace, the official residence of the Pope, in Vatican City. Originally known as the Cappella Magna, the chapel takes its name from Pope Sixtus IV, who restored it between 1477 and 1480. Since that time, the chapel has served as a place of both religious and functionary papal activity. Today it is the site of the Papal conclave, the process by which a new pope is selected. The fame of the Sistine Chapel lies mainly in the frescos that decorate the interior, and most particularly the Sistine Chapel ceiling and The Last Judgment by Michelangelo.

During the reign of Sixtus IV, a team of Renaissance painters that included Sandro Botticelli, Pietro Perugino, Pinturicchio, Domenico Ghirlandaio and Cosimo Rosselli, created a series of frescos depicting the Life of Moses and the Life of Christ, offset by papal portraits above and trompe l'oeil drapery below. These paintings were completed in 1482, and on 15 August 1483 Sixtus IV celebrated the first mass in the Sistine Chapel for the Feast of the Assumption, at which ceremony the chapel was consecrated and dedicated to the Virgin Mary."

According to Sistine Chapel: Facts, History & Visitor Information by Jessie Szalay October 29, 2013, "In 1990, some physicians suggested that the flying-seat shape and figure of God in "The Creation of Adam" makes up an anatomically correct image of the human brain. In 2010, it was asserted that "The Separation of Light From Darkness" panel contains a human brain stem. Other theorists have suggested that Michelangelo depicted kidney imagery on the ceiling. As a sculptor, Michelangelo was fascinated by the human form. He studied cadavers to get a better sense of anatomy, and would have been familiar with the human brain.

Painting the Sistine Chapel was an exhausting task, and Michelangelo's relationship with the Catholic Church became strained doing it. Perhaps to depict his unhappiness, he hid two miserable-looking self-portraits in "The Last Judgment." He painted his deceased face on Holofernes' severed head and his ghoulish visage on Saint Bartholomew's flayed skin."

We toured the inside of the Colosseum which was my second time visiting it, but this time I got to go inside and walk around. According to history located just east of the Roman Forum, this massive stone amphitheater was commissioned around AD 70–72 by Emperor Vespasian of the Flavian dynasty as a gift to the Roman people. In AD 80, Vespasian's son Titus opened the Colosseum—officially known as the Flavian Amphitheater—with one hundred days of games, including gladiatorial combats and wild animal fights. After four centuries of active use, the magnificent arena fell into neglect, and up until the eighteenth century it was used as a source of building materials. Though two-thirds of the original Colosseum have been destroyed over time, the amphitheater remains a popular tourist destination, as well as an iconic symbol of Rome and its long, tumultuous history.

Next, we were off to Rome to see piazzas and the fountains of Rome's Piazza Navona, which is a public open space built on the site of the Stadium of Domitian, in the first century AD. The ancient Romans went there to watch the agones known as "Circus Agonalis." In ancient Rome, the site was a stadium built during Emperor

Domitian's rule. Today, Piazza Navona is best known as a location for Baroque architecture, such as Gian Lorenzo Bernini's famous Fontana dei Quattro Fiumi (Fountain of the Four Rivers).

Day 5: As a tour group we were invited to enjoy a home-cooked dinner prepared by the lovely and gracious owner of a beautiful four-hundred-year-old estate in the town of Greve in Chianti, (30 kilometers south of Florence), and we toured the fabulous estate.

Day 6: We traveled into the Swiss Alps and Austria. Our tour director pointed out that the 1964 and 1976 Olympics were held in Innsbruck, Austria, where we saw the Olympic rings and the winter ski jump, which was fascinating! We took a day trip to Mount Pilatus and took the cogwheel train (called the Pilatus Railway) from Alpnachstad up the steep mountain to the top. Pilatus Railway is the world's steepest cogwheel railway, operating from May to November (depending on snow conditions), and the whole year with aerial panorama gondolas and aerial cableways from Kriens. According to Wikipedia, Tomlishorn is located about 0.81 miles to the southeast of the top cable car and cog railway station. Two other peaks, closer to the stations, are called Esel (donkey, 6,949 feet, which lies just east over the railway station) and Oberhaupt (leader, 6,906 feet, on the west side). The scenery was absolutely spectacular.

Our next tour was in Engelberg, Switzerland, where we enjoyed a horse-drawn carriage out to a local cheese farm in the Swiss countryside. The owners graciously gave us a tour of their farm and had us taste their handmade cheese, which is exclusively sold only in Switzerland.

Our final stop of the tour was to enjoy a night at the Moulin Rouge cabaret in Paris, where we saw a spectacular performance. Moulin Rouge, according to Wikipedia, is best known as the birthplace of the modern form of the can-can. Originally introduced as a seductive dance by the courtesans who operated from the site, the can-can dance revue evolved into a form of entertainment of its

own and led to the introduction of cabarets across Europe. Today, the Moulin Rouge is a tourist attraction, offering musical dance entertainment for visitors from around the world. The club's decor still contains much of the romance of fin de siècle France. I had my first experience eating escargot. I ate six of them, and they were exquisite. Escargot is a dish consisting of cooked, edible land snails. They are often served as an hors d'oeuvre and consumed by the French, as well as people in Germany, Great Britain, Italy, Portugal, and Spain.

Day 7: We couldn't leave Paris without viewing the famous Eiffel Tower. According to Wikipedia, the Eiffel Tower is a wrought-iron lattice tower on the Champ de Mars and is named after the engineer, Gustave Eiffel, whose company designed and built the tower. Locally nicknamed "La dame de fer" (French for "Iron Lady"), it was constructed from 1887 to 1889 as the entrance to the 1889 World's Fair and was initially criticized by some of France's leading artists and intellectuals for its design, but it has become a global cultural icon of France and one of the most recognizable structures in the world. The Eiffel Tower is the most-visited paid monument in the world; 6.91 million people ascended it in 2015.

The tower is 1,063 feet tall, about the same height as an eighty-one-story building, and the tallest structure in Paris. Its base is square, measuring 410 feet on each side. During its construction, the Eiffel Tower surpassed the Washington Monument to become the tallest man-made structure in the world, a title it held for forty-one years until the Chrysler Building in New York City was finished in 1930. The tower has three levels for visitors, with restaurants on the first and second levels. The climb from ground level to the first level is over three hundred steps, as is the climb from the first level to the second. Although there is a staircase to the top level, it is usually accessible only by lift.

Chapter 74

I had the pleasure of leading my very first Paint and Sip Night in November for fellow coworkers, their family and friends. It was an exciting first-time experience. My coworker Erin helped me coordinate and set up for the event at our workplace. Another coworker, Jan, organized the drinks and snacks for the evening event. She provided an elegant display of snacks. We had an attendance of twenty-five people who were thirsty for the creative experience. My theme was "Joy," and we had festive holiday music streaming throughout the evening. I was nervous about my first event as a leader, but I did okay and everyone seemed pleased.

The chief executive officer of the company, DeSha, introduced herself and the purpose for the evening's first-time special event, and she wished us all well to have a good time and enjoy the experience. I nervously started by introducing myself and describing the art project we were about to create.

I supplied each table with paints, paintbrushes, and water, as well as a sample of a basic acrylic painting of the word "Joy" for the holiday season. I demonstrated the steps to paint their canvas using acrylics. I encouraged everyone to use their creative instincts to come up with a unique piece with their choice of color and glitter. The event was a success, and everyone painted a beautiful piece using their own unique style.

I led my second Paint and Sip Night the following February teaching many of the same people as the one before. Erin again helped me coordinate and set up for the event at our workplace, and again we provided drinks and snacks for the evening. We again had an attendance of twenty-five people who were thirsty for the creative experience. My theme was four-leaf clovers, and I demonstrated how to paint a two-stroke clover. Again, we had festive music streaming throughout the experience. I wasn't as nervous as I had been for my first event as a leader.

This time, in the second half of the workshop, I asked participants to choose a piece of glassware from my collection, including wine glasses, water glasses, shot glasses, glass bowls, beer mugs, candy dishes, etc. I had everything! They loved that.

I supplied each table with paints, paintbrushes, and water. I demonstrated the steps to paint their canvas using acrylics, and I encouraged everyone to come up with a unique piece using their choice of color and glitter. The event was a success, and everyone painted a beautiful piece using their own unique style.

Chapter 75

Bill AB5, 2020 (Disaster for the entertainment industry)

On January 1, 2020, California Bill AB5 went into effect. It states that for a promoter to hire an entertainer for a gig, they must put that entertainer on the payroll and pay payroll taxes. Entertainers are no longer allowed to be independent contractors. If a musician wants to hire other musicians to play a gig with him or her, that initial musician has to pay to create a corporation, list the other musicians as employees, have a payroll company pay the musicians, and also pay the payroll taxes for the musicians hired—even if it's only for a couple of gigs. If a restaurant wants to have musicians play at their establishment or have an actor perform, the restaurant now needs to hire the musician/actor as an employee on their payroll and pay payroll taxes for the artist. This means that live music/work, which is already diminishing, will become even less for entertainers.

Music and entertainment are a big part of California's industry, and musicians, actors, comics, etc. should be able to keep the status of independent contractor and not be subject to AB5. Entertainers are independent entities who take gigs and can set prices for the work they do. They work with the clients who hire them to provide the appropriate entertainment for their event. We are independent contractors and need to be acknowledged as such by the State of California regarding AB5. This bill will hurt a lot of people in the entertainment/event industry.

Chapter 76

Over the years I have consulted with several mentors. Since Mom always told me to consult your local Small Business Administration (SBA), as well as chamber of commerce organizations, for small business advice. I took her advice and reached out to the local SBA. I signed up for business workshops and classes and learned a lot.

Allen Shelton was my first business coach from the Small Business Administration. He guided me through creating a business plan and gave me numerous tips and ideas on how to expand and grow with marketing and advertising as a startup business. Since then, I have updated my business plan and have a marketing plan.

I've had the privilege of having Gary McKinsey, a retired CPA, as an invaluable mentor from the beginning, and he continues to check on me from time to time to hear about my success. He is a business growth and profit coach, keynote speaker, and seminar presenter.

His mission for over forty years is to work with entrepreneurs and business owners to achieve their goals and avoid expensive, time-consuming mistakes. He has been my hero for years. He advised me when I started my business and gave direction on how to run my business. He helped set up a spreadsheet for me with the categories of expenses I would need to report on my income taxes. I took a couple of small business classes from him. I also sought help and advice in the beginning from the SBA and have taken classes on social media marketing, etc.

Gary recommended that I keep a list of all my business colleagues and entertainers for reference. He also helped me set up my books for recordkeeping and advises me on tax information. It's so important to have my business organized. Gary is an enrolled agent and has been engaged in income tax preparation and business advisement for over thirty-five years. He is also a certified guerrilla marketing coach, certified speaking coach, and certified one-page business planning coach. In 1995, he was appointed to the White House Conference on Small Business and continues to this day in that capacity as the associate tax chair for the State of California. He chaired the Tax Committee for Governor Schwarzenegger's Small Business & Entrepreneurship Conference in 2008. He also serves on the Small Business Tax Advisory Council of the US Chamber of Commerce, and he chairs the Northern California Political Action Committee for the National Federation of Independent Business (NFIB). This organization is recognized as one of the most effective small business lobbying organizations in Washington, DC.

Gary also is very active in his local community, where he holds leadership roles in local organizations. He is a frequent speaker for state and local business organizations. His topics include how to improve your person-to-person networking skills, how to market your business through public speaking, the nuts and bolts of running a home-based business, and how to increase your profit through guerrilla marketing. I took Gary's class on "Nuts and Bolts of Running a Home-Based Business." I learned about my buying market, where I

will find them, how I will market to them, how I describe the benefits of my service, why they should buy from me, and how to maintain records, as well as licenses, permits, registrations, and regulations. Maintaining records was a huge lesson, even before I took his class. I met with him personally years ago, and he set me up with the categories for my spreadsheet for tax purposes.

Lisa was my first life coach who advised me along my journey from the very beginning, and she taught me about social media marketing solutions. I spent quite some time with her coaching and marketing ideas for my business. She taught me how to tag my business under a ladder page, how to look at a post in the comment section to see what others have posted and helped me improve my first website. Lisa was an intuitive life coach at the time, channeler, and breaker of perception who I met through Natalie's USM (Ultimate Success Master Class). She helps people break through their perceptions, self-limiting beliefs, and fears so they can access the wisdom of their inner child, their higher self, and the divine wisdom of the universe in order to find the answers they are seeking in life. When we can get past our fear, our ego, and our monkey mind, we are able to manifest our dream life; we are able to live that life without fear. We are able to access all the wisdom of the universe that we need in order to know our passions, our purpose, our destiny, and our gifts, so we can live the life that we choose and a life that can help humanity.

Jennifer Boland has a special place in my heart. She introduced herself to me through the local SBA as a professional business consultant, and she has been a valued business mentor and graphic

consultant from the start. She created business profiles for my business and posted them on several social media sites, such as Yelp, Yahoo, Google, and Yellowpages, as well as on several party and entertainment sites. Jennifer and I have been in contact for a number of years and always met at local coffee houses with her notepad and laptop in hand to plan our course of action. She was a great inspiration and help to me. As a mom, she often hired me to face paint at her children's birthday parties. And when I started getting into fine art, she was a devoted advocate for my art career and purchased one of my paintings that touched her deeply. I owe a lot to her. Love you, Jennifer!

Stephanie Gagos served as my personal business consultant and advised me on how to grow my face painting business. She was a great influence on my business journey. She coached me on how to build my clientele through social media marketing, and she advised me to stick with just one social media outlet, focus on it, and perfect it rather than trying to learn numerous ones. During the time she helped me, she was also a life coach, writer, speaker, group and retreat facilitator and survivor advocate and was also the founder of My Voice of Truth Coaching. She runs support groups for women as well and enjoys sharing her life and healing process on her blog. She also has two survivor sites for men and women who were sexually abused as children, My Voice of Truth and Letters to My Abusers.

Lynn Telford-Sahl has a master's degree in psychology and is a certified money coach (CMC)®, as well as a certified addiction counselor who helps women solve their money problems, break through money barriers, and live their dreams. She was a positive

inspiration for the growth of my business. She helps women and men solve their money challenges using the 4-Step Money Coaching System. This proven system illuminates patterns, beliefs, and obstacles that get in the way of reaching your full financial potential. She also offers Women's Money Circle groups along with individual and couples money coaching. Lynn speaks nationally about financial topics such as "Three Steps to Turn Financial Stress into Freedom" and "Mind Over Money." She is also the author of the "hit" book (New York Daily News) *Intentional Joy: How to Turn Stress, Fear & Addiction into Freedom* and the spiritual novel *The Greatest Change of All,* about women managing the changes of life with fun, food, and connection.

I took two of her Women's Money Circle group workshops and gained tremendous knowledge on how to appreciate money and budget it carefully. The information I learned helped with the management of revenue for my businesses.

Tami Rae is a certified professional coach (CPC) with twenty years as a leadership educator and a transformational life coach for women over fifty. She also offers the Finding Your Voice Retreat Series. These retreats revolve around the Finding Your Voice theme, including Finding Your Voice through Energy, Finding Your Voice through Creativity, and Finding Your Voice through Vision, and so much more!

It is her intention to empower women to find their Voice so they can begin living the purposeful life they have been putting on hold. Tami has a deep desire to facilitate women in the creation of a clear "vision" of what women want their life to look and feel like. Once that vision is clear, she teaches how to take "ownership" of that vision through choices, actions, and language. Women will gain a trust in and understanding of their "intuition," knowing that you

hold all the answers within you. A major part of this journey will involve embracing your courage to face the gremlins that have been holding you back; seeking connection with others, with spirit, and with yourself; and exploring the creativity inside you that allows you to express yourself. Finally, you will master your ability to create positive energy and express yourself fully.

I connected with Tami when she was one of the keynote speakers at a Modesto Women's Leadership Conference and participated in her retreat for creative women—Finding Your VOICE: "Access Your Intuition, Sharpen Your Insight, and Cultivate Creativity." The women in the group and I learned about meditating and focusing and being creative. We were given supplies to create our "spirit doll" (from meditation), which was quite a good experience. I created my doll's body from sticks; for the head I chose a faceless head of muslin fabric; I used fuzzy, colorful yarn for her hair; and I clothed her body in colorful metallic fabric. She turned out to be sort of a free-spirited gypsy girl.

Tami Rae has become my personal life coach and counsels me with business and personal endeavors. She has led me through things that have helped me to succeed with my business as far as, business license, liability insurance, assistant to post flyers, car wrap advertisement, professionalism, good interaction with children and parents, effective website, warm and friendly personality, flyers, coaching, communicating with corporate event planners, having a business plan and a marketing plan, sticking with it, having an overall plan, making a timeline or deadline for action plans, utilizing an assistant, setting intentions and affirmations, and prioritizing. From that, we created a vision for success and action steps. She has been a huge help and a mentor for my personal growth.

Chapter 77

For the longest time I can recall having the dream of writing and publishing a book. I have had many starts on writing one, but nothing became of them. The following are books that I started to write and will someday complete:

Bob's Story: This book was to be about my ex-husband, Bob. We had two children together, but we had too many irreconcilable differences, and our marriage ended up in divorce. However, several years after the divorce, Bob and I developed a special trusted friendship and became best friends. He had an unusual quality to tell stories of his life and always overexaggerated his storyline; he was funny. He and his best friend, Mike (the best man at our wedding), seemed to always have a made-up name for so many things in life. They were quite a creative team. They called themselves "salt and pepper" since Bob was white and Mikey was black. Bob was very supportive of my art career and helped me out while I was attending the Academy of Art University in San Francisco. He was, in a sense, a very creative person too.

Bob dreamed of accomplishing two things in his life: The first was to buy a mobile hotdog cart and peddle it around San Francisco, selling his homemade perogies and Philadelphia cheesesteak sandwiches. Early on, he had introduced me to those two food items

while visiting Bethlehem, Pennsylvania, his hometown. His second dream was to write a book with photos of the homeless on the streets of San Francisco and to include the funny things they said to him. Since his main territory as a salesman was right smack in the middle of San Francisco, he experienced crazy things from the street people daily—"city shenanigans" as he called them.

If he had lived long enough, I'm sure he would have accomplished his two dreams, and I certainly would have helped him create his book. Sadly, he passed away one night from a hypertensive cardiovascular disease at the young age of forty-nine. After we had divorced, he led a life of drinking, smoking cigarettes, and eating too much junk food, and he never renewed his blood pressure medicine—which all contributed to his death.

Flying Through Life by the Seat of My Pants: It was to have been a comical book that I didn't finish; I may someday. It was to be about how I have glided through life literally by flying by the seat of my pants without a plan; I just sort of followed others and never had my own direction. My sister Nancy calls it sliding through life on a wing and a prayer. This expression hit a chord with me. The phrase originated during World War II. The earliest reference I could find on the internet was in the 1942 film *The Flying Tigers*. The screenplay, written by Kenneth Gamet and Barry Trivers, has John Wayne's character, Captain Jim Gordon, saying this in reference to the flight of replacement pilots. *Gordon*: "Any word on that flight yet?" *Rangoon hotel clerk*: "Yes sir, it was attacked and fired on by Japanese aircraft. She's coming in on one wing and a prayer."

You need to first understand the meaning behind the expression in order to grasp how I had come to that point in my life. The meaning of "fly by the seat of your pants," according to www.collinsdictionary.com is "If you fly by the seat of your pants or do something by the seat of your pants, you use your instincts to tell you what to do in a new or difficult situation rather than following a plan or relying on equipment."

There are many references to it in US newspapers from 1943

on and was actually released as a Hollywood film in 1944. I also learned that this phrase originated with the World War II patriotic song "Comin' in on a Wing and a Prayer" (1943), by Harold Adamson and Jimmy McHugh, which tells of a damaged warplane, barely able to limp back to base.

Dream Flight: I had the idea and desire many years ago to write another book, but this one would be about a dream flight because I have always wanted to fly. Since I was a young child, my friends and I would make a cape, drape it across our shoulders, climb up on my fence, and flap the cape like wings and try to fly off the fence. Thank goodness we never tried to fly off the roof of a house! As long as I can remember, I wanted to be free like a bird and fly, feeling the wind whip through my hair. Experiencing the freedom to fly on my own has always been such an intense desire. To this day, I have dreams of running to get momentum to leap up and up and up until I am gliding. I have many dreams of flying over lakes and rivers and breathing in the beauty of nature below me. What a sense of freedom with no ties.

The Cat Next Door: This will be a children's book, which I intend to write next. It will be a silly fantasy story inspired by my daughter-in-law Vicky about the antics of the cat next door.

Adventures of Sneedleberry Farm: This will be another children's book, inspired by my young friend Kell Sneed. Years ago, when Kell and her husband, Danny, had a farmyard full of animals in Waterford, Kell and I talked about writing a book about the adventures on their property with all their farmyard animals. This will be a whimsical kind of project someday. Kell, I promise, I will write this for you!

Special Significance of the Tattoo: My sister Nancy and I once brainstormed about writing a book on tattoos. The book would include people with tattoos, and we would ask them what the special meaning was behind their tattoos. We would photograph their tattoos, and I would draw their tattoos for the book. We will write this, too, someday.

Chapter 78

Worldwide Spread of Covid-19 Pandemic. In March 2020, US President Trump declared a public emergency and issued the highest level of travel warning because of the coronavirus. Trump gave an Oval Office address to the public, and the World Health Organization announced that it was a global pandemic. President Trump suspended all travel from Europe to the US. Young and healthy persons should expect to recover quickly if they get the virus. The highest risk is for the elderly population and those with underlying health conditions. The best defense, we were told, is good hand hygiene and education. We were advised to practice good hygiene, including washing our hands or using hand sanitizer, trying not to touch our face or eyes, and coughing or sneezing into our armpit or sleeve. A mask in the beginning was not required, unless we were around people who were coughing or sneezing a lot. Clorox wipes kill the coronavirus, and we should wipe down surfaces, such as our desks, and allow to air dry. If we were sick, we were advised to seek medical advice/help from our physician and to stay home until we were well.

Many of my fellow face and body painters were beginning to lose their gigs during that time, and eventually I experienced the same loss of clients. I remember feeling that it was not real and that

I was not going to lose my clients—until I experienced losing my first gig in March and then another and another, just like my colleagues. That is when the reality hit home, and I began to realize it was a real situation. We all felt numb. How could this happen? How could this be? Was it really real? My business has usually grossed at least $12,000 to $15,000 a year, which is a nice supplement to my full-time income. It has been a pretty lucrative side business until the day when it came to a sudden halt. After a couple months, it sank in that it was real and not just a joke, and we as entertainers fell under the same mandate as spas, gyms, hairdressers, masseuses, etc. We were strongly advised to shut down in order to slow the spread of this deadly global virus. The new stay-at-home order was way too surreal.

A stay-at-home order is an order from a government authority that restricts movements of a population as a mass quarantine strategy for suppressing or mitigating an epidemic or a pandemic. Residents are ordered to stay home, except for essential tasks or for work in essential businesses. The medical distinction between such an order and a quarantine is that a quarantine is usually understood to involve isolating only selected people who are considered to be possibly infectious rather than the entire population of an area. In many cases, outdoor activities are allowed and nonessential businesses are either closed or adapted to working from home. In some regions, it has been implemented as a round-the-clock curfew or called a shelter-in-place order, but it is not to be confused with a shelter-in-place situation. Similar measures have been used around the world, and both officially and colloquially, different names have been used to refer to them, often only loosely linked to the term's actual medical meaning.

California Governor Gavin Newsom declared a stay-at-home order in March 2020, except for essential needs or jobs, and indoor shopping malls and nonessential retail were required to close. Newsom said the statewide order was consistent with the local orders. Places like grocery and convenience stores, delivery

restaurants, gas stations, pharmacies, banks, and laundromats would remain open. Bars, nightclubs, theaters, gyms, and convention centers had been ordered closed. The goal was to encourage "social distancing," which health experts have stressed can slow the spread of the disease and keep health systems from being overwhelmed. The governor hoped people would voluntarily obey the order to stay at home if possible, saying, "There's a social contract here. People, I think, recognize the need to do more and to meet this moment." California, which has a population of about forty million, was among the first states to order restrictions statewide.

I tend to overreact to new and strange situations, so on the first day that we were mandated to wear face masks, I recall walking into my day job to find everyone wearing a mask. I felt a real sense of anxiety as if I was in a zombie movie. When I was told that I was required to wear one too, I freaked out. How could this be real? After the first day of this new reality, I told my boss I couldn't do this anymore; I needed to quit. Thank goodness she convinced me that my feelings were normal under the present situation, and the reality began to set in. I realized I was not alone.

We as face painters, body painters, DJs, caricature artists, henna artists, photographers, balloon twisters, etc.—everyone in the entertainment/event industry and other industries—have been suffering with each of our businesses. We must all wear face masks in public and on the job, as well as practice good handwashing hygiene and social distancing (staying at least six feet apart). It was a horrible shock to us all. At the time of this writing, the global pandemic has lasted almost two years.

What saddens me is that businesses have spent thousands of dollars to guard against Covid-19, buying personal protective equipment for their employees, special signage, vinyl protective shields for workstations, and infrared temperature thermometers, not to mention the time and effort spent on creating a new process for screening employees as they enter the building. So many people around the world have been getting this horrible disease, and many

with underlying health conditions have been dying from it. Adults of any age with certain underlying medical conditions are at increased risk for severe illness from the virus that causes Covid-19.

When vaccinations were developed and became available, I resisted for the longest time only because I was healthy and never even had a flu or shingles vaccination, so I was determined that I would never get Covid-19 and didn't need to get vaccinated. As time went on, I learned that possibly in the future, the vaccinations would be required in order to fly and even face paint for events—it was enough to convince me, so I am now completely vaccinated without any symptoms.

At the time of this writing, my face painting colleagues and I were starting to receive several requests for events. It will take me a while to feel comfortable enough to resume my business, so I just dusted off my face painting kit, ordered new product, and looked forward to getting back into the swing of things. I was excited to be reunited with my balloon-twisting partner, Daryl. We both had to dust off our supplies and very happy to get back into the business! I certainly began using the utmost hygiene when face painting kids.

Daryl and I met several years ago when I first started face painting. We worked a birthday gig together in Newman in 2013. We exchanged business cards back then but never crossed paths again until five or six years later. Daryl, Mr.e.balloons, called me to see if I would join him in working a gig, so I did. Since then we've developed a friendship and a close working relationship and have worked together over the years. I enjoy working next to Daryl. He is so good with children and creates wonderful balloon characters. He dresses up in a tie-dye T-shirt and hat. His favorite line is asking the child how old he or she is and if they have ever been married. I laugh every time. My other favorite line of his is "What grade are you in?" Then he comments that he was once in that grade too.

Positive news: As of late June 2021, many people have received their vaccinations against this deadly global disease, and the world is starting to open up shops, restaurants, etc. We have learned as face

painters and entertainers how to conduct our businesses while protecting ourselves, as well as our clients, as we continue to practice our artistry for the public.

Effective June 15, 2021, California was to align its mask guidance with CDC recommendations. This guidance provides information about where masks may still be required or recommended. The goal is to prevent transmission to people with a higher risk of infection; those with prolonged, cumulative exposures (like workers); or those whose vaccination status is unknown. When people who are not fully vaccinated wear a mask consistently and correctly, especially indoors, they protect others as well as themselves. We have hope and pray for an ending of this horrible global pandemic.

Chapter 79

The "Positive Vibes" video program was created shortly after the governor declared a stay-at-home order 2020. My employer designed a series of videos for children who were ordered to stay home to learn online how to keep busy at home by creating fun arts and crafts projects. I had the pleasure of demonstrating four different craft projects.

My first video demonstration was using a heart-shaped Styrofoam piece and wrapping it with tied and cut strips of fabric and then applying glitter for a festive effect. I was pretty nervous since it was out of my comfort zone, but I pressed on for the experience.

My second video demonstrated how to create a gift box by folding a greeting card in a certain way. Mom showed me how to make these several years ago. You need to have a really thick card; otherwise, your box will be flimsy. My second experience behind the camera was a little easier, and we had fewer retakes.

My third video was demonstrating how to decorate a Christmas ornament using a clear ball with paint and glitter on the inside and outside. And the fourth was a demonstration of placing two pieces of fleece fabric together, clipping two-inch cuts all around the fabric, and then taking each set of strips and tying them together which makes a cute little blanket or throw to cover yourself while watching TV.

Doing the videos was a great experience for me in front of a live camera, which gave me confidence in speaking and demonstrating my craft. Later the photographer made a funny video of bloopers from all the people demonstrating their crafts. I was in the video a couple of times. It was hilarious.

Chapter 80

The following books and publications have given me inspiration in my art, in my business, and in my personal self-growth:

The Artist's Way: A Spiritual Path to Higher Creativity: My dear friend and coworker, Tanya, gave me the book, written by Julia Cameron, and it is highly recommended for artists. It's an empowering book for aspiring and working artists. With the basic principle that creative expression is the natural direction of life, the author leads you through a comprehensive twelve-week program to recover your creativity from a variety of blocks, including limiting beliefs, fear, self-sabotage, jealousy, guilt, additions, and other inhibiting forces, and replace them with artistic confidence and productivity. The *Artist's Way* links creativity to spirituality by showing in nondenominational terms how to tap into the higher power that connects human creativity with the creative energies of the universe. The book guides you through a variety of highly effective exercises and activities that spur imagination and capture new ideas. With your spiritual orientation, *The Artist's Way* will resonate in your creative mind with truth, wisdom, and inspiration.

A learning exercise that I took away from the book was the ""morning pages." "In order to retrieve your creativity, you need to find it. Every day you write three pages of your stream of

consciousness. There is no wrong way to do morning pages. They are not meant to be art. "Writing is simply one of the tools," writes Julia Cameron in her book. "Pages are meant to be, simply, the act of moving the hand across the page and writing down whatever comes to mind. Nothing is too petty, too silly, too stupid, or too weird to be included. The morning pages are not supposed to sound smart—although sometimes they might. Most times they won't, and nobody will ever know except you." Nobody can read them except you. And you shouldn't even read them for the first three weeks or so. Just write three pages daily in a journal. All that angry, whiny, petty stuff that you write down in the morning stands between you and your creativity. The morning pages are the primary tool of creative recovery.

As blocked artists, we tend to criticize ourselves mercilessly. Even if we look like functioning artists to the world, we feel we never do enough and what we do isn't right. We are victims of our own internalized perfectionist, a nasty internal and external critic, the censor who resides in our left brain and keeps up a constant stream of subversive remarks that are often disguised as the truth. The censor says wonderful things like "You call that writing? What a joke! You can't even punctuate" or "If you haven't done it by now, you never will" or "You can't even spell. What makes you think you can be creative?" Make this a rule: always remember that your censor's negative opinions are not the truth. This takes practice. By spilling out of bed and straight onto the page every morning, you learn to evade the censor. The point is to stop taking the censor as the voice of reason and learn to hear it for the blocking device that it is. Morning pages will help you do this. They will teach you to stop judging and just let yourself write. Your artist is a child and it needs to be fed. Morning pages feed your artist child, and they do get us to the other side—the other side of our fear, our negativity, and our moods.

Artist Brain is our inventor, our child, our very own absent-minded professor. It is our creative, holistic brain. It thinks in patterns and shadings. Artist brain is associative and freewheeling. It makes new

connections. The morning pages teach the logic brain to stand aside and let the artist brain play. We will alter our brain hemisphere, lower our stress, discover an inner contact with a creative source, and have many creative insights. Through meditation, we acquire and eventually acknowledge our connection to an inner power source that can transform our outer world. In other words, meditation gives us not only the light of insight but also the power for expansive change. The morning pages are a pathway to a strong and clear sense of self. They are a trail that we follow into our own interior where we meet our own creativity and our creator. Without them, our dreams may remain terra incognita. By using them, the light of insight is coupled with the power for expansive change. Anyone who faithfully writes morning pages will be led to a connection with a source of wisdom within."

Art & Fear: Observations on the Perils (and Rewards) of Artmaking: This book, written by David Bayles and Ted Orland, discusses the questions: "What is your art really about? Where is it going? What stands in the way of getting it there? These are questions that matter, questions that recur at each stage of artistic development, and they are the source for this volume of wonderfully incisive commentary. *Art & Fear* explores the way art gets made, the reasons it often doesn't get made, and the nature of the difficulties that cause so many artists to give up along the way. This is a book about what it feels like to sit in your studio or classroom, at your wheel or keyboard, easel, or camera, trying to do the work you need to do. It is about committing your future to your own hands, placing free will above predestination, choice above chance. It is about finding your own work."

Some takeaways I learned from this book are as follows: "Most who begin, quit. It's a genuine tragedy. Worse yet, it's an unnecessary tragedy. After all, artists who continue and artists who quit share an immense field of common emotional ground. We are all subject to a familiar and universal progression of human troubles—troubles we routinely survive, but which are, oddly enough, routinely fatal to

the art-making process. To survive as an artist requires confronting these troubles. Basically, those who continue to make it are those who have learned how to continue or have learned how to not quit. Artists quit when they convince themselves that their next effort is already doomed to fail. And artists quit when they lose the destination for their work—for the place where their work belongs. Fear that your next work will fail is a normal, recurring, and generally healthy part of the art-making cycle. It happens all the time; you focus on some new idea in your work, try it out, run with it for a while, reach a point of diminishing returns, and eventually decide it's not worth pursuing further. Writers even have a phrase for it—"the pen has run dry"—but all media have their equivalents.

In the normal artistic cycle this just tells you that you've come full circle, back to that point where you need to begin cultivating the next new idea. Quitting is fundamentally different from stopping. The latter happens all the time. Quitting happens once. Quitting means not starting again—and art is all about starting again. A second universal moment of truth for artists appears when the destination for the work is suddenly withdrawn.

Your desire to make art—beautiful or meaningful or emotive art—is integral to your sense of who you are. If making art gives substance to your sense of self, the corresponding fear is that you're not up to the task, that you can't do it, can't do it well, can't do it again; that you're not a real artist, not a good artist, or have no talent or nothing to say. Those all are big ones for me! The line between the artist and his or her work is a fine one at best, and for the artist it feels like there is no such line. Making art can feel dangerous and revealing. Making art precipitates self-doubt, stirring deep waters that lay between what you know you should be and what you fear you might be. For many people, that is enough to prevent ever getting started at all—and for those who do, trouble isn't long in coming." This is really an invaluable book for all artists to read!

As they say, "Quitting is not an option."
Building Your Family Entertainment Brand with Quality Facebook

Content: Christopher Weed has a demonstrated history of working in multiple industries, including showtime magic, entertainment, balloons, and bubble making. This publication was one that I purchased at one of the conventions I attended. It is a narrative of his real-world experiences with his businesses. His intention is to show what he has done that works and doesn't work, and to share some common mistakes he has seen many performers make. His primary focus is to discuss branding as it relates to family entertainers with examples of content to help build a brand and grow your business. His publication was very helpful for my business and included topics such as branding, advertising and marketing, photos, long-term growth, social media content, events, tagging a business or organization on social media, and how to maintain your client list.

Practical Facebook Marketing for Family Entertainers: I also purchased Christopher Weed's publication at another convention. His publication focuses on today's marketing world for entertainers. One thing that stood out was in order to compete in today's environment, you have to be better than just a commodity. You need a better, more unique product. The better and more unique your product, the better suited you are as a Facebook advertiser. He discusses in his book the marketing mix, rules for marketing on Facebook, success requiring an ongoing commitment, marketing plans, Facebook content, event posts, understanding your target customer, income, budget, duration, and measuring results. Both of Christopher's publications have been an asset to me with an abundance of knowledge to grow my business.

Face and Body Art International Convention Magazine: I've purchased several magazines, books, and publications over the years, pouring over the contents and learning from the visual designs I use in my own business. One in particular that I purchased several editions of is this particular magazine written by Marcela Murad. I also have purchased a number of these magazines that highlight the annual FABAIC conventions in Orlando, Florida. Marcela says, "This has been a dream come true and made a reality." Artists in the US were

just beginning to discover the wonderful world of face and body painting, and through the years, she has seen many transformed into professional artists who bring smiles to faces, create living masterpieces, employ and empower other artists, and help our industry reach new levels. Her personal goal has always been to be influential in helping to expand our industry in ways that create more jobs, educate new painters, and inspire painters to never stop learning.

Marcela has said, "Most of us feel uncomfortable thinking of ourselves as artists, but we are. An artist is someone who creates. Someone with good listening skills who accesses the creative energy of the universe to bring something on the material plane that was not here before. This could manifest in the form of a book, a painting, a ballet, or a new face design. We create our artwork by making big and little choices between playing it safe and risking it. We need to trust our instincts in order to develop our own style. Each time we hold a face as our canvas, we are given a chance to try something new, remembering that work in progress is never perfect. Maybe another color can be added to the canvas, a line can be extended, or the placement of details experimented with. Each time we experience the new, we become receptive to inspiration."

Extreme Face Painting: 50 Friendly and Fiendish Step-by-Step Demos: I purchased this book, written by Brian and Nick Wolfe, and it has inspired me in my own business with examples and designs. Quoted from their book is "Brian and Nick Wolfe have been painting faces professionally for years. Influenced by comic books, movies, fantasy, fine art, and anatomy, they perfected their craft in major theme parks, haunted attractions, fairs, and festivals. The twins have demonstrated their art at trade shows, conventions, and in private homes all around the world. They have studied techniques and theories behind the creative process, and new age, self-help, and quantum physics books have influenced their philosophies. They are quick with a smile and find the good in everyone and every situation. They describe their workshops as spiritual healing classes with a face painting gimmick, and they are the current world champion

brush and sponge body painters. When they are home in Orlando, they are making costumes, playing heavy metal guitar, singing, or partying with friends and family. They are extremely enthusiastic and eagerly share their ideas at eviltwinfx.com.

This fabulous book includes fiendish faces, materials, split paint cakes, face painting kit setup, color wheel, sponge techniques, brush techniques (painting thick to thin lines, stars, swirls and curls, raindrops and teardrops and eyes). It also includes cotton swab techniques, shading and outlining, and more." It contains valuable information for the face painter, and I've the pleasure of meeting both Brian and Nick Wolfe in person a few times and have attended their workshops and learned so, so much from them!

Illusion: The Magazine for Today's Face and Body Artist: This magazine has been an inspiration for me all along my face painting journey. The following is stated on Illusion's website. "Illusion is 'the' magazine for face and body artists across the world. Published three times a year in Spring (March), Summer (July) and Winter (November), regular features include:

- The Magazine for Today's Face and Body Artist
- Claire Pick
- Julie Oliver
- Welcome to
- In-depth interviews with world-renowned artists (click on 'featured artists' to take a look at some of the stars we've spoken to already)
- Original artwork created exclusively for Illusion to wow and inspire you
- Innovative business ideas and advice
- Easy to follow step-by-steps
- Under the spotlight feature focusing on emerging talent
- Gallery page—our pick of the best submissions from our readers
- Product and book reviews

Tattoo Johnny: I purchased this book written by David Bolt on three thousand tattoo designs in 2012 from Silly Farm Supplies in Florida when owner Marcela Murad gave me a personal tour of the shop. The tattoos in this reference book provide inspiration for face painting designs and I refer to it many times for ideas.

Steal Like an Artist: Written by Austin Kleon, this is a fun book to read. The author shares ten things nobody told you about being creative. His chapters include "Don't Wait Until You Know Who You Are to Get Started," "Write the Book You Want to Read," "The Secret: Do Good Work and Share it with People" and "Creativity is Subtraction." In his book, the author quotes T. S. Eliot: "Immature poets imitate; mature poets steal; bad poets deface what they take, and good poets make it into something better, or at least something different. The good poet welds his theft into a whole of feeling which is unique, utterly different from that from which it was torn."

Show Your Work: Also written by Austin Kleon, this book lists ten ways to share your creativity and get discovered. Chapters include "You Don't Have to Be a Genius," "Think Process, Not Product," and "Open Up Your Cabinet of Curiosities." The author quotes Honoré de Balzac: "For artists, the great problem to solve is how to get oneself noticed."

The Blank Canvas (Inviting the Muse): This book, written by Anna Held Audette, is a really good book to read. Chapters include "Art from Art," "Other Popular Sources," "Overcoming Difficulties," and "Getting Started Figuratively." The motivating introduction begins with "Every art student will, at some point, be faced with a blank piece of paper, an empty canvas, or a lump of clay and must respond to the daunting question, 'What shall I do?' Suddenly the teacher's supportive, descriptive pictorial assignments have stopped. There is no instructor to give the subject or framework of what must be done, leaving just the specifics to be filled in."

Entertainment Business Magic: This booklet written by Lori M. Hurley holds invaluable information about making real money as an artist or entertainer at special events. The preface states, "In an

unstable world, in a fluctuating economy, people are searching for a solid foundation for building financial freedom. Many people will abandon their dreams to work a 'stable' job during the best, most productive years of their lives, hoping to amass enough wealth so that they can someday retire and finally do that thing they always said they wanted to do, even though their bodies will be far from able to do that thing, and their children will be too busy raising their own families to notice that their parents are finally available. The book is written for the entertainer who is ready to take life by the horns and create the kind of success and freedom that others are waiting for retirement to have. The writer is not opposed to having a great retirement, but is even more committed that the entertainers who read this book begin to recognize that they can have a life worth living right now, while they are young enough, healthy enough, vibrant enough, and still skilled enough to have that life!"

Code to Joy: The Four-Step Solution to Unlocking Your Natural State of Happiness: This book was recommended in a self-improvement workshop for artists that I took. It is the proven four-step program to lifelong happiness. It draws the reader to a new way of thinking and being, and eliminates that fog of distress that haunts so many. George Pratt, PhD, is a master clinician and skilled storyteller whose work will guide you to a happier, more joyful life. The book is an inspiring, enlightening journey to connect with your true self and be the loving being you were created to be. This made quite an impact on me.

An Illustrated Life: I became a "Danny Gregory groupie" at one point and started following him. Danny has written a dozen internationally best-selling books on art and creativity and is the founder of Sketchbook Skool with tens of thousands of students worldwide. Through his books and in the large online communities he oversees, Danny has shown tens of thousands of people how to ignite their inner artist, embrace their creativity, and tell the stories of their lives. From Boston to Beijing, people who haven't drawn since grade

school have picked up the creative habit and have gone on to publish books of their own and show and sell their artwork.

Sketchbook Skool is a video-based art school designed to inspire creative storytelling through illustrated journaling. Taught by the world's best illustrators, artists, and educators, Sketchbook Skool encourages its global community of over fifty thousand students to draw and keep a sketchbook regardless of skill level.

Danny spent three decades as one of New York's leading advertising creative directors and has created award-winning, global campaigns for clients such as Chase, JP Morgan, American Express, IBM, Burger King, Ford, and Chevron. He was born in London; grew up in Pakistan, Australia, and Israel; and graduated from Princeton University. He lives in Phoenix, Arizona.

For inspiration, I also purchased his books *Art Before Breakfast: A Zillion Ways to Be More Creative No Matter How Busy You Are, The Creative License: Giving Yourself Permission to Be the Artist You Truly Are,* and *Everyday Matters: A Memoir.*

"Be around people who can keep your energy and inspiration high. While you can make progress alone, it's so much easier when you have support." –Joe Vitale

Chapter 81

Reflections.

The following are my reflections I've observed as a face painter over the years. I learned face painting by trial and error and repetitiveness. I've overcome my shyness, fear, and self-doubt. Going out on a gig is basically like getting on stage and performing in front of strangers. I've gotten used to it from experience over and over and have gained the confidence to "perform" without hesitation and nervousness—the butterflies are gone. With each gig I've learned to interact with people and am now able to not only perform with my standard designs but also to create or duplicate designs on demand. This experience has given me confidence and the ability to think on my feet and find the freedom to create. With every gig I used to have butterflies in my stomach from nervousness, hoping I was good enough for my client and guests. I had those butterflies for many years until I became confident that I knew my clients were satisfied with my work. I no longer compared my skill level with other face painters.

Many time moms standing in line with their children waiting to be face painted ask me how I got started in the business of face painting. I always enjoy sharing the story of my own mom encouraging me to pursue it, and without her persistence even when I resisted, I would not even be writing this book! I love you Mom.

Chapter 81

And I will never get tired of my subjects sitting in my chair while I'm painting their faces ask me, "Are you a real artist?!" Do you know how good that feels to ones confidence?

In my twenty-five-plus years of face painting, I have gained the confidence to perform at an event without hesitation or butterflies in my stomach. I have also gained the confidence to travel alone without fear or apprehension. As an artist, I feel good that I have never given up or stopped but keep going. With other arts and crafts, I have gone with the seasons of my life, and nothing really stuck like face painting but I've never lost interest in this industry; I enjoy painting children and seeing their reaction when they look in the mirror. My best months in the business are April through September. January through March is kind of a downer because of the lack of business, but I do make use of those months to catch up on my paperwork, filing, bookkeeping, and marketing for the upcoming months.

I've received consultation from mentors, and with their help, I am constantly learning technology, marketing techniques and strategies, and communication skills. The face painting workshops and conventions that I've attended have taught me invaluable techniques, skills, and marketing tips and have given me the opportunity to meet and network with fellow face painters all over the globe.

My face painting business has given me the feeling of camaraderie with other face painters and entertainers. It has given me the ultimate reward and satisfaction, knowing my clients love my work. When I tell the child in my chair that he or she is beautiful or handsome, or that a particular paint or design looks good on their face, or compliment them on their choice of design, it gives me ultimate gratification, especially when they light up with glee. Over the years I have been hired by several corporations for their grand openings, holiday events, employee appreciation events, baseball games, customer appreciation events, and more; all of which I appreciate because these events lead to more events, more exposure, and repeat events year after year. I think the biggest accomplishment in

the business is when I'm asked to paint a specific image, logo, or cartoon character and it comes out good. What a great feeling.

I used to lower my price when clients would ask if I could "do better with pricing." A few clients complained about having to pay for the ponies, clown, taco guy, magician, and snow cone machine and expected me to lower my fee. I fell for it twice, and that was enough.

I evaluated these experiences afterward and realized that I had allowed myself to succumb to their whining, thereby lowering my standards, not to mention feeling like a twit!

Many times I was asked to do freebies for nonprofits or community events and was promised that it would be good exposure for my business. Some even offered to put my business name in their advertising, which would give me even more exposure. I finally learned that it didn't work for me and it was never a win-win situation. It was a win for the client and a loss for me.

In the beginning I opened a private mailbox and had it for two years. During that time, I used the mailbox address for my marketing and advertising. What a waste of money. It did not get me one client.

I also learned over my years in business that I could make more money by the hour with private or corporate events than I would make at an all-day festival sitting in the hot sun or dealing with the elements of nature, such as extreme wind, dust, and even rain. Back in the day when I first started my business, festivals were very lucrative, and I would sometimes make up to $1,000 in one day. Not anymore. Parents no longer want to put out the money to have their children's faces painted at a festival just to go home and wash it off. Needless to say, I don't do festivals anymore unless a fellow face painter asks me to share their booth to help them out or when there's a highly populated festival and they are doing, say, sugar skulls, which are extremely popular.

One of the things a face painter deals with when working outdoor events is the elements. I have dealt with hot climates where my paints would start melting. Sometimes when working at a park, the

wind would be so ferocious that I had to anchor down my supplies and sample sheets. When working under the shelter of trees, many times you have to deal with spiders and leaves and dust that get in your paints. And how do you deal with sweating in hot weather? Many times I have brought a mini fan or water sprayer for my face to keep me comfortable. When painting in the colder climate, you have to deal with your hands going numb. That's embarrassing. So I use fingerless gloves for those occasions.

Face and body art conventions: I have attended numerous face and body art conventions and workshops in San Francisco, San Bruno, San Jose, Los Angeles, Visalia, Florida, Washington, DC, and St. Louis.

Working cruise ships: I've taken five Caribbean tours so far providing face painting to passengers on the cruise ships. That is a thrilling adventure, and I plan on continuing to work the ships. Islands I've toured are San Juan, Puerto Rico; St. Croix, Virgin Islands; St. Maarten/St. Martin Kingdom of the Netherlands; Martinique, West Indies; Barbados, West Indies; Grenada (the Island of Spice); St. Thomas; Bahamas; Cayman Islands and Key West.

Chapter 82

The following are my reflections I've observed as an artist over the years. Art has always been an exhilarating experience for me. I love abstract painting because there's a certain freedom for me that sets my imagination free. I also love watercolor because it's challenging, and I love how the pigment seems to dance with the water. I tend to paint more realism with watercolor because I get more detailed. Each painting I complete is a celebration of the instinct that guides my every brushstroke. Daily sketching keeps me aligned with my purpose and on track with who I really am. I paint because it makes my heart sing. After finishing a painting, I get an indescribable feeling of accomplishment.

I've learned that my goal is to create alignment between my inner core values and my external actions which leaves me with a sense of clarity, happiness, and fulfillment. My core value gives me the foundation to build on when it comes to making decisions and taking actions in this area of my life.

Over the years I printed out scenes that I plan to paint someday and placed them in binders, but that someday never seems to come. One day when I was dusting, I came across three to four binders full of hundreds of scenes that I want to paint. Well, it took quite a while to go through each page, tossing most and keeping my favorites. I

got it down to just one binder. So, you see, even an artist can be not only a procrastinator but a pack rat as well.

With crafts I had the intention of trying every single one that I liked. I've tried several crafts, but after a time I learned that this is counterproductive because I cannot possibly work on multiple projects at the same time or one after another. If you've ever heard of "Jack of all trades and master of none," this figure of speech is used about a person who has dabbled in many skills, rather than gaining expertise by focusing on one. A jack of all trades is often a compliment for a person who is good at fixing things and has a good broad knowledge. This person is a generalist rather than a specialist. I sometimes feel like that person because I jump from one project to another, depending on my mood, and do not focus on one particular skill and mastering it.

When I start a painting, either acrylics or watercolor, I always feel like it will turn out inferior because it looks like nothing or it looks like mud until it's completed. A few times I've scribbled through the piece and wrinkled up the paper in a huff and walked away from the project. But when I do complete a painting that I'm satisfied with, it is such a feeling of joy that I cannot describe especially when it turns out looking like the actual subject! I feel so good about myself and my accomplishment. Using watercolor is the most difficult of all mediums to work with and you have to get the pigment to work with you. You can't overdo it; otherwise, your colors will get all muddled together and look like mud. I started out using watercolor but sometimes switch over to acrylics for abstract painting. Abstract art is somewhat difficult for me because I have to think outside the box and create with my imagination as opposed to painting from a subject. At least for me, that's how I work with acrylics, but it is a complete release of freedom when I've completed a piece. And what's interesting with abstract art, people interpret what they see in the painting, and sometimes people see different things.

I've also learned, as fellow artist Mary once told me, is that we, as artists, have our ups downs when it comes to the flow of creative

juices or ideas. We paint or write when we have those juices flowing, and sometimes we can hit a dry spell for months to years before we get it back. It's kind of like an ebb and flow, which is a recurrent or rhythmical pattern of coming and going or decline and regrowth. This expression makes reference to the regular movement of the tides, where ebb means move away from the land and flow move back toward it.

One thing I've come to realize is that from time to time over the years I threatened to discard my drawing table and my painter's easel that I received on my thirteenth birthday from Mom, Dad, and Nana. I am so grateful that I never discarded those two tools that have been essential in my life of painting.

wind would be so ferocious that I had to anchor down my supplies and sample sheets. When working under the shelter of trees, many times you have to deal with spiders and leaves and dust that get in your paints. And how do you deal with sweating in hot weather? Many times I have brought a mini fan or water sprayer for my face to keep me comfortable. When painting in the colder climate, you have to deal with your hands going numb. That's embarrassing. So I use fingerless gloves for those occasions.

Face and body art conventions: I have attended numerous face and body art conventions and workshops in San Francisco, San Bruno, San Jose, Los Angeles, Visalia, Florida, Washington, DC, and St. Louis.

Working cruise ships: I've taken five Caribbean tours so far providing face painting to passengers on the cruise ships. That is a thrilling adventure, and I plan on continuing to work the ships. Islands I've toured are San Juan, Puerto Rico; St. Croix, Virgin Islands; St. Maarten/St. Martin Kingdom of the Netherlands; Martinique, West Indies; Barbados, West Indies; Grenada (the Island of Spice); St. Thomas; Bahamas; Cayman Islands and Key West.

Chapter 82

The following are my reflections I've observed as an artist over the years. Art has always been an exhilarating experience for me. I love abstract painting because there's a certain freedom for me that sets my imagination free. I also love watercolor because it's challenging, and I love how the pigment seems to dance with the water. I tend to paint more realism with watercolor because I get more detailed. Each painting I complete is a celebration of the instinct that guides my every brushstroke. Daily sketching keeps me aligned with my purpose and on track with who I really am. I paint because it makes my heart sing. After finishing a painting, I get an indescribable feeling of accomplishment.

I've learned that my goal is to create alignment between my inner core values and my external actions which leaves me with a sense of clarity, happiness, and fulfillment. My core value gives me the foundation to build on when it comes to making decisions and taking actions in this area of my life.

Over the years I printed out scenes that I plan to paint someday and placed them in binders, but that someday never seems to come. One day when I was dusting, I came across three to four binders full of hundreds of scenes that I want to paint. Well, it took quite a while to go through each page, tossing most and keeping my favorites. I

got it down to just one binder. So, you see, even an artist can be not only a procrastinator but a pack rat as well.

With crafts I had the intention of trying every single one that I liked. I've tried several crafts, but after a time I learned that this is counterproductive because I cannot possibly work on multiple projects at the same time or one after another. If you've ever heard of "Jack of all trades and master of none," this figure of speech is used about a person who has dabbled in many skills, rather than gaining expertise by focusing on one. A jack of all trades is often a compliment for a person who is good at fixing things and has a good broad knowledge. This person is a generalist rather than a specialist. I sometimes feel like that person because I jump from one project to another, depending on my mood, and do not focus on one particular skill and mastering it.

When I start a painting, either acrylics or watercolor, I always feel like it will turn out inferior because it looks like nothing or it looks like mud until it's completed. A few times I've scribbled through the piece and wrinkled up the paper in a huff and walked away from the project. But when I do complete a painting that I'm satisfied with, it is such a feeling of joy that I cannot describe especially when it turns out looking like the actual subject! I feel so good about myself and my accomplishment. Using watercolor is the most difficult of all mediums to work with and you have to get the pigment to work with you. You can't overdo it; otherwise, your colors will get all muddled together and look like mud. I started out using watercolor but sometimes switch over to acrylics for abstract painting. Abstract art is somewhat difficult for me because I have to think outside the box and create with my imagination as opposed to painting from a subject. At least for me, that's how I work with acrylics, but it is a complete release of freedom when I've completed a piece. And what's interesting with abstract art, people interpret what they see in the painting, and sometimes people see different things.

I've also learned, as fellow artist Mary once told me, is that we, as artists, have our ups downs when it comes to the flow of creative

juices or ideas. We paint or write when we have those juices flowing, and sometimes we can hit a dry spell for months to years before we get it back. It's kind of like an ebb and flow, which is a recurrent or rhythmical pattern of coming and going or decline and regrowth. This expression makes reference to the regular movement of the tides, where ebb means move away from the land and flow move back toward it.

One thing I've come to realize is that from time to time over the years I threatened to discard my drawing table and my painter's easel that I received on my thirteenth birthday from Mom, Dad, and Nana. I am so grateful that I never discarded those two tools that have been essential in my life of painting.

Chapter 83

Snafus.

The following snafus and disappointments that I experienced as a face painter are now somewhat hilarious to me; but not so at the time!

One time I drove away from a corporate gig in Napa with my paintbrushes on the roof of my car, losing everything.

At another event I miscalculated the travel time to a street event in Daly City and showed up late without my paintbrushes in my kit; fortunately, I found a nearby store that had some brushes that I purchased. But the coordinator frowned at me for my tardiness and arriving disorganized. There was already a lineup of kids expecting to get their faces painted. So stressful!

Another time I overlooked a private gig because I didn't have it recorded in my day planner due to the client booking at the last minute. The client was unforgiving so I issued her a free coupon for her next event.

A couple of times I overbooked two events, but luckily, I was able to find someone else to fill in. It's really good to have a networking group of fellow face painters when times like this occur.

Another time I missed a repeat client's event because when I got to the venue, a ball park, no one was there that I could see and there

were no cars, so I turned around and went home. Later the client messaged me that he was there, but he had scheduled me much too early so no one was around.

Once I locked my car keys inside my car before a gig and couldn't start till AAA showed up. I also locked my cars keys inside my car after a gig and couldn't leave till AAA showed up.

Another time I forgot my mirror, which is essential for the children to see their beautiful faces. Can you imagine showing the child in your chair their beautiful face design with no mirror? It was devastating. But I improvised by letting them see their face using my cell phone camera as a mirror.

Once in the late fall I came down with the flu and I had to cancel four events—all from repeat clients! Luckily, however, I was able to reassign them to a fellow face painter, Lisa, who filled in for me. She was great.

After somewhat recuperating from my illness, I took on a repeat client, but since I had an injury to my right hand that left it numb, I couldn't use my mini spray pump to spray my face paints and it was quite an awkward challenge which I remedied by using both hands to pump the sprayer.

At one of the international FABAIC conventions I attended in Florida, my hotel roommate, Sandy, and I had the pleasure of painting a full-face green monster with fangs on a rep who was selling his product at a vendor booth. We did a stellar job painting his face as a team. He was so pleased that he asked if we would be open to the idea of teaching face painting to a group of teachers in New Orleans for pay, representing his product. We were on top of the world with excitement and the big time! And for me, any excuse to revisit New Orleans would be a dream come true. Well, unfortunately, he never followed up with either of us—a total disappointment.

A client once hired me for her fortieth birthday party, which was an adult outdoor event on her private premises. I face painted and bodypainted very few clients since, in my experience, not too many adults want to be painted. I finished my scheduled time, tried to

Chapter 83

track down my client for payment, and found her on stage with male strippers entertaining her. I wasn't about to approach her at that time, so I went home and communicated to her later for payment. With many excuses from her, it took six months to collect payment for a simple three-hour gig. From that experience I learned to collect payment or at least a deposit upfront.

Another time a repeat client from a golf and country club invited me to face paint at their annual Halloween event, which was held outdoors in their makeshift haunted house/barn. I happily accepted the invitation since they had been a faithful client for years. Well, it happened that her event was, of course, in the dark, and they were not prepared to provide proper lighting for me in their barn. I had children lined up for miles it seemed and as darkness started to fall, I could not see what I was doing. I asked for help, but it took a while for proper lighting to be installed. In the meantime, I learned that because of change of management, two other face painters were hired for the event and were located at the other end of the barn. So, with the lack of lighting and the competition, I was not that busy. That's okay; just another learning experience.

Epilogue

Now you know my secret!

Since you've read my book through to the end, you know that the reason I paint is because it makes my heart sing! (That is my purpose, and it began with making daisy chains.)

Art has always been an exhilarating experience for me. I am inspired by art with its beauty and because of the freedom I feel when I paint—my imagination is set free, and each painting I complete is a celebration of the Holy Spirit that guides my every brush stroke. Painting keeps me in alignment with my purpose and on track with who I am. *I paint because it makes my heart sing.*

As of this writing (February 2022), the outbreak of the coronavirus disease 2019 (COVID-19), originating in China, has spread pandemically now for over two years, and I am looking forward to the day that we can resume our lives as "normal" as once before—or at least as the "new normal" as they say.

After two long years without face painting, my career has begun to pick up and clients are starting to call me. I look forward to earning revenue again so I can resume with my travel plans exploring new places and meeting new people. I also plan to write another book and pursue my dreams.

"If you don't have some self doubts and fears when you pursue a dream, then you haven't dreamed big enough." –Joe Vitale

I hope you've enjoyed the reading!

Lynn Takacs

CPSIA information can be obtained
at www.ICGtesting.com
Printed in the USA
JSHW062259210622
27360JS00003B/8